WORLD WAR II ABANDONED PLACES

WORLD WAR II ABANDONED PLACES

MICHAEL KERRIGAN

amber
BOOKS

Published by
Amber Books Ltd
United House
North Road
London N7 9DP
United Kingdom
www.amberbooks.co.uk
Appstore: itunes.com/apps/amberbooksltd
Facebook: www.facebook.com/amberbooks
Twitter: @amberbooks

ISBN: 978-1-78274-549-5

Project Editor: Michael Spilling
Designer: Mark Batley
Picture Research: Terry Forshaw

Printed in China

Contents

Introduction

It lasted six years; involved almost a hundred countries; cost 70 million lives… yet the immense reality of World War II remains elusive. For the oldest among us, it's nothing more (or less) than 'living memory'; for the youngest, nothing less (or more) than 'history'. So close, chronologically, we feel we ought to be able to reach out and touch it; yet it's just tantalizingly out of reach, over time's horizon.

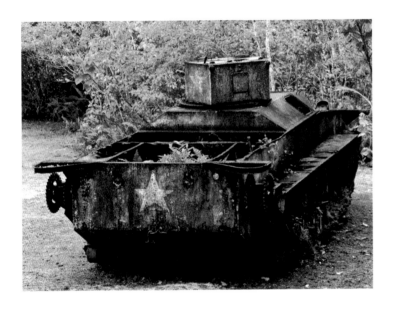

It's surely this that gives the derelict sites of World War II their special character. A mossy pillbox by a remote roadside; a ship wreck; a beach with tank-traps … unspectacular sites, yet peculiarly evocative. Any ruin is atmospheric, representing as it does both the destructiveness of time and the endlessly-reiterated presence of the past in the present moment. Where it is a past in whose shadow we still dwell, and whose violence is frequently recorded in the ruin itself, the deepest of emotions may be stirred.

ABOVE:
A US Marine Landing Vehicle Tracked (LVT) stands folorn on the Pacific island of Peleliu, a leftover from the vicious battle fought between the Americans and Japanese during 1944.

RIGHT:
Fort Istibey was a part of the Metaxas Line, a chain of defences built along Greece's northern border. Home to more than 300 soldiers, the fort surrendered following the German invasion in April 1941.

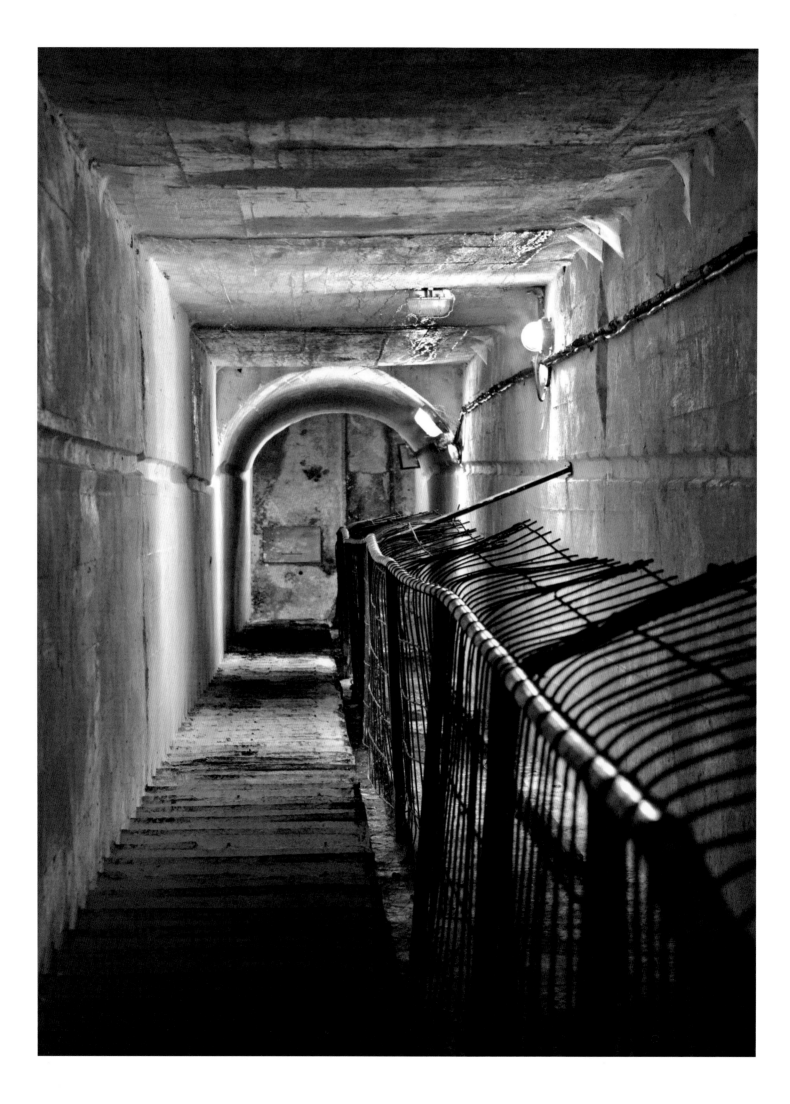

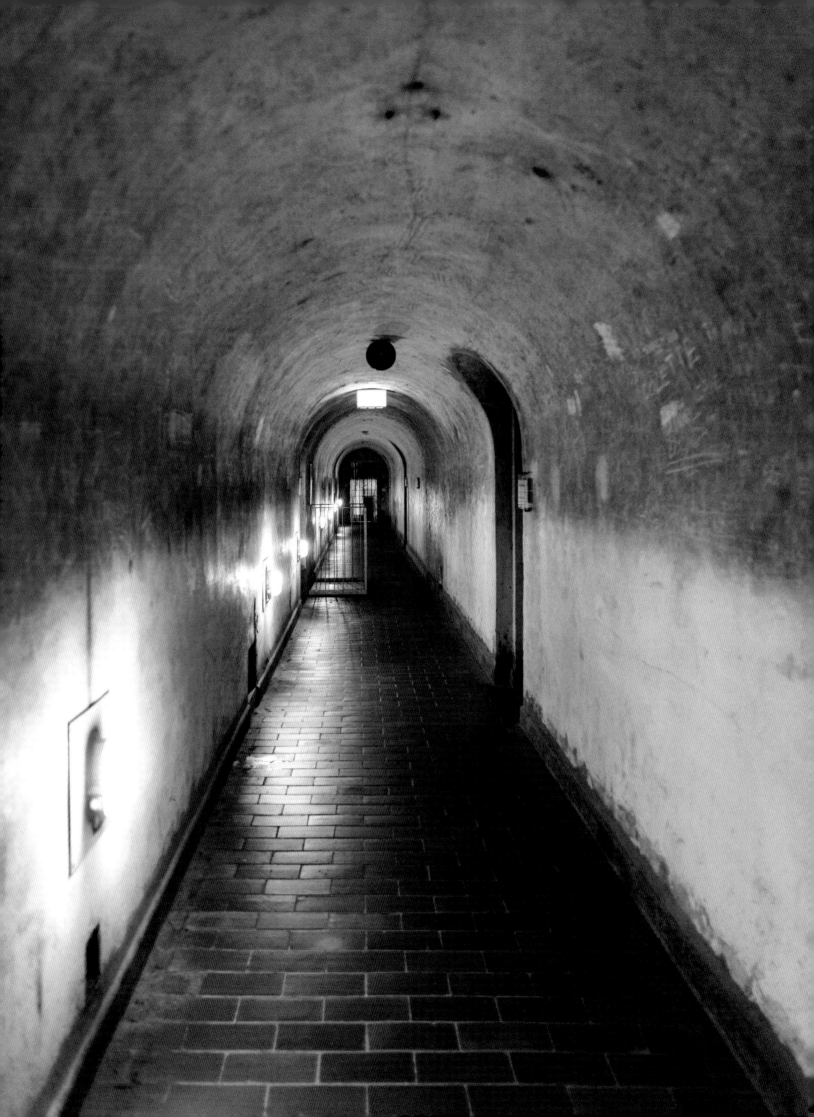

Germany and Central Europe

Hitler's idea had always been that his Nazi state would export its violence; that it would strike out boldly to east and west. If he'd dreamed for decades of seizing *lebensraum* ('living space') for his countrymen in the endless Russian marches, he was thrilled at the thought of conquering the wealthy democracies of the west.

The frontiers of the homeland had to be secured, of course: hence the construction of a 600-km (370-mile) Westwall – a network of fortifications extending all the way down its borders with the Netherlands, Belgium, Luxembourg, France and Switzerland. The Western Allies knew this as the 'Siegfried Line' – though that name belonged more properly to a World War I fortification the Germans had built in northern France.

The reality was that, the longer the war went on, the more surely and grimly it 'came home' to its country of origin. German cities were increasingly beleaguered by extensive air raids from the Western Allies. And then, in the months after the defeat at Stalingrad in early 1943, the threat from the east just grew and grew, till Soviet forces spilled across the German border at the beginning of 1945. By May of that year, Hitler's ambitions – and Germany – soon lay in ruins.

LEFT:

Tunnel, Obersalzberg, Bavaria
Hitler had been coming to the beautiful Alpine resort of Obsersalzberg for years before the war. When the fighting started, he had his weekend residence, the Berghof, fortified. Beneath ground level here was an air-raid shelter fit for a Führer – a far cry from the blank functionality of the bunkers to be seen elsewhere.

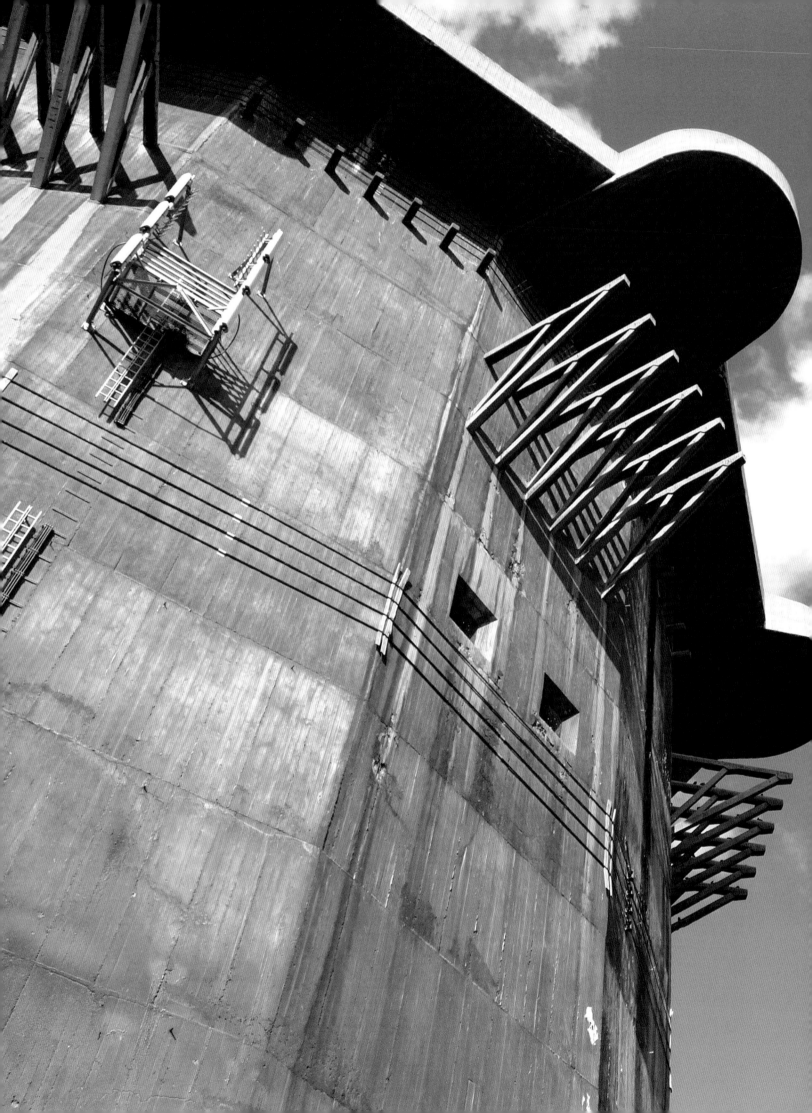

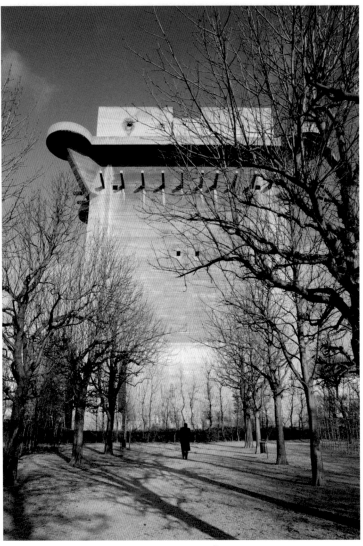

LEFT:

Flak Tower L, Vienna, Austria
It may look like a medieval
castle keep, but this tower could
hardly have been more modern
in its conception and was built as
recently as 1940. It served a dual
purpose: as an air-raid shelter for
the local population and as an
elevated platform for anti-aircraft
weapons.

ABOVE:

Flak Tower G, Vienna, Austria
So enamoured were the Germans
with the idea of the flak tower that
they built three in Vienna alone; a
further three in Berlin; a couple in
Hamburg and others in Frankfurt
and Stuttgart. The evidence
suggests, however, that they're
more impressive as monuments
than they ever were as protection
against air raids.

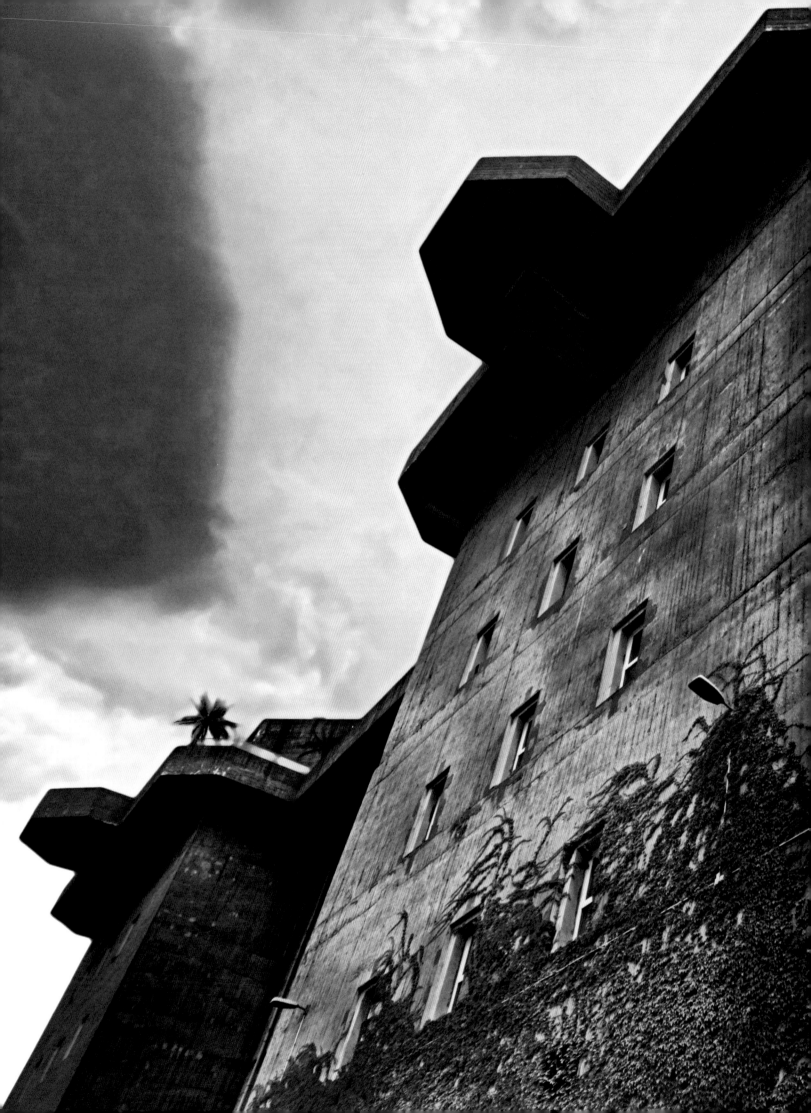

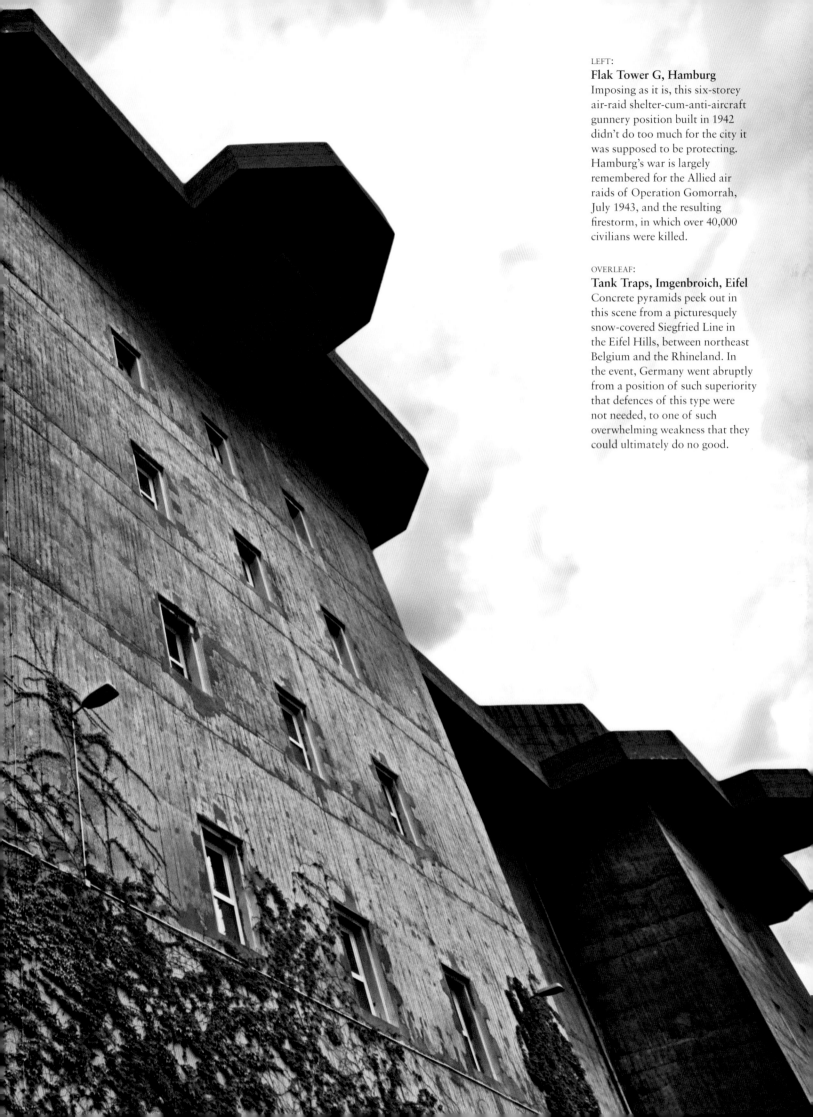

LEFT:

Flak Tower G, Hamburg
Imposing as it is, this six-storey air-raid shelter-cum-anti-aircraft gunnery position built in 1942 didn't do too much for the city it was supposed to be protecting. Hamburg's war is largely remembered for the Allied air raids of Operation Gomorrah, July 1943, and the resulting firestorm, in which over 40,000 civilians were killed.

OVERLEAF:

Tank Traps, Imgenbroich, Eifel
Concrete pyramids peek out in this scene from a picturesquely snow-covered Siegfried Line in the Eifel Hills, between northeast Belgium and the Rhineland. In the event, Germany went abruptly from a position of such superiority that defences of this type were not needed, to one of such overwhelming weakness that they could ultimately do no good.

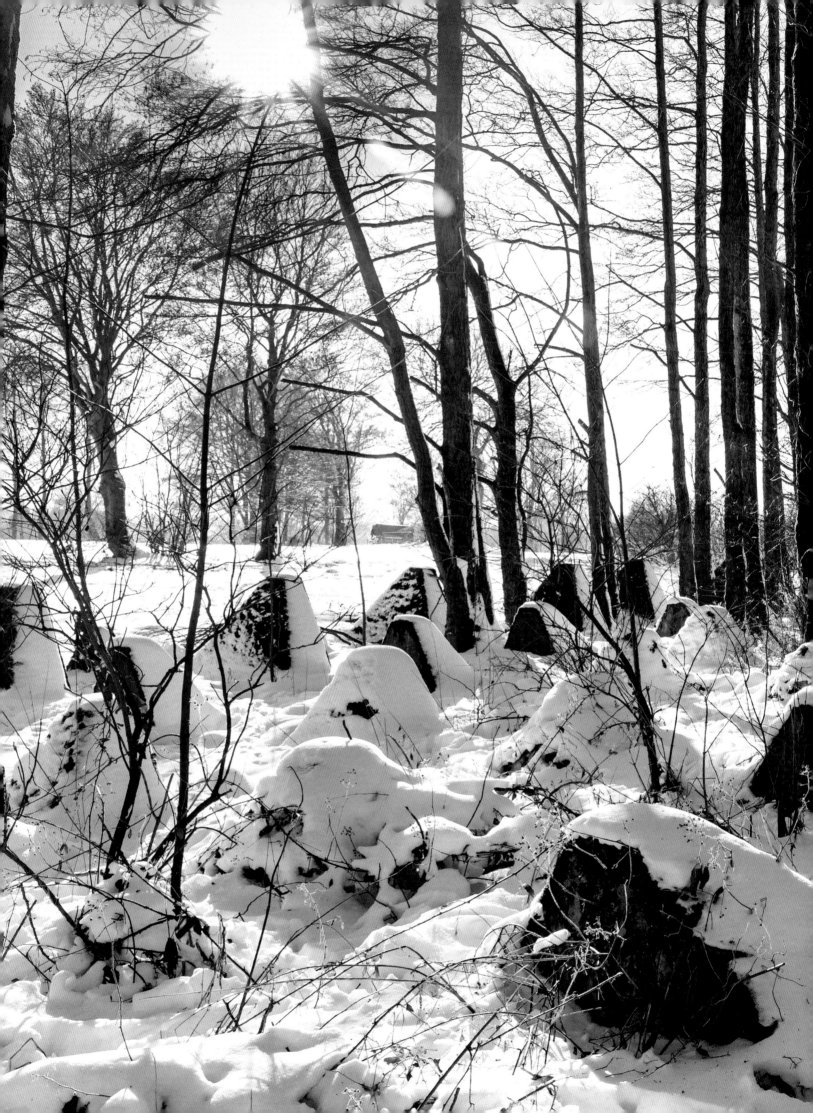

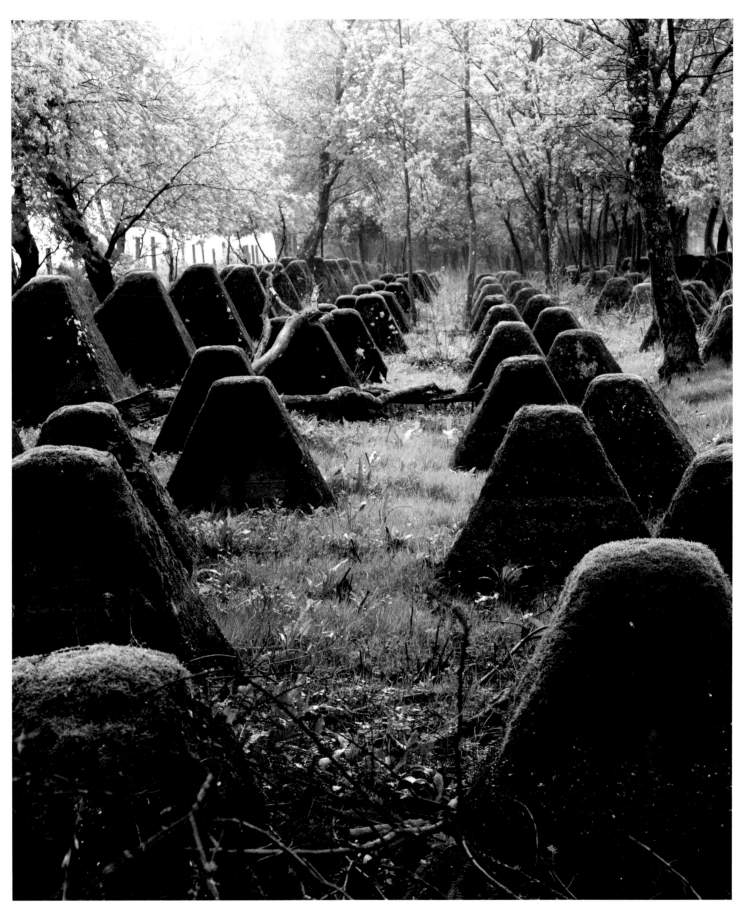

ABOVE:

Tank Traps, Hollerath, Eifel
Spring comes to the Siegfried
Line: here we see another section,
outside another little Eifel village,
not far from Hellenthal, near the
Belgian border. These defences
did hold back the Allied advance
in 1944–5, but only to the extent
of prolonging the inevitable. The
Nazi order was rapidly unravelling
by then.

OPPOSITE (BOTH):

**Bunker (exterior and interior
view), Huertgen Forest, Eifel**
High summer now, and a sun-
dappled Siegfried Line: this bunker,
hidden by thick forest, would have
felt a lot less hospitable with the
descent of winter. In the event, the
advancing Americans reached this
point in September 1944: not until
that December did they succeed in
pushing through.

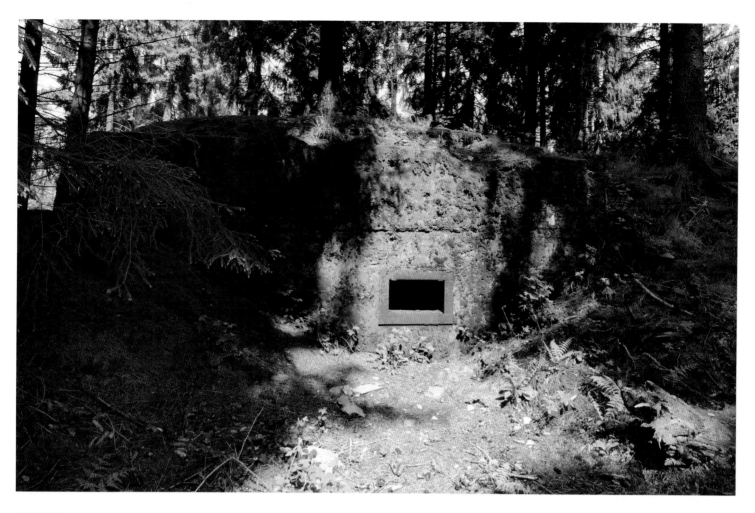

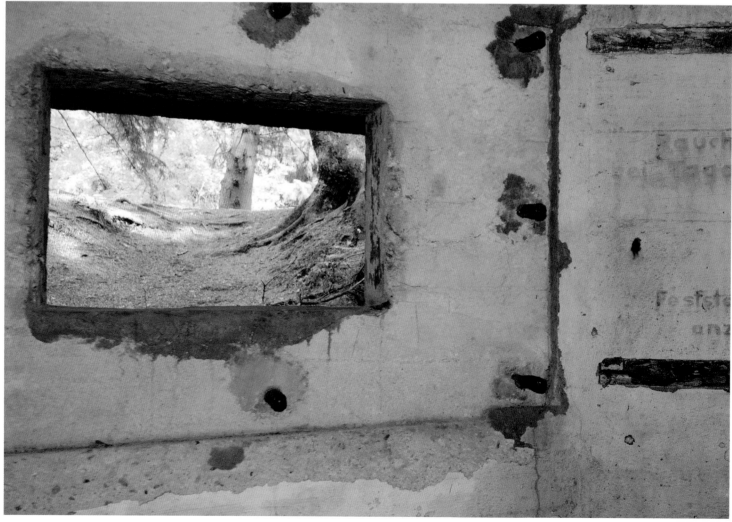

RIGHT:
Bunker, Lostau, Saxony-Anhalt
American soldiers occupied this
area of Germany in the spring of
1945 – before handing it over to
Soviet administration. From its
defenders' perspective, though,
this claustrophobic crampedness
does at least testify to the thickness
of the walls and to the depth of
the earth bulwark shielding the
position on two sides.

OVERLEAF:
**Bunker Entrances, Mecklenburg-
Vorpommern**
This part of northern Germany is
famous for its ancient burial sites:
swollen earthen mounds crowning
chambers built with megaliths –
massive stones. In World War II,
with the Allies advancing, it seems,
Mecklenburg-Vorpommern's
defenders reverted to type: these
openings wouldn't be out of place
in a prehistoric tomb.

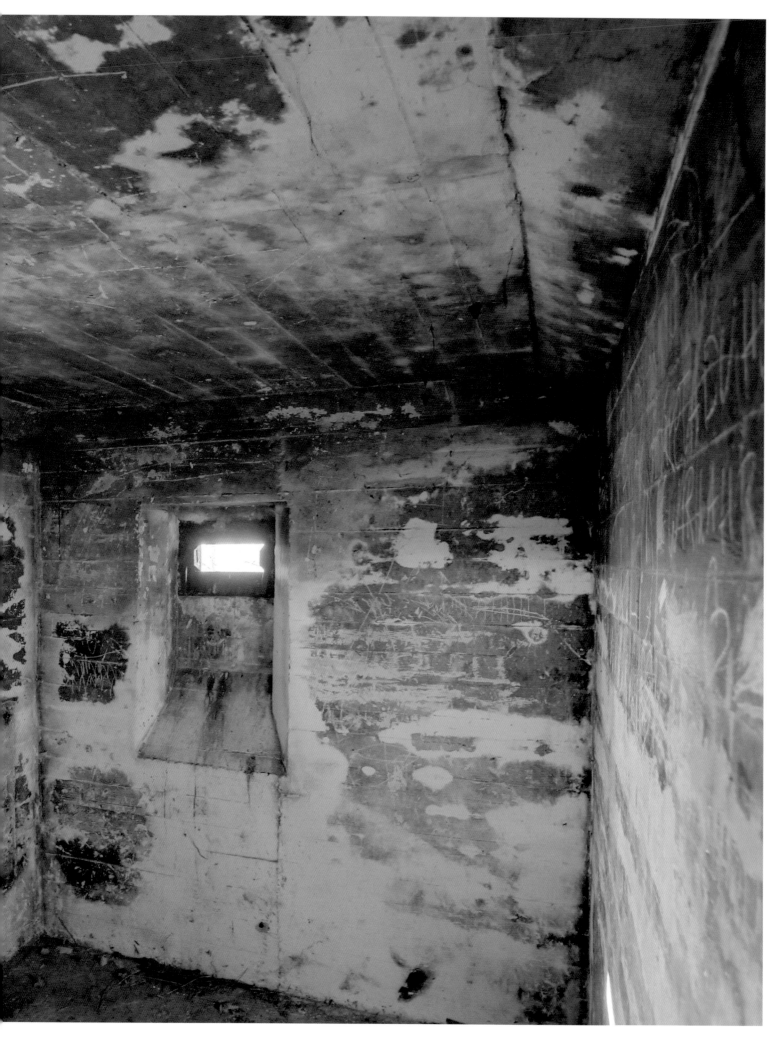

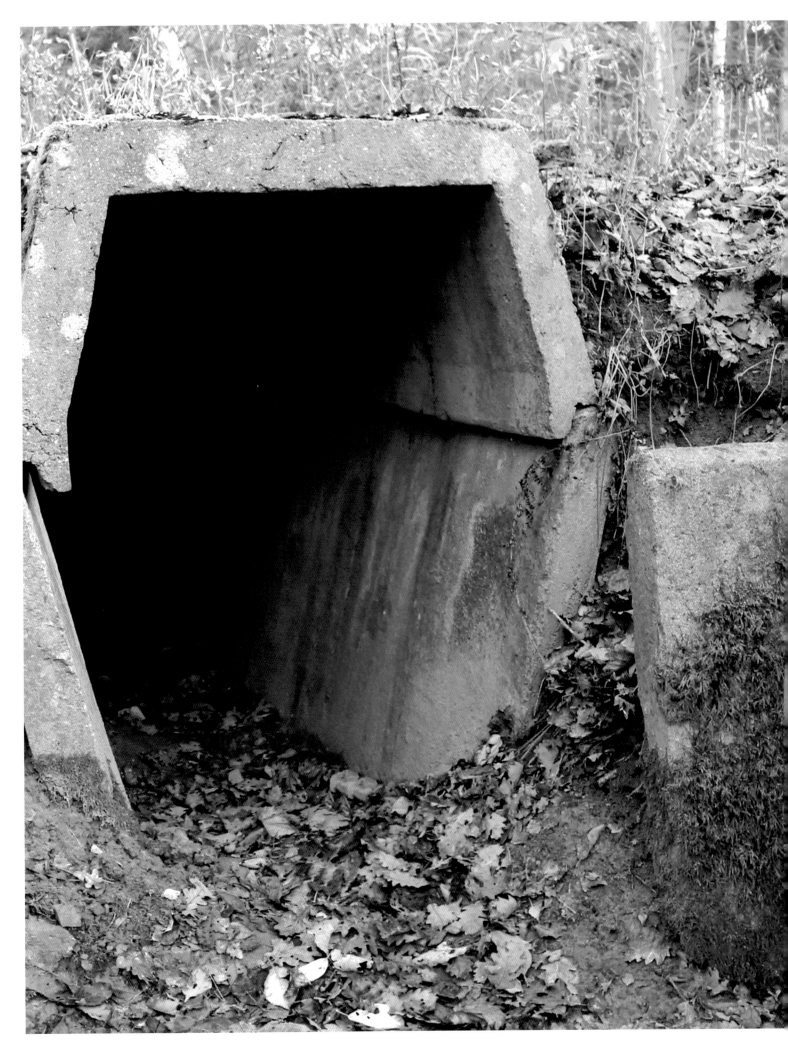

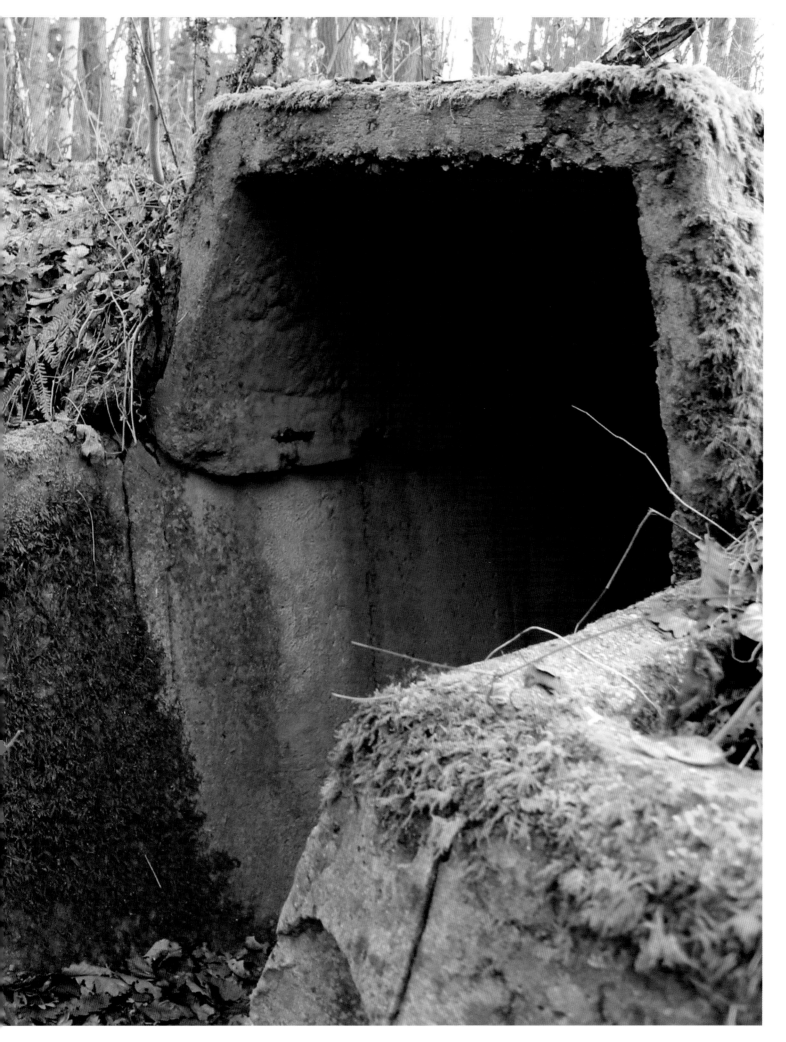

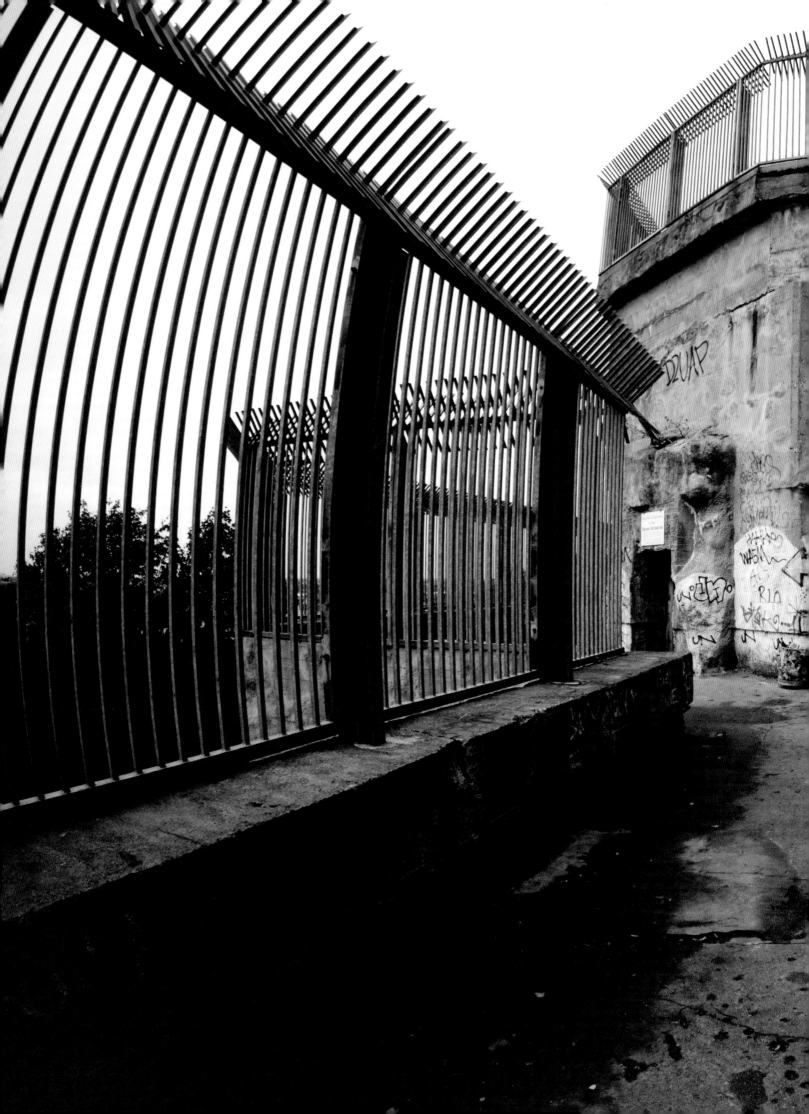

Flak Tower, Humboldthain, Berlin
Built between 1941 and 1942 in one of Berlin's most popular parks, this massive tower was blown up by French military engineers after the war. The rubble was left lying where it fell, however, and in recent years it has been substantially rebuilt by enthusiasts, a monument to the air war over Berlin.

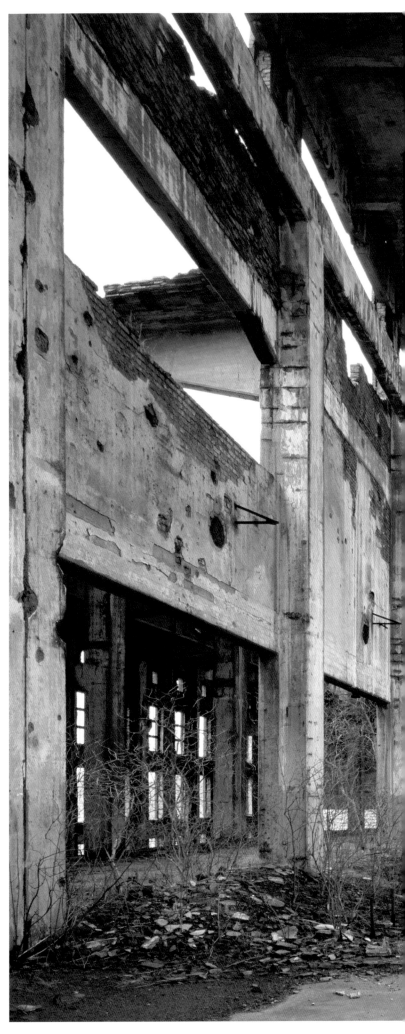

ABOVE:

V-2 Rocket Factory, Peenemünde, Usedom

The entire northern part of the Baltic island of Usedom was purchased by the German Luftwaffe in 1938 to be used as a research centre. In its earliest stages, a coastal site was favoured for the ready launching and recovery of prototypes.

After the Allies bombed the plant in the summer of 1944, production was moved to an underground location at Mittelwerk in central Germany.

RIGHT:

Liquid Oxygen Plant, Sauerstoffwerk II, V-2 Rocket Factory, Peenemünde, Usedom

The plant produced liquid oxygen from early 1943 until February 1945, when it was captured by Soviet troops.

The V-2 powered itself into space to an altitude of up to 190km (120 miles) before falling back – at supersonic speed – upon its target. That required a carrier rocket some 14m (46ft) long and 1.65m (5ft 5in) in diameter – and, accordingly, a spacious and high-ceilinged assembly plant.

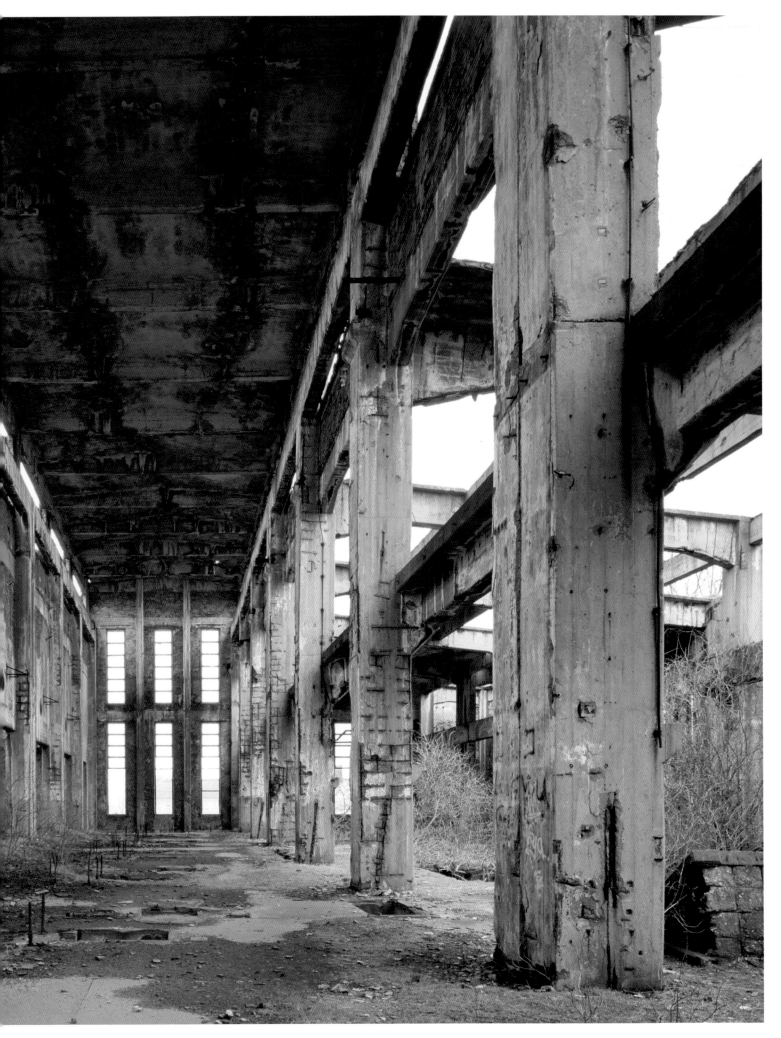

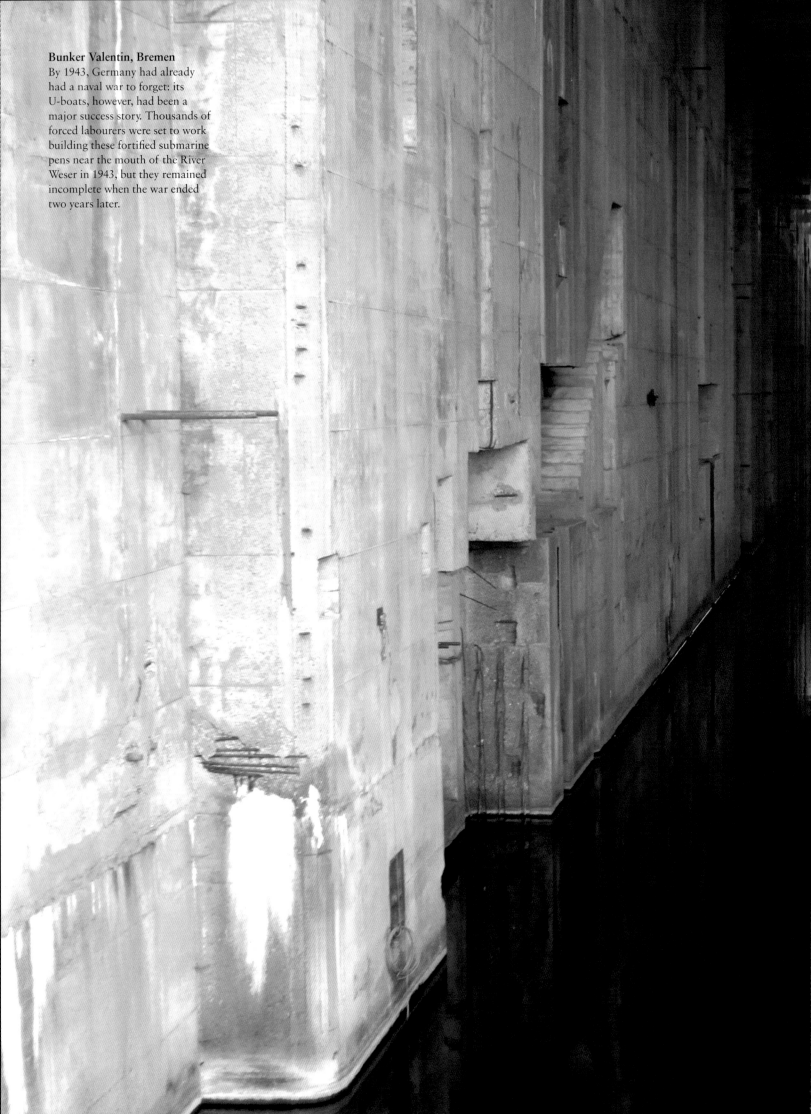

Bunker Valentin, Bremen
By 1943, Germany had already had a naval war to forget: its U-boats, however, had been a major success story. Thousands of forced labourers were set to work building these fortified submarine pens near the mouth of the River Weser in 1943, but they remained incomplete when the war ended two years later.

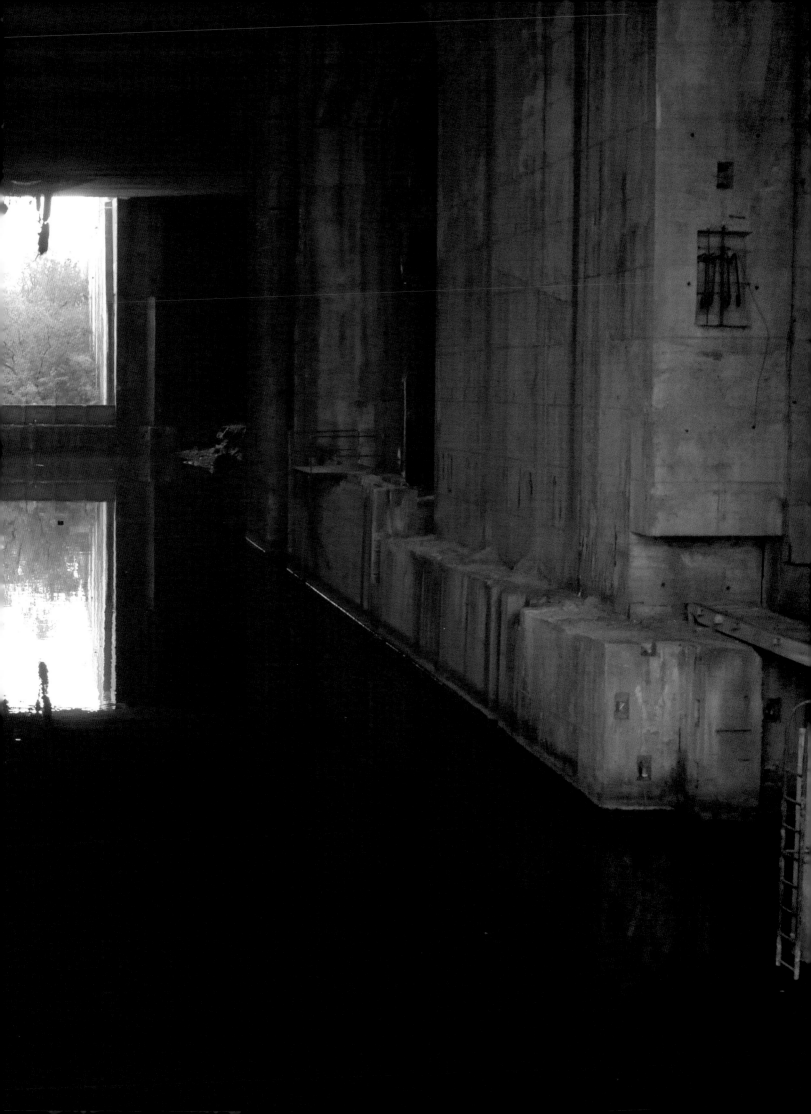

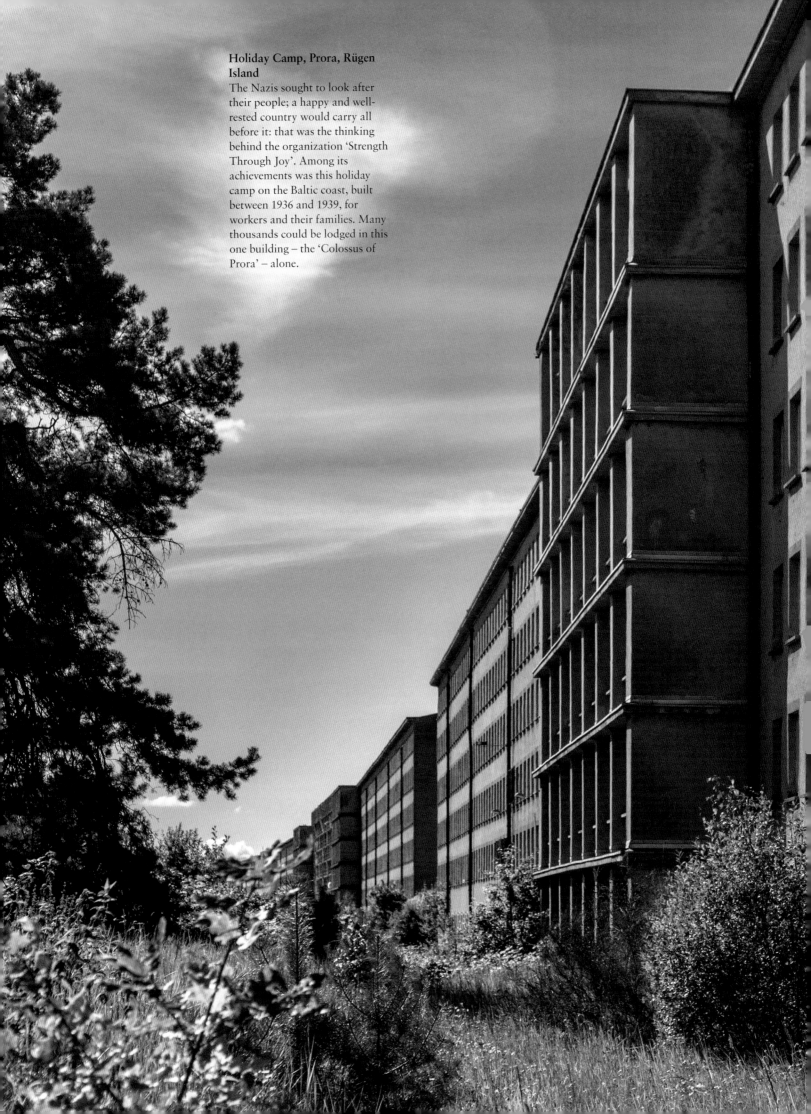

Holiday Camp, Prora, Rügen Island
The Nazis sought to look after their people; a happy and well-rested country would carry all before it: that was the thinking behind the organization 'Strength Through Joy'. Among its achievements was this holiday camp on the Baltic coast, built between 1936 and 1939, for workers and their families. Many thousands could be lodged in this one building – the 'Colossus of Prora' – alone.

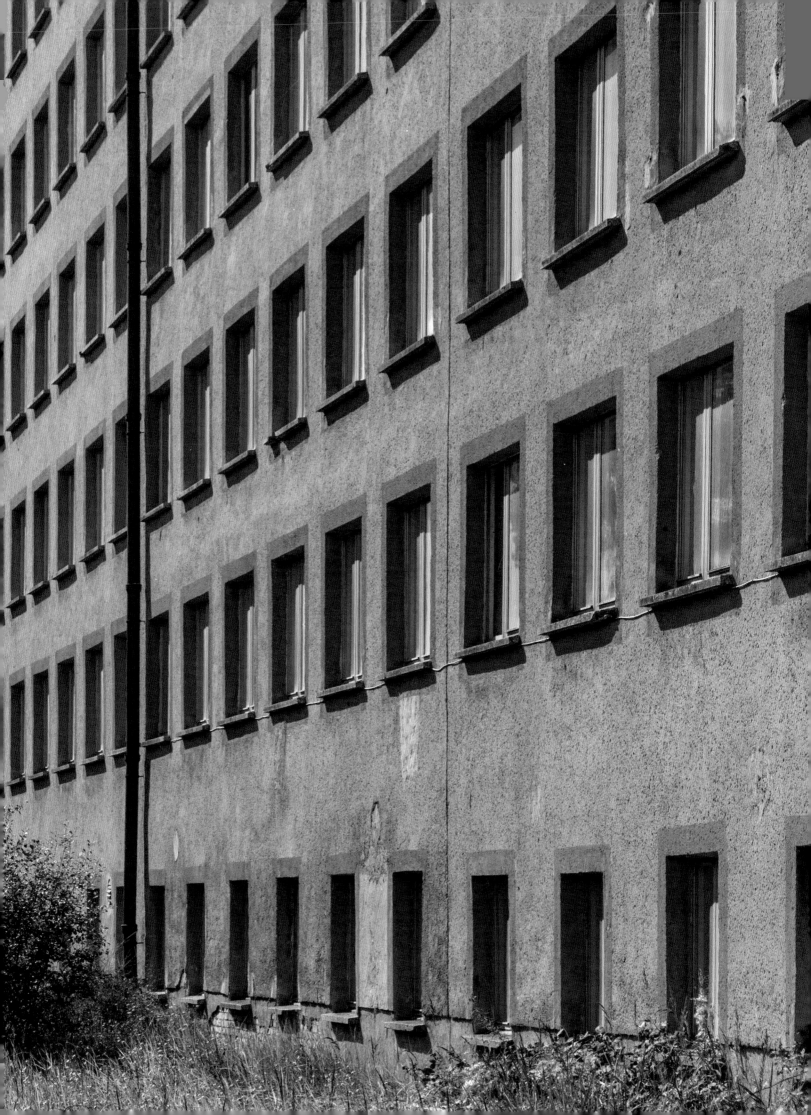

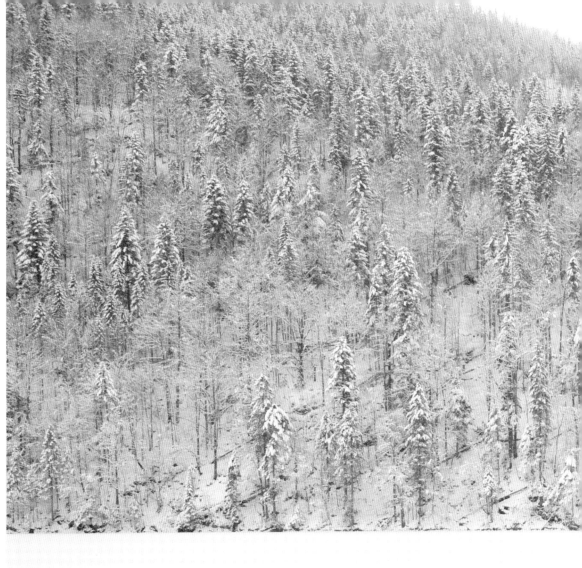

RIGHT:
Lake Toplitz, Austria
Hedged around by dense pine forests and dizzying alpine peaks, this lake, with its deep and silent waters, seems to challenge the visitor with its air of mystery. Hence the treasure-hunters, seeking 'Nazi Gold'. Toplitz's true secrets, though less lucrative, are every bit as interesting: the Nazis tested secret naval weapons in seclusion here.

OVERLEAF:
Bunker, Switzerland
The Swiss were well aware that their neutrality would have to be defended. A German invasion appeared more likely than not. Plans were made for the country's defenders to hole up in an Alpine Réduit – essentially a warren of tunnels and bunkers like this one – and sally forth to conduct a guerrilla war.

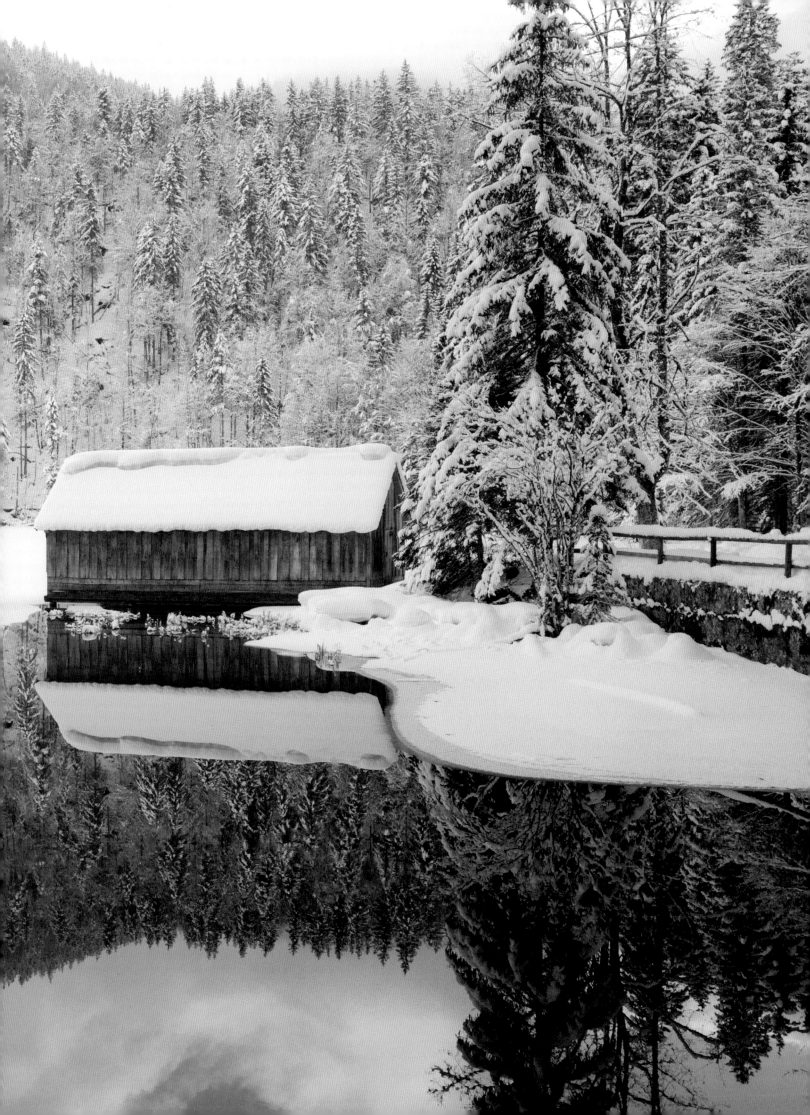

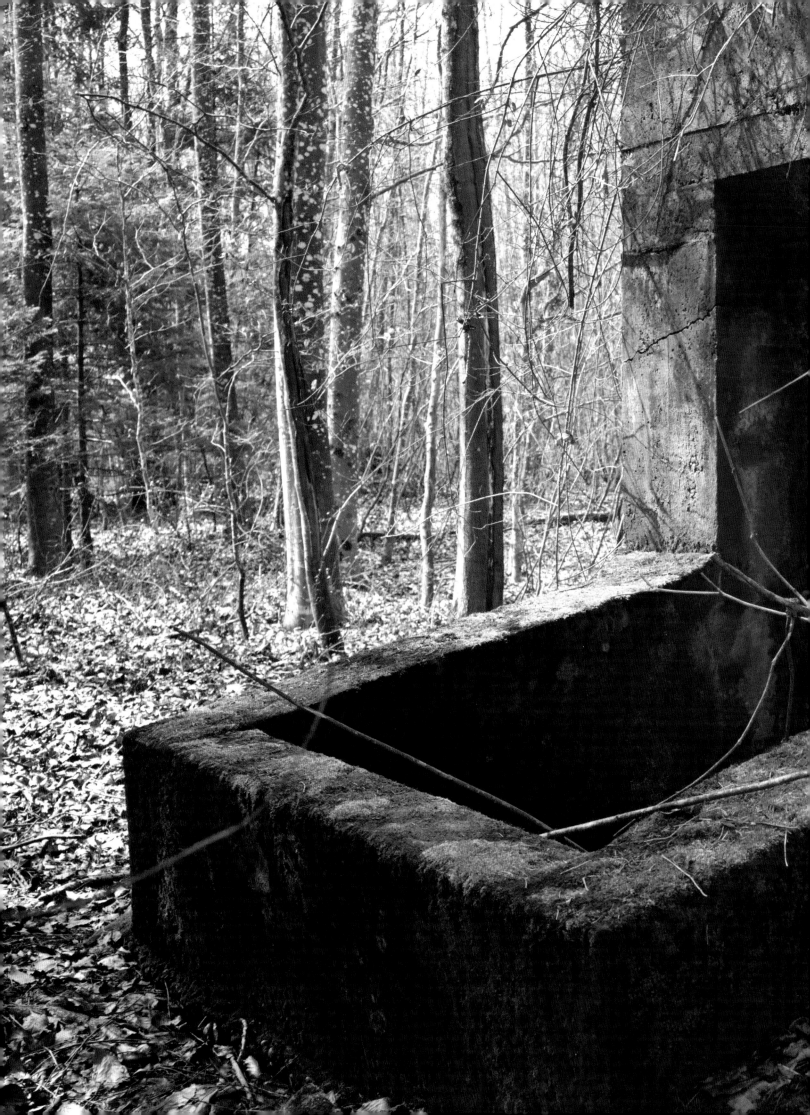

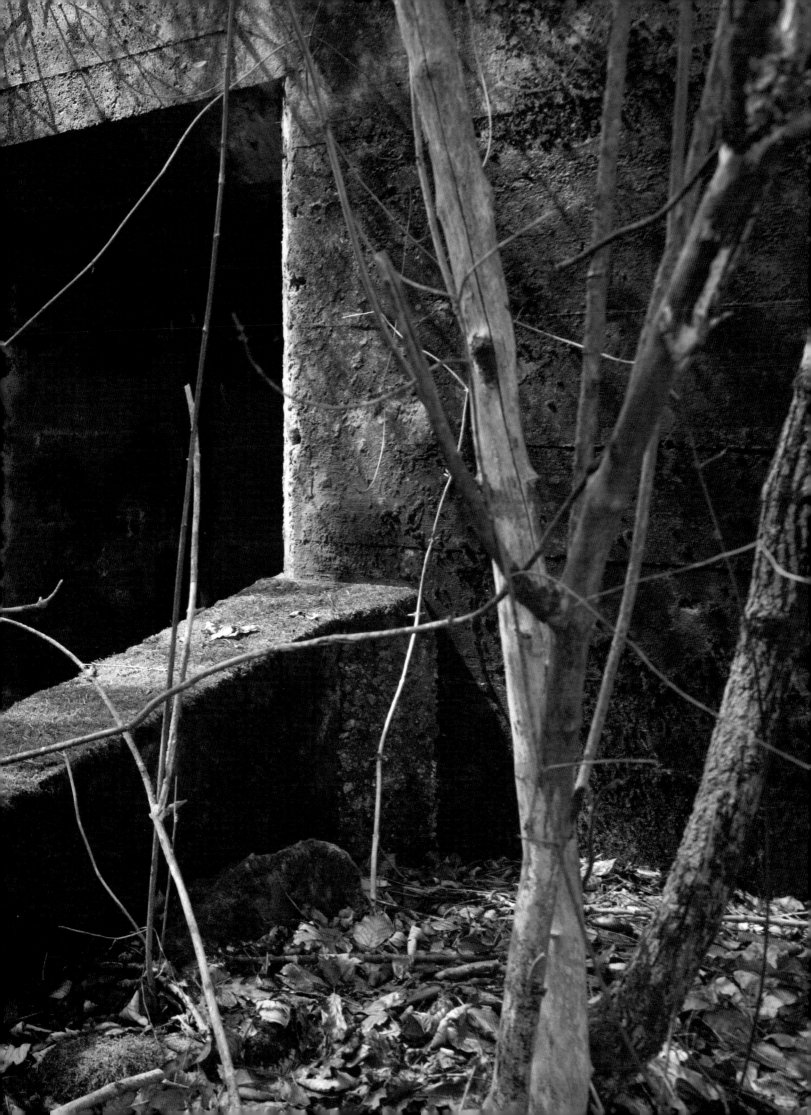

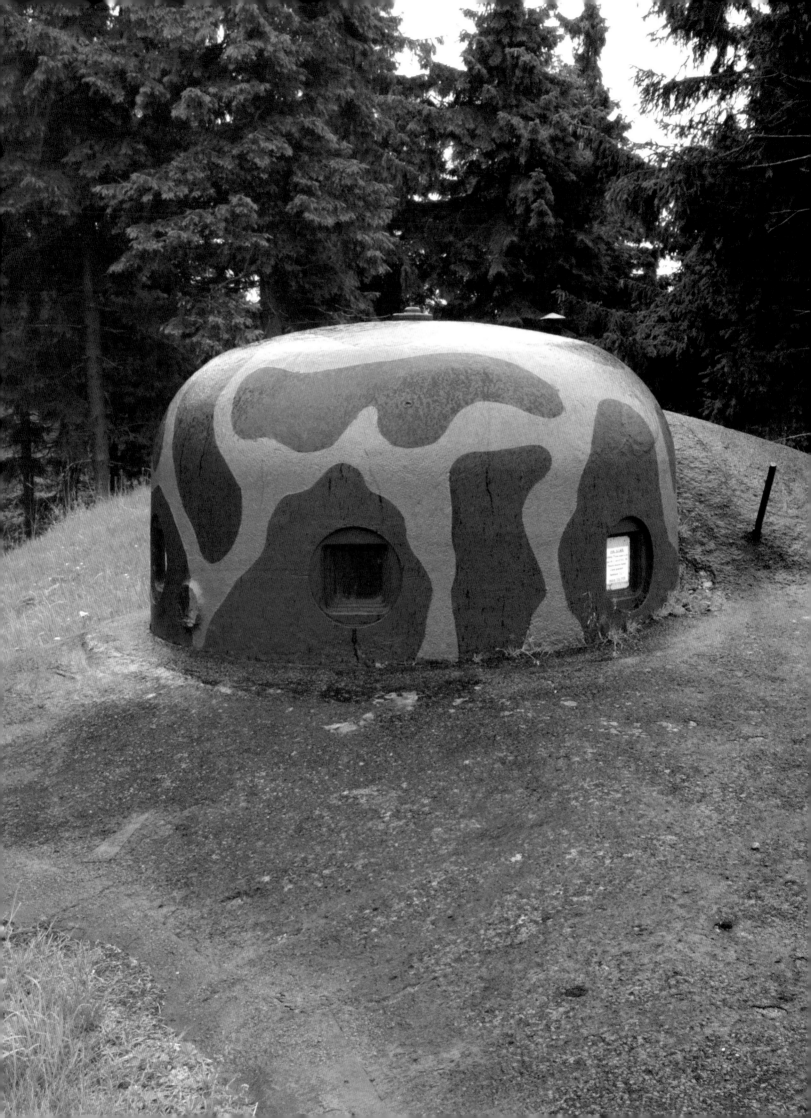

Eastern Europe

Eastern Europe was the arena for a war within a war. Unique hatreds – and unique cruelties – came into play. Driven by the desire for *lebensraum* ('living space'), Germany's expansion eastward had been underwritten by deep assumptions of racial superiority to the locals. As their name suggested, the 'Slavs' were to be worked as slaves. Those, at any rate, who survived the massacres the Germans committed as they advanced. Not that other racial prejudices were to be set aside. Confined by the Russian Tsars in a 'Pale of Settlement' that swept across eastern Europe, western Russia and Ukraine from north to south, the region's Jews were to bear the brunt of the Nazi Holocaust. Not surprisingly, once the tables turned, Russian soldiers sought revenge. They were, in any case, under a leadership that was ideologically inclined to ruthlessness, impatient with any notion of the individual and his or her welfare.

In Britain, the ruins of World War II hark back to a time of cheerful camaraderie and upbeat pride; in western Europe to a darker, more disturbing and yet thankfully short-lived ordeal. In the East, however, where the horrors of 1941–45 segued seamlessly into the oppression of the Cold War, these monuments often have a much more sombre air.

LEFT:
Bunker, Hory Mountains, Bohemia, Czech Republic
As impregnable as it appears, this bunker endures as a monument to the vanity of human hopes. In anticipation of attack by an increasingly bellicose Nazi Germany, the Czechs built an extensive system of border defences during the 1930s. In 1939, however, arguably sold out by sometime allies, the country was very quickly occupied and the defences rendered redundant.

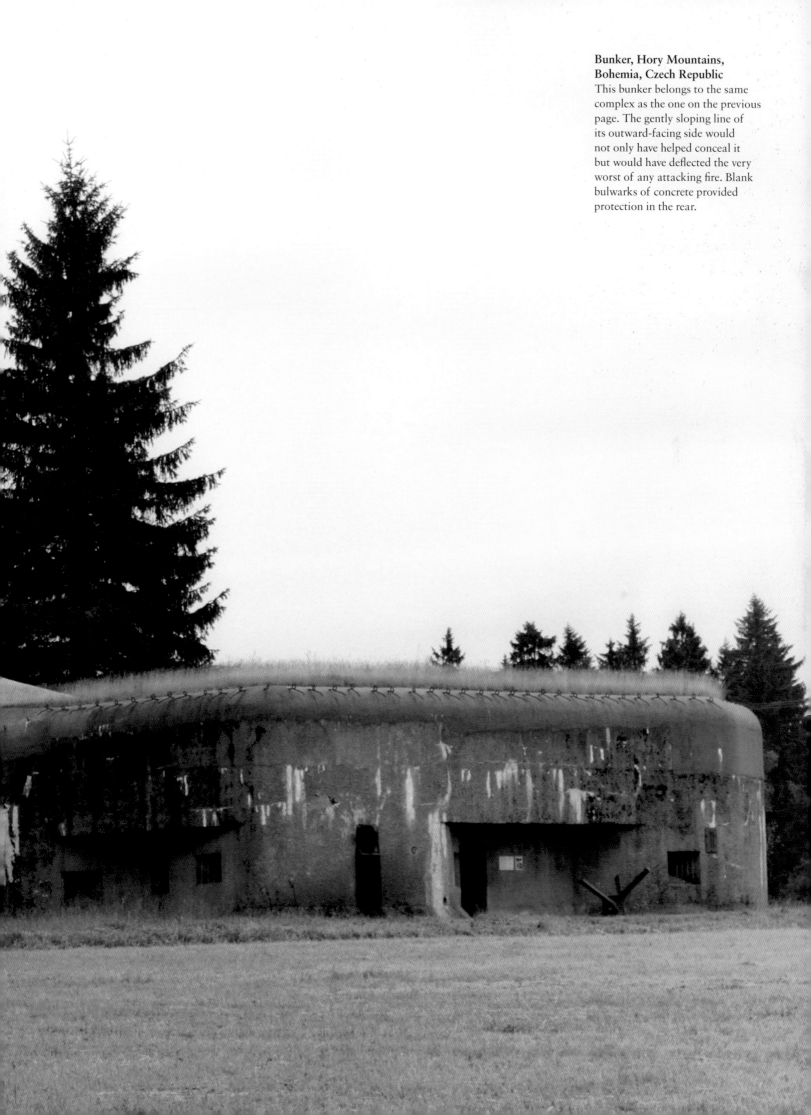

Bunker, Hory Mountains, Bohemia, Czech Republic
This bunker belongs to the same complex as the one on the previous page. The gently sloping line of its outward-facing side would not only have helped conceal it but would have deflected the very worst of any attacking fire. Blank bulwarks of concrete provided protection in the rear.

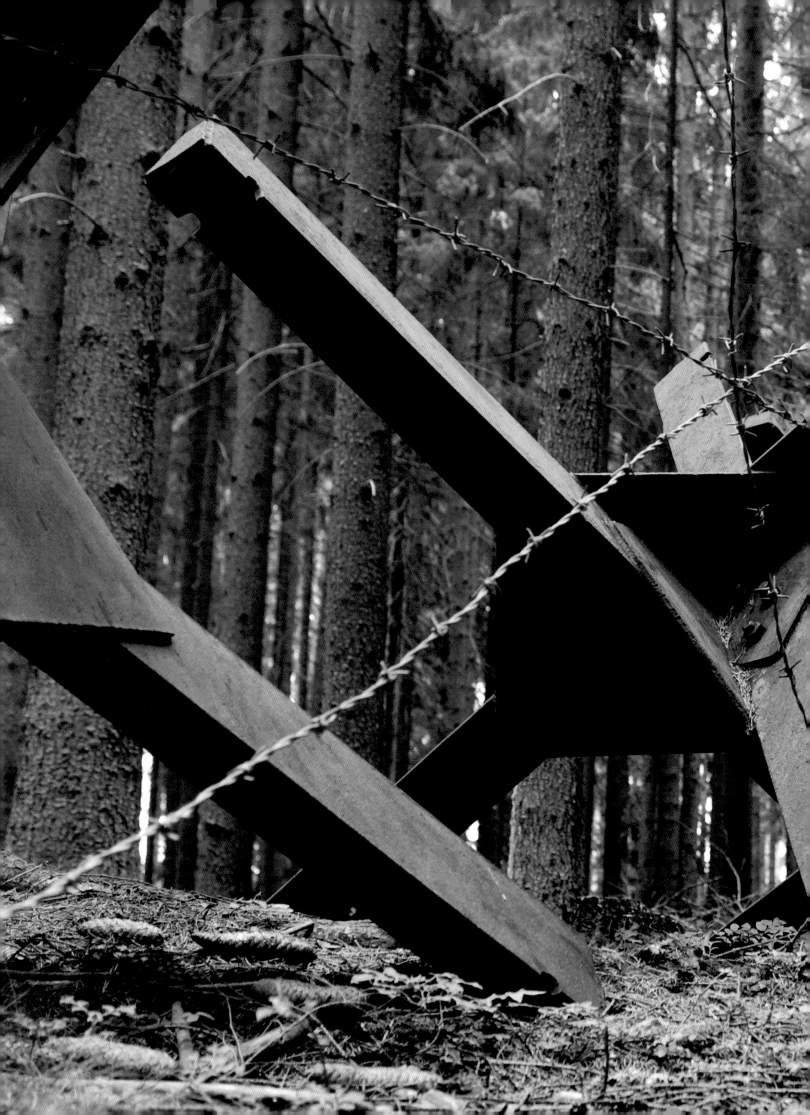

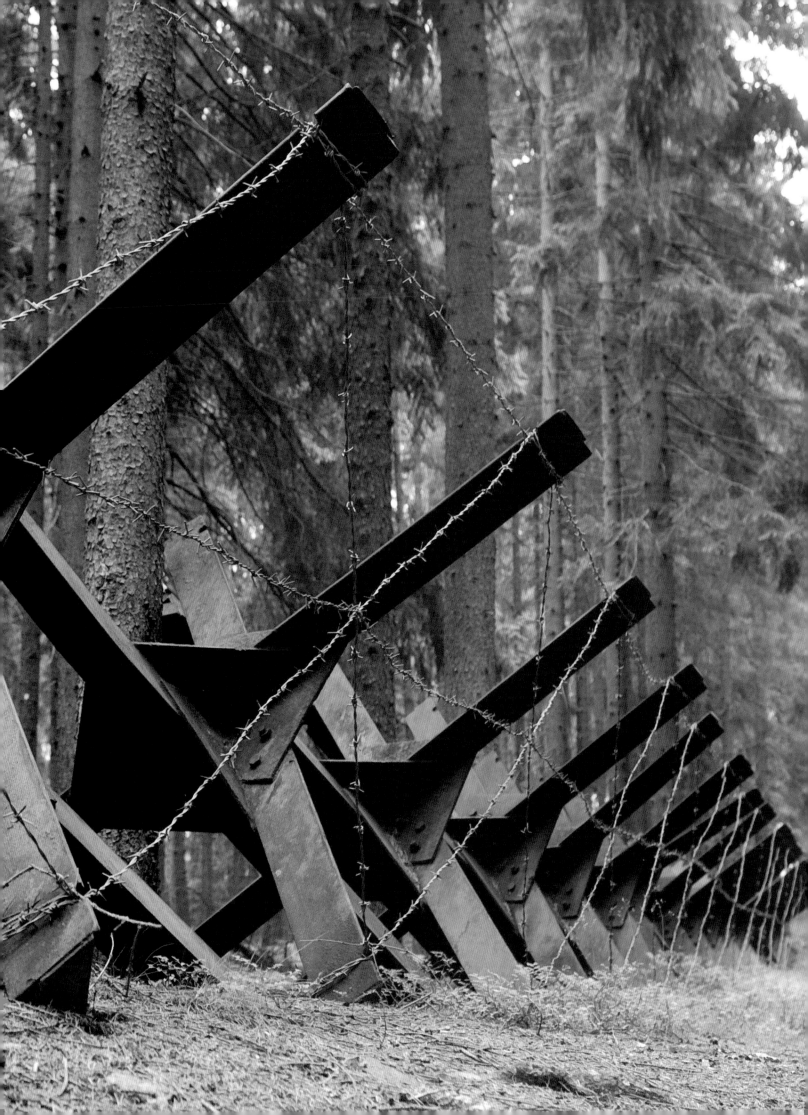

PREVIOUS PAGES:

**Tank Traps, Slavonice,
Czech Republic**

Situated in a border area at the
southernmost margin of Moravia,
Slavonice had always seemed
vulnerable – especially so after
neighbouring Austria joined
Germany in the Anschluss of 1938.
Incursions through the forest were
discouraged by a complex network
of bunkers, with barbed-wire
barriers and tank traps running
in between.

RIGHT:

**Concentration Camp, Terezin,
Czech Republic**

Better known by its German name
of Theresienstadt, this camp
was the hellish home to tens of
thousands of civilians – men,
women and children. A great many
were to die here, though this was
not officially an extermination
site: trains ran from here to death
camps further east at Auschwitz
and Treblinka.

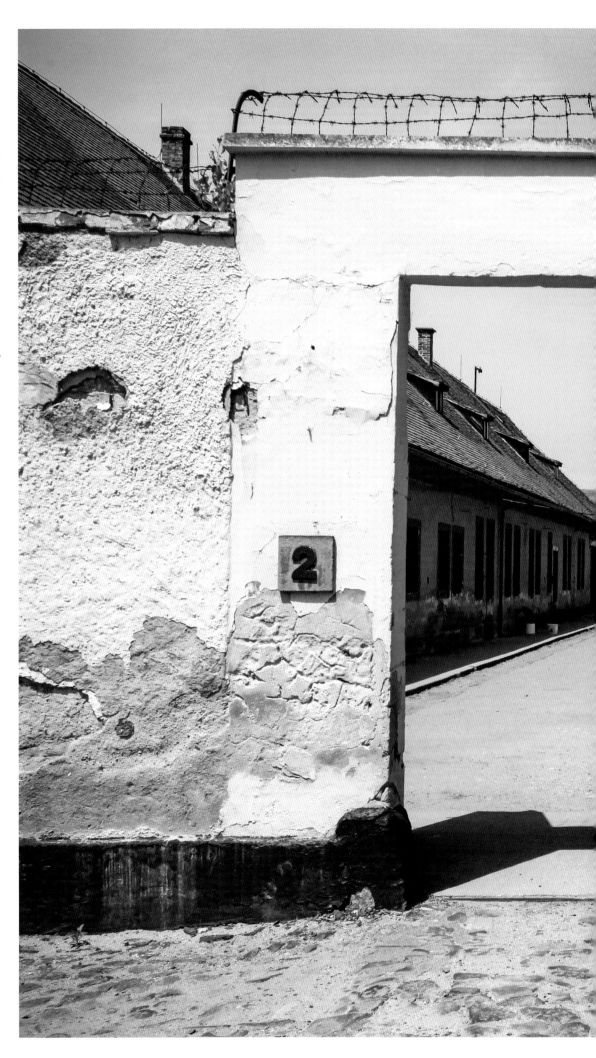

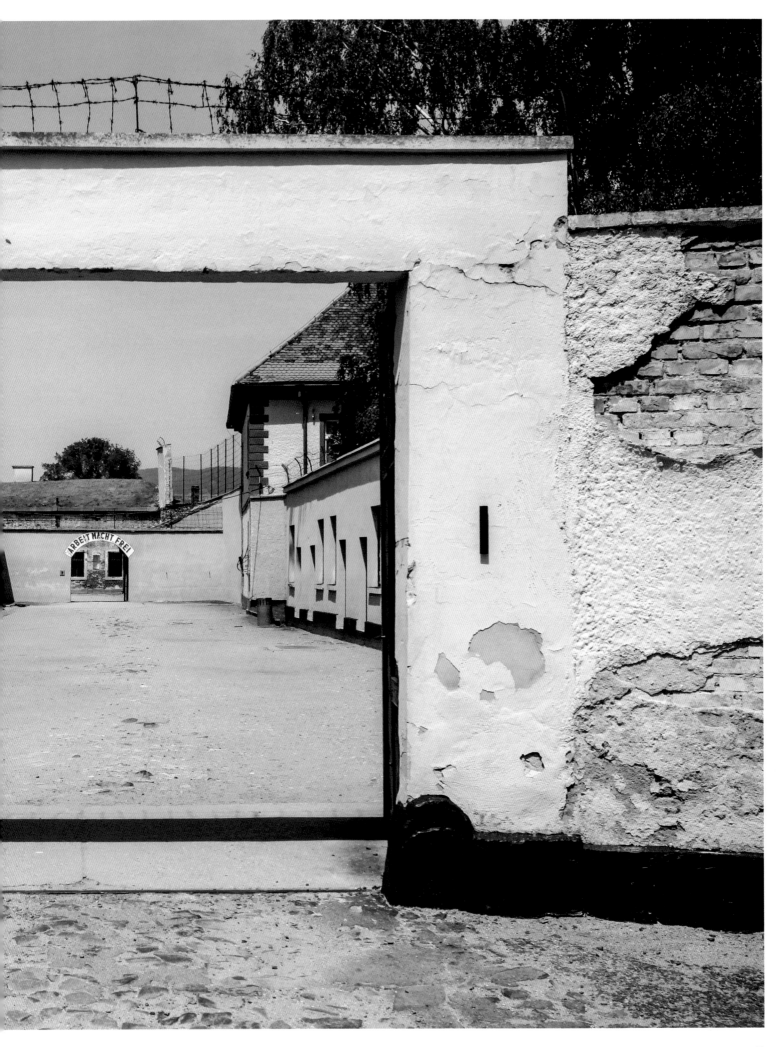

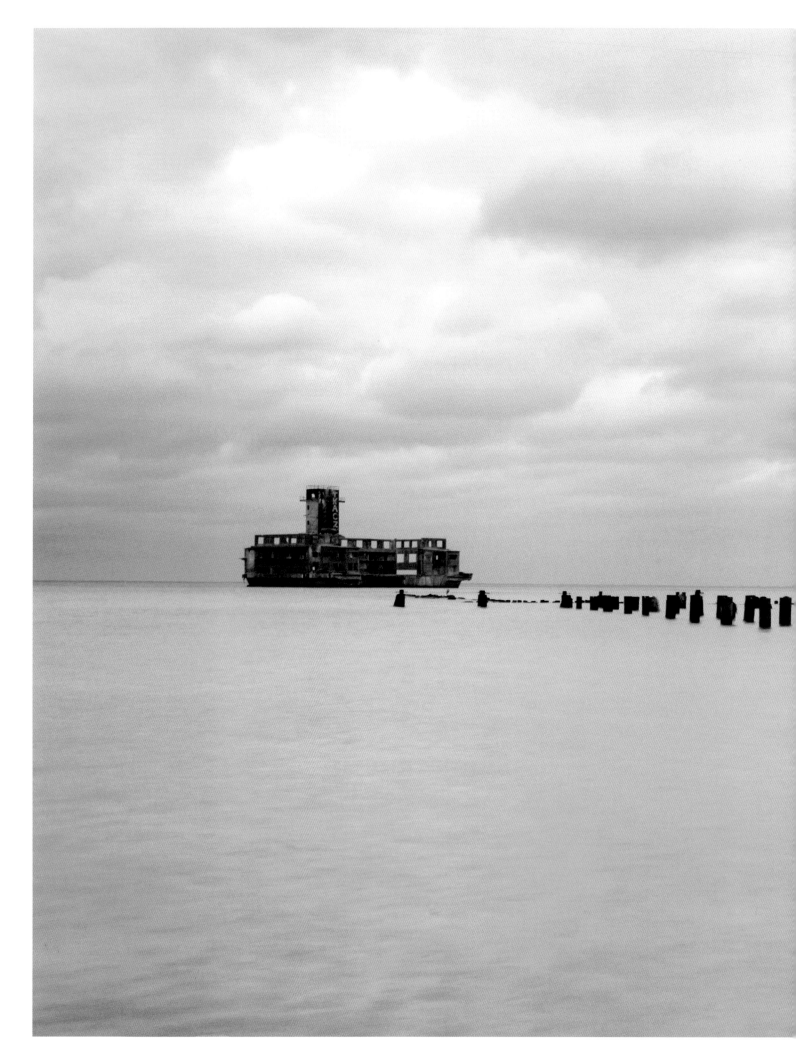

Torpedo Research Station, Gdynia Oksywie, Poland
What remains of a pier leads out to the ruined structure of a torpedo assembly and testing station: essentially a caisson constructed some way offshore. The Nazis built both this complex and another not far away at Babie Doly: torpedoes could be assembled and test-launched into deep water through airlocks here.

Bunkers, Árpád Line, Carpathian Mountains, Ukraine

Árpád was a semi-legendary leader who united the tribes of Hungary in the ninth century. So: a sort of Magyar Siegfried? Were these defences just a copy of the Siegfried Line? Not quite: Hungary's system of 'flexible defence' involved more scattered centres of resistance, rather than some fixed, continuous and supposedly impregnable barrier or wall.

OPPOSITE PAGE:
Lookout, Saaremaa Island, Estonia

Believed to have been built by the Soviets as an observation post for a nearby battery (the surrounding trees have grown up since the war), this tower may have been deliberately designed to resemble one of the broken-down windmills with which this island still abounds. It was subsequently occupied by the Germans.

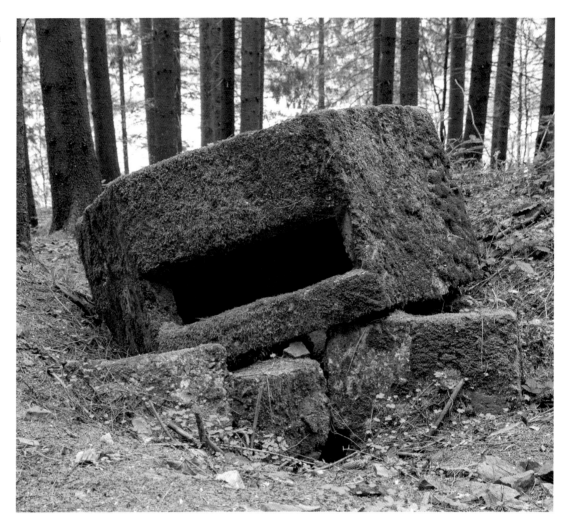

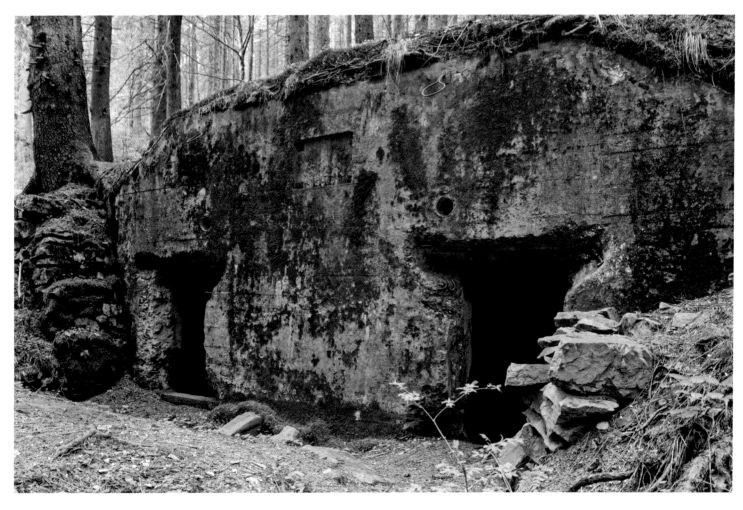

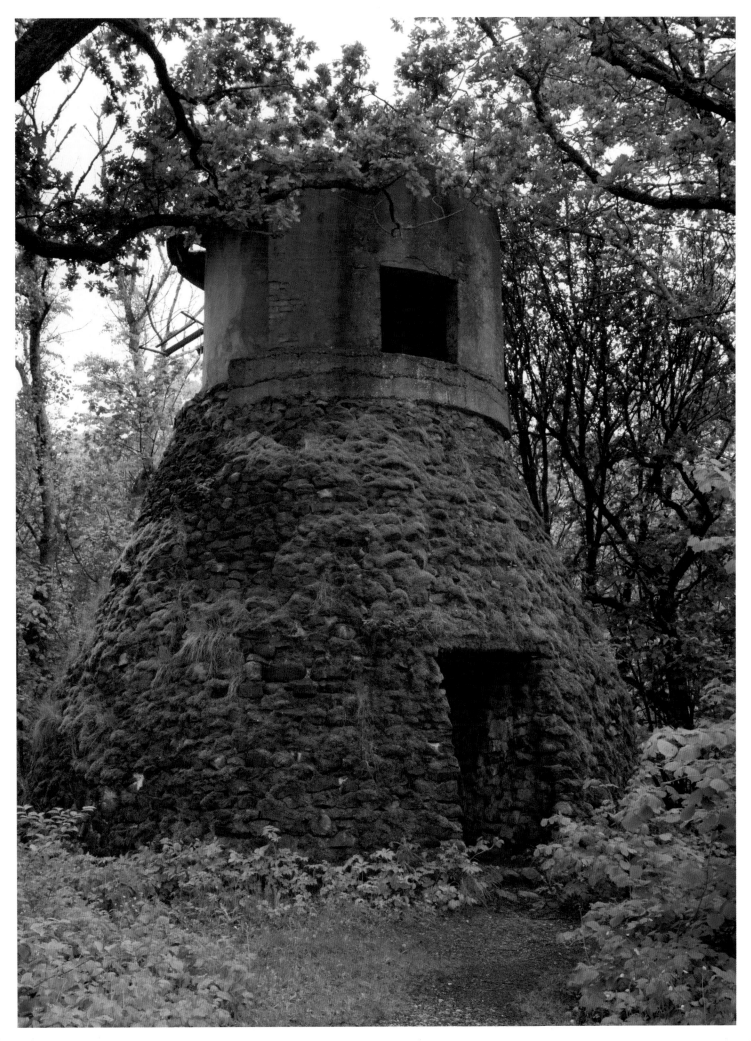

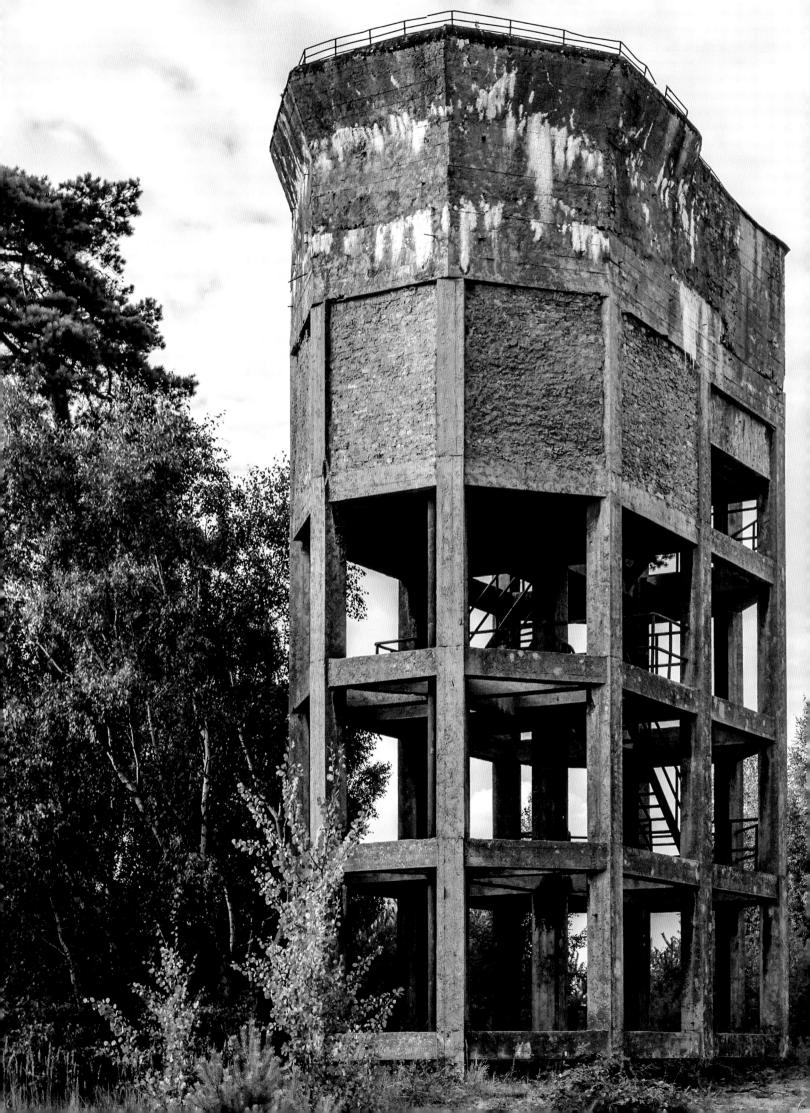

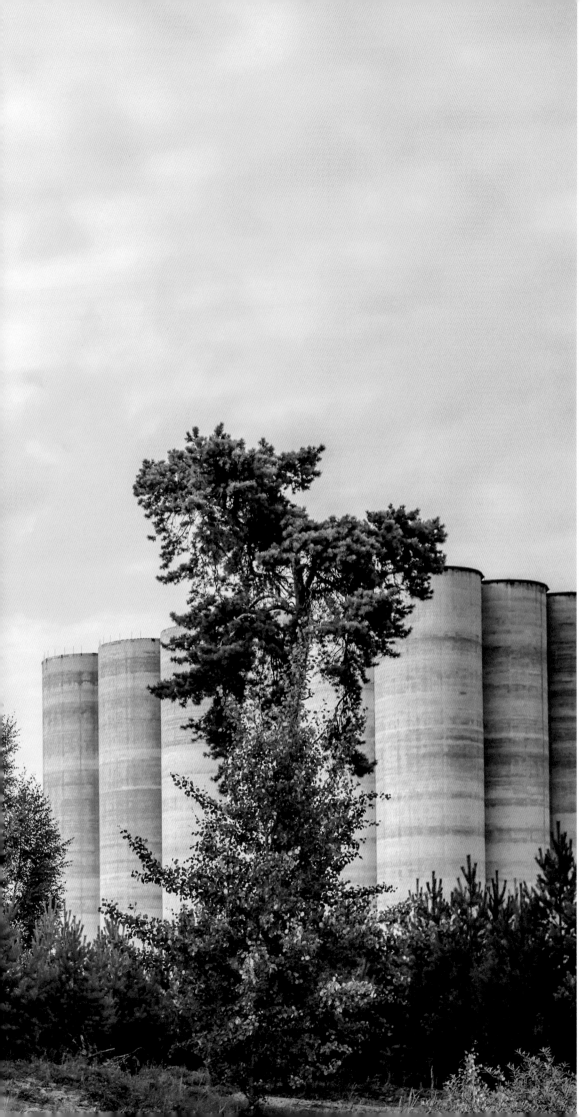

Artillery Battery Platform, Gdansk, Poland
Raised up to command the widest possible range over the entrance to this vital Baltic port, this concrete tower designed to house artillery guns was built by a nervous Polish government in the 1930s. Designated a 'Free City', Gdansk was captured by German forces during the first few days of the invasion of Poland in September 1939, notwithstanding a heroic effort by Polish troops defending the Westerplatte stronghold.

47

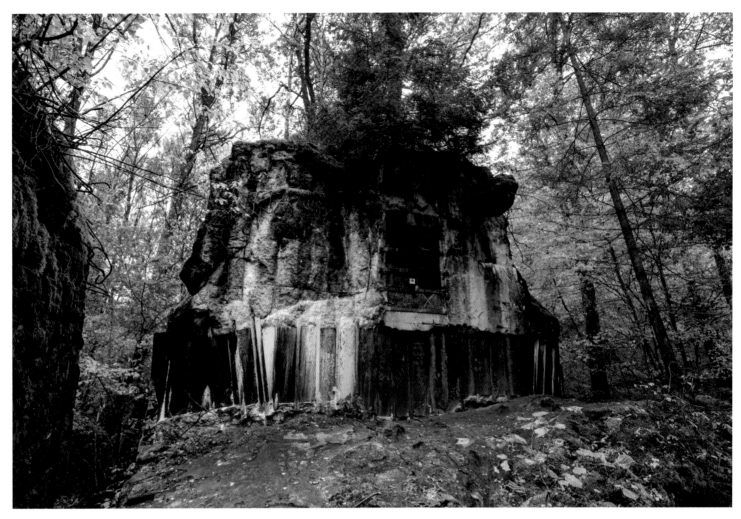

ABOVE:
Wolf's Lair Bunker, Ketrzyn, Poland
Living out his own adventure story, Hitler had this hideout built at the time of Operation Barbarossa in June 1941. From here, deep in the East Prussian forest, he could coordinate the eastward expansion of his empire into the Soviet Union.

RIGHT:
Concealed Passage, Wolf's Lair
Buckled, the structures of the Wolf's Lair (*Wolfsschanze*) complex were so strongly built that they resisted all attempts by the retreating Germans to destroy them. Here, a passage remains substantially intact – though we clearly see the iron reinforcement within its ferroconcrete walls.

OPPOSITE TOP AND BOTTOM:
Officers' Quarters and Outbuildings, Wolf's Lair
Hitler's military headquarters was staffed by a considerable pack of aides and officials. Anything up to 2,000 people worked in a complex of camouflaged bunkers and buildings that extended for several kilometres through the woods of Masuria, now northern Poland.

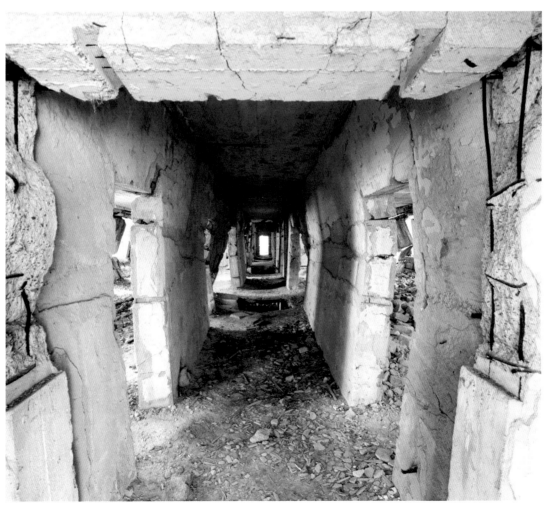

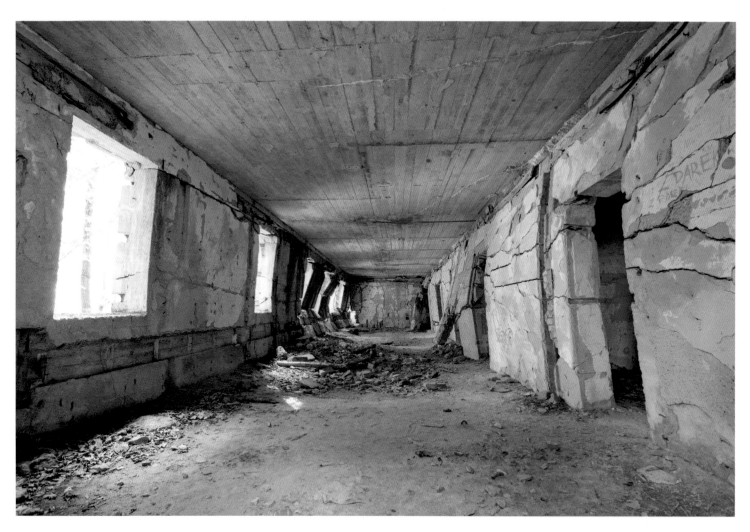

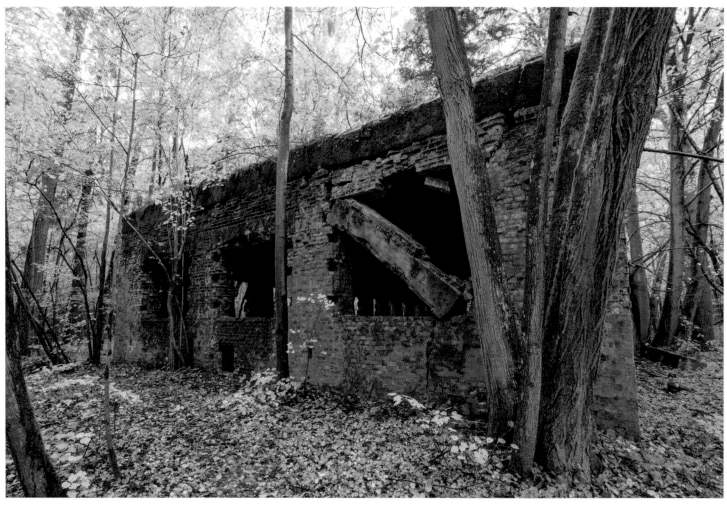

ABOVE, RIGHT AND OPPOSITE:

'Hochwald', Himmler's Headquarters, Pozezdrze, Poland

The Nazi high command could sometimes seem little more than an agglomeration of egos. As SS chief, Heinrich Himmler had to have his own answer to his Führer's 'Wolf's Lair', just 27 kilometres (16.5 miles) from his leader's HQ. And extremely imposing it was, too – hard though this may be now to appreciate as, year after year, the forest closes over its crumbling ruins.

If Nazism was an evil, the SS was its spearhead: Himmler's paramilitaries were always in the forefront when it came to oppression, torture, murder and genocide. You'd never know that now, walking in these quiet places and stumbling on this moss-covered bunker entrance, barely breaking the lush continuity of the forest floor.

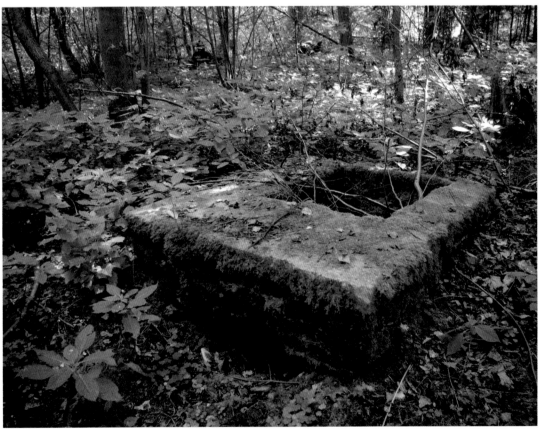

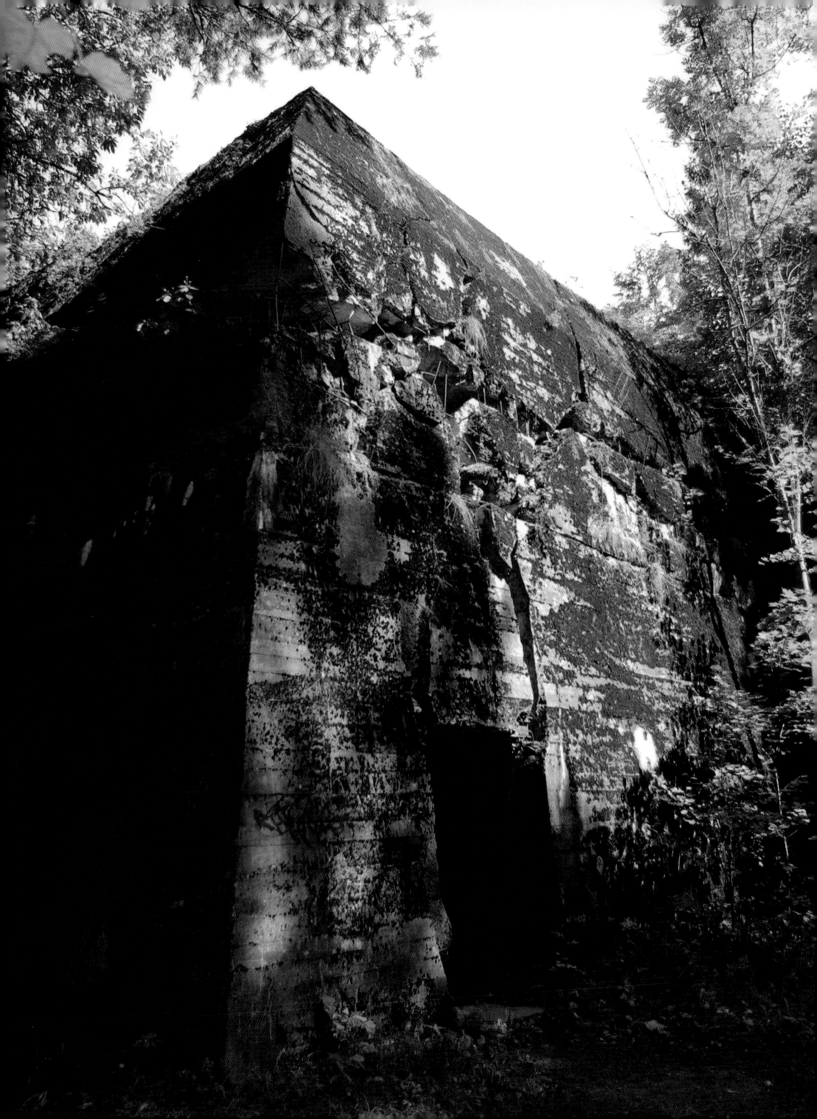

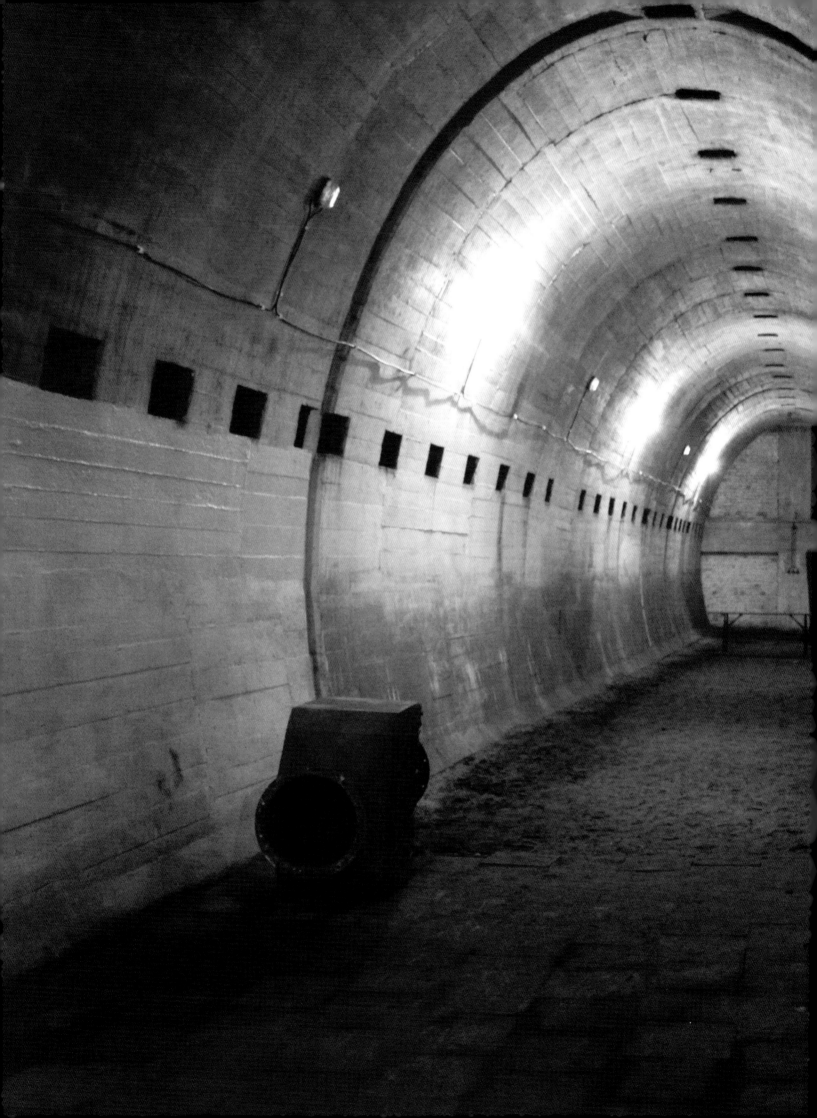

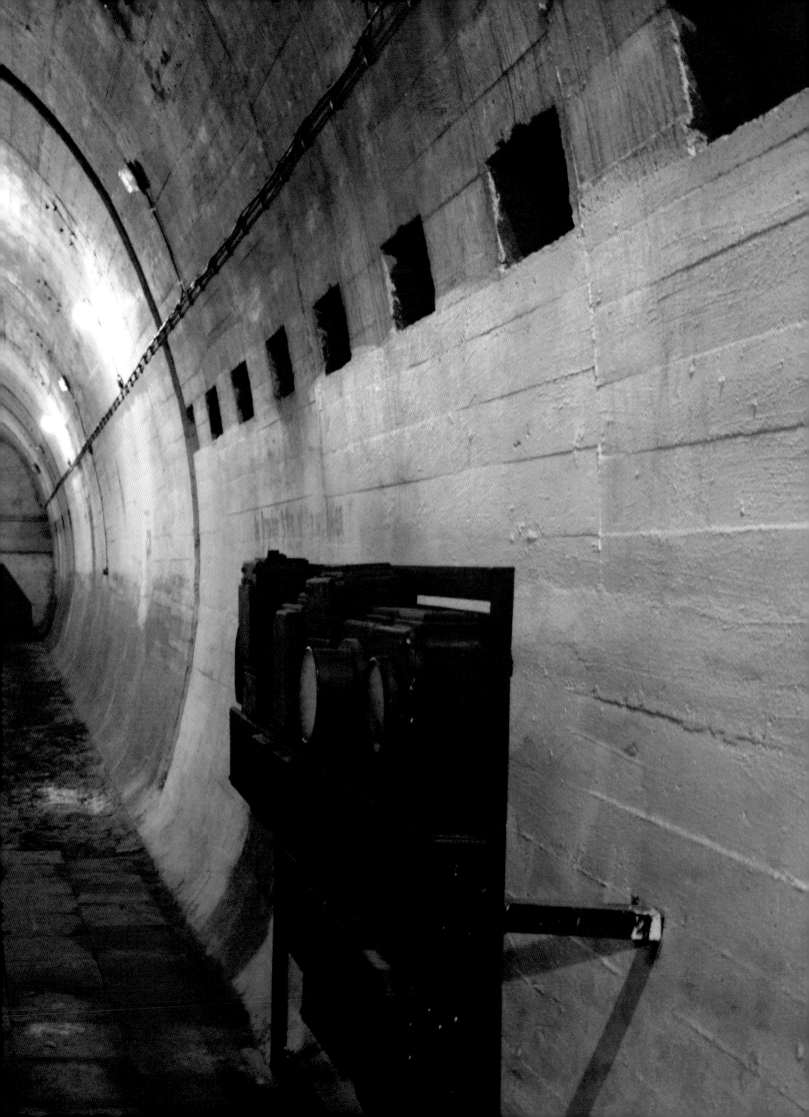

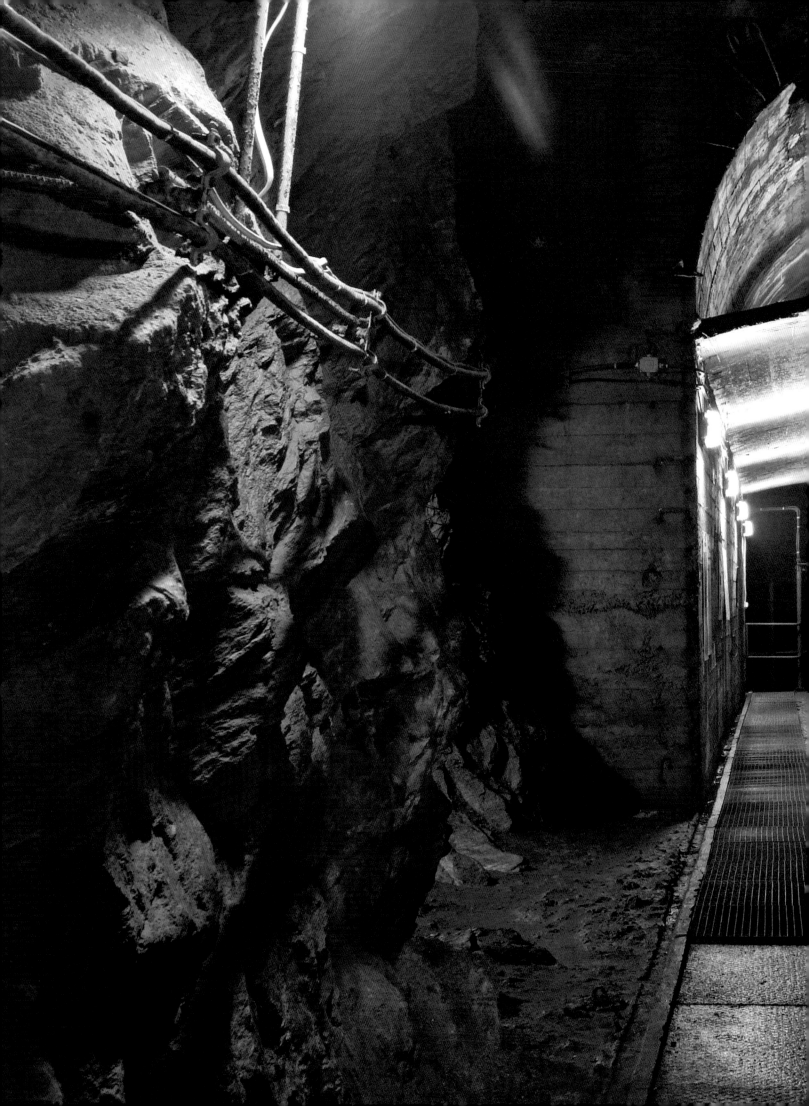

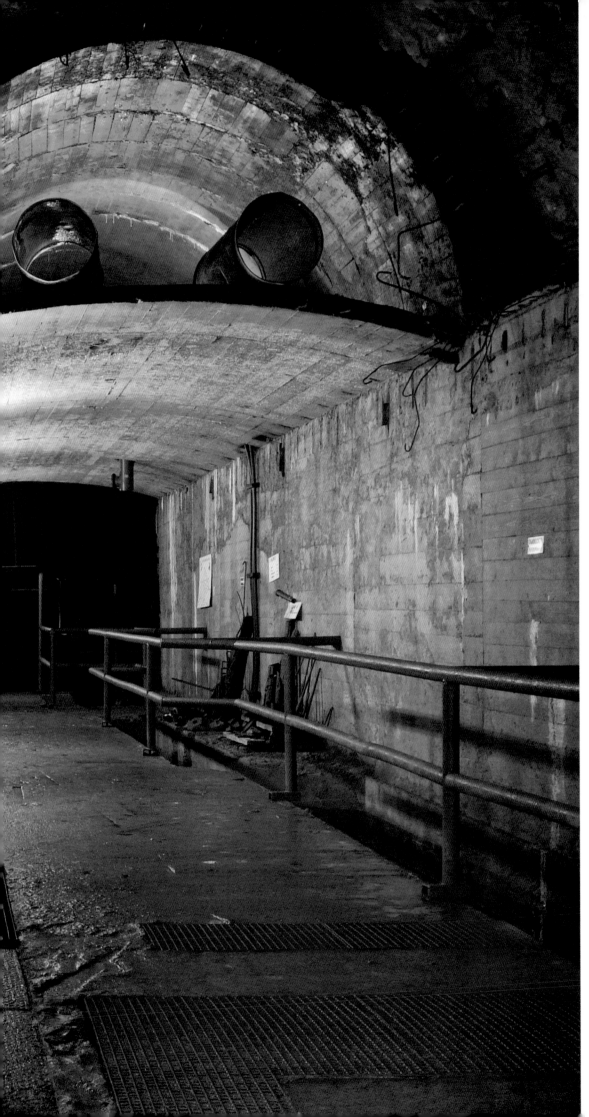

**Underground Factory, Wlodarz,
Lower Silesia, Poland**
The 'secret weapon' that was
supposed to win the war, the V-2
rocket – an early intercontinental
ballistic missile (ICBM) –
inevitably attracted the attention
of Germany's enemies to east
and west. Hence the elaborately
constructed, heavily protected,
underground facilities in which
the missiles were manufactured.
Thousands of slave-labourers were
to die in terrible conditions here.

**Fortification, Miedzyrzecz,
Poland**
The Germans built this fortfication
complex to protect their eastern
border. It comprises a vast network
of underground bunkers, connected
by almost 30km (20 miles) of
tunnels, with subterranean railway
lines and even stations. Today
it has found a peaceful function
as a tourist destination – and
its remoter reaches as home to
colonies of rare bats!

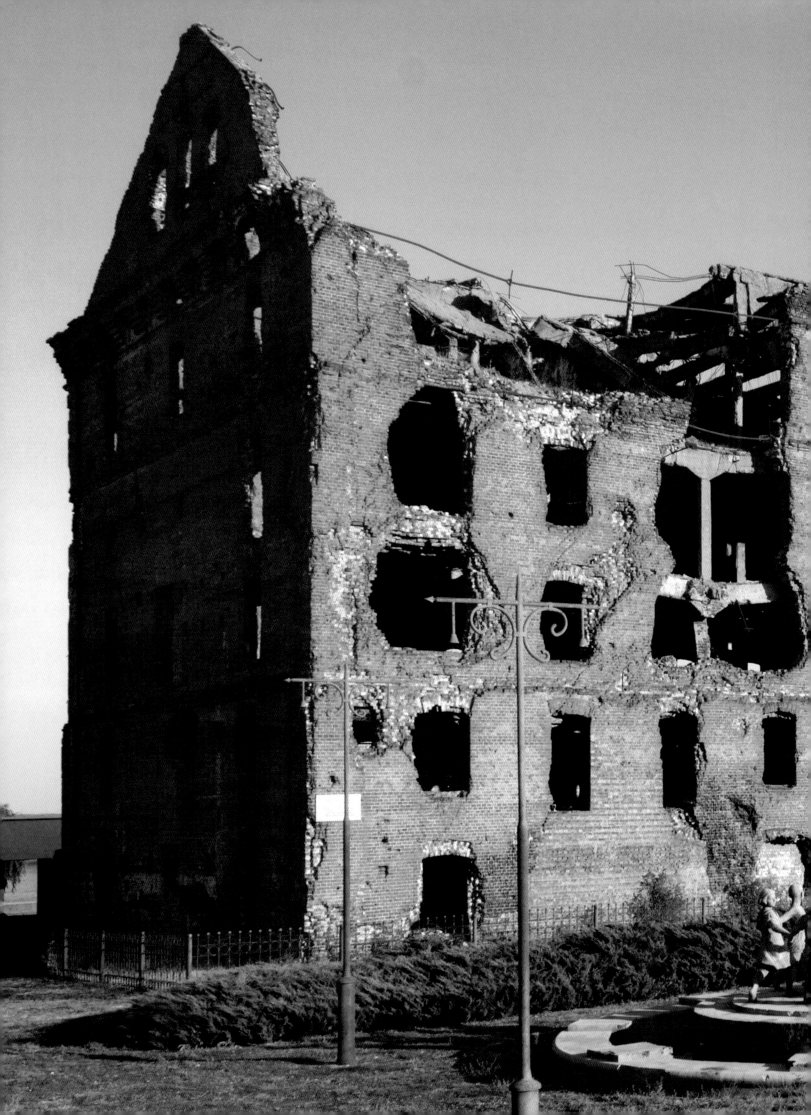

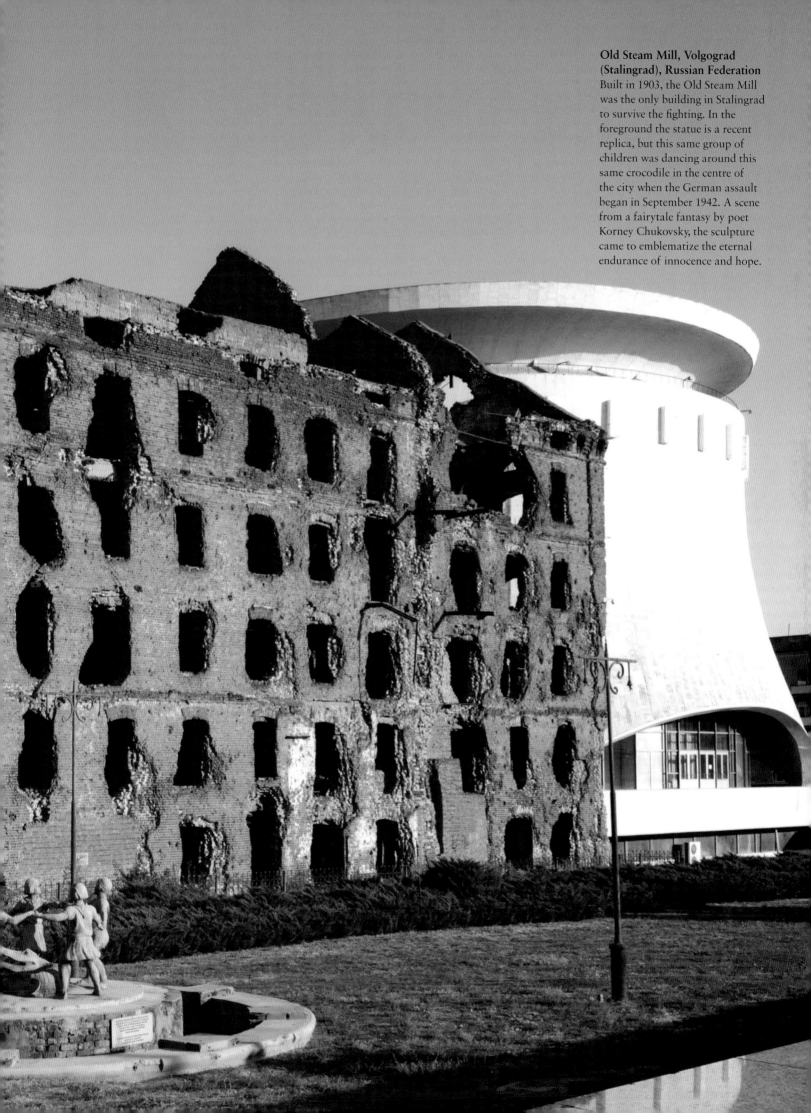

Old Steam Mill, Volgograd (Stalingrad), Russian Federation
Built in 1903, the Old Steam Mill was the only building in Stalingrad to survive the fighting. In the foreground the statue is a recent replica, but this same group of children was dancing around this same crocodile in the centre of the city when the German assault began in September 1942. A scene from a fairytale fantasy by poet Korney Chukovsky, the sculpture came to emblematize the eternal endurance of innocence and hope.

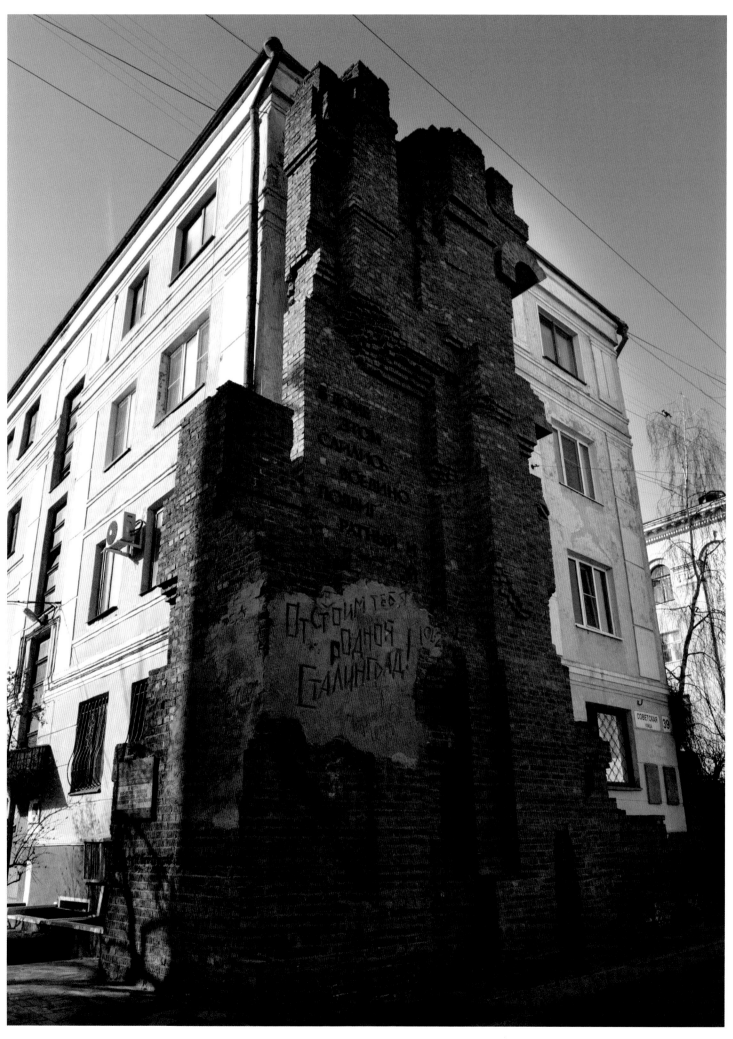

OPPOSITE:

**Pavlov's House, Volgograd
(Stalingrad), Russian Federation**
This post-war apartment building
has been raised around what
remains of the celebrated brick-
built block in which a group
of Soviet soldiers successfully
withstood a ferocious 60-day
siege by German forces. It takes
its nickname from Sergeant Yakov
Pavlov, commander of the platoon
whose heroic resistance inspired
the Red Army as a whole.

RIGHT AND BELOW:

**Oreshek Fortress Prison,
Shlisselburg, Russian Federation**
There's been a fortress here since
the fourteenth century; through the
seventeenth it lay in Swedish hands
till Peter the Great recaptured it
for Russia in 1702. In 1942–44,
however, a heroic new chapter in its
history was written by the group of
soldiers who held out here for 500
days under German siege.

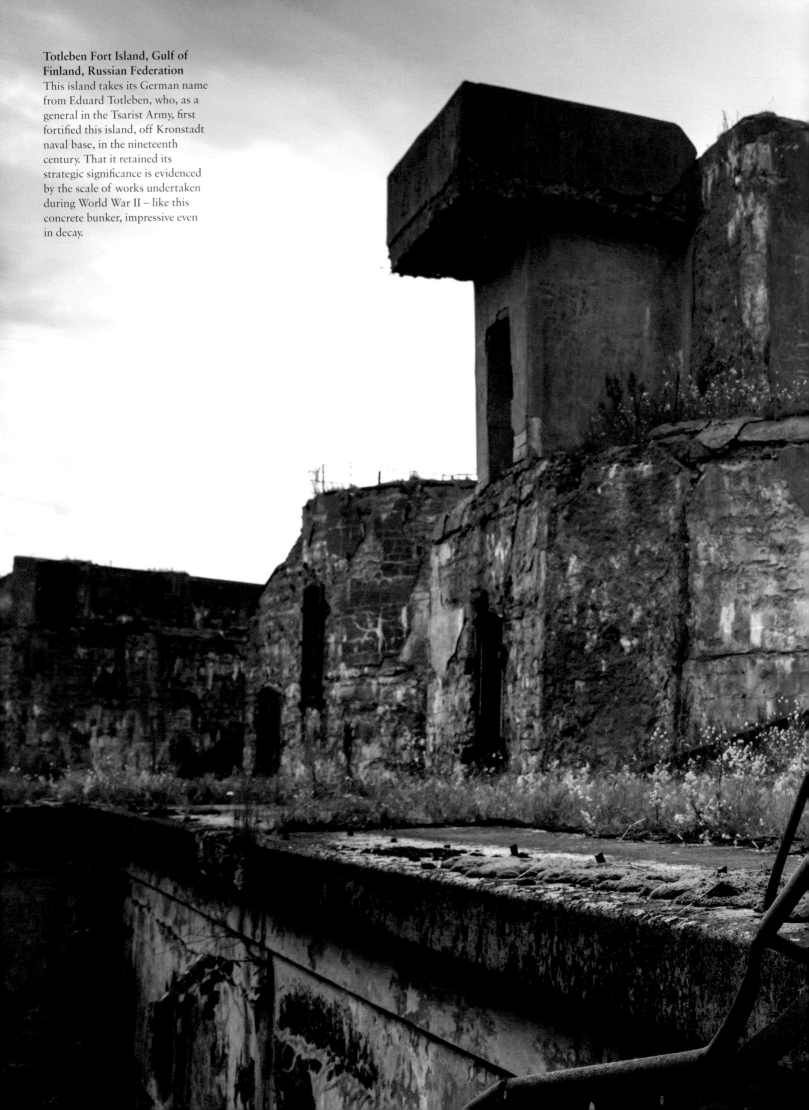

Totleben Fort Island, Gulf of Finland, Russian Federation
This island takes its German name from Eduard Totleben, who, as a general in the Tsarist Army, first fortified this island, off Kronstadt naval base, in the nineteenth century. That it retained its strategic significance is evidenced by the scale of works undertaken during World War II – like this concrete bunker, impressive even in decay.

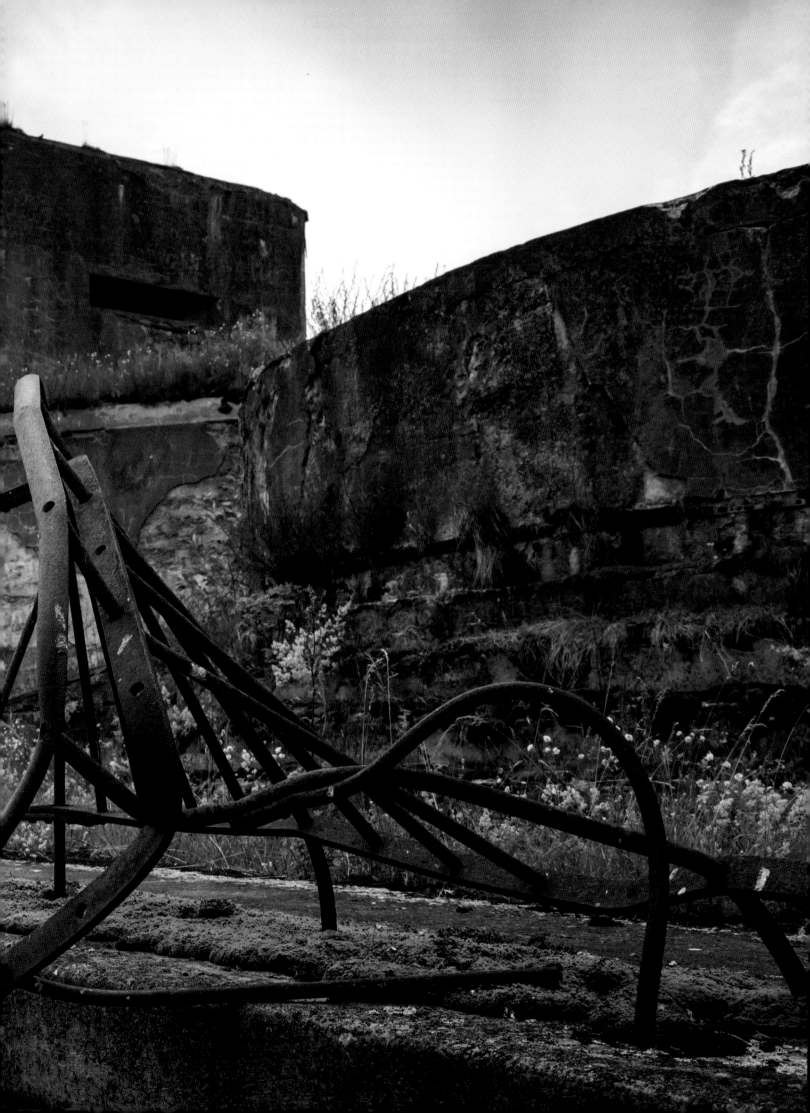

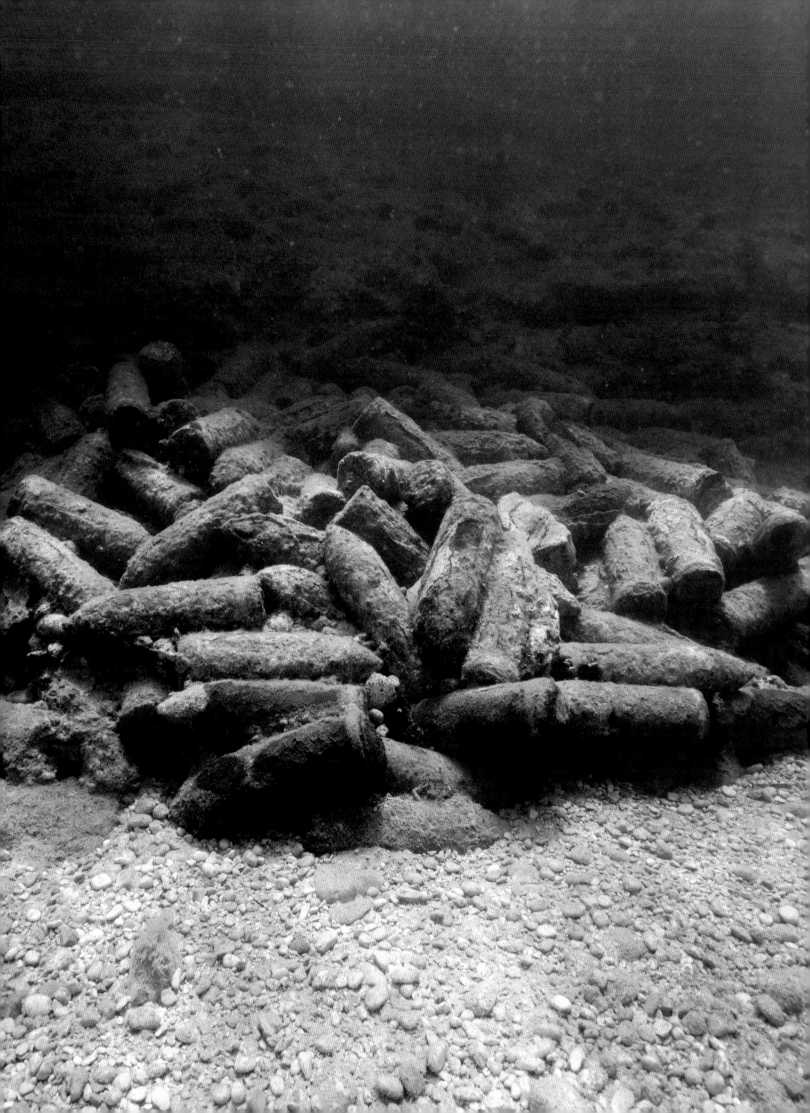

Mediterranean, Africa and Middle East

Ten thousand years ago, human civilization started in the Middle East: in time, the birth of agriculture brought the growth of cities. Uruk, Sumer, Babylon… the Egypt of the Pharaohs arose along the Nile. From Lebanese seaports like Tyre and Sidon, Phoenician traders exported their influence westward around North Africa and Southern Europe. As the ancient era approached its end, the locus of power shifted to a Mediterranean-centred world directed by Greece and Rome.

But if this region was the 'Cradle of Civilization' it has also been the graveyard to countless cultures – ever since Troy was taken, Carthage was destroyed, and Rome was sacked.

The modern era saw a further shift. By World War II, this sphere seemed secondary to the real historical action taking place further north. Southern Europe was now the 'soft underbelly' by which the Axis might be attacked; control of North Africa key to launching that assault; the Middle East the scene of strategic squabbles over colonial possessions.

The net result was the same, though: violent destruction, rack and ruin, the tumbledown temples and broken statues joined by decaying bunkers and burned-out tanks. Ancient shipwrecks with their amphorae had to make room on the seabed for sunken submarines and shot-down aircraft; abandoned jeeps were left slowly rusting on desert dunes.

LEFT:

Unexploded Shells, Albania
The Mediterranean, the Aegean and the Adriatic have been yielding up a new and sinister type of archaeological treasure in recent years – exciting, if potentially very dangerous, for divers. These unexploded shells would seem to have been dumped off the Albanian coast at the end of World War II.

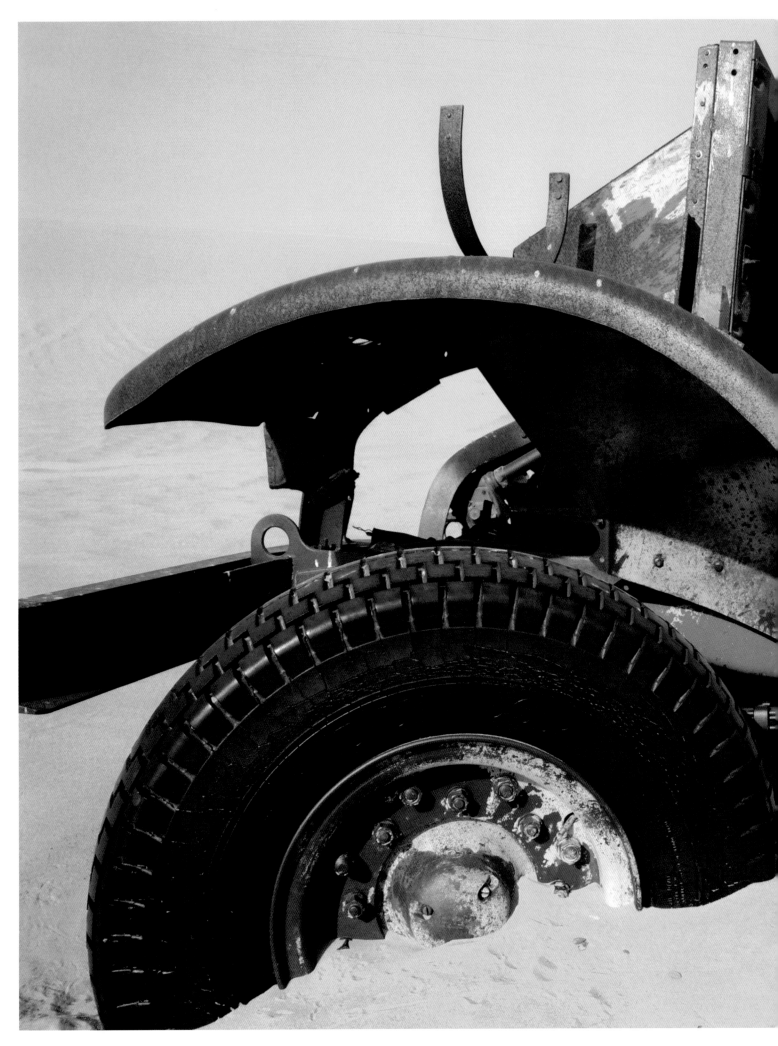

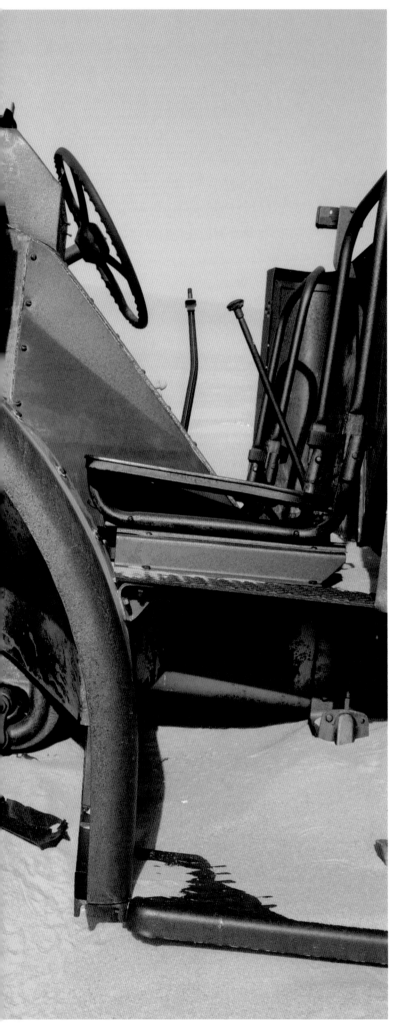

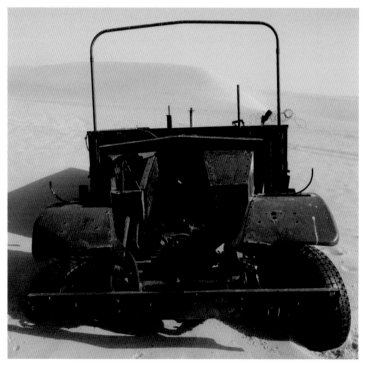

LEFT:

Abandoned Vehicle, Western Desert, Egypt

What stories this heap of wreckage could tell! This vehicle is known to have belonged to the British Army's Long Range Desert Group (LRDG), but what it was doing here – or what happened to its crew – remains obscure. Its brief brush with history over, this part of the Sahara was once again deserted, left a sea of empty sand.

ABOVE:

Abandoned Vehicle, Western Desert, Egypt

The same wreck seen from a different angle. The LRDG was founded in 1940 to carry out reconnaissance and raiding tasks well behind Axis lines. These were empty, untracked territories in which less skilled and specialized forces would have found it impossible to navigate successfully – let alone to fight.

RIGHT:
Truck in Hold of Sunken SS
Thistlegorm, **Red Sea, off Egypt**
A UK merchant vessel, the SS
Thistlegorm was sent to the
bottom by German bombers on
6 October 1941. Much of her
cargo – which included guns,
ammunition, motor vehicles
and even a steam locomotive –
remained on or close to the ship
when she went down, making her
wreck a favourite playground for
modern divers.

OVERLEAF:
Motorcycle in Hold of Sunken SS
Thistlegorm, **Red Sea, off Egypt**
Another treasure of the
Thistlegorm, this motorbike (a
British-built Norton) would most
likely have been used by a desert
courier had it made its destination
in Alexandria. Ironically, the
Thistlegorm had come 'the back
way', via the Cape, for safety's
sake, because of an intensification
in German attacks on Allied
shipping in the Mediterranean.

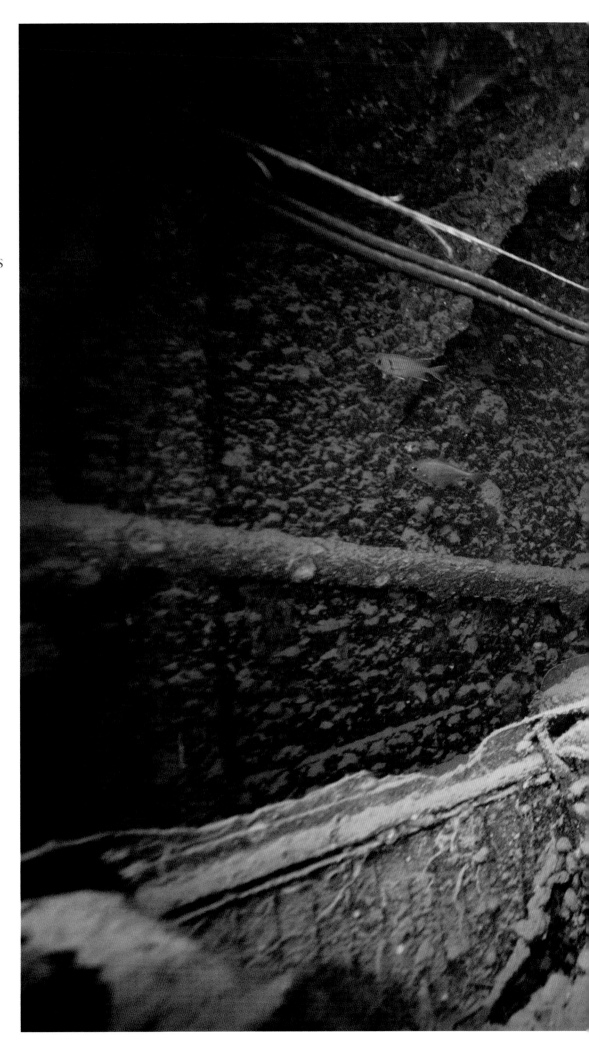

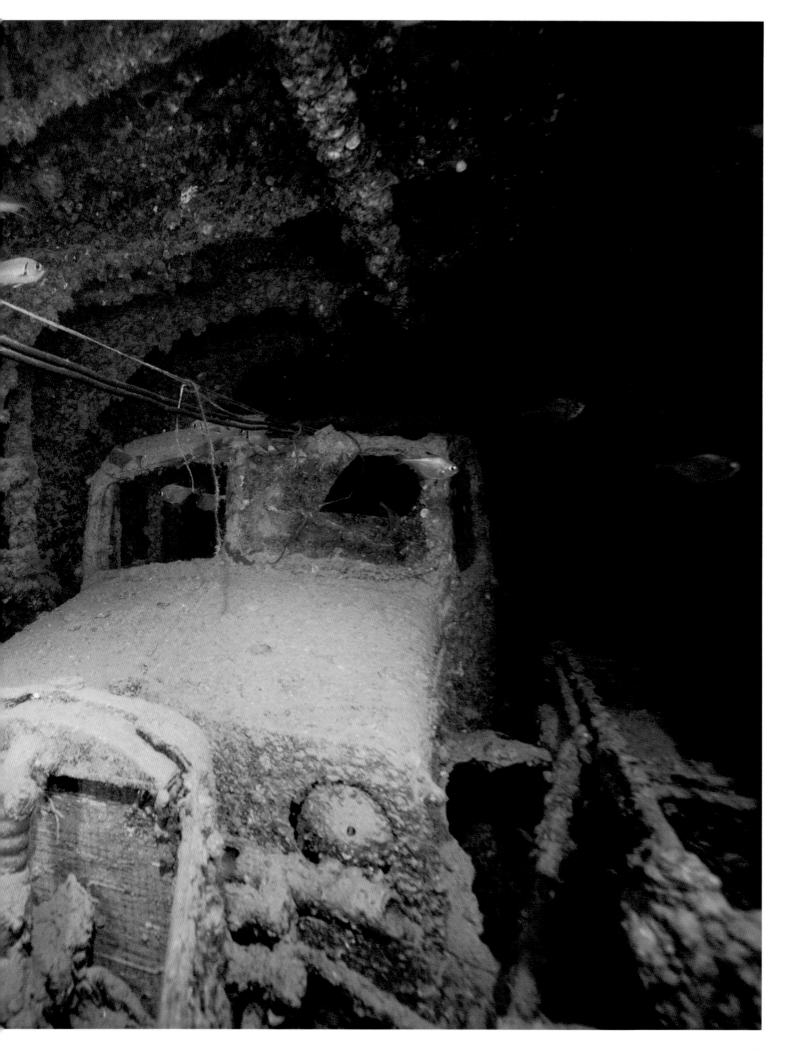

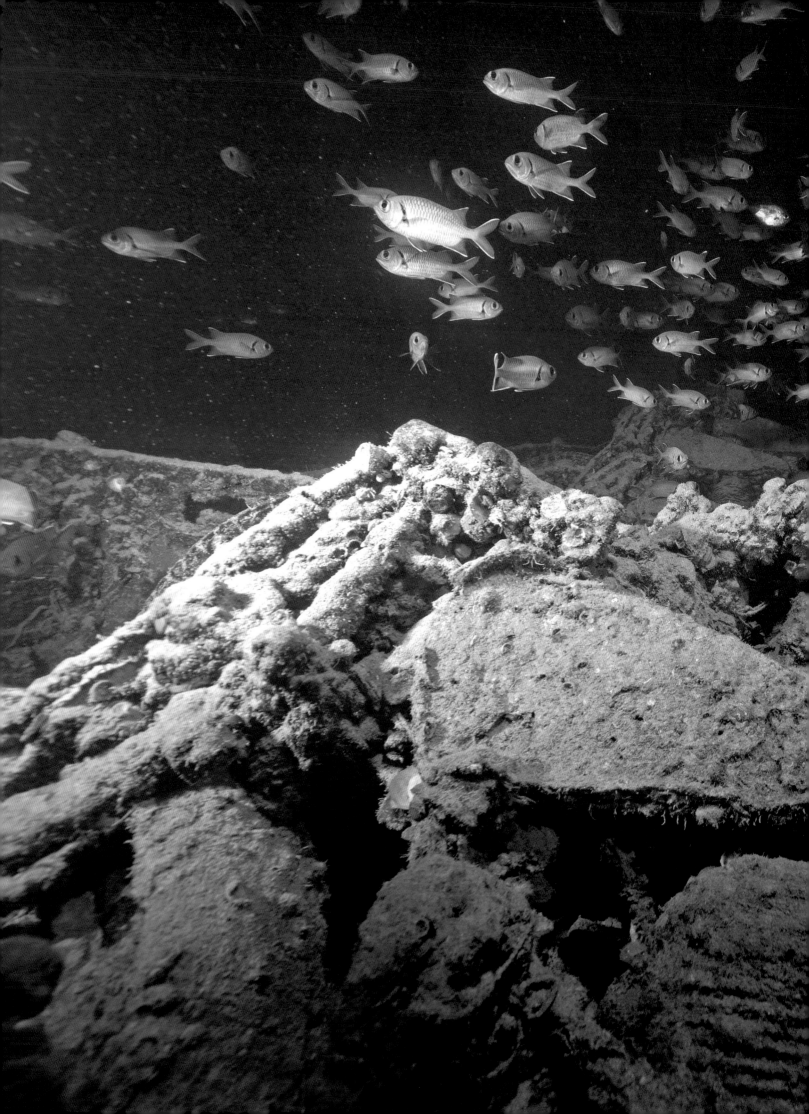

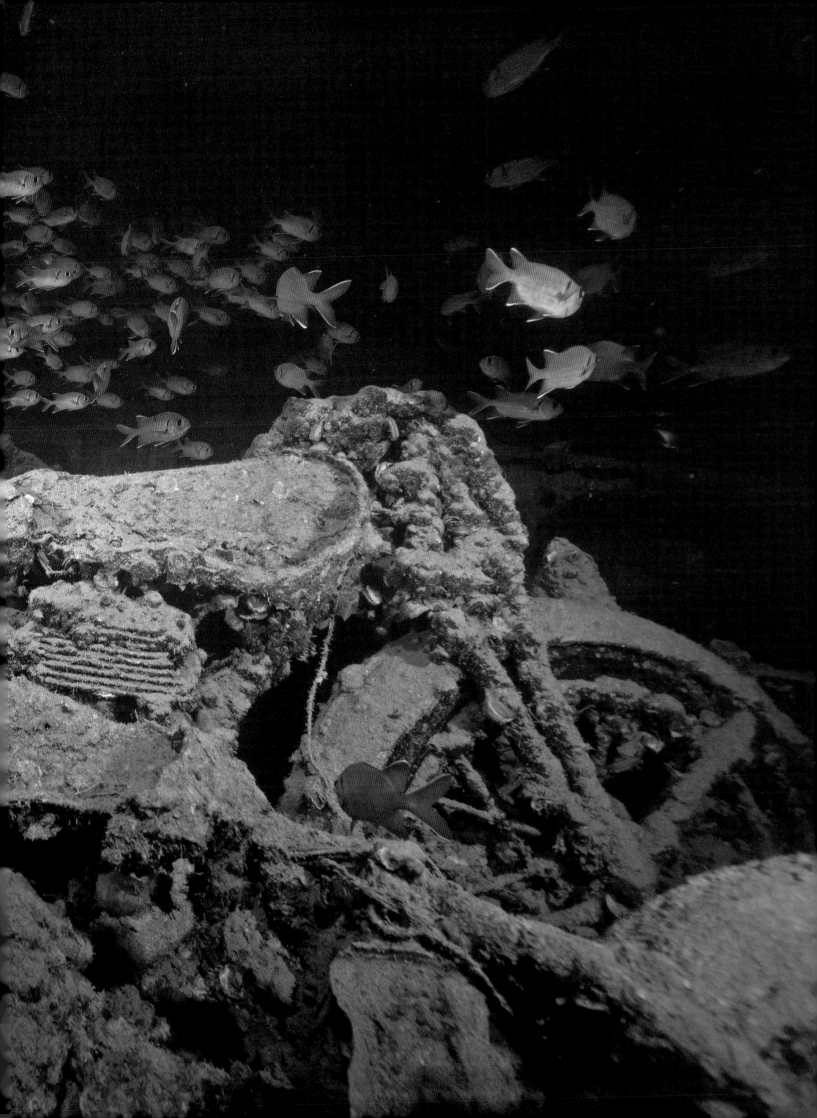

LEFT:

**Italian Submarine *Scirè*,
Haifa Bay, Israel**

Forever at peace now, the *Scirè*
came off second best in an
encounter with the *Islay*, a British
naval trawler armed with a
12-pounder naval gun, anti-aircraft
weaponry and depth charges. It
was depth charges that, on 10
August 1942, sent the *Scirè* to the
bottom.

BELOW:

**Italian Submarine *Scirè*,
Haifa Bay, Israel**

Built in 1938, the *Scirè* was a
coastal submarine of the Adua-
class, displacing 680 tonnes
(740 tons) and measuring 60
metres (200ft) in length. In 1984,
the remains of 44 crew members
were recovered and repatriated for
burial (16 remain missing) and the
wreckage was seized and registered
as a war memorial.

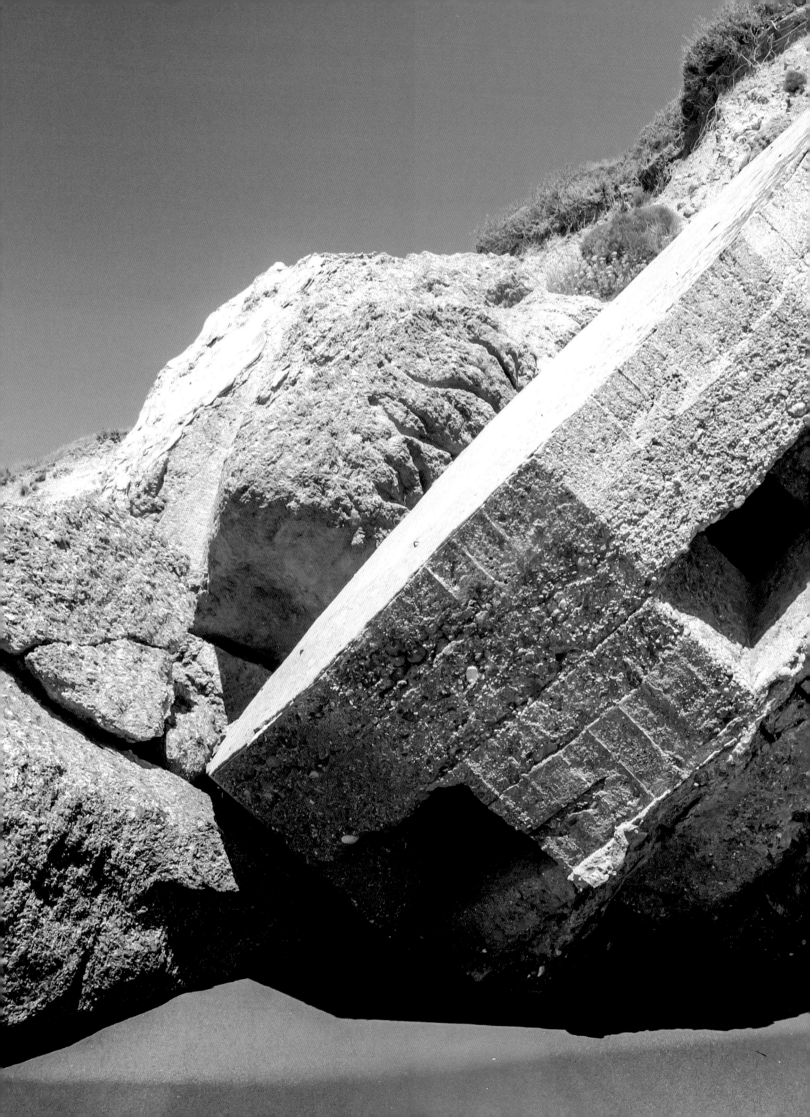

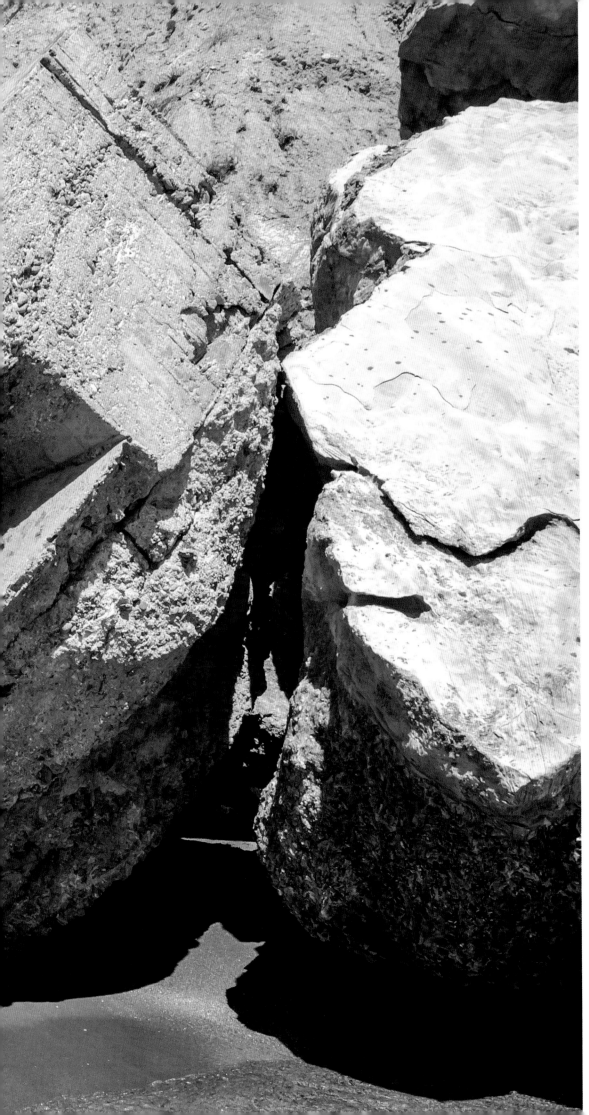

LEFT:
Collapsed Bunker, Kalamaki Beach, Zakynthos, Greece
A landslide carried this bunker down from the crest of the headland on which it perched: now it rests at a crazy angle on the beach it once looked out over. The Germans occupied the Greek islands in April 1941, and quickly dug in to resist expected Allied attempts to recapture them.

FOLLOWING PAGES:
Corridor, Fort Istibey, Serres, Macedonia, Greece
Named for the prime minister who ordered its construction, the 'Metaxas Line' was built in the 1930s to prevent an attack on Greece by a resurgent Bulgaria. A part of this larger fortification, atop Mount Beles, Fort Istibey was strongly built, and garrisoned by over 300 men, but still fell quickly to the advancing Germans.

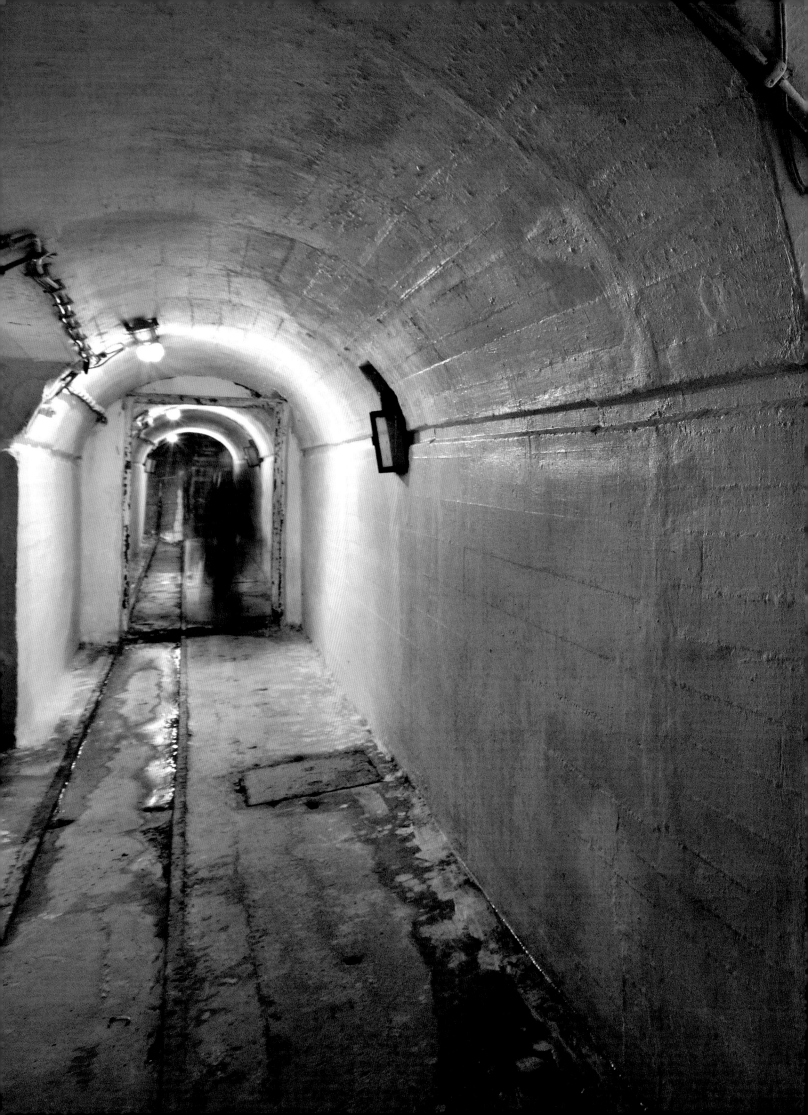

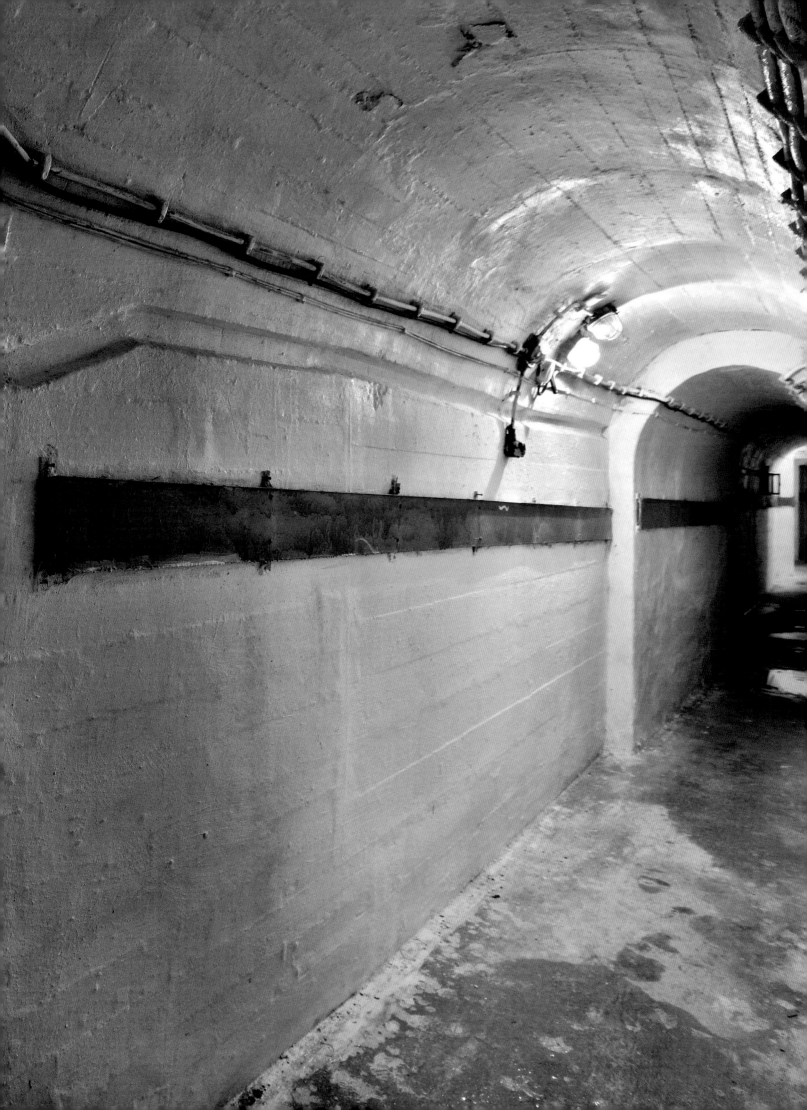

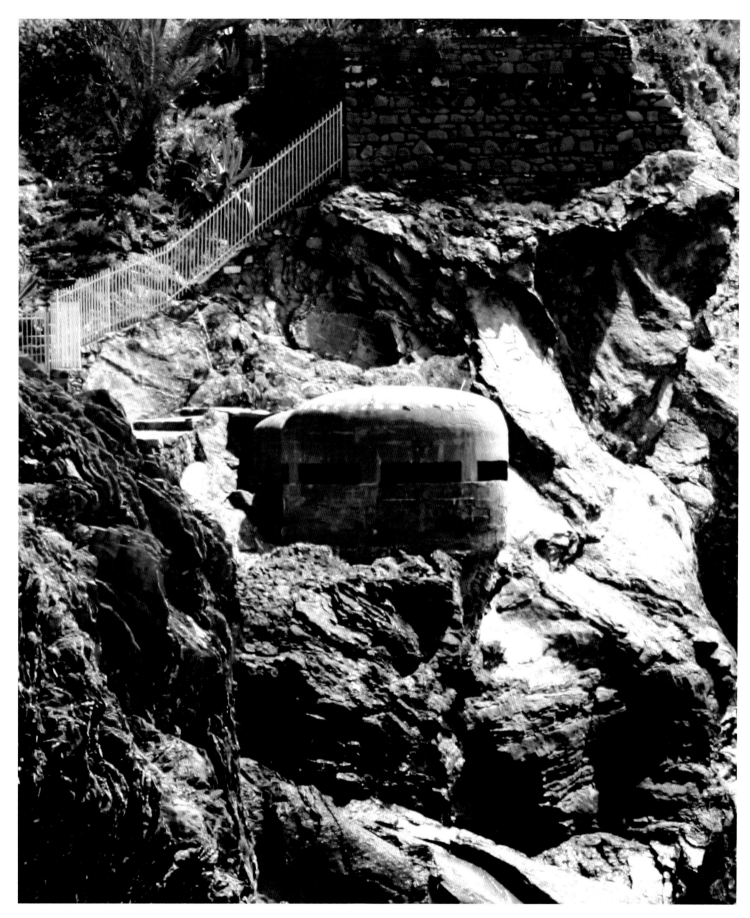

ABOVE:

Concrete Pillbox, Cinque Terre, Liguria, Italy
These rocky cliffs were rugged enough to deter attack all by themselves, it might be thought, but the Germans who built these

defences didn't fancy taking chances. Rightly so, for the Allies did see Italy as representing a 'soft underbelly', vulnerable to an attack that they finally mounted in the summer of 1943.

OPPOSITE (BOTH):

Bunker, Punta Chiappa, Liguria, Italy
It seems so much more than a bunker: built in 1941, Battery 202, south of Genoa on Italy's scenic northwest coast, is, in its brutish

way, a thing of beauty. Here we see it both from below, in an attacker's-eye-view, and from inside, from the perspective of its defender.

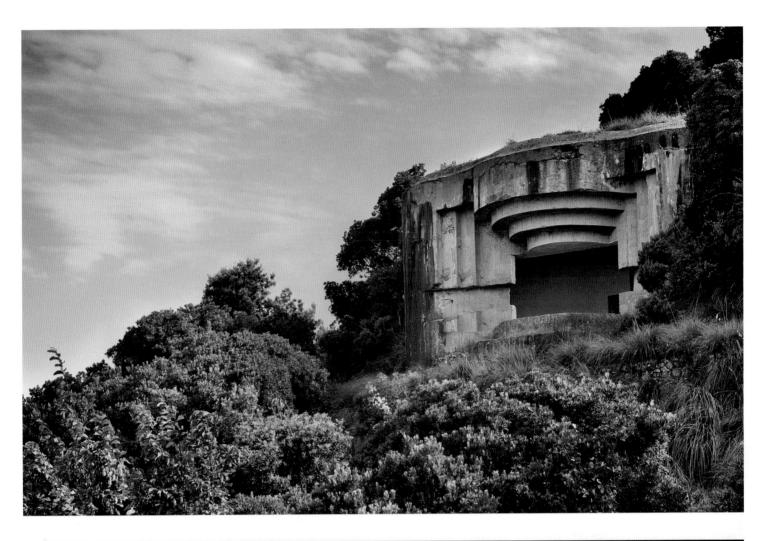

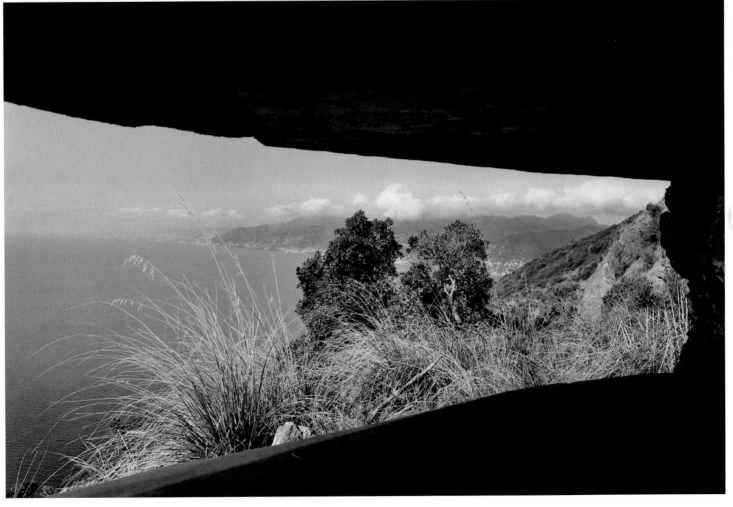

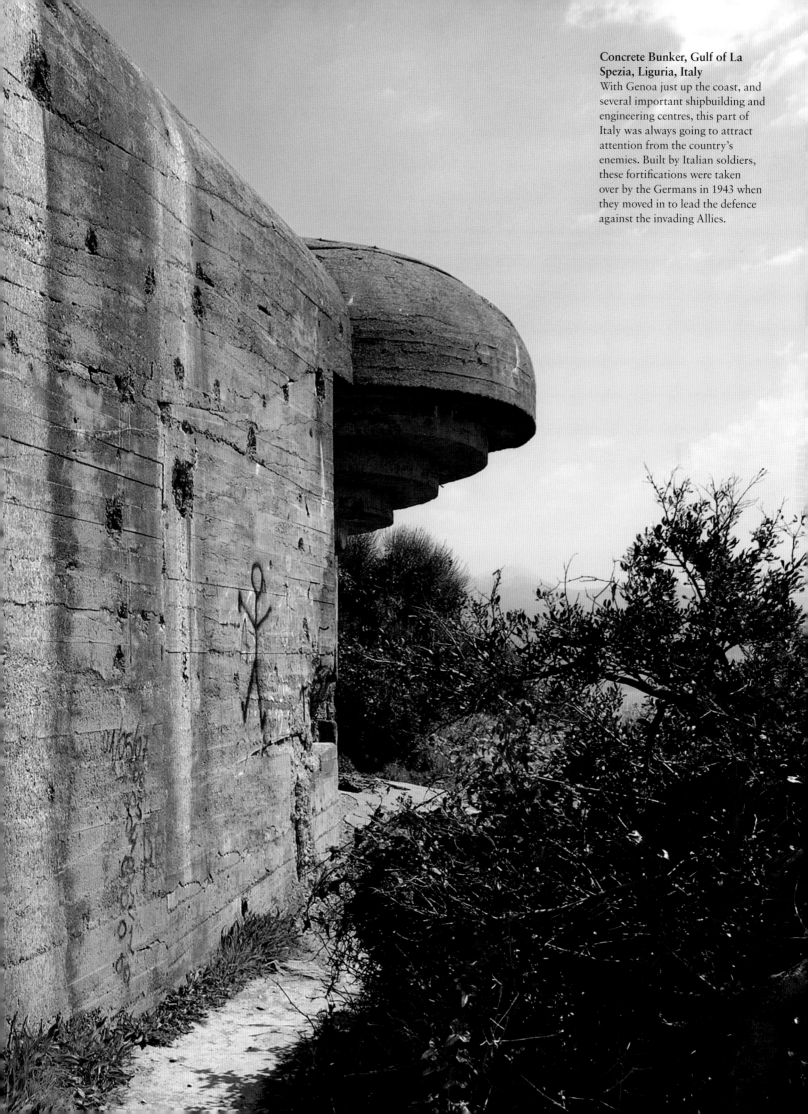

Concrete Bunker, Gulf of La Spezia, Liguria, Italy
With Genoa just up the coast, and several important shipbuilding and engineering centres, this part of Italy was always going to attract attention from the country's enemies. Built by Italian soldiers, these fortifications were taken over by the Germans in 1943 when they moved in to lead the defence against the invading Allies.

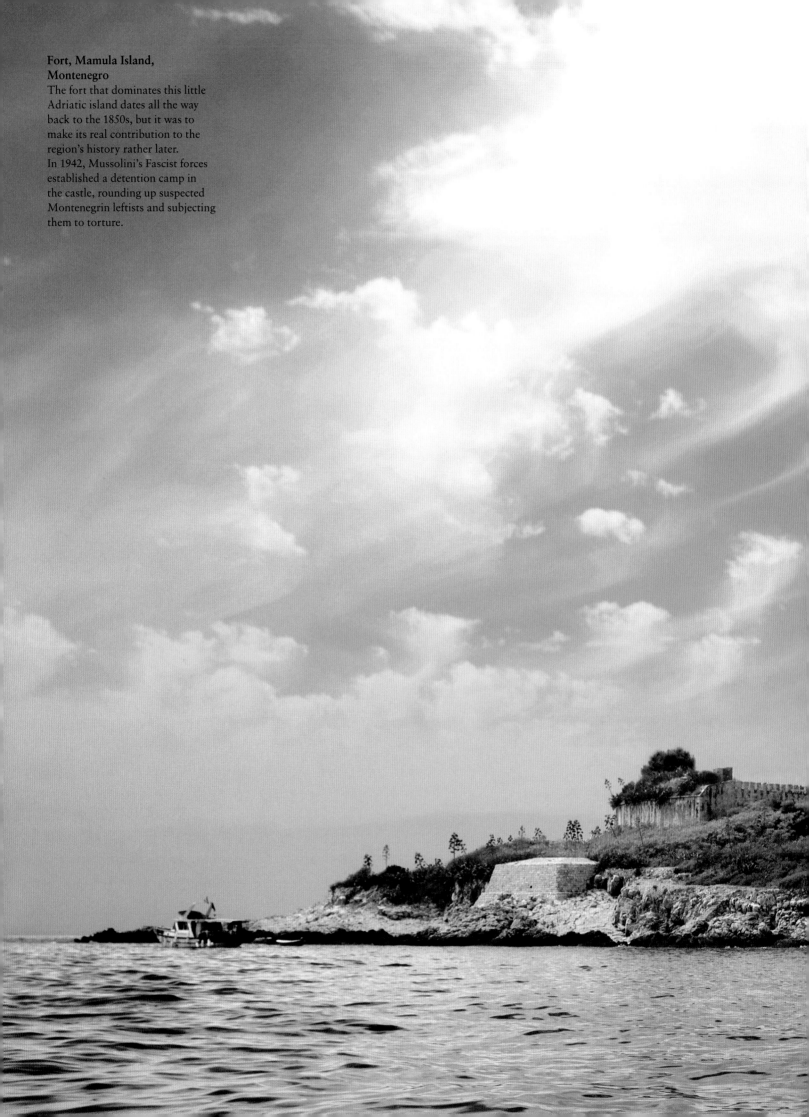

Fort, Mamula Island, Montenegro

The fort that dominates this little Adriatic island dates all the way back to the 1850s, but it was to make its real contribution to the region's history rather later. In 1942, Mussolini's Fascist forces established a detention camp in the castle, rounding up suspected Montenegrin leftists and subjecting them to torture.

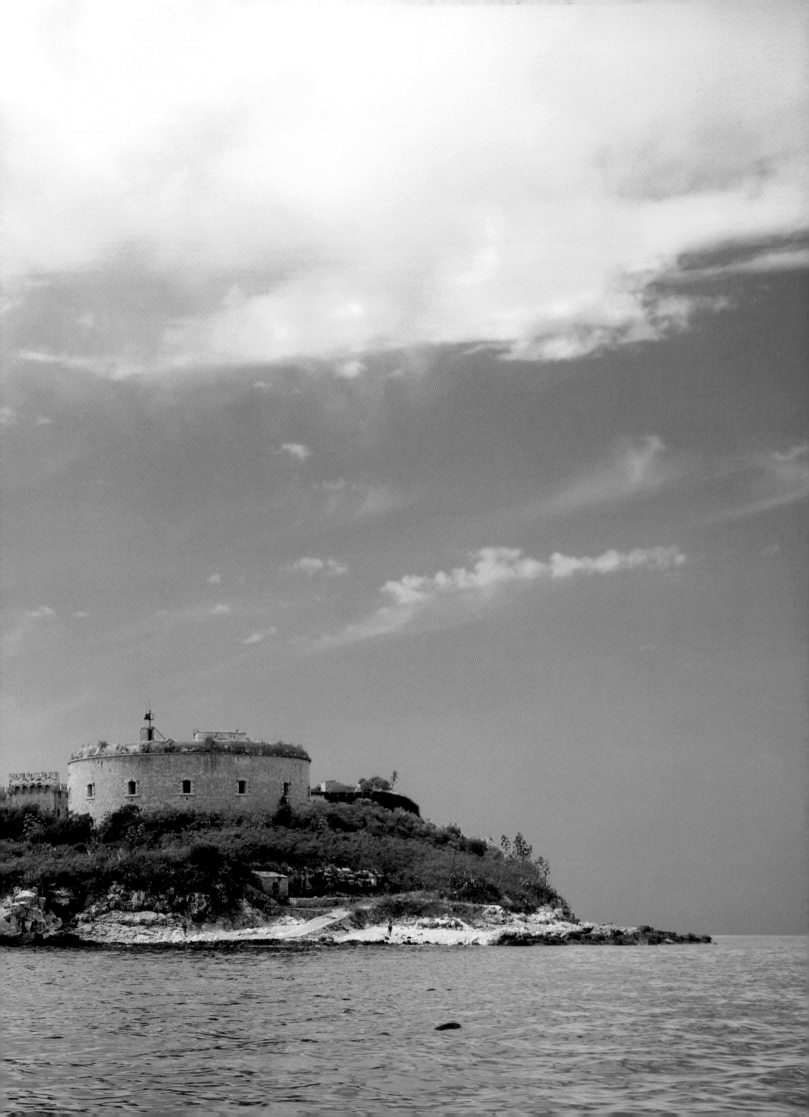

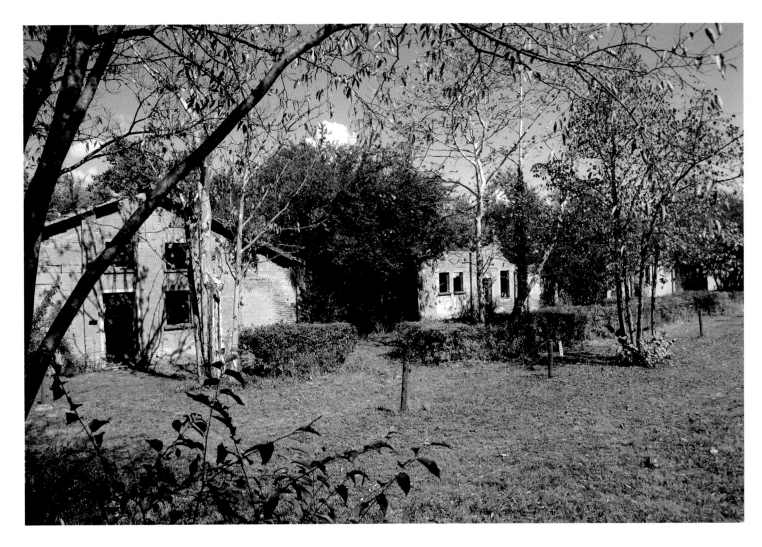

**Campo di Fossoli,
Emilia-Romagna, Italy**

This centre's changing functions
trace out an inhuman chronology
of mass-detention and movement
of people that was one of the
ugliest features of World War II.
Built to house Allied prisoners-
of-war (POWs), it became a
concentration camp (2,800 Jews
passed through en route to the
death camps of the east) before
becoming a centre for forced
labour.

Even when the war was over, the
Campo di Fossoli's work was far
from done: it was home, first to
Italian POWs; then to displaced
persons. Finally, a Catholic charity
took it over as accommodation for
some of Italy's many thousands of
war orphans.

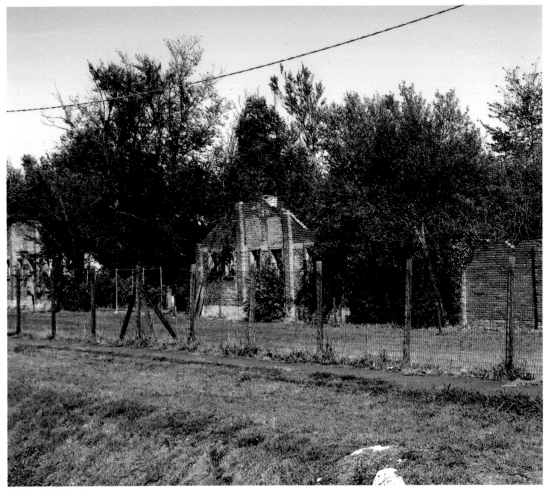

**Dodge WC Series Truck,
Ouadane, Mauritania**
An outlying territory
administered from the outlying
territory of French West Africa,
Mauritania had, by broad
standards, a quiet war. Even so,
as a possession of Vichy France,
it was inevitably of interest to
the Allies – especially because
a series of droughts deepened
existing anti-colonial unrest.

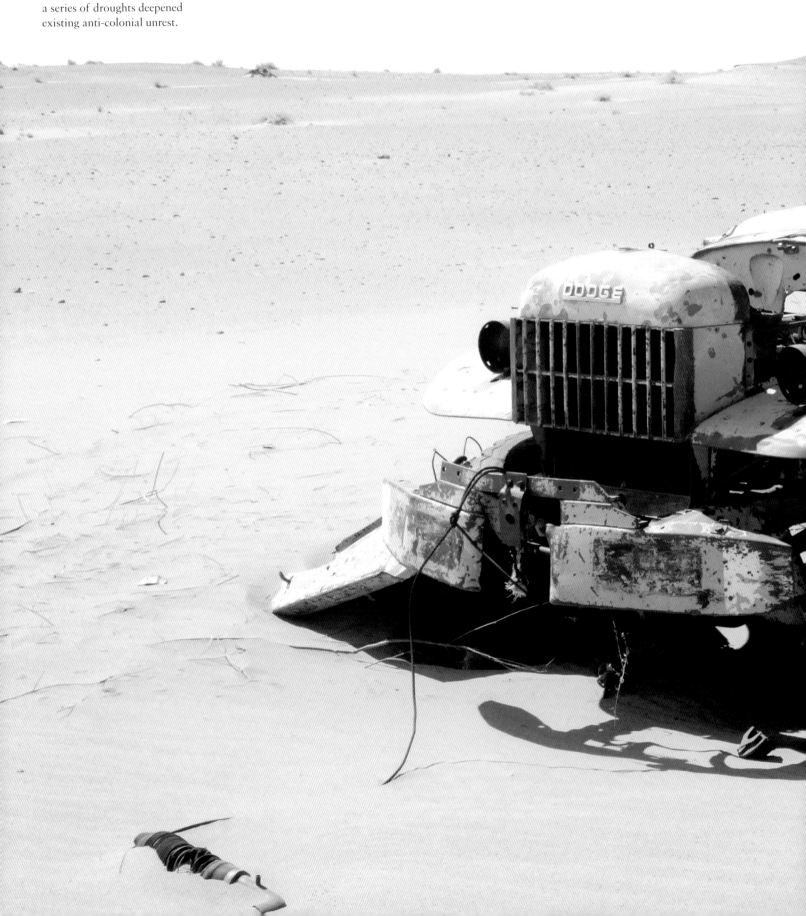

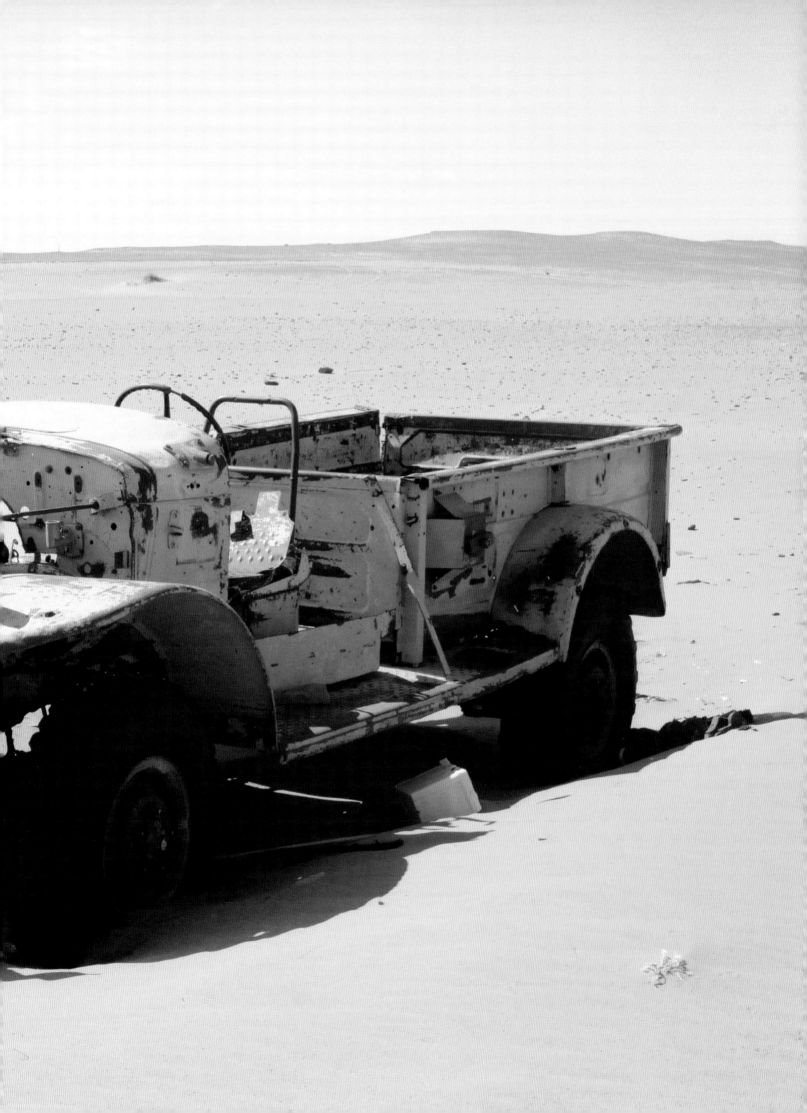

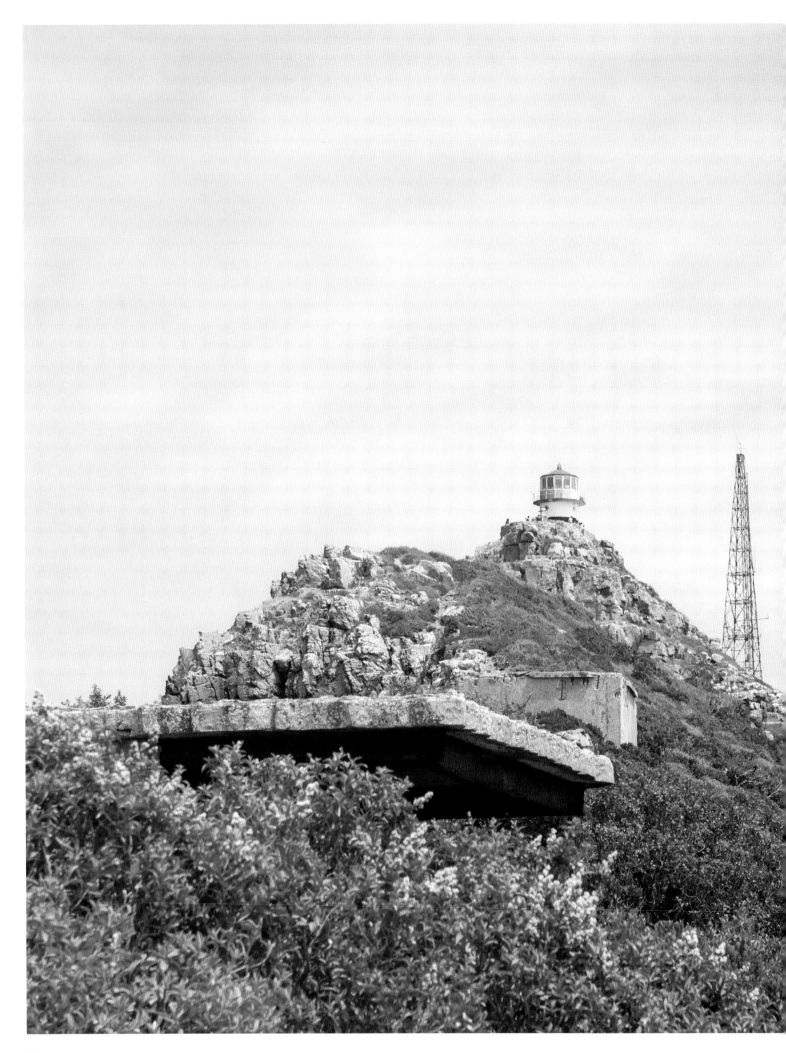

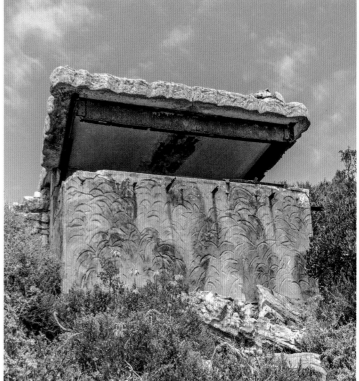

LEFT:

Observation Post, Cape Point, South Africa
Stunning scenery; beautiful birds; glorious flowers and plants … there's plenty to see on this rocky promontory some 60km (37 miles) south of Cape Town. During the war, though, the most important view was seaward, to where German U-boats lay in wait for Allied shipping headed for the Cape.

ABOVE:

Observation Post, Cape Point, South Africa
In the early months – and even years – of the war, before the advent of effective radar, enemy planes and ships could only really be tracked by eye. Observation posts like this one, high up on the Cape Point cliffs, helped preserve innumerable mariners and assure the safe passage of crucial supplies.

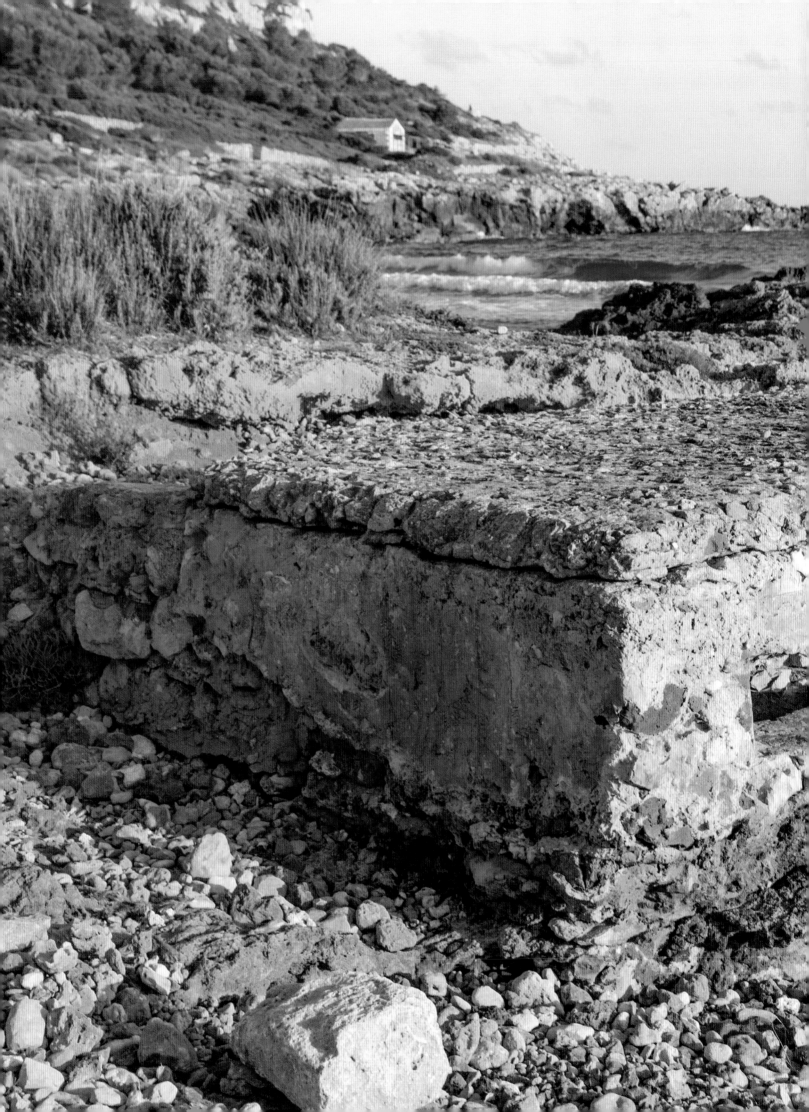

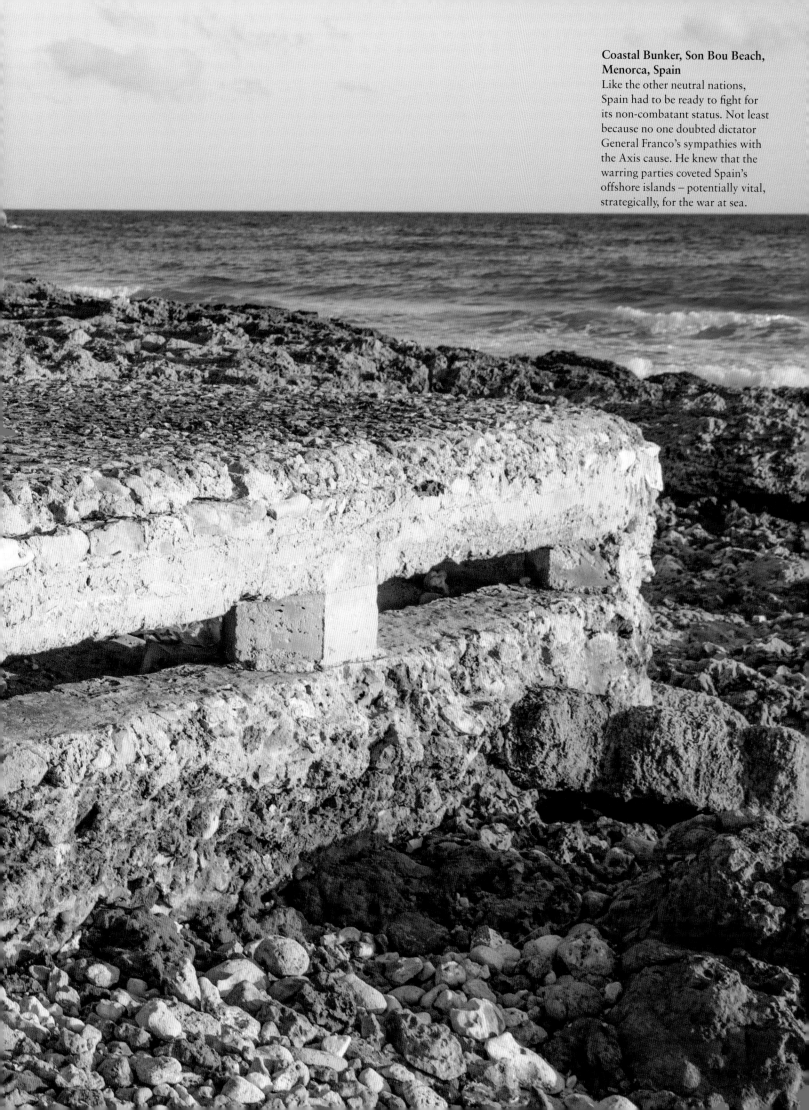

Coastal Bunker, Son Bou Beach, Menorca, Spain
Like the other neutral nations, Spain had to be ready to fight for its non-combatant status. Not least because no one doubted dictator General Franco's sympathies with the Axis cause. He knew that the warring parties coveted Spain's offshore islands – potentially vital, strategically, for the war at sea.

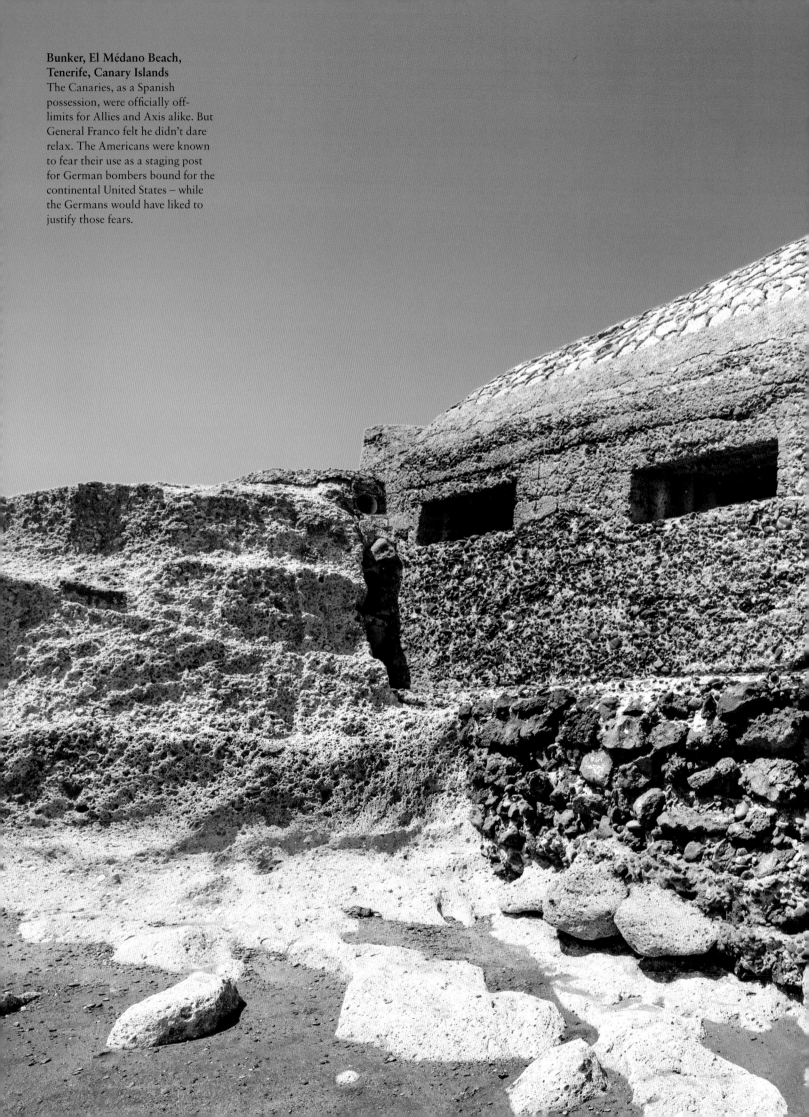

Bunker, El Médano Beach, Tenerife, Canary Islands
The Canaries, as a Spanish possession, were officially off-limits for Allies and Axis alike. But General Franco felt he didn't dare relax. The Americans were known to fear their use as a staging post for German bombers bound for the continental United States – while the Germans would have liked to justify those fears.

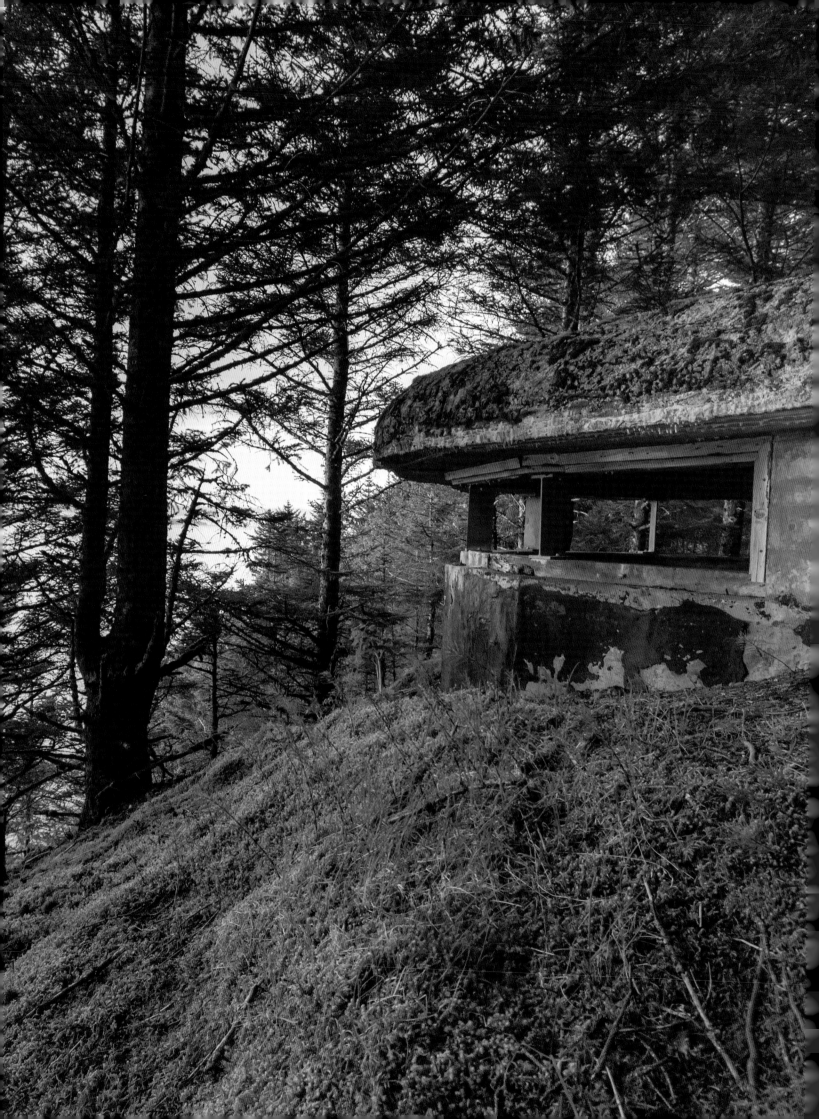

North America

If we want to find the legacy of World War II in North America, we have to look a little harder than we do elsewhere. The conflict never actually 'came home' to the United States and Canada in quite the way it did to Europe, North Africa, the Middle East and the Pacific, tearing up the countryside and leaving cities smoking ruins and populations scattered or enslaved. No barbed-wire-lined beaches; no bombed-out earthworks; no shot-down aircraft or abandoned villages...but that doesn't mean the conflict didn't make its mark.

That it did so on the more than 400,000 Americans and 40,000 Canadians who gave their lives in the fighting (and their families) goes without saying; that it impacted on the mass of civilians in economies orientated increasingly – and finally completely – around the war effort is also true. For all this, though, the evidence is to be found largely in the history books and memoirs. The traces on the ground are far more thinly spread.

This only gives such monuments as have endured a greater capacity to startle us and stir our feelings, so far as they now seem from what we remember of the war. There's a dissonance about these sights that only makes them seem so much more poignant, more evocative than they might otherwise have been.

LEFT:
Bunker, Kodiak Island, Alaska
When we think of the Pacific War, we think, for better or worse, of tropical forests and coral beaches; of searing sun and torrential monsoon rain. Through 1942–43, though, the fight was on for control of the much colder Aleutian Islands, seen as strategically crucial by both sides. Kodiak's naval base was vital for the Allies.

RIGHT:

Logging Camp, Louise Island, British Columbia, Canada

Canadian lumber was especially important to the British war effort at a time when supplies from Scandinavia were cut off. Timber has myriad uses, of course, but wood felled here was to see action particularly directly in the airframe of the DH.98 Mosquito bomber. Spruce was favoured, being both resilient and light.

FOLLOWING PAGES:

Abandoned US Base, Ikkatteq, Greenland

Up to 800 servicemen and civilian staff were established here in 1942, dwarfing nearby settlements along the Sermilik Fjord. Three years later, the war was over and by 1947 the visitors had all gone, but the impact on local communities – and, as we see here, the local landscape – was to be lasting.

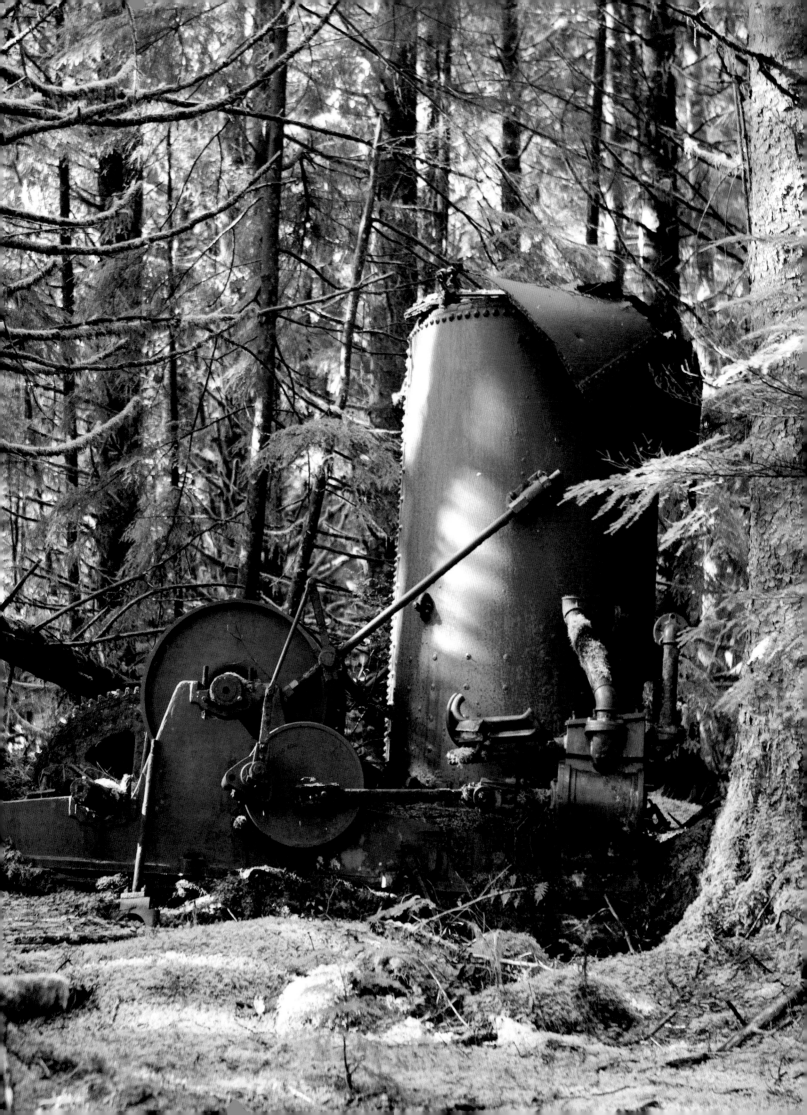

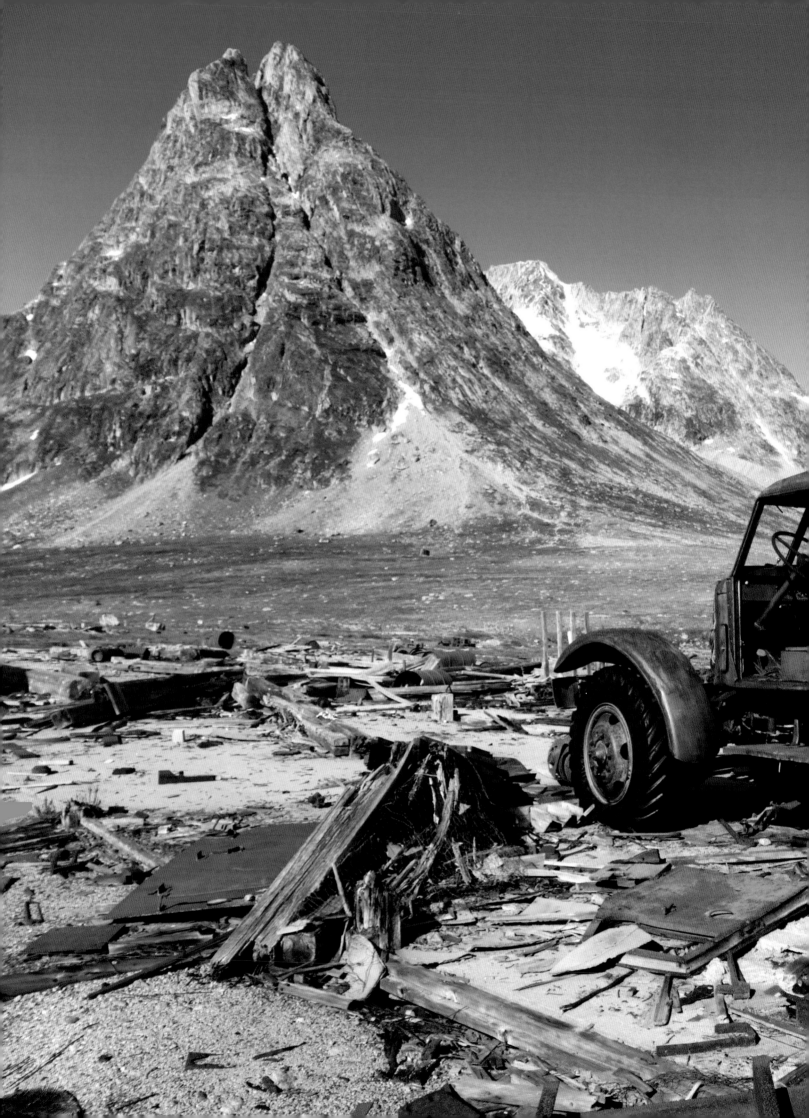

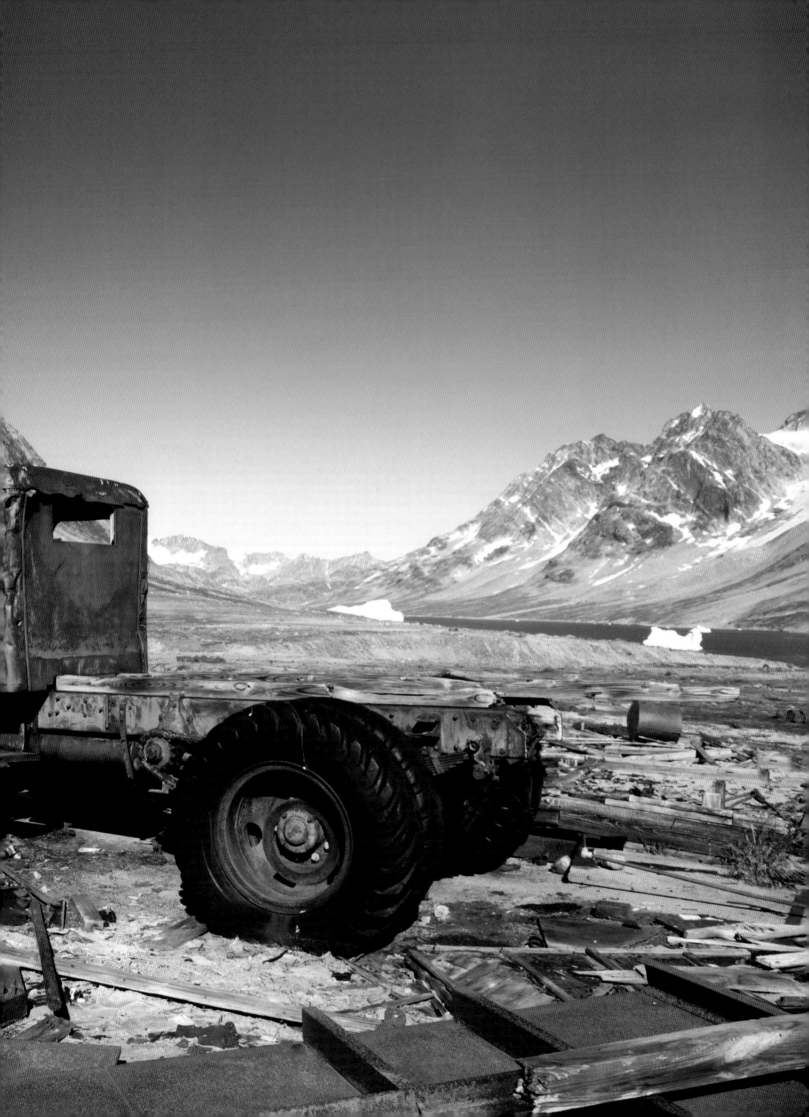

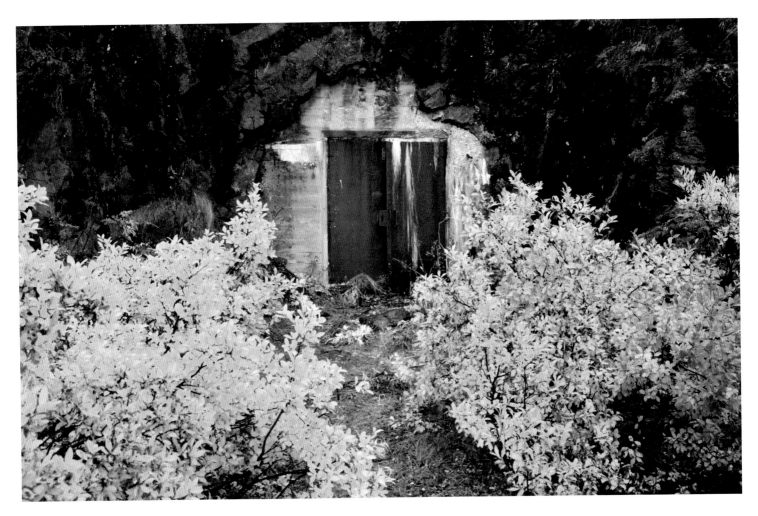

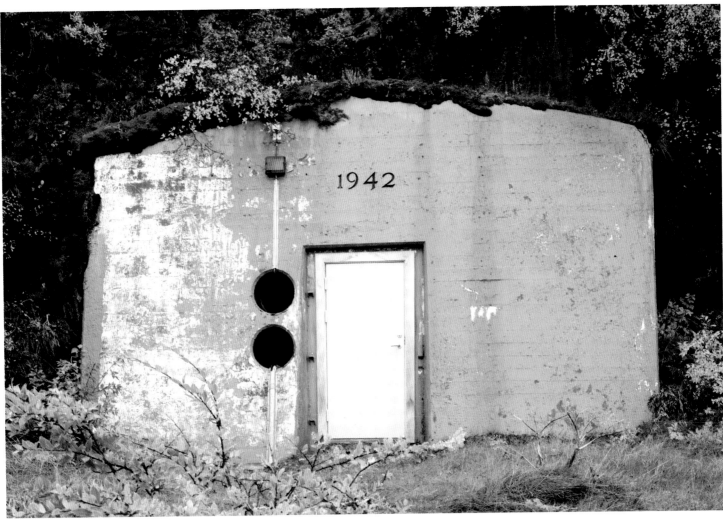

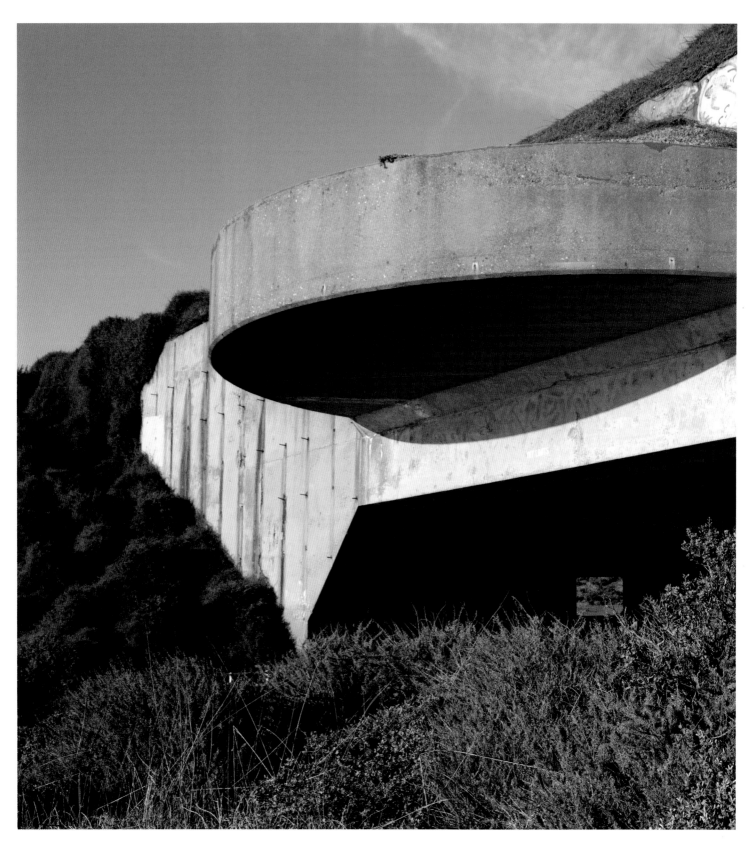

Air-Raid Shelter, Narsarsuaq, Greenland
This base at Greenland's southern tip was built in 1941, a staging-post for aircraft bound for Europe and North Africa. Over 10,000 flights are estimated to have passed through during the war. Tucked into an existing cave, this shelter was well-nigh impregnable, enjoying as it did the protection of many metres of solid rock.

Air-Raid Shelter, Narsarsuaq, Greenland
Narsarsuaq – or, in US airman's parlance, 'Bluie-West 1' – was probably the most important airfield in 'Bluie', or Greenland. Built on a wide and level area of moraine at the mouth of a glacier, BW-1, it was at its height the home to up to 4,000 American servicemen – there to maintain and refuel transatlantic flights.

Battery Townsley, Fort Cronkhite, California
This battery slightly predates the fort of which it now forms part, though both were in service by the start of World War II, helping guard the northerly entrance to San Francisco Bay and the Golden Gate Bridge. A giant 40cm (16in) gun sited here had a range of over 50km (30 miles).

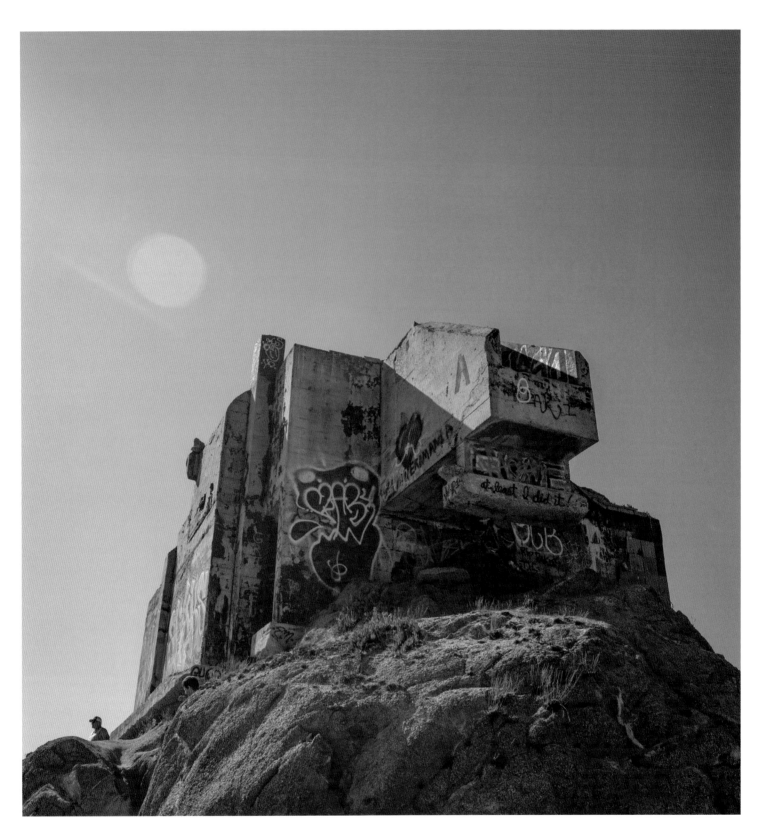

ABOVE:

'Bunker Point', off Highway 1, Half Moon Bay, California
High up on the so-called 'Devil's Slide', an abandoned bunker perches – precariously poised, as though on the point of coming crashing down. From this vertiginous lookout post, observers monitored shipping offshore, passing positions to the gunners in nearby batteries, like the ones at Fort Funston, a few miles further north.

OPPOSITE:

Guard Tower, Manzanar Internment Camp, Mojave Desert, California
Call it a 'concentration camp', an 'internment camp' or a 'relocation centre': Manzanar is pretty ugly by any name. In 1942, over 10,000 Japanese-Americans were rounded up to be transported here and held in harsh conditions for the duration of the war; another 90,000 were detained in other camps elsewhere.

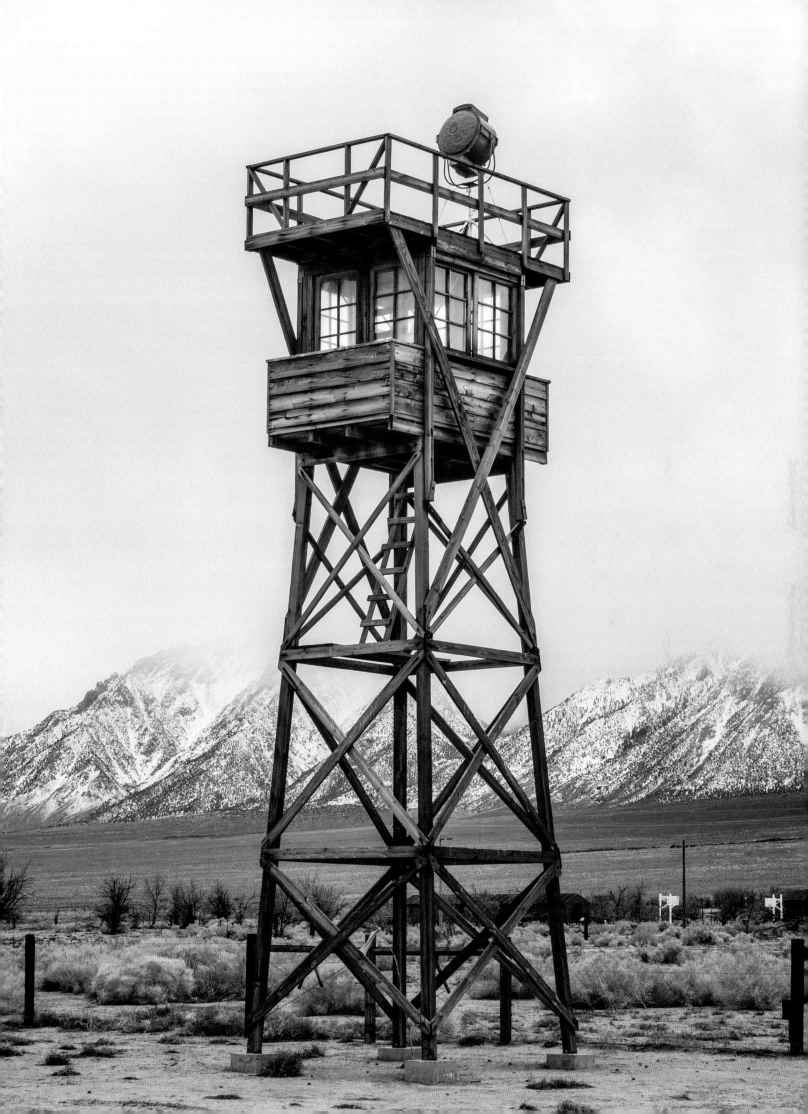

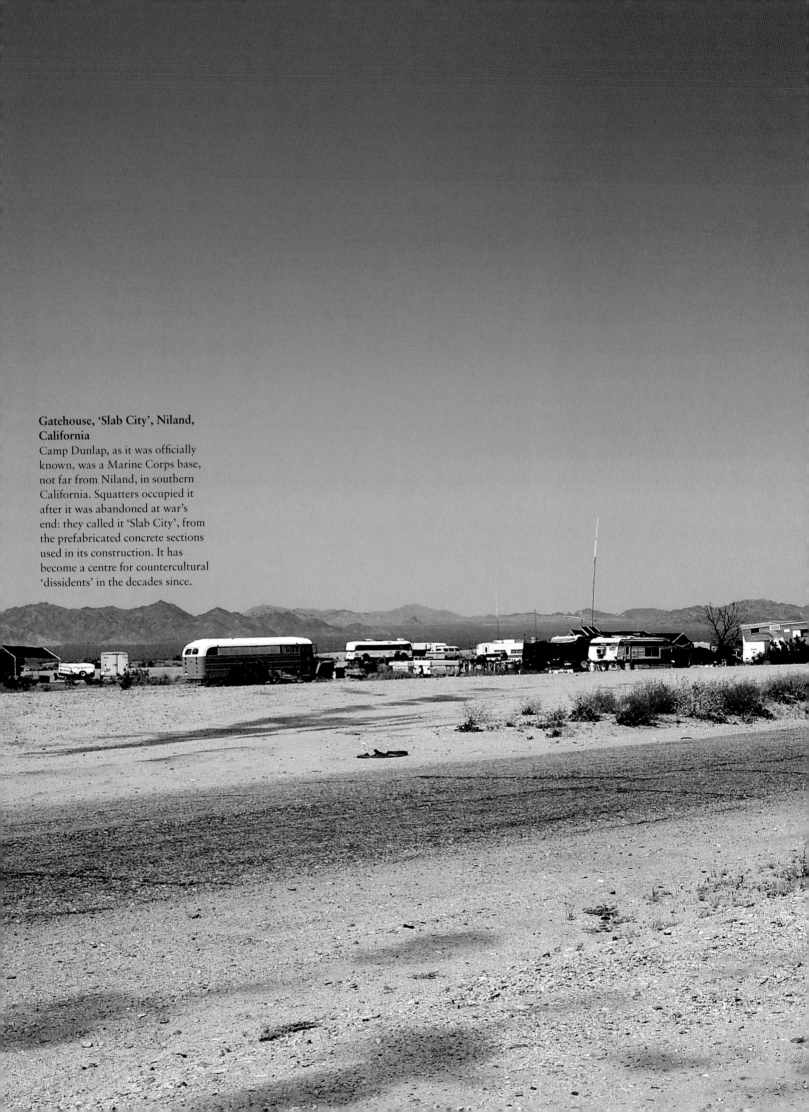

Gatehouse, 'Slab City', Niland, California
Camp Dunlap, as it was officially known, was a Marine Corps base, not far from Niland, in southern California. Squatters occupied it after it was abandoned at war's end: they called it 'Slab City', from the prefabricated concrete sections used in its construction. It has become a centre for countercultural 'dissidents' in the decades since.

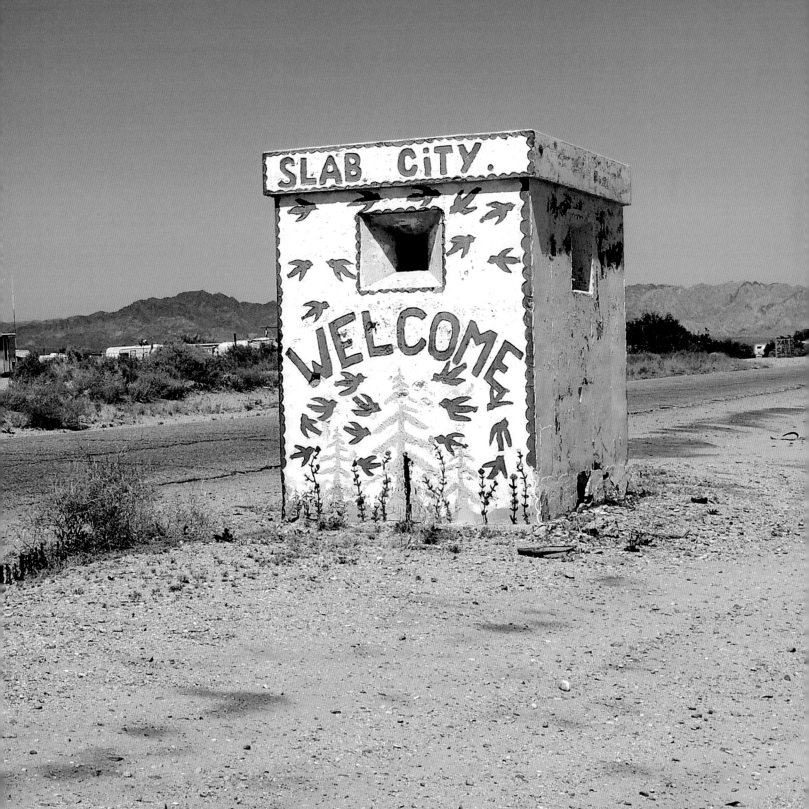

Munitions Storage Bunker, Sandy Hook, New Jersey
A low-lying sandspit extending northward into the southerly approaches of New York Harbor, Sandy Hook has been a hazard to shipping, but at times a protector to the port. Batteries placed here in the 1890s were updated at the time of World War II. Sandy Hook was also used for marshalling and training up new recruits.

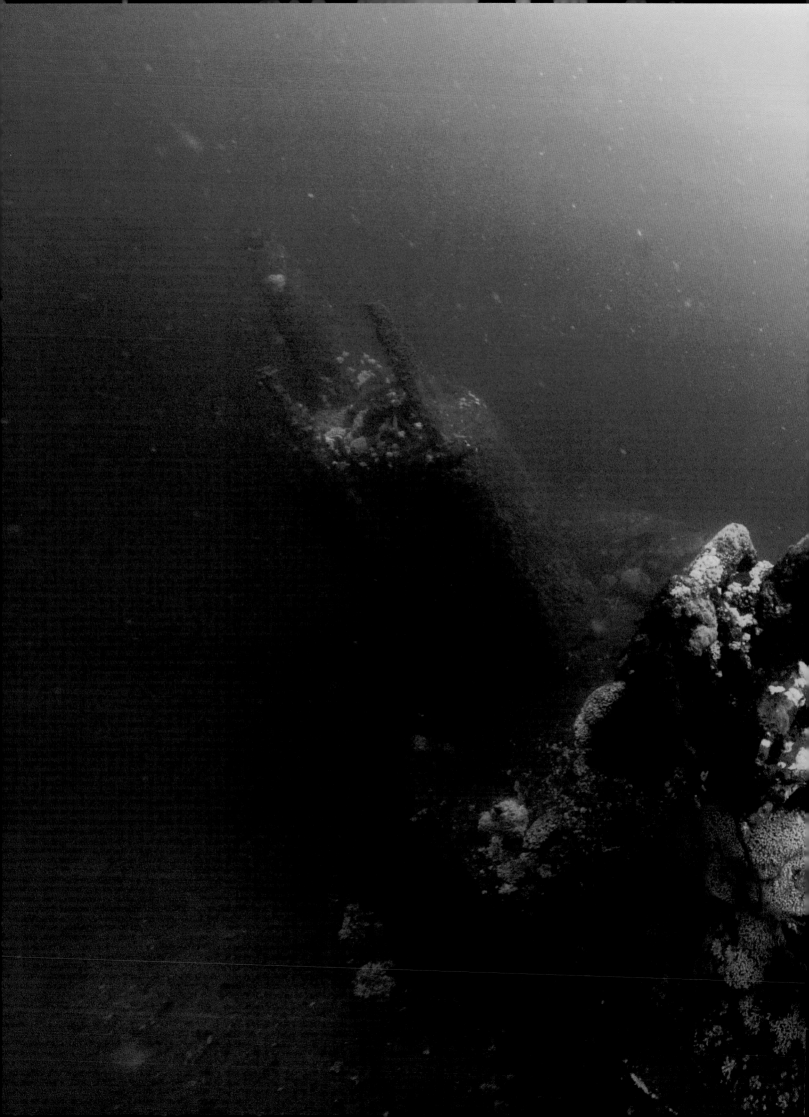

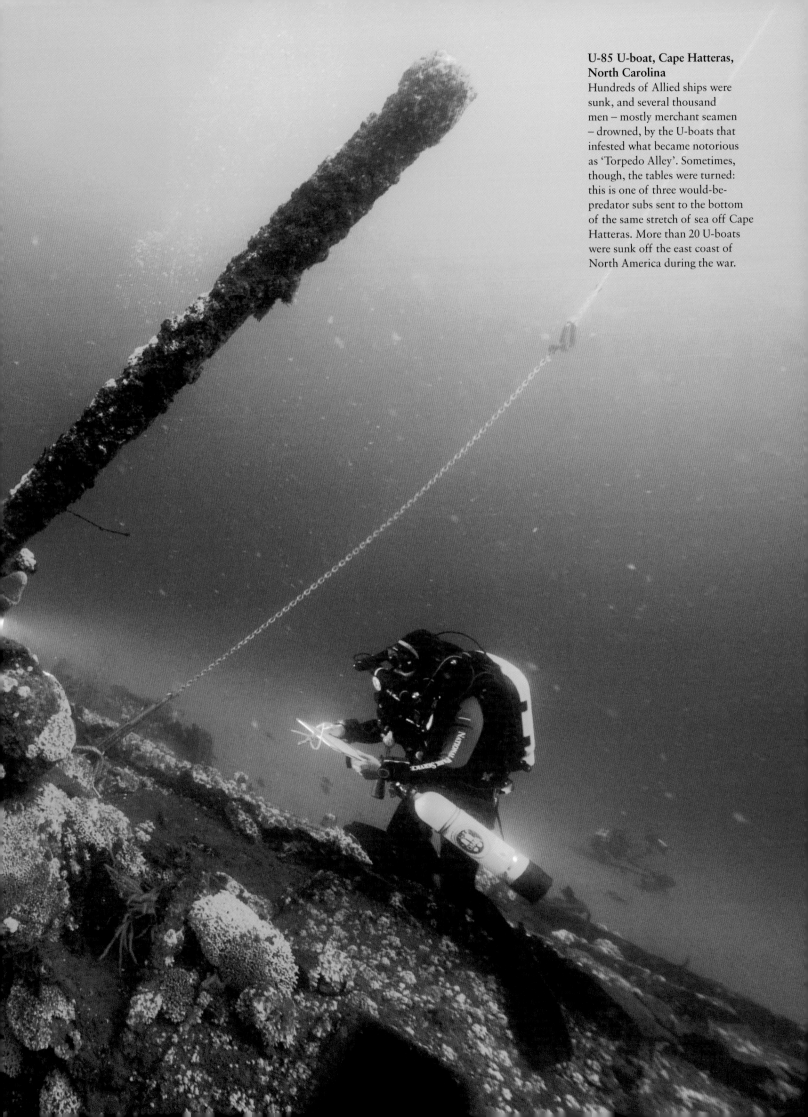

U-85 U-boat, Cape Hatteras, North Carolina
Hundreds of Allied ships were sunk, and several thousand men – mostly merchant seamen – drowned, by the U-boats that infested what became notorious as 'Torpedo Alley'. Sometimes, though, the tables were turned: this is one of three would-be-predator subs sent to the bottom of the same stretch of sea off Cape Hatteras. More than 20 U-boats were sunk off the east coast of North America during the war.

Observation Tower, Rehoboth Beach, Cape Henlopen State Park, Delaware
Standing on Rehoboth Beach, this is one of a number of observation towers built by the US military at the entrance to Delaware Bay. The nearby Fort Miles was completed in 1941 to protect the bay and was home to coastal batteries manned by more than 2000 military personnel. The observation towers provided early warning for any potential Axis maritime activity.

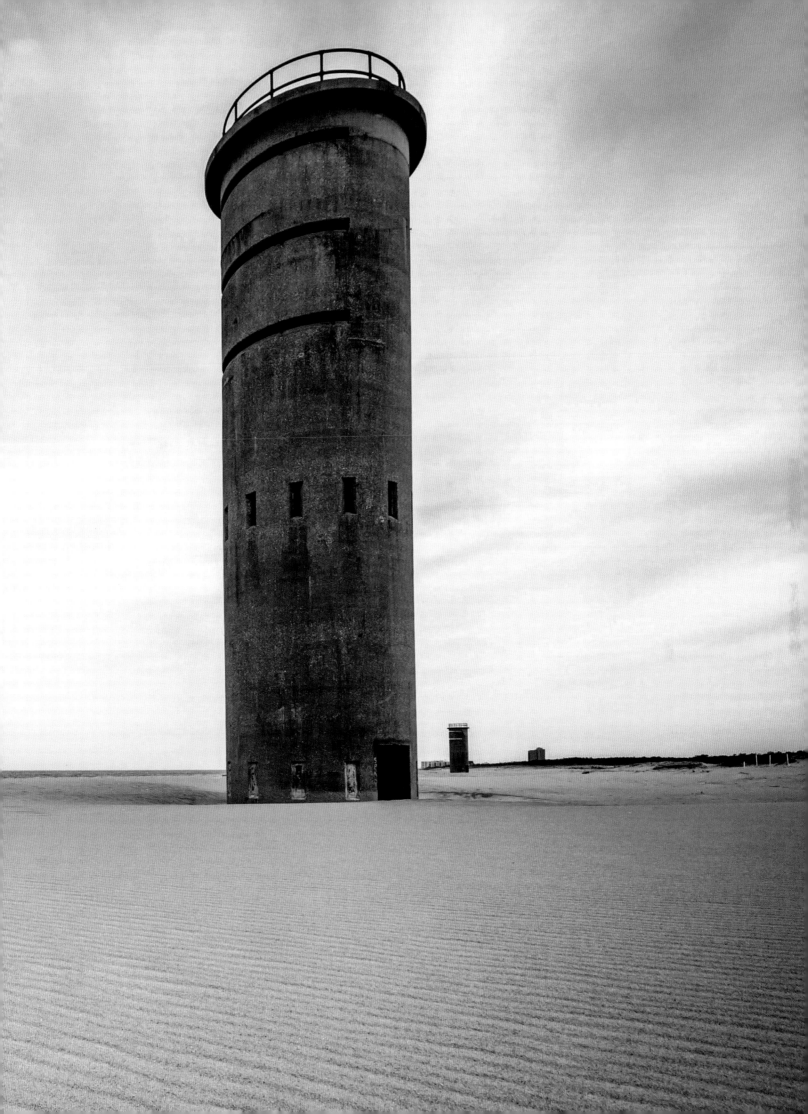

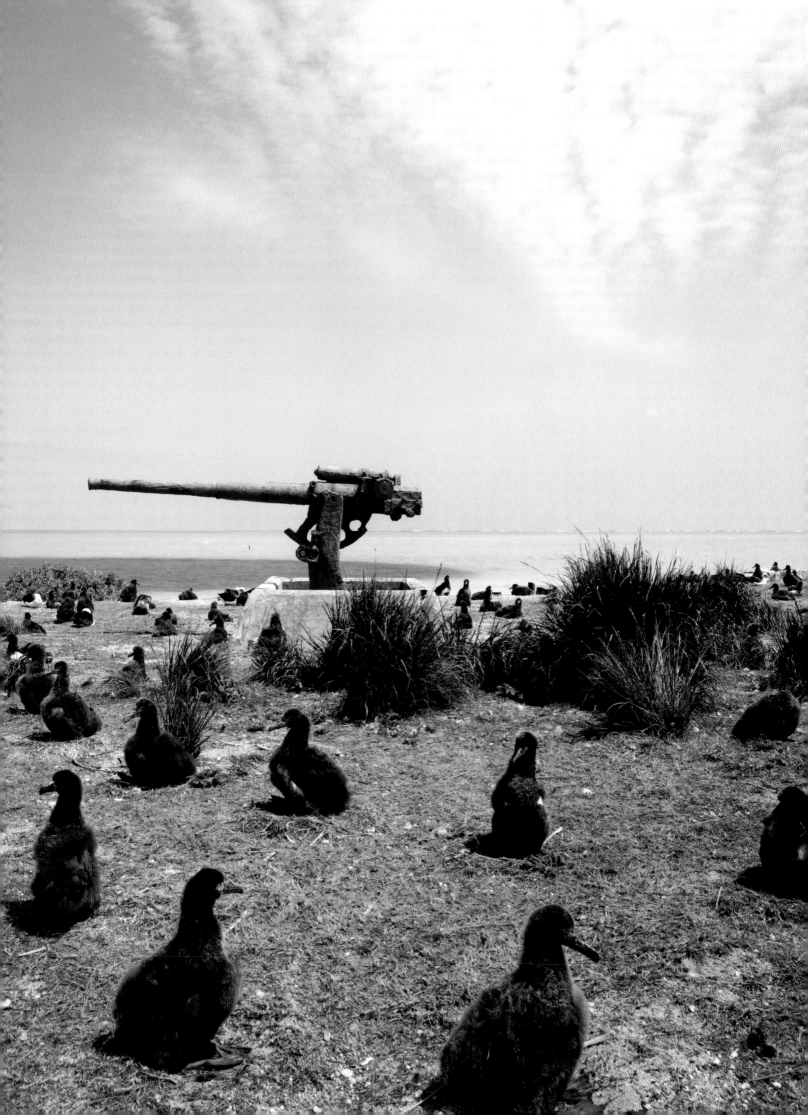

Far East and the Pacific

Arguably a 'colonial' conflict for both Imperial Japan and the Western Allies, the Pacific War was waged over enormous areas of what its participants felt to be profoundly foreign – and in many cases 'virgin' – territory. Hence its savage ruthlessness and the freewheeling ferocity with which it was pursued: none of the combatants felt much kinship with the peoples among whom they fought. Certainly, its geographical range was vast. Fighting took place across many millions of square kilometres: from Singapore to the Solomon Islands; from Hawaii to Hong Kong; from the northern coast of Australia to the Philippines. Battle was joined; bases built; barracks, warehouses and hangars constructed; camps pitched and positions established over innumerable far-flung islands – many of them uninhabited before and since.

The Ocean itself was vast and largely empty – but so too was the land here – much of it dense rainforest or mangrove swamp. As a result, along with the kind of military 'real estate' that has survived since the war in Europe – abandoned airfields; gun emplacements; underground bunkers – all sorts of items of weaponry and equipment have endured. Burned-out tanks; crashed aircraft; bits of miscellaneous kit of every kind have lain quietly rotting on sandy beaches or in jungle clearings, ready to be rediscovered in the present day.

LEFT:

Anti-Aircraft Gun, Eastern Island, Midway Atoll
Laysan albatross chicks wait patiently for their parents to return ashore and feed them, seemingly oblivious to the American three-inch gun seated on its concrete pedestal in their midst. In 1942, Midway was, of course, the scene of one of the bloodiest air and sea battles of the Pacific War.

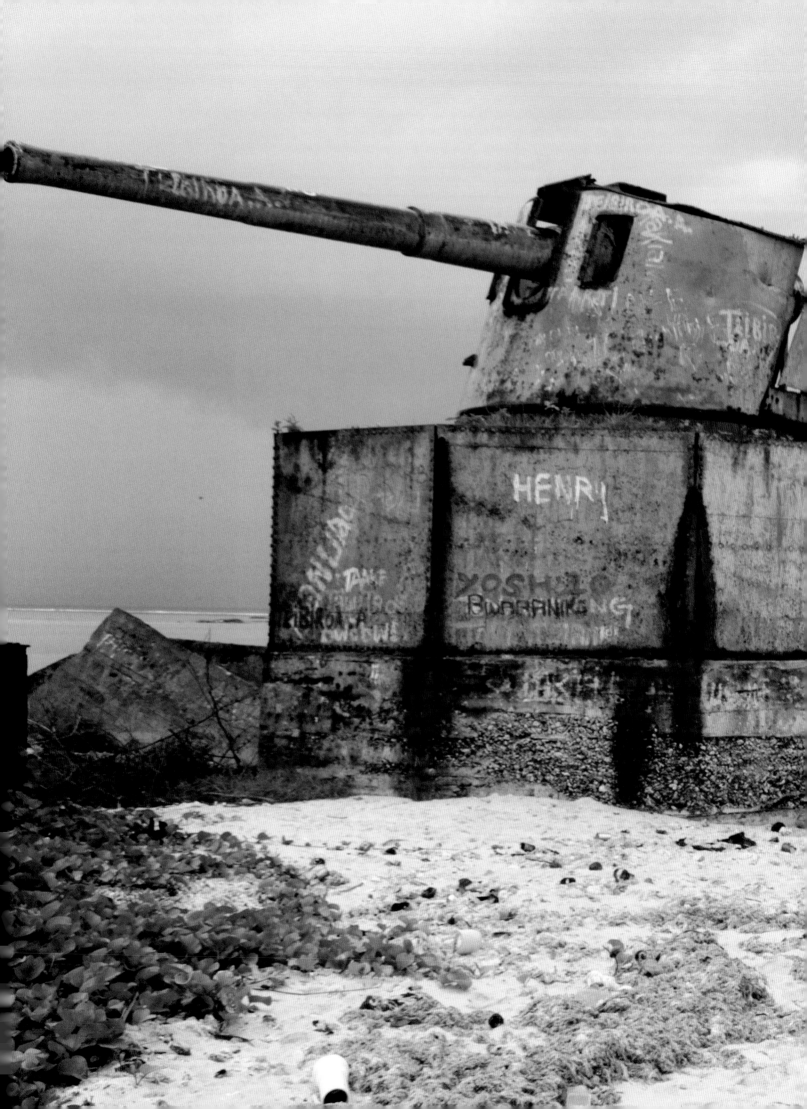

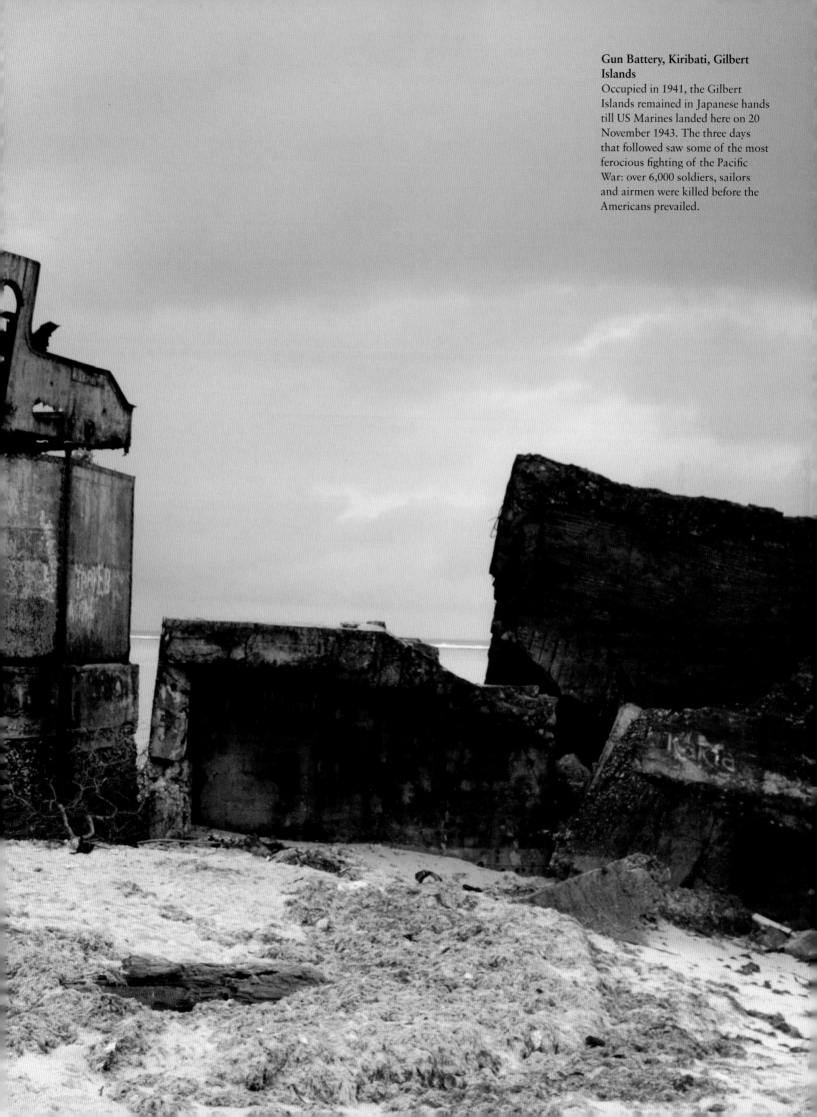

Gun Battery, Kiribati, Gilbert Islands
Occupied in 1941, the Gilbert Islands remained in Japanese hands till US Marines landed here on 20 November 1943. The three days that followed saw some of the most ferocious fighting of the Pacific War: over 6,000 soldiers, sailors and airmen were killed before the Americans prevailed.

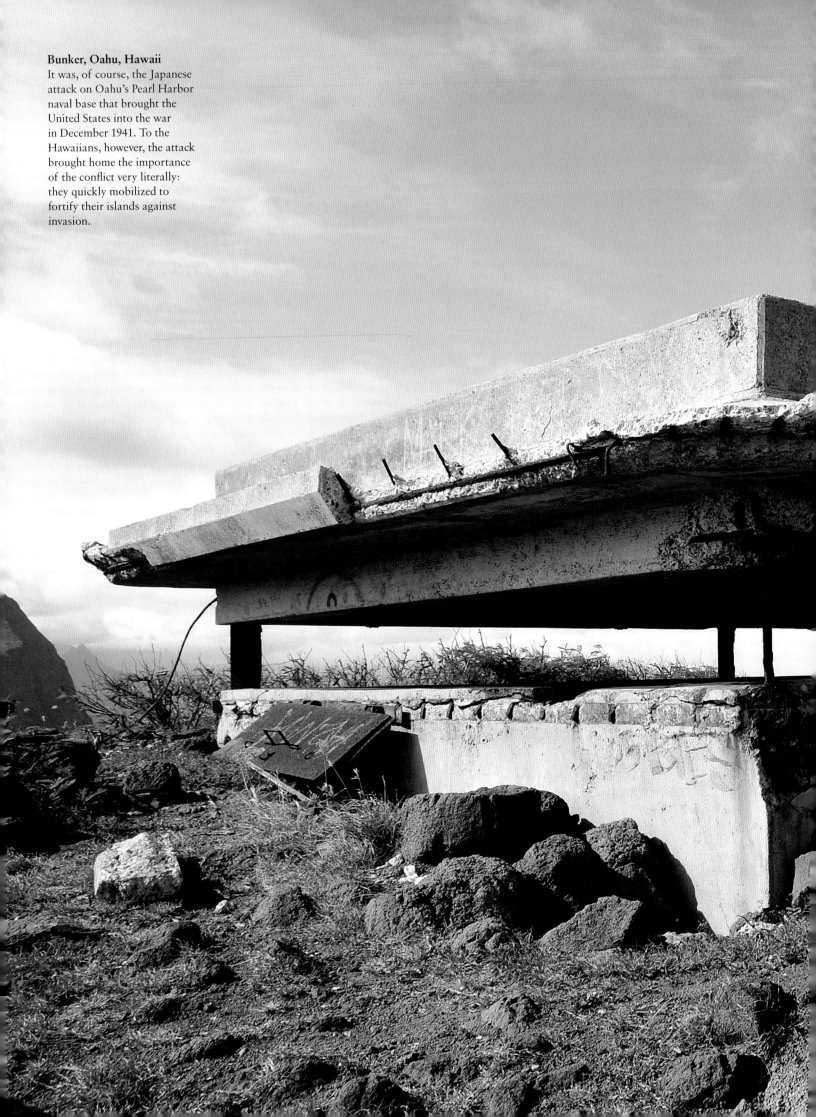

Bunker, Oahu, Hawaii
It was, of course, the Japanese attack on Oahu's Pearl Harbor naval base that brought the United States into the war in December 1941. To the Hawaiians, however, the attack brought home the importance of the conflict very literally: they quickly mobilized to fortify their islands against invasion.

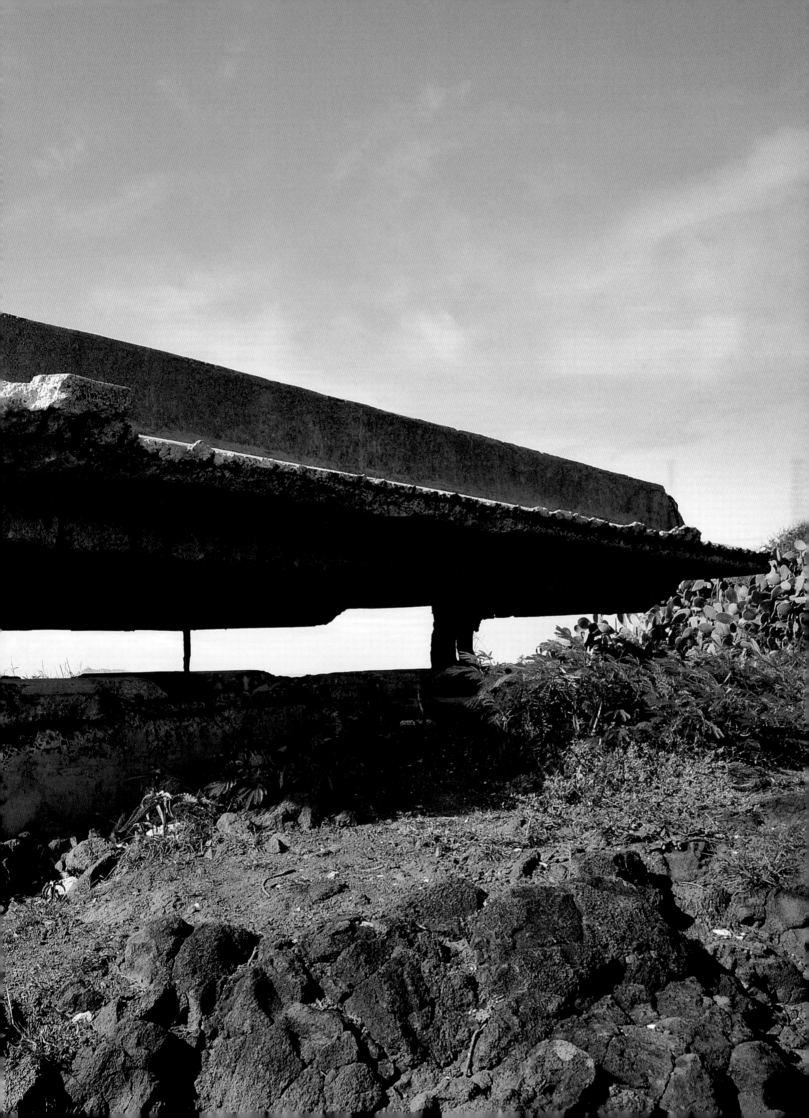

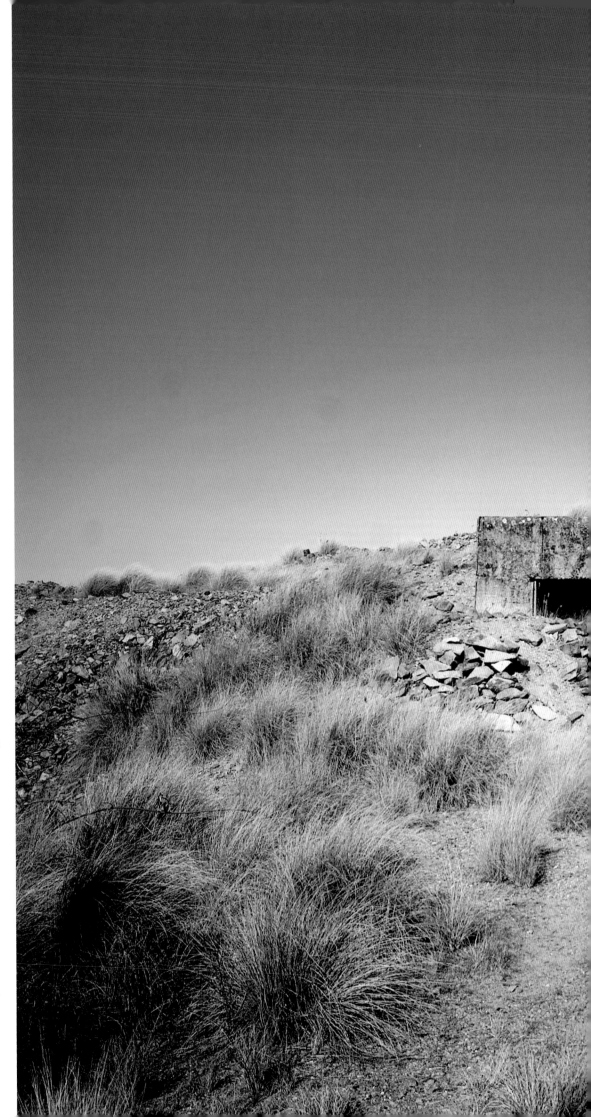

RIGHT:

Munitions Store, Charters Towers, Queensland, Australia

This fortified munitions store may seem incongruously sited now, but in northern Queensland the thought of Japanese attack didn't seem too fanciful. In 1942, air raids had actually been launched on coastal Mossman and Townsville (and, more spectacularly, on Darwin in the Northern Territory). Australians thought it wise to be prepared.

OVERLEAF, TOP LEFT:

Pillbox, Johor, Malaysia

The British built this fortified position to control comings and goings along the main highway between the town of Kota Tinggi and the coastal town of Mersing on British Malaya's east coast. Defended fiercely by Commonwealth forces, this southernmost part of the peninsula was captured in January 1942 by the Japanese, a few weeks before the fall of Singapore.

OVERLEAF, BOTTOM LEFT:

Pillbox, Eastern Island, Midway Atoll

The airstrips at Midway were key to the American presence in the Pacific, and only second to Hawaii in importance. The Americans established land defences there over the course of 1940 and 1941. On 7 December 1941, the same day that the Japanese attacked Pearl Harbor, Midway Atoll was bombarded by Japanese destroyers. American shore artillery replied in kind and an amphibious invasion was averted. This area is now of interest mainly to military historians and ornithologists.

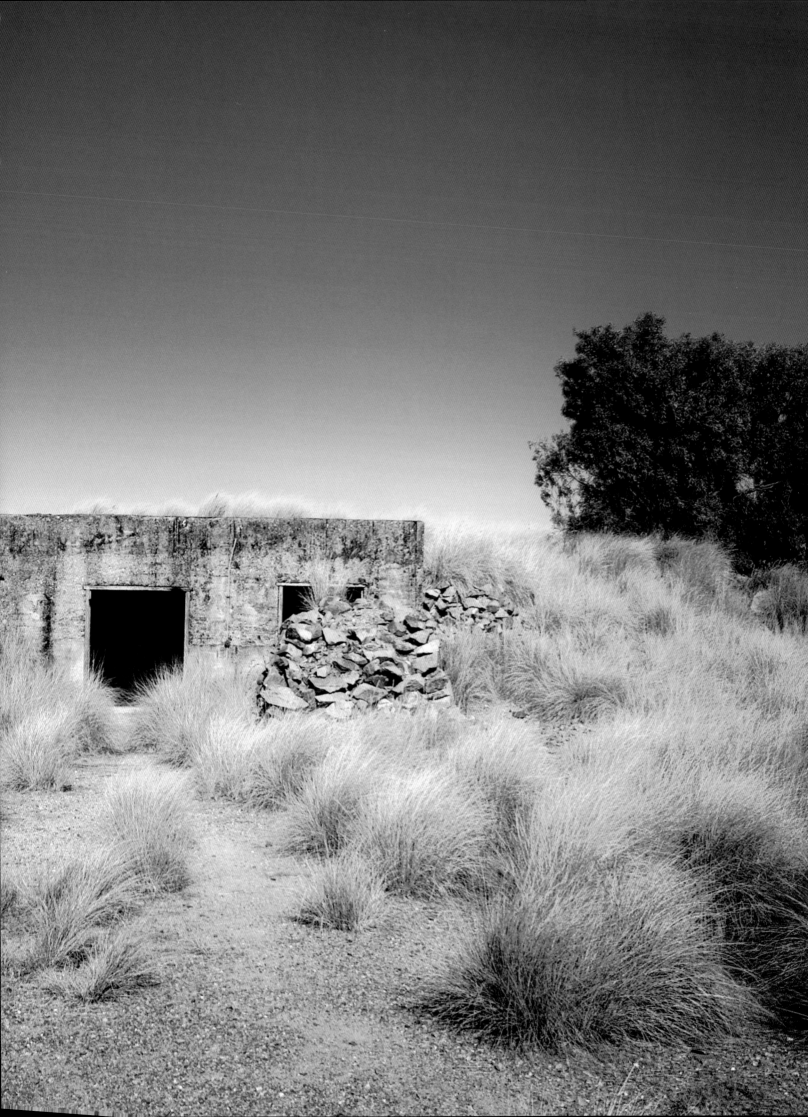

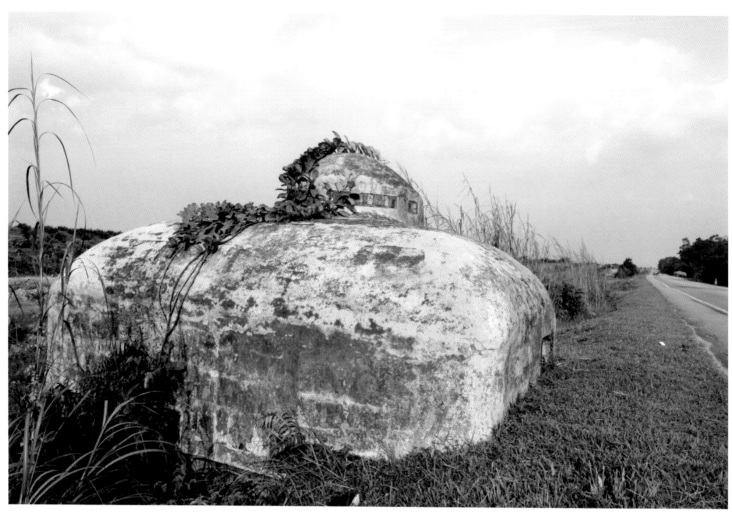

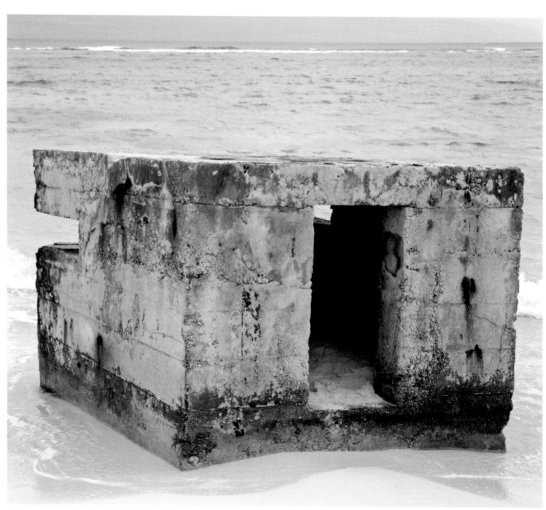

OPPOSITE TOP:

Bunker, Wong Nai Chung Gap, Hong Kong

Built in the early 1930s, this fortified complex became the headquarters for the West Brigade during the defence of Hong Kong in December 1941. The Wong Nai Chung Gap is strategically located at the centre of Hong Kong Island, and was the scene of the most ferocious fighting between Commonwealth and Japanese forces.

OPPOSITE BOTTOM:

Abandoned Military Building, Mount Davis, Hong Kong

The violence and confusion of the Battle of Hong Kong (8–25 December 1941) long forgotten, this old structure is one of several standing high above the city on the slopes of Mount Davis in what is now a beautiful and peaceful park.

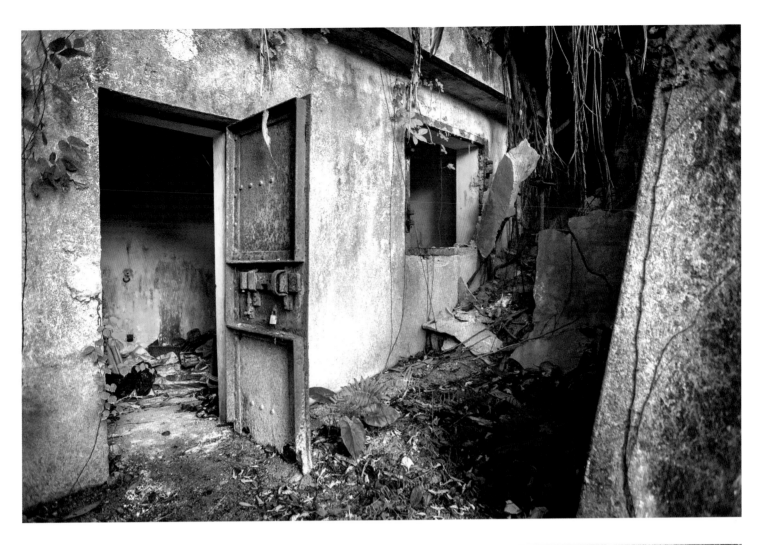

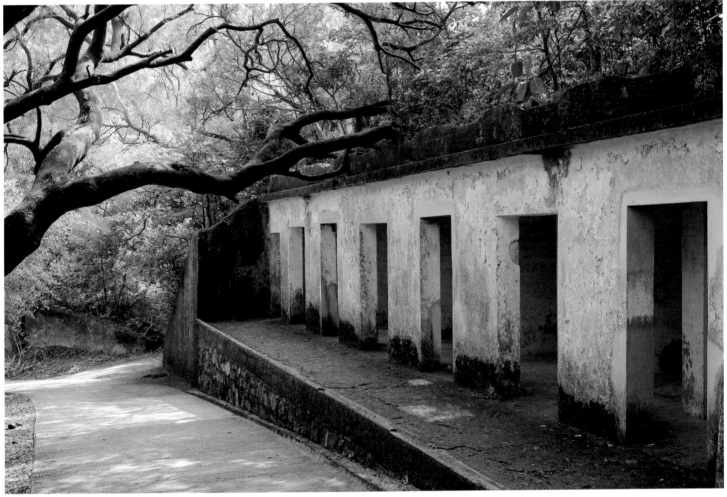

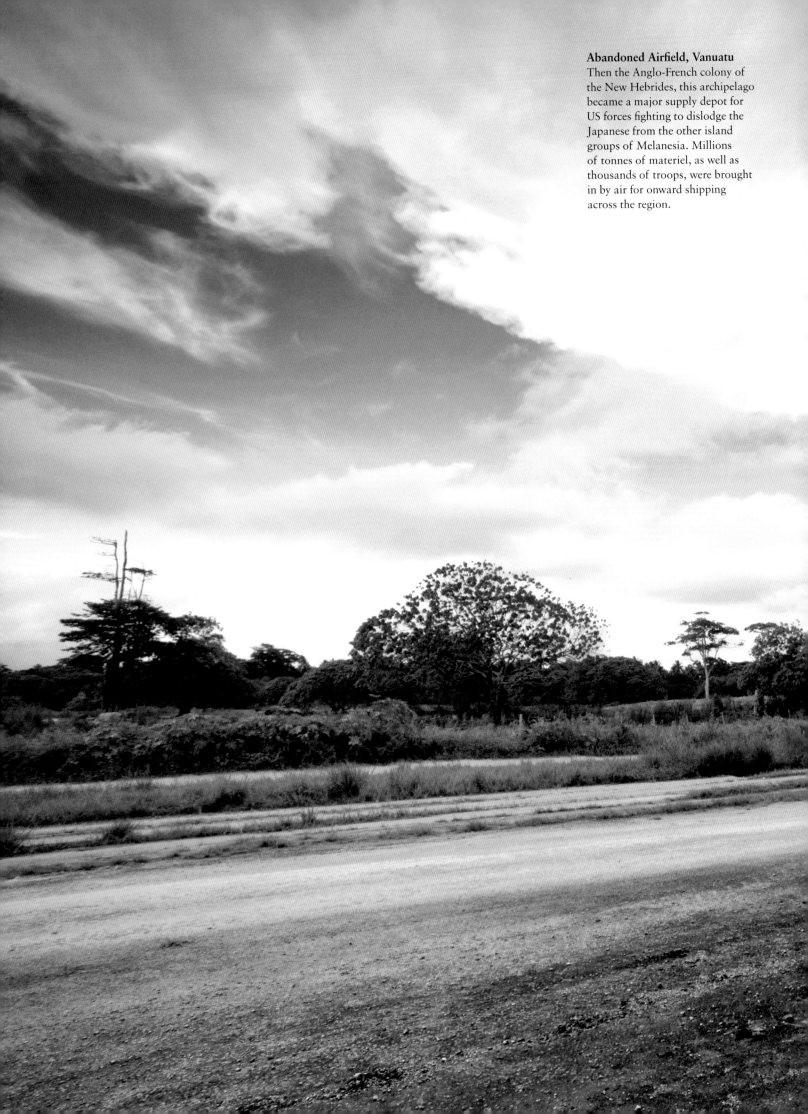

Abandoned Airfield, Vanuatu
Then the Anglo-French colony of the New Hebrides, this archipelago became a major supply depot for US forces fighting to dislodge the Japanese from the other island groups of Melanesia. Millions of tonnes of materiel, as well as thousands of troops, were brought in by air for onward shipping across the region.

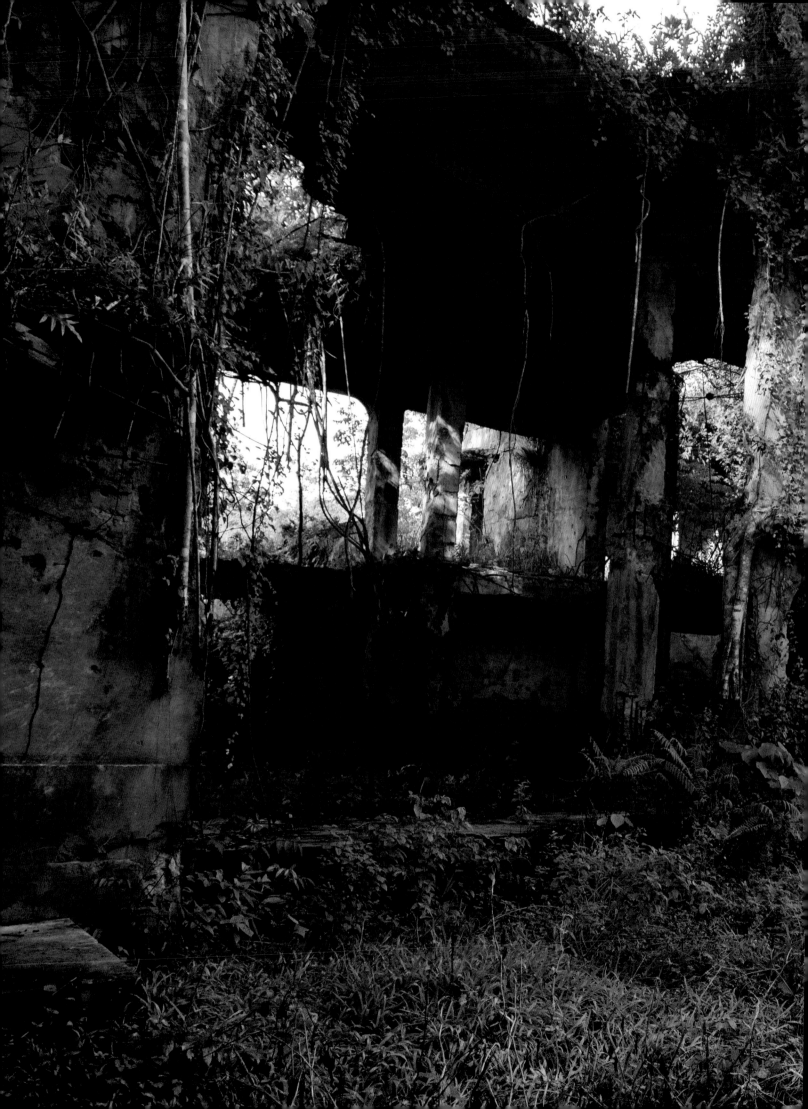

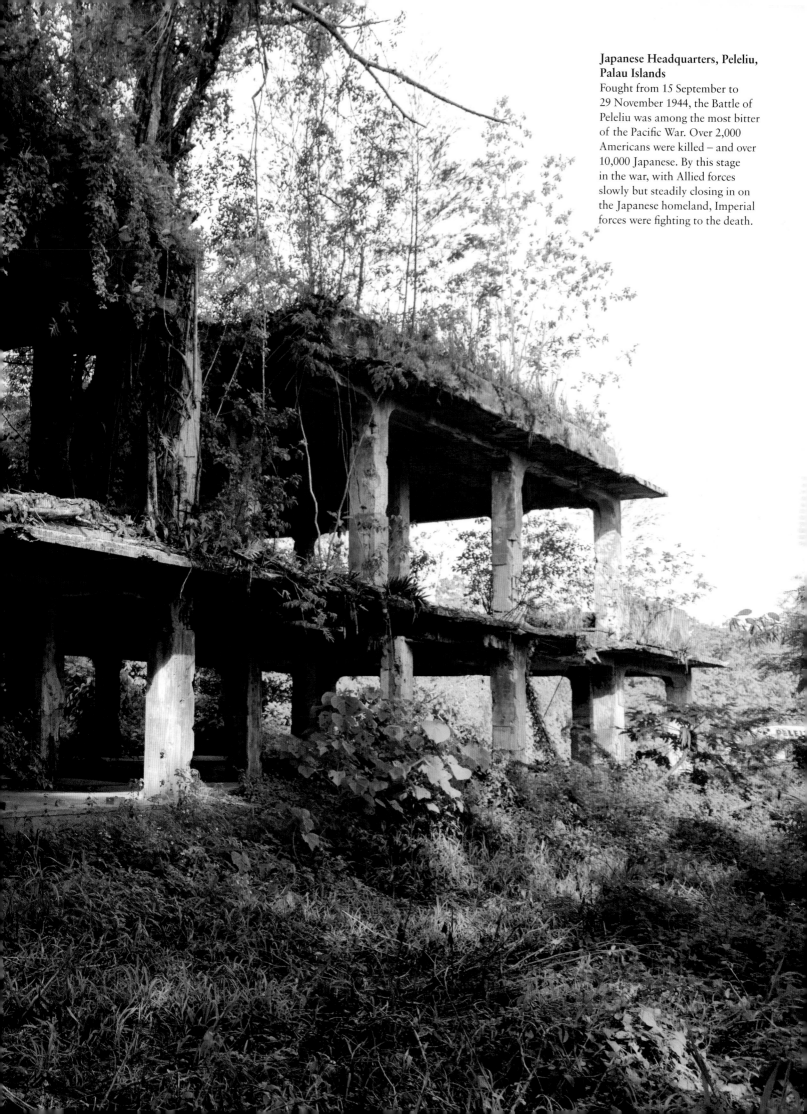

Japanese Headquarters, Peleliu, Palau Islands
Fought from 15 September to 29 November 1944, the Battle of Peleliu was among the most bitter of the Pacific War. Over 2,000 Americans were killed – and over 10,000 Japanese. By this stage in the war, with Allied forces slowly but steadily closing in on the Japanese homeland, Imperial forces were fighting to the death.

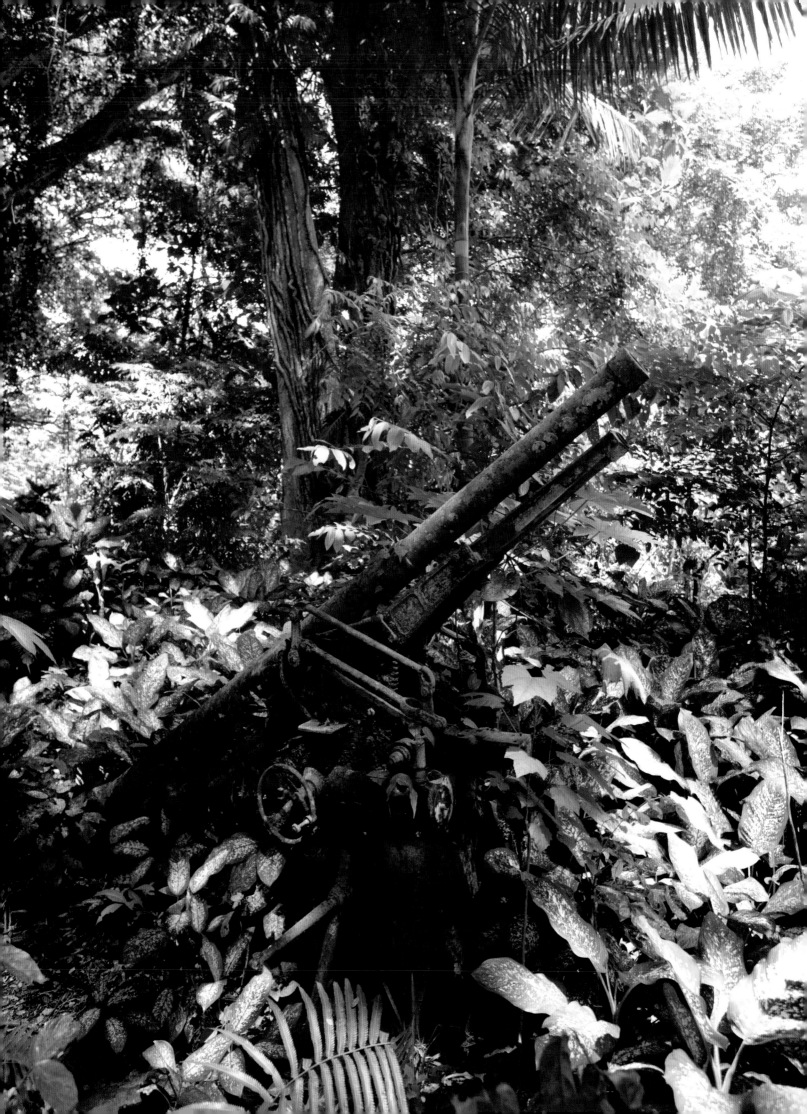

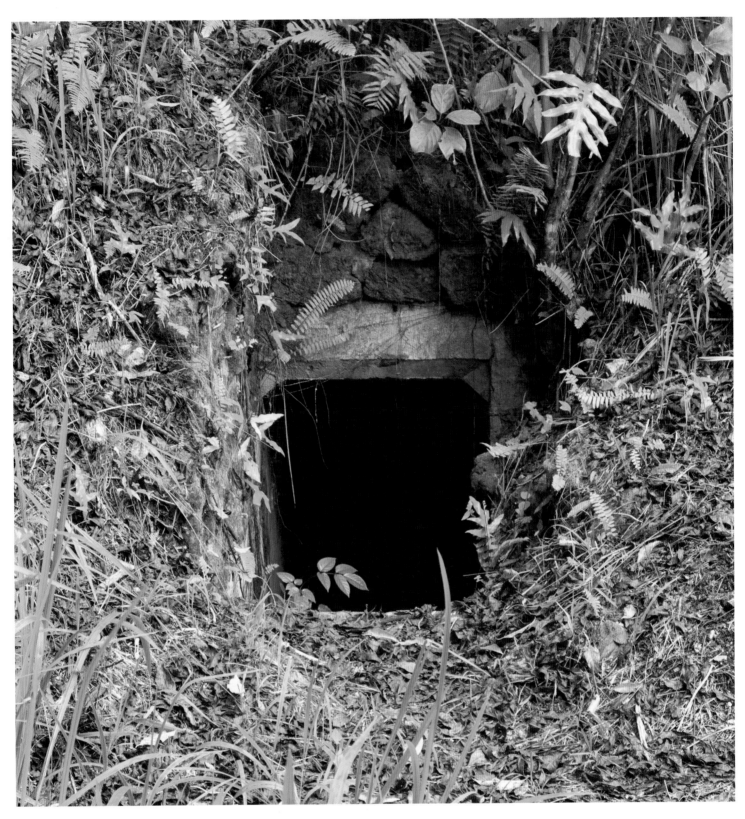

OPPOSITE:

Japanese Anti-Aircraft Gun, Mission Hill, Wewak, Papua New Guinea

The rainforest reclaims what was once a field of battle. On 10 May 1945, with hostilities in Europe already over, the Pacific War was raging on unchecked. Australia's 2/4th Infantry Battalion fought hard to take this hill from its occupiers, troops of Japan's 18th Army: there is a monument now, on the summit, high above.

ABOVE:

Air-Raid Shelter, Peleliu, Palau Islands

By the time they came to defend Peleliu, late in 1944, the Japanese were extremely experienced in island fighting: they had learned the hard way, in a series of ferocious battles. The attacking Americans found their foe not just determined but well dug in, in strong and sophisticated tunnel works underground.

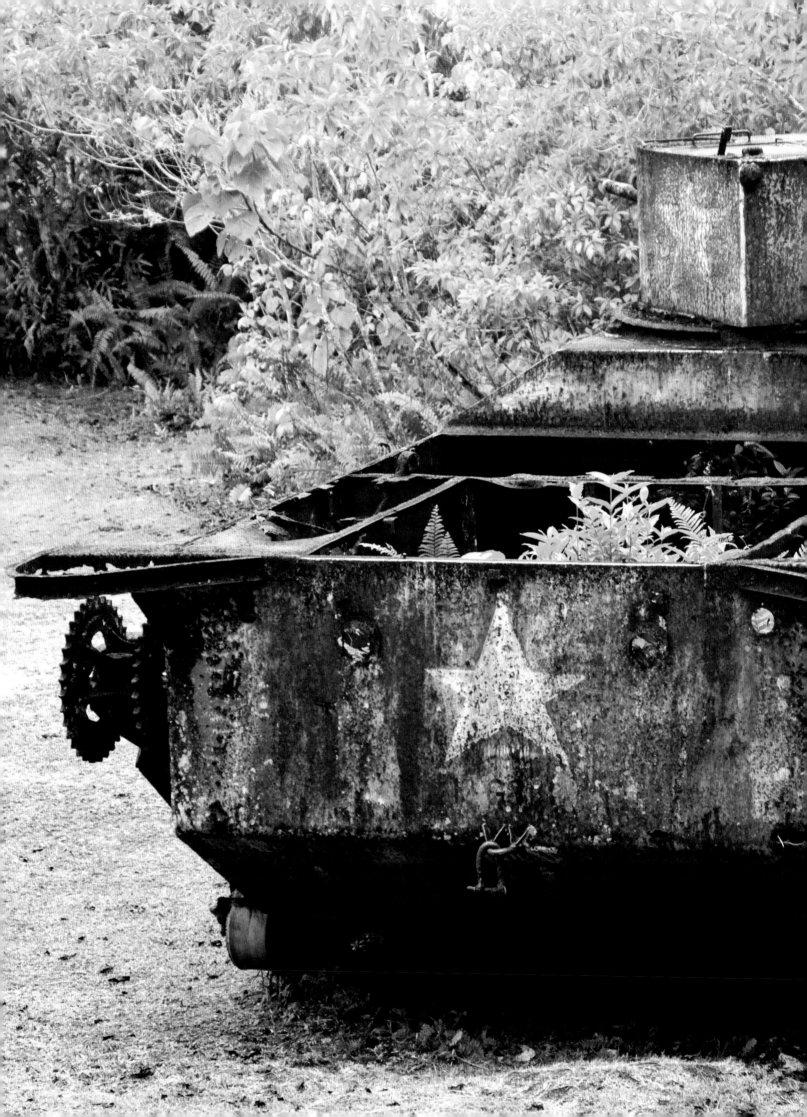

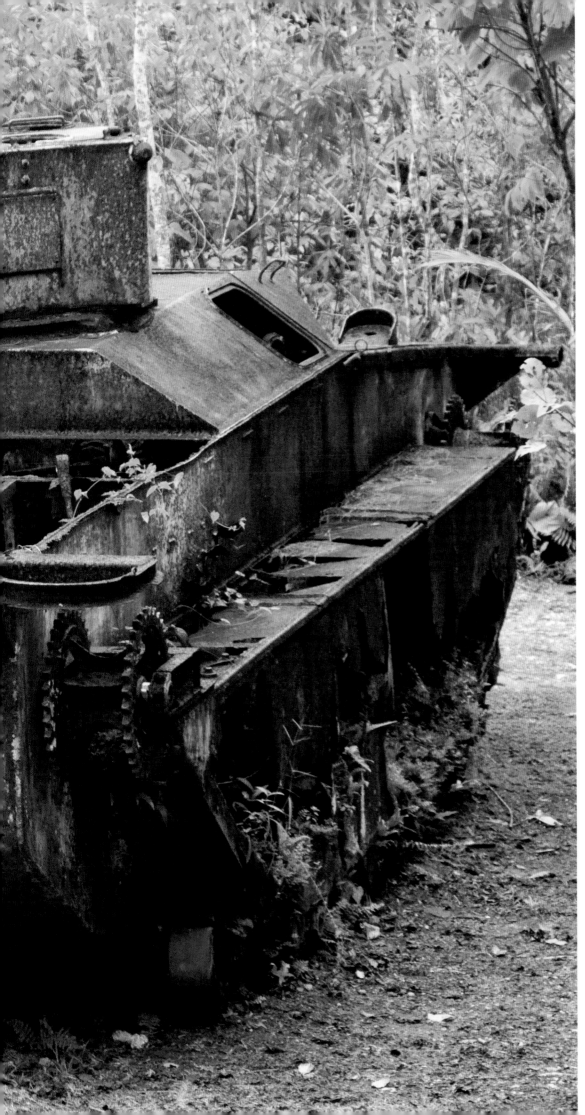

US Amphibious LVT, Bloody Nose Ridge, Peleliu, Palau Islands
The burned-out shell of an LVT ('Landing Vehicle, Tracked') stands rusting, an inanimate metal monument to the thousands of men who died attacking and defending this one ridge alone. As the nickname they gave it wryly suggests, the capture of this hill was among the toughest challenges the US 1st Marine Division were ever to face.

Labrador Battery, Singapore

The greatest threat to this British colony had always seemed to come from seaward – hence this battery at the entrance of Keppel Harbour. There'd been a fort here since 1843, but this had been expanded in the 1870s in anticipation of colonial competition. Mines were laid and gun emplacements built on either side of the harbour entrance. By the 1930s, with an Imperial Japan pushing for territorial advantage across Asia, Singapore seemed to face its greatest menace yet.

RIGHT:
Machine Gun Pillbox

All *art moderne* elegance, perhaps, but this pillbox housed a machine gun to protect the battery from a beachward assault.

BELOW:
Six-inch Naval Gun with Figures

This formidable weapon could target enemy shipping at a maximum range of 14km (8.7 miles). In the event, the Japanese invaded overland.

OPPOSITE TOP AND BOTTOM:
Six-inch Naval Gun

Weighing 6.5 tonnes (7.1 tons), this gun fired a 45kg (100lb) shell.

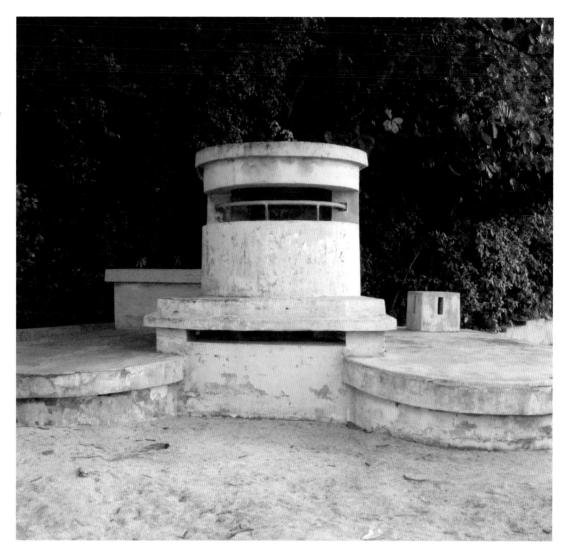

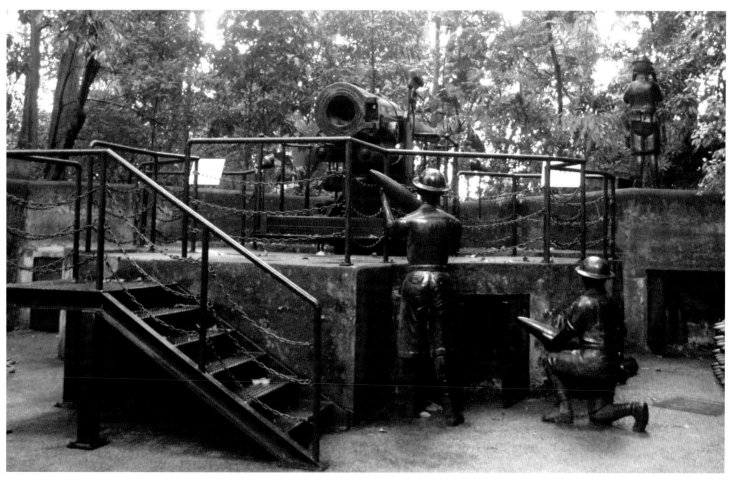

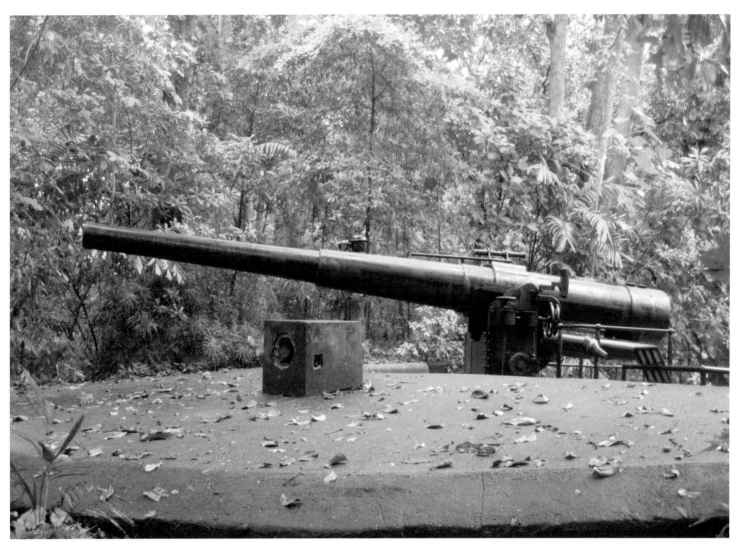

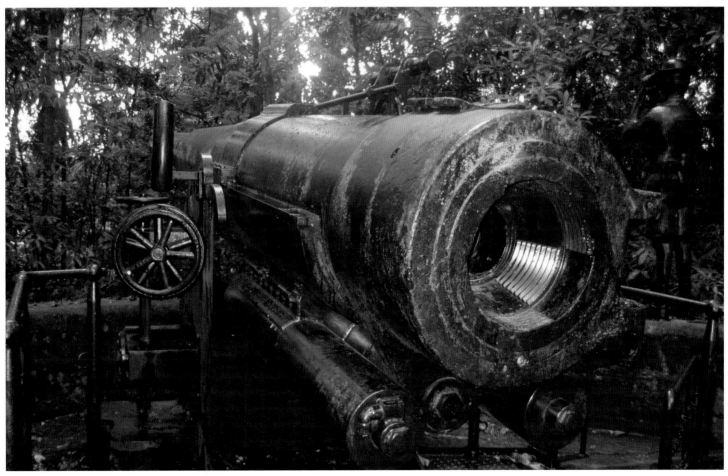

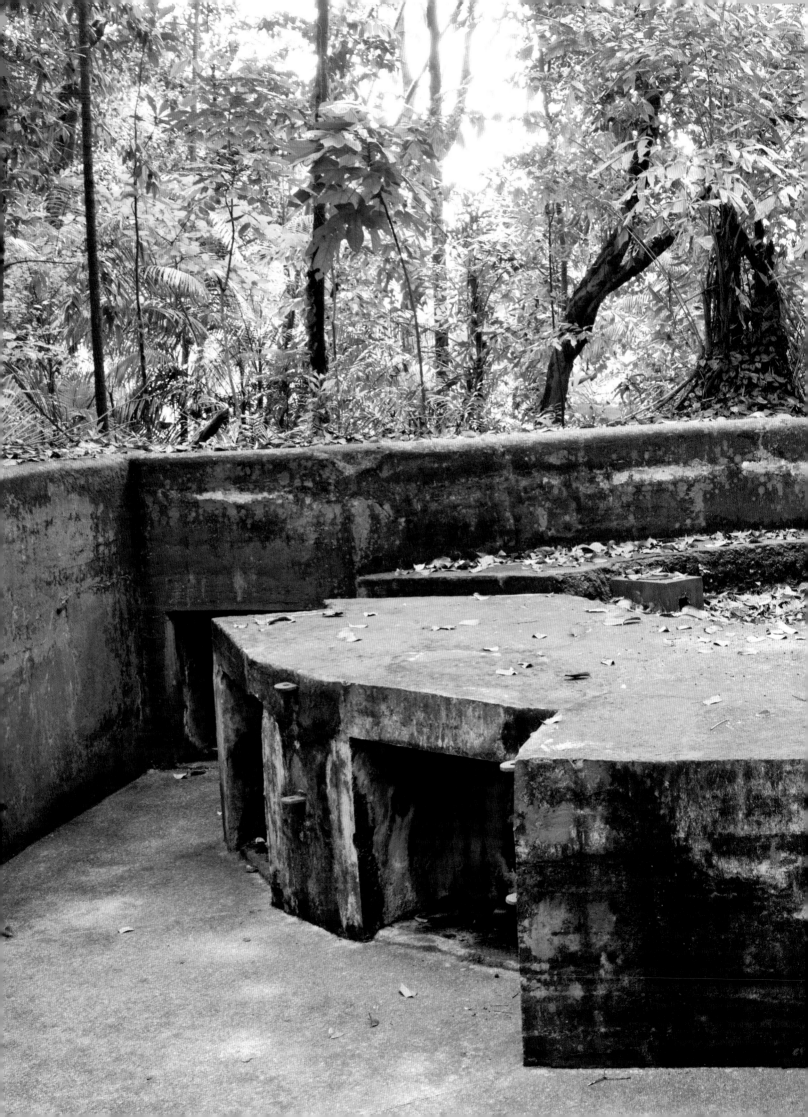

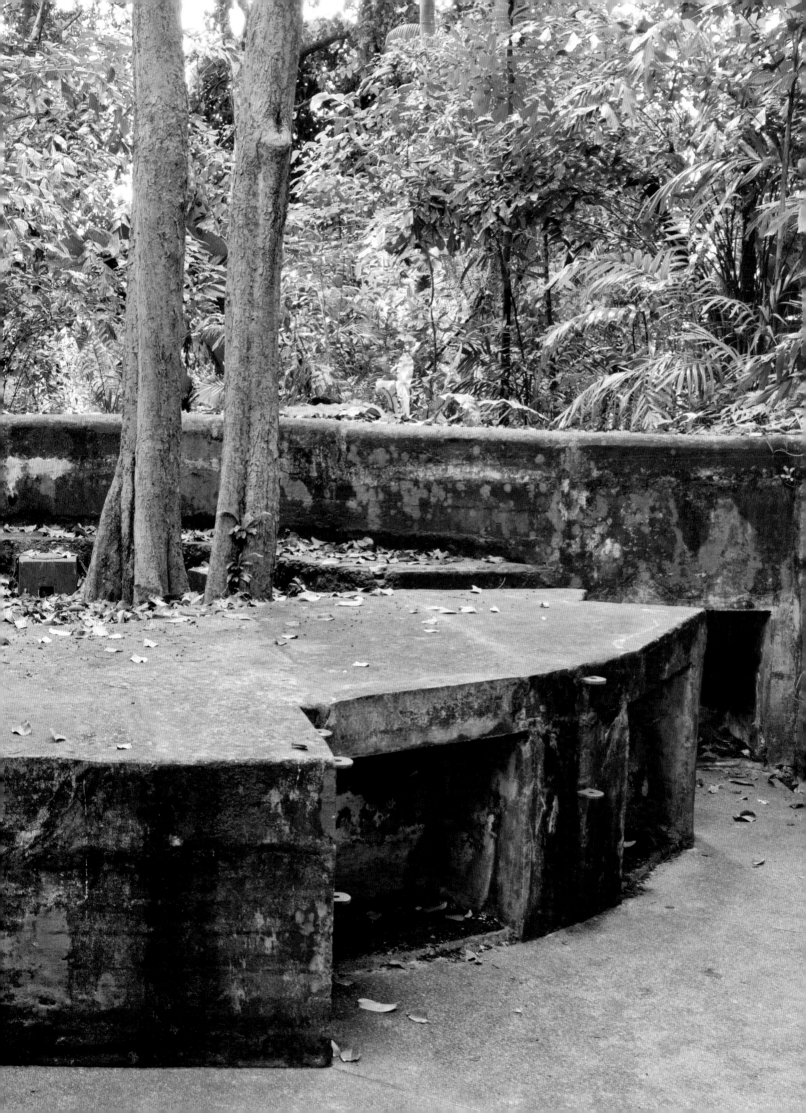

PREVIOUS PAGES:

Gun Emplacement, Labrador Battery, Singapore

The second of the large concrete emplacements designed to site the six-inch (152mm) naval guns has since become overgrown with jungle. The naval gun currently displayed at Labrador Park was brought here from a nearby site. The two original guns were both lost during the war.

RIGHT:

Japanese Type 95 Ha-Go Tank, Chuuk Lagoon, Micronesia

50m (160ft) beneath the surface of this beautiful blue lagoon lies the wreck of the Japanese cargo ship, the *San Francisco Maru*. Attacked by US aircraft in 1944, she went down with five crewmembers – along with three light tanks like this one, plus several trucks.

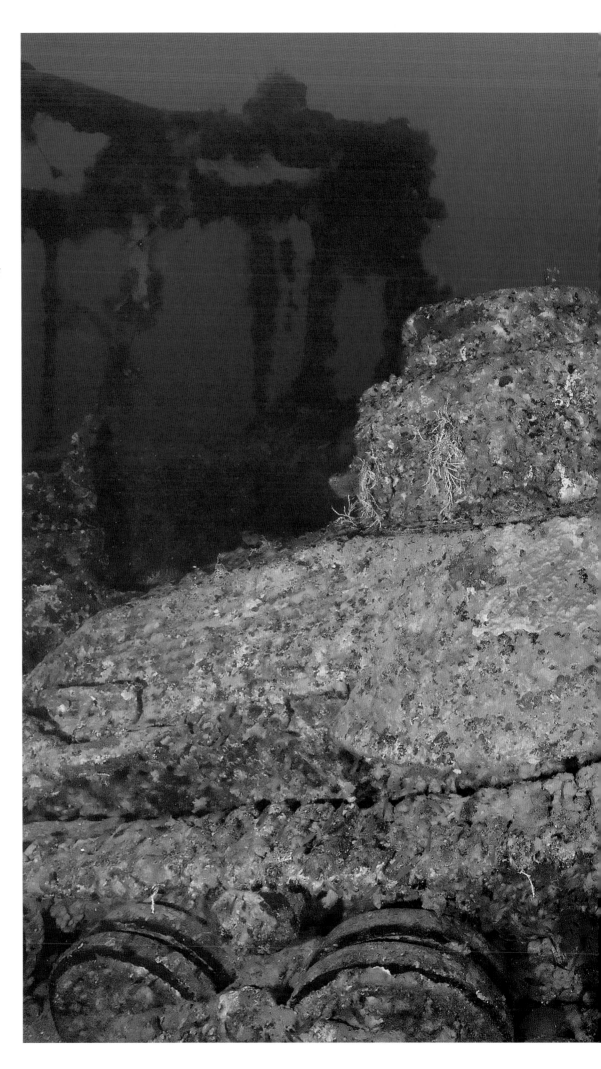

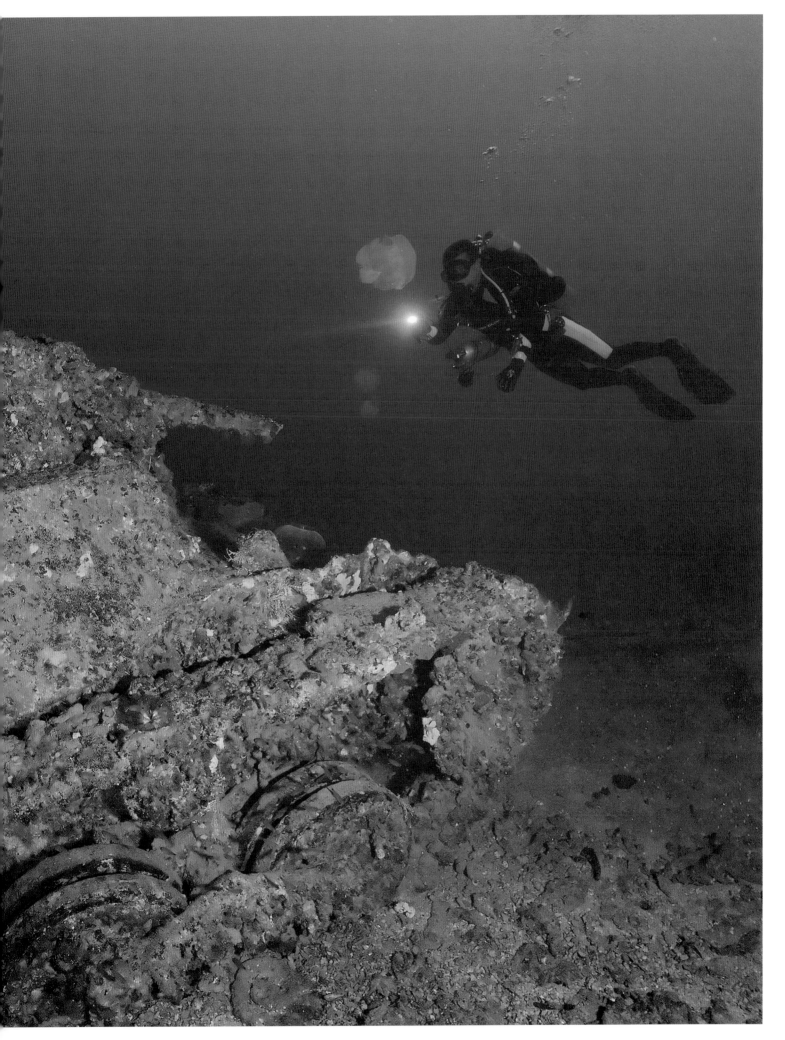

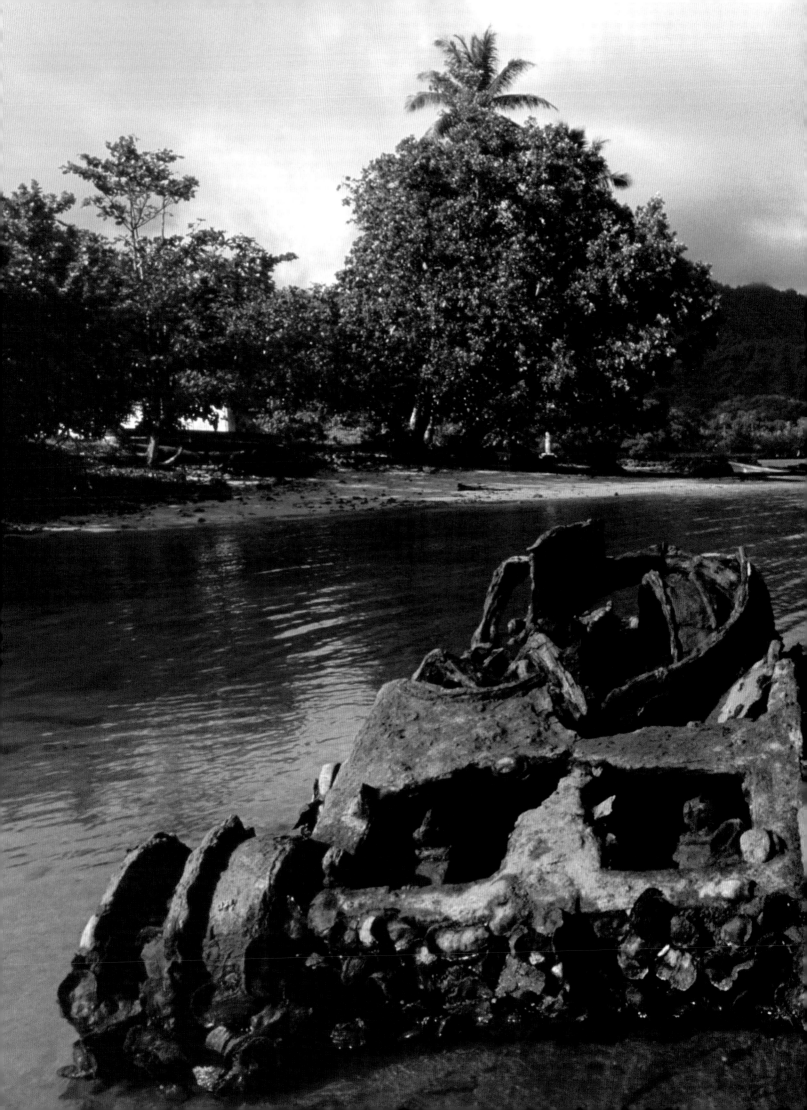

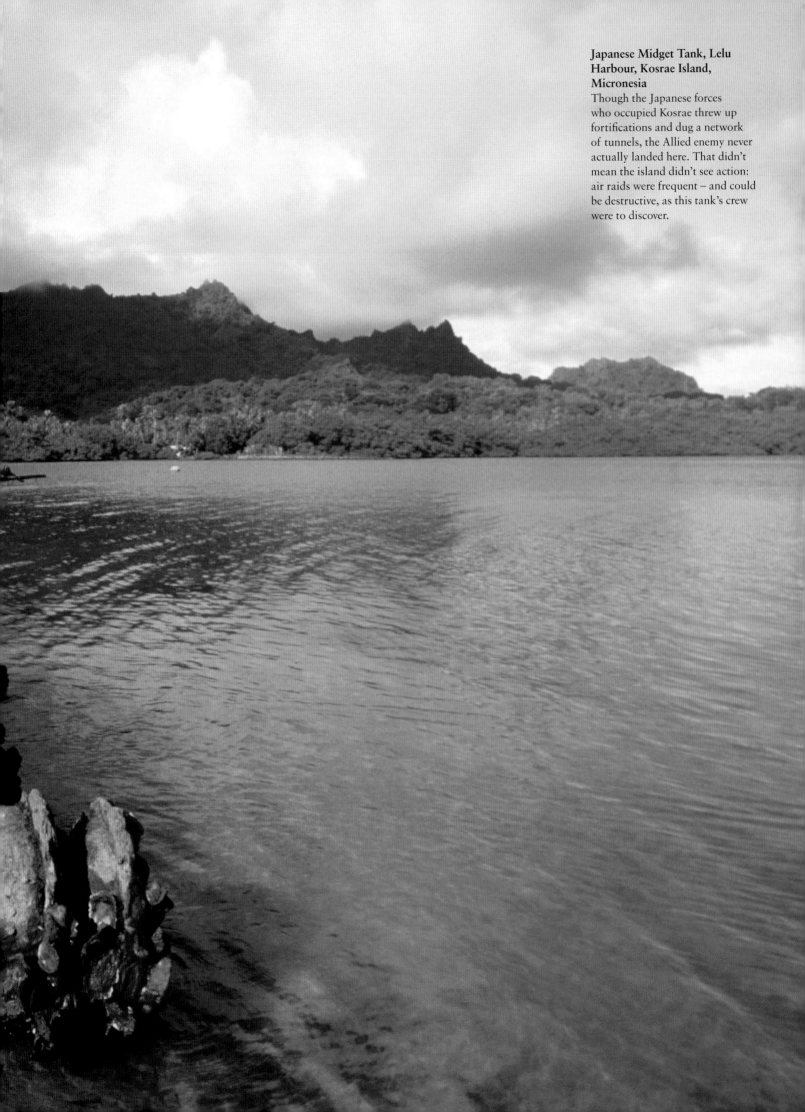

Japanese Midget Tank, Lelu Harbour, Kosrae Island, Micronesia
Though the Japanese forces who occupied Kosrae threw up fortifications and dug a network of tunnels, the Allied enemy never actually landed here. That didn't mean the island didn't see action: air raids were frequent – and could be destructive, as this tank's crew were to discover.

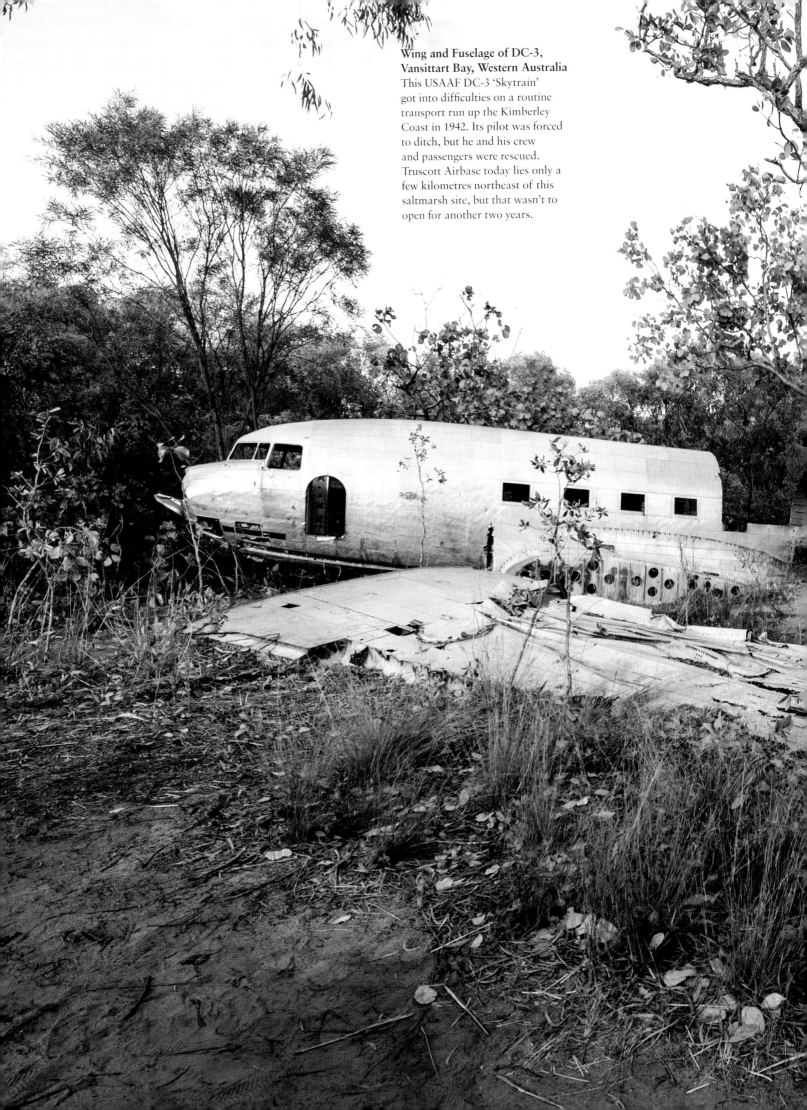

**Wing and Fuselage of DC-3,
Vansittart Bay, Western Australia**
This USAAF DC-3 'Skytrain'
got into difficulties on a routine
transport run up the Kimberley
Coast in 1942. Its pilot was forced
to ditch, but he and his crew
and passengers were rescued.
Truscott Airbase today lies only a
few kilometres northeast of this
saltmarsh site, but that wasn't to
open for another two years.

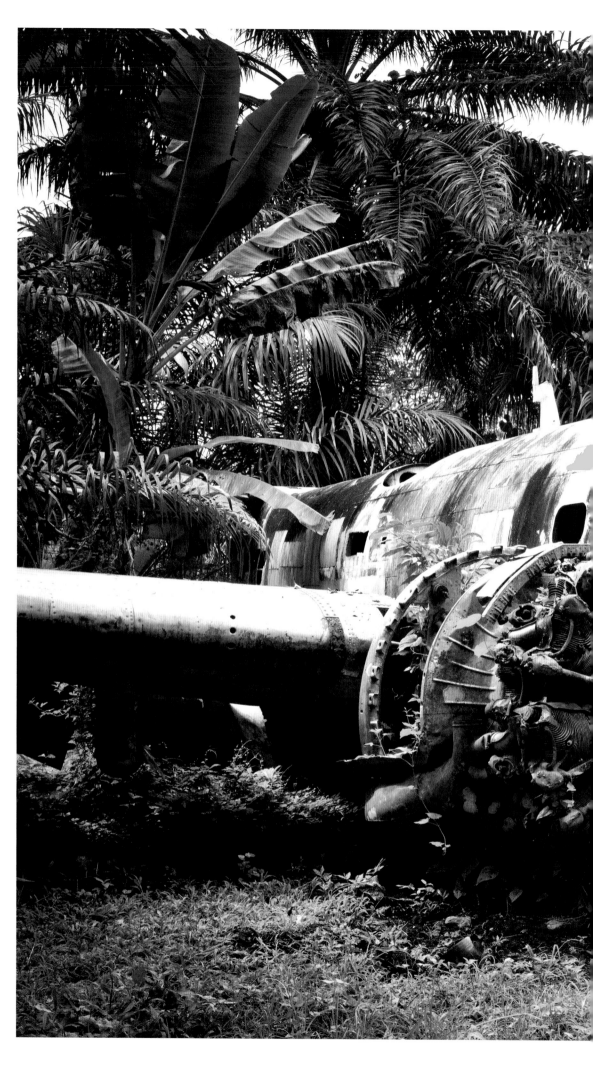

RIGHT:

Lockheed Ventura, Kimbe, West New Britain, Papua New Guinea
The jungle steadily reclaims a Lockheed Ventura of the New Zealand Air Force. This aircraft crashed at Talasea Airfield when it suffered from engine failure in September 1944, following a bombing mission against Japanese shipping in Rabaul Harbour, New Britain.

OVERLEAF:

Mitsubishi Ki-21, Rabaul, East New Britain, Papua New Guinea
Codename 'Sally' to the Allied pilots and gunners, the Ki-21 packed an unladylike punch when she dropped her bombs – on targets from China to India, from Malaya to Australia's northern coast. This one was destroyed on the ground at Lakunai Airfield, in Rabaul.

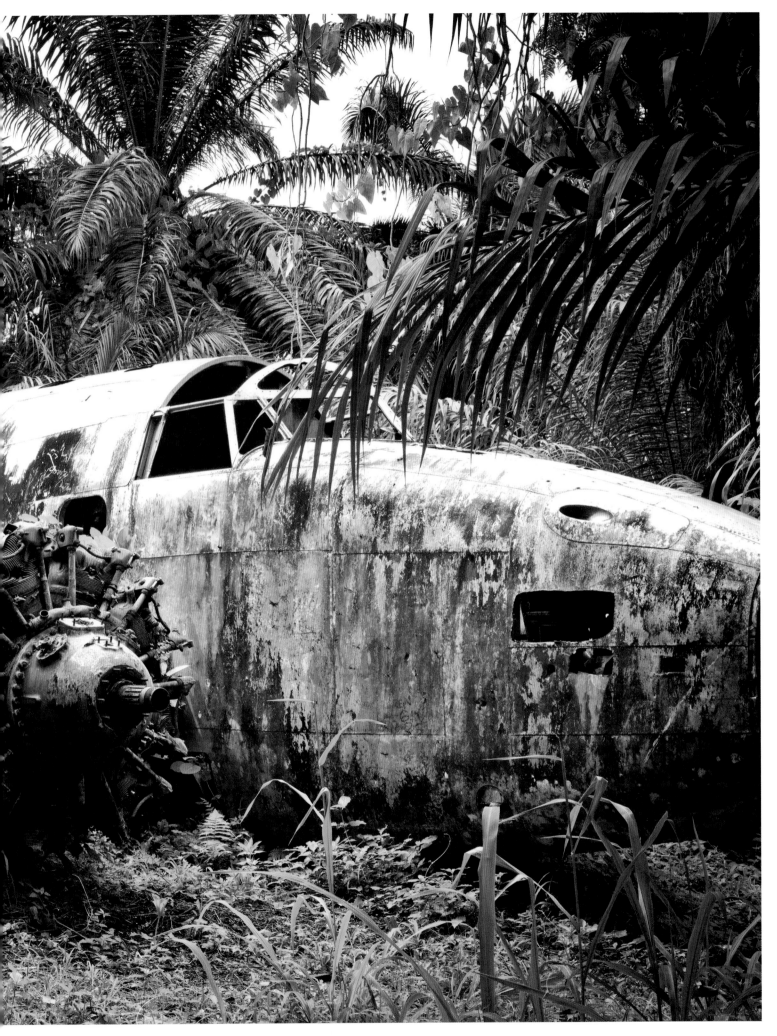

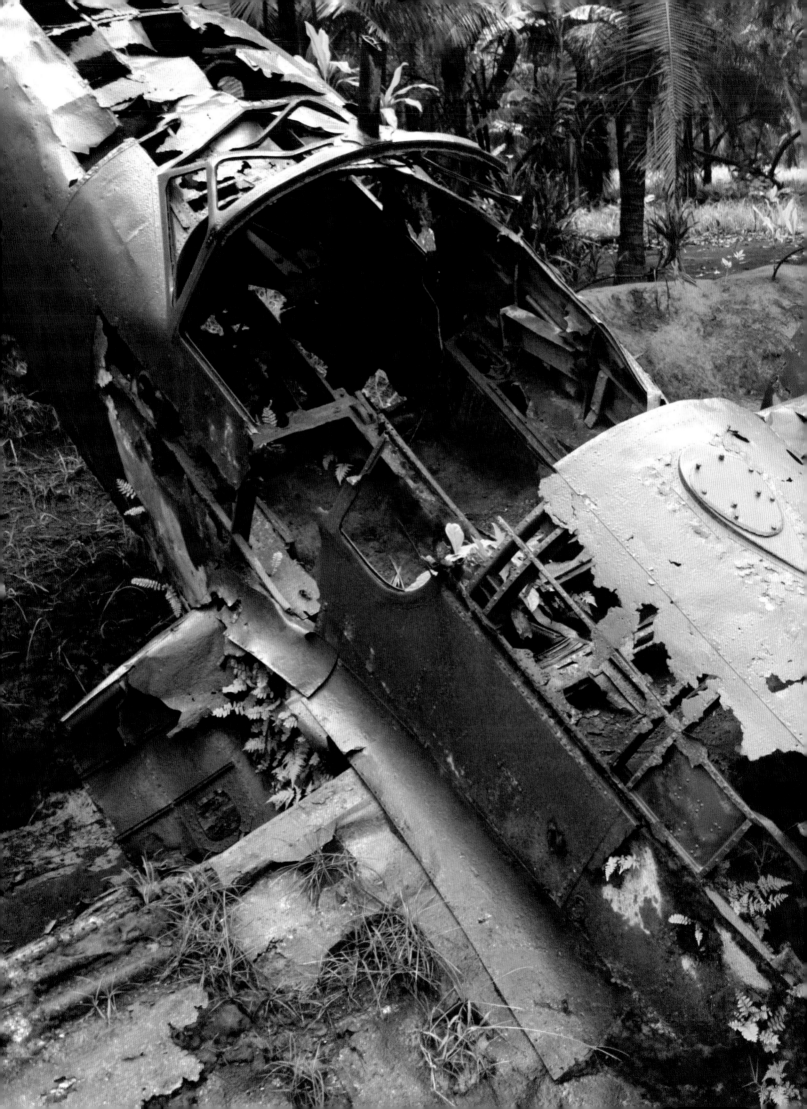

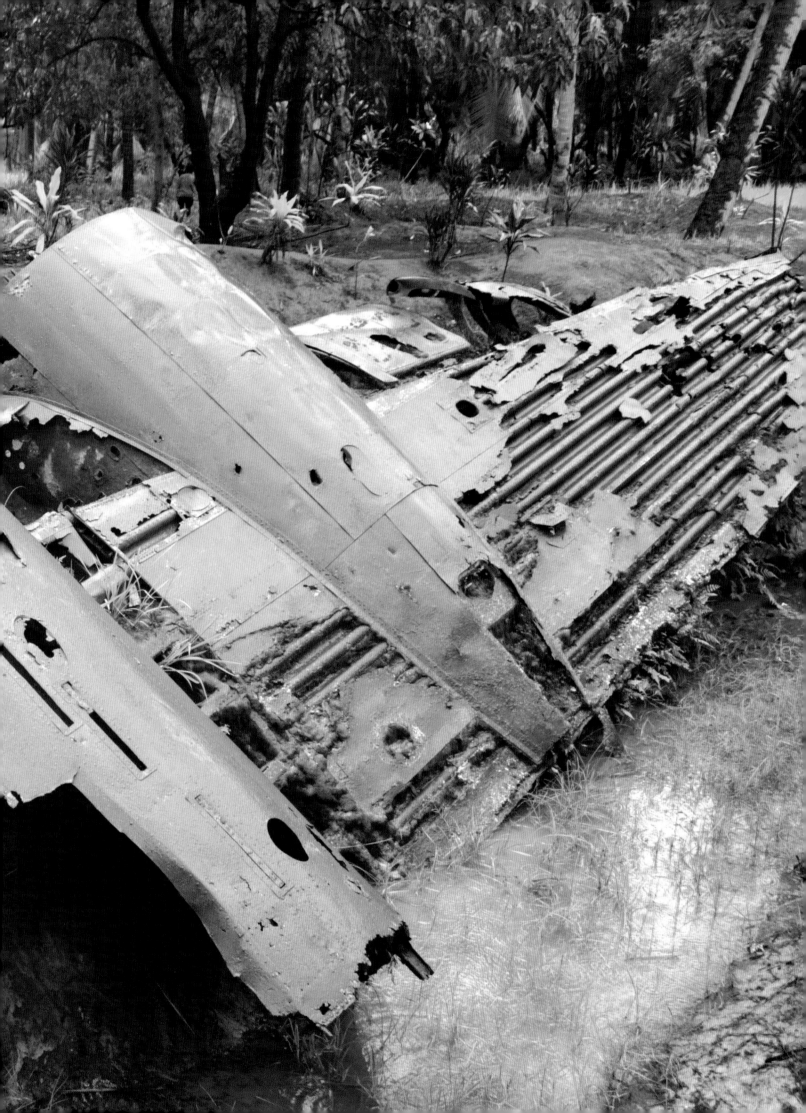

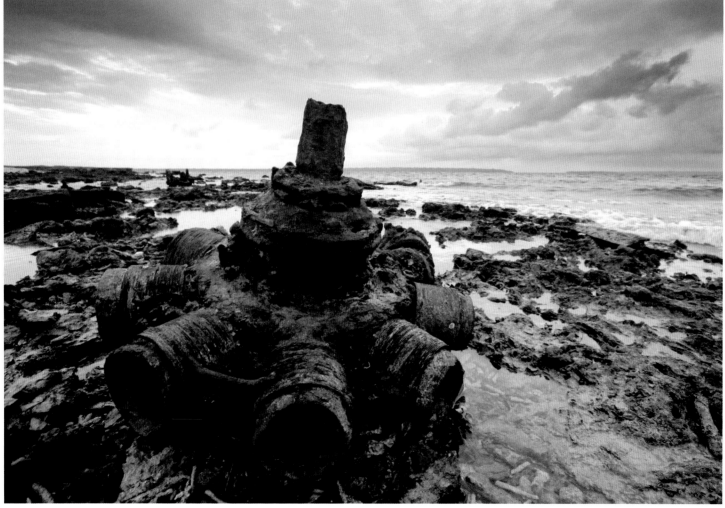

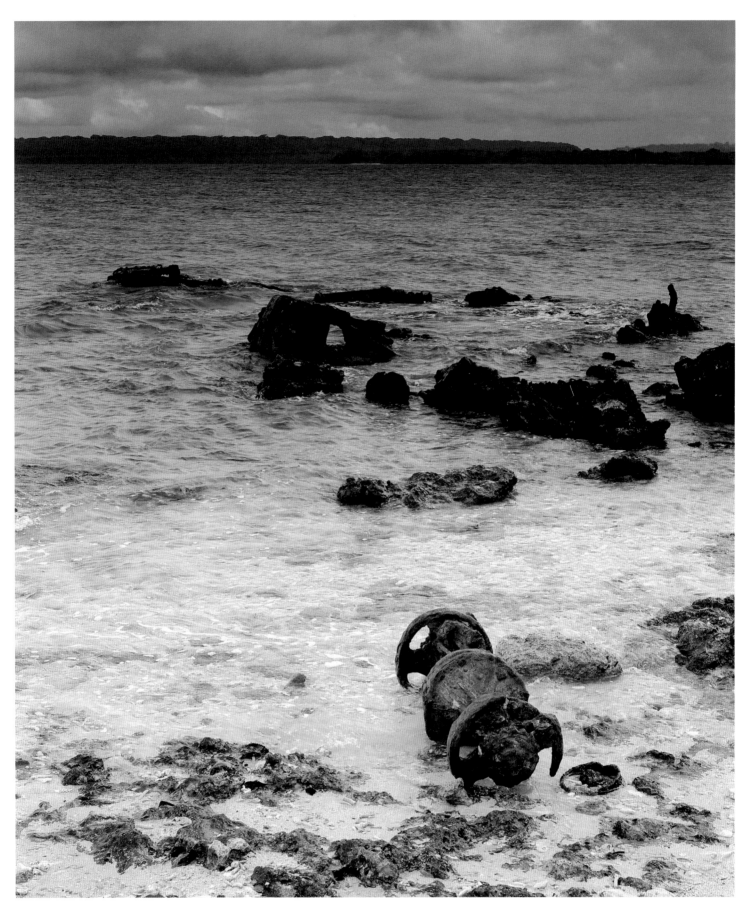

OPPOSITE TOP:

Mitsubishi A6M 'Zero' Fighter, Palau, Micronesia

Its body built with a special top-secret aluminium alloy (T-7178), the 'Zero' type downed over 1,500 enemy aircraft in the course of the Pacific War. It was justly feared by Allied pilots, seafarers and soldiers. This time, however, the tables were to be turned: the wreckage is barely visible beneath the water here.

OPPOSITE BOTTOM AND ABOVE:

Abandoned Equipment, Million Dollar Point, Espiritu Santo Island, Vanuatu

When the war came to an end, the victorious Americans faced an administrative and logistical headache: how to get tonnes of now-redundant weaponry, ammunition, equipment and miscellaneous supplies back home. In the event, they simply dumped the whole lot in the sea, at what was to become known as 'Million Dollar Point'.

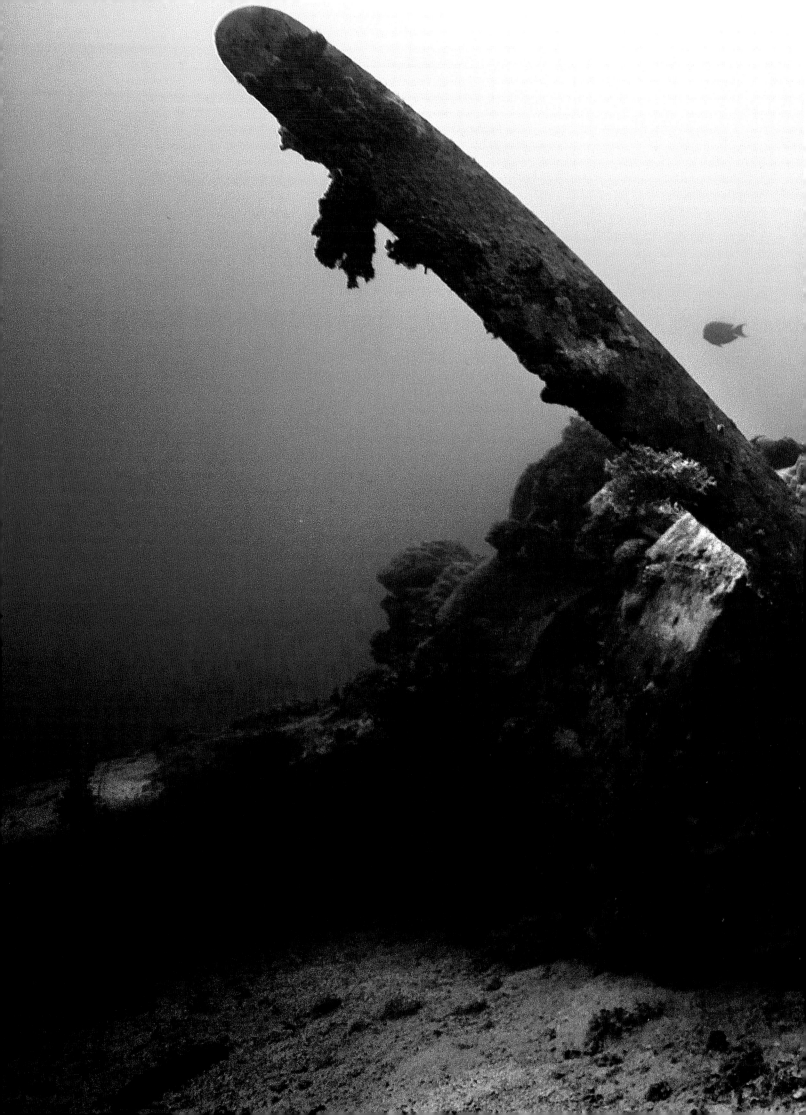

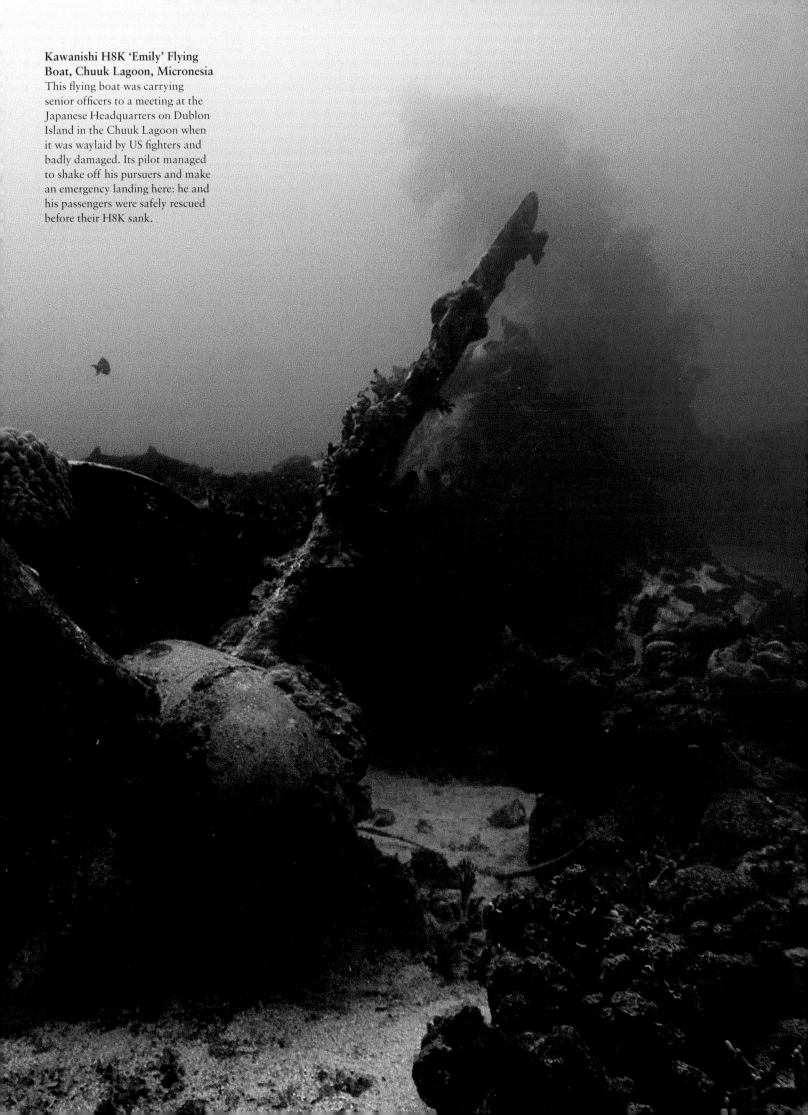

Kawanishi H8K 'Emily' Flying Boat, Chuuk Lagoon, Micronesia
This flying boat was carrying senior officers to a meeting at the Japanese Headquarters on Dublon Island in the Chuuk Lagoon when it was waylaid by US fighters and badly damaged. Its pilot managed to shake off his pursuers and make an emergency landing here: he and his passengers were safely rescued before their H8K sank.

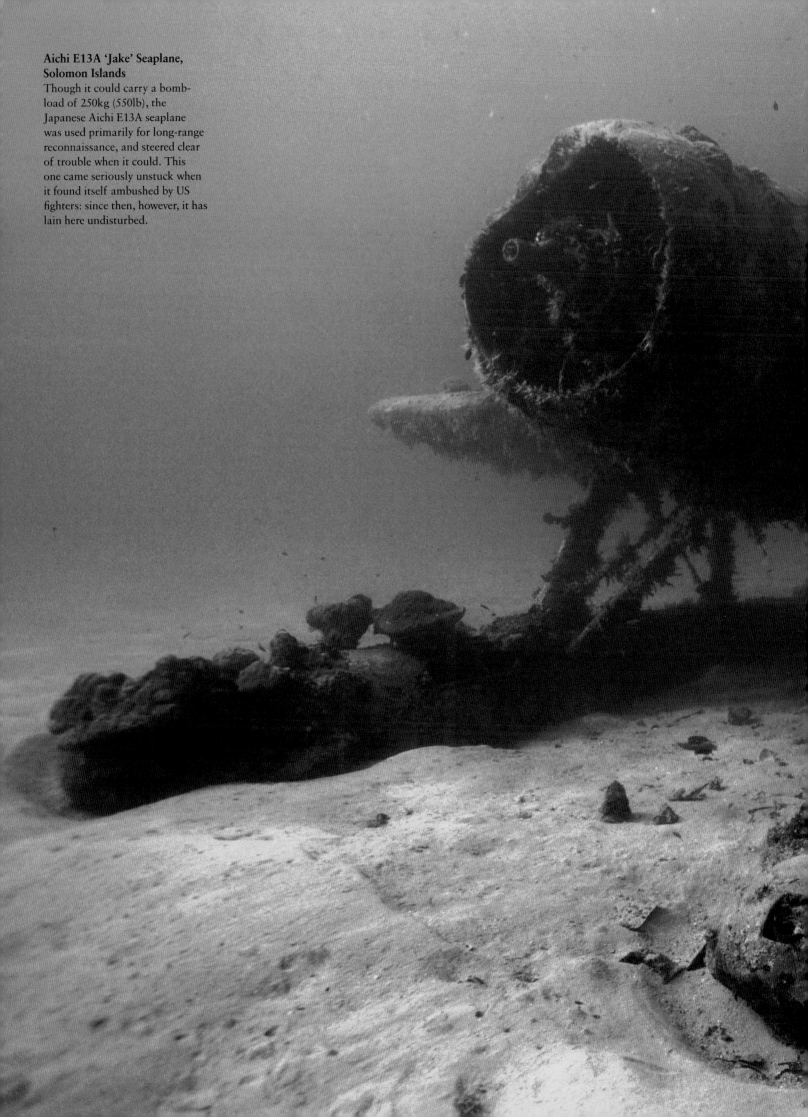

Aichi E13A 'Jake' Seaplane, Solomon Islands
Though it could carry a bomb-load of 250kg (550lb), the Japanese Aichi E13A seaplane was used primarily for long-range reconnaissance, and steered clear of trouble when it could. This one came seriously unstuck when it found itself ambushed by US fighters: since then, however, it has lain here undisturbed.

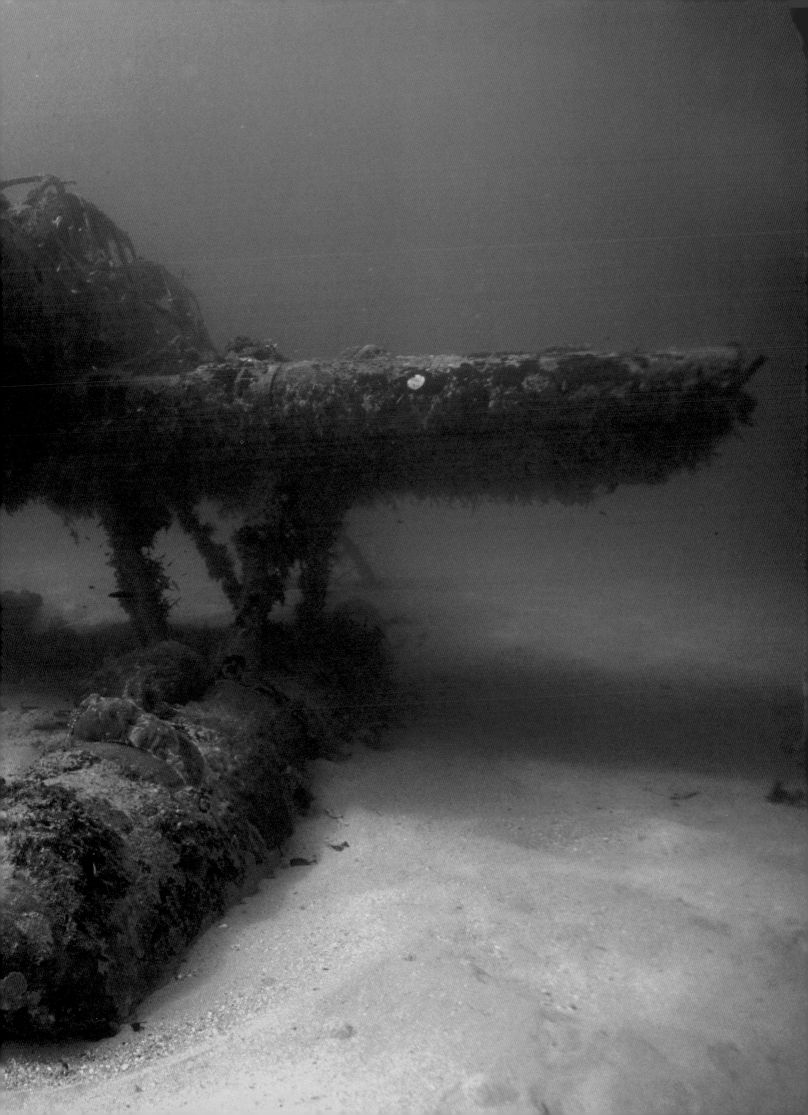

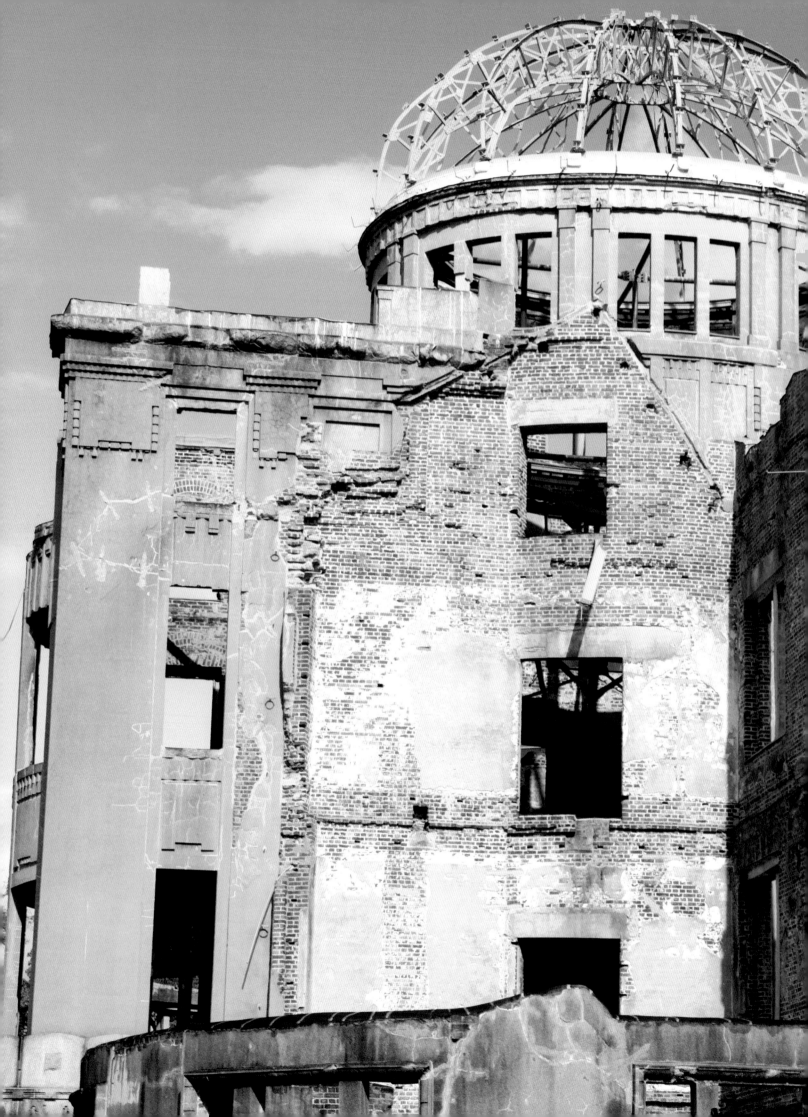

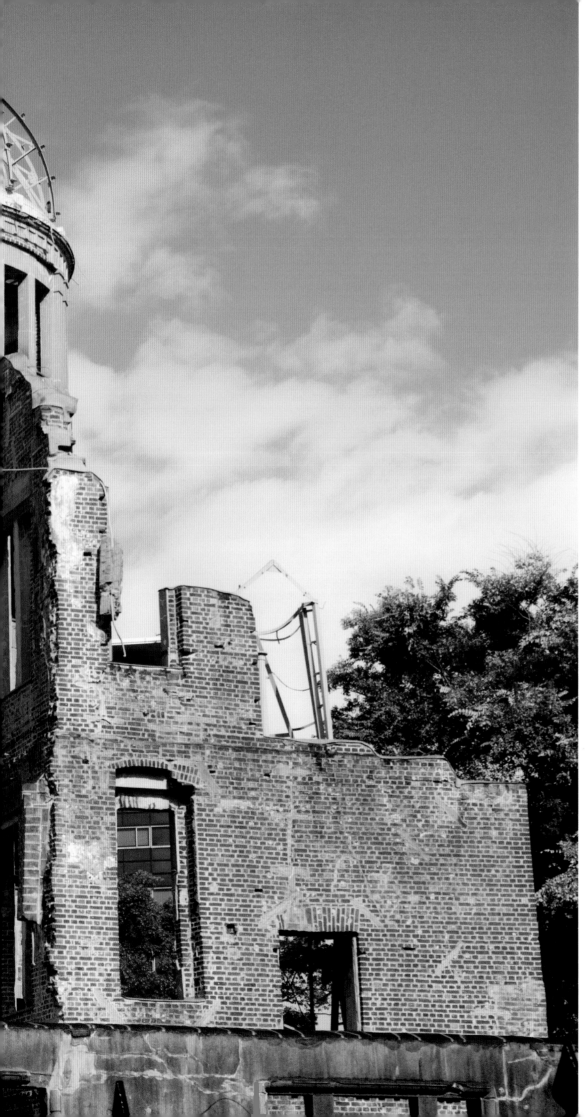

The A-Bomb Dome, Hiroshima, Honshu, Japan
What once was a commercial exhibition hall and is now a gutted shell has been preserved that way as a memorial to the tens of thousands killed by the dropping of the first atom bomb. The explosion of 'Little Boy', on 6 August 1945, while arguably ending the war, also ushered in the Nuclear Age.

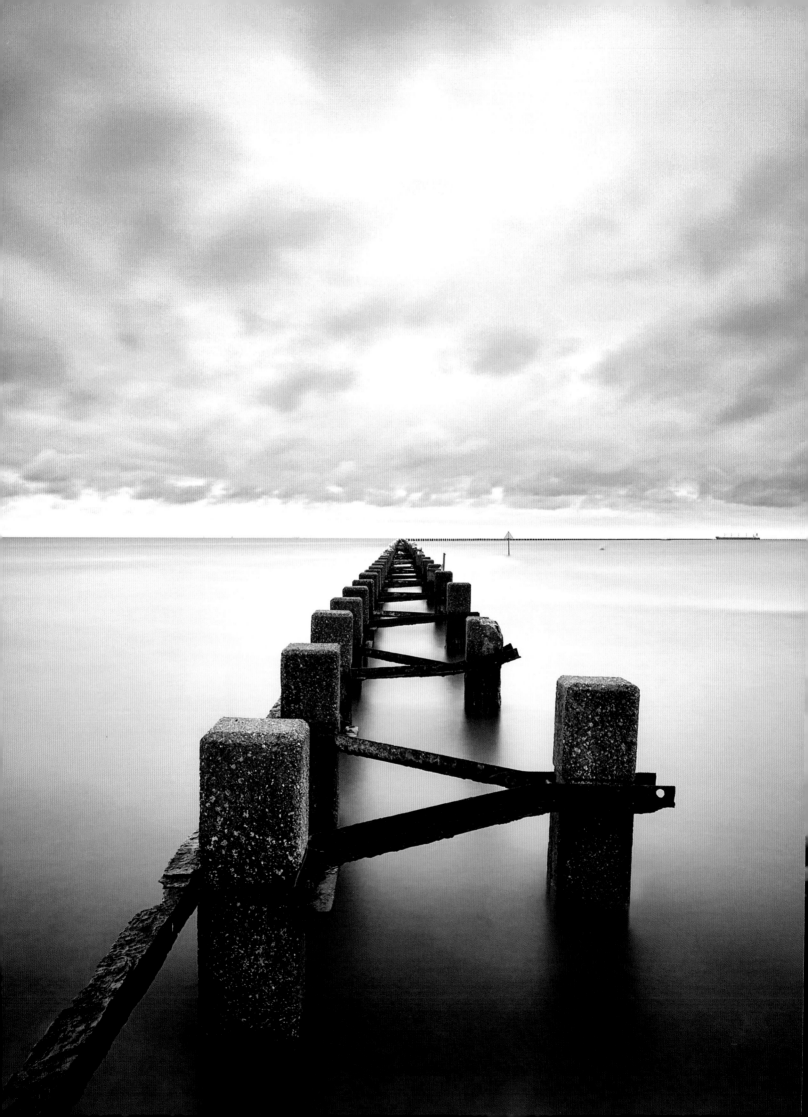

Great Britain and Ireland

On 16 March 1940, James Isbister of Brig o'Waithe – a tiny village on the Orkney Islands off the northern coast of the Scottish mainland – became the UK's first civilian casualty of World War II. German Junkers 88 aircraft were offloading excess bombs after a raid on the British fleet in Scapa Flow. The coincidence that caught him may have been grotesque; the thought of the conflict's reaching so remote and idyllic a spot utterly improbable, but the implication was clear: nowhere in Britain was out of the war's reach.

If the fear of immediate invasion subsided after the summer of 1940, the sense of beleaguerment only grew with German gains in Europe. Seaports like Liverpool and Bristol saw any amount of action in the air raids of 1940–41; so did industrial centres like Manchester, Coventry and Clydebank, and historic cities like Canterbury and Colchester. London – especially its docks – was belaboured night after night by German bombers.

That damage was mostly repaired or cleared, though: much of Britain's surviving infrastructure from this period relates to invasion fears that were never realized. We stumble on it today in what now seem unexpected – even oddly random – places. Yet this only gives them an additional dimension of atmosphere, an extra eeriness: real and recent as they are, these ruins seem fantastical somehow.

LEFT:

Coastal Defences, Shoeburyness, Essex
This boom stopped submarines and ships from coming too close inshore at what was a strategic point on the Thames Estuary and site of a vital experimental-weapons station. Uniquely, these defences were restored as part of 1950s Cold War planning, though they've since been allowed to go to rack and ruin.

**Pillbox at Cornelian Bay,
Scarborough, Yorkshire**
Being ready for anything meant
preparing for everything – hence
this mini-fortress on England's far-
flung northeastern coast. So-called
for their distinctive shape, pillboxes
were placed across Britain in their
thousands. Hundreds remain,
looming up out of nowhere
alongside country roads or – like
this one – blending slowly into the
coastal scene.

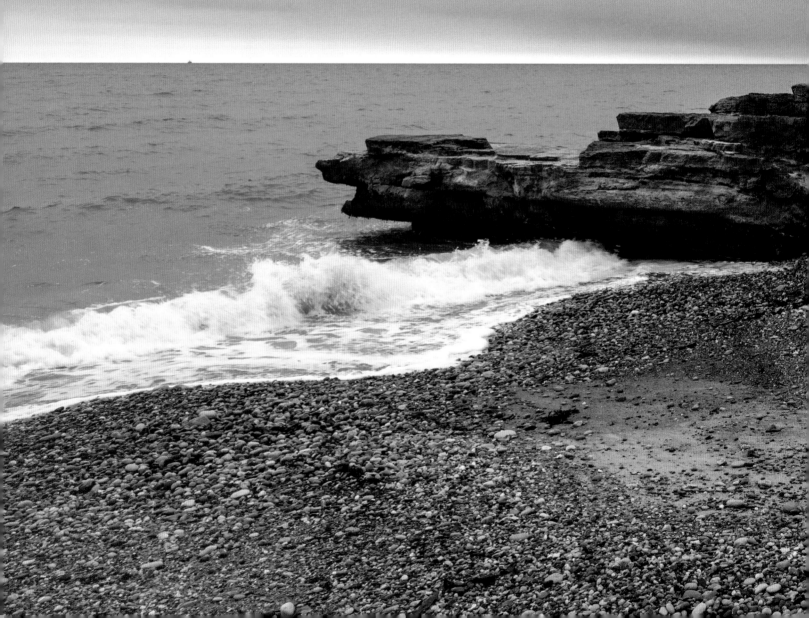

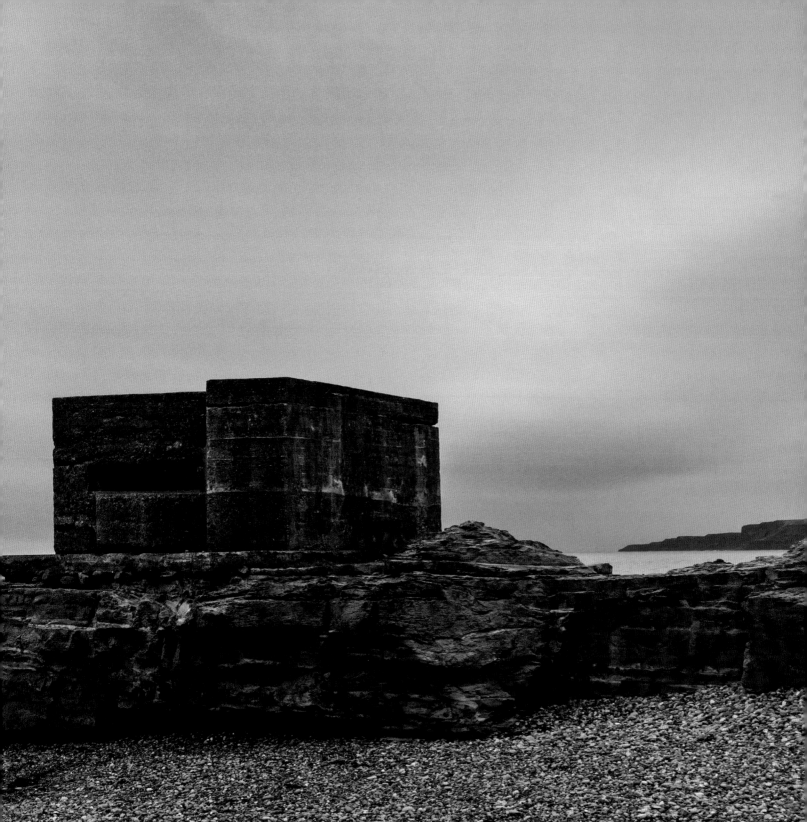

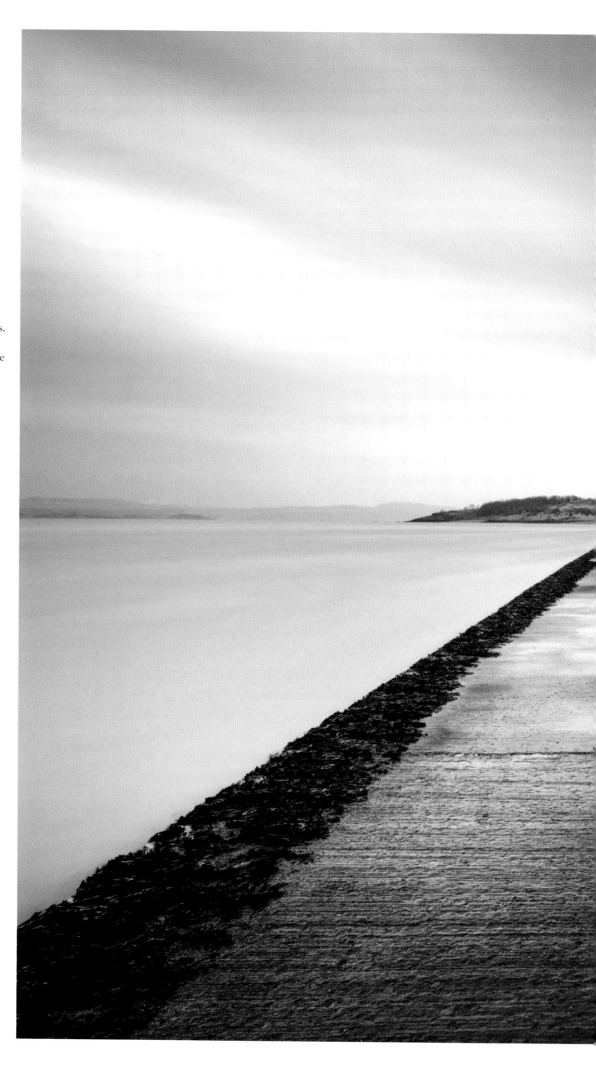

RIGHT:
Causeway to Cramond Island, Edinburgh

To the west of Edinburgh's port of Leith, Cramond Island remained strategically important in commanding the approaches to the Forth Bridge and the Royal Dockyard at Rosyth. Gun emplacements on the island were reached at low tide by this causeway; submarines kept out by the boom of pylons to the right.

OVERLEAF:
Tank Traps, Inverbervie, Scotland

Preparations against a Nazi invasion naturally focused on England's Channel coast – the shortest of hops for German forces. Ultimately, though, who knew where they would strike? Hence the state of readiness all the way up Great Britain's eastern side – even here, above the beach outside this village near Montrose.

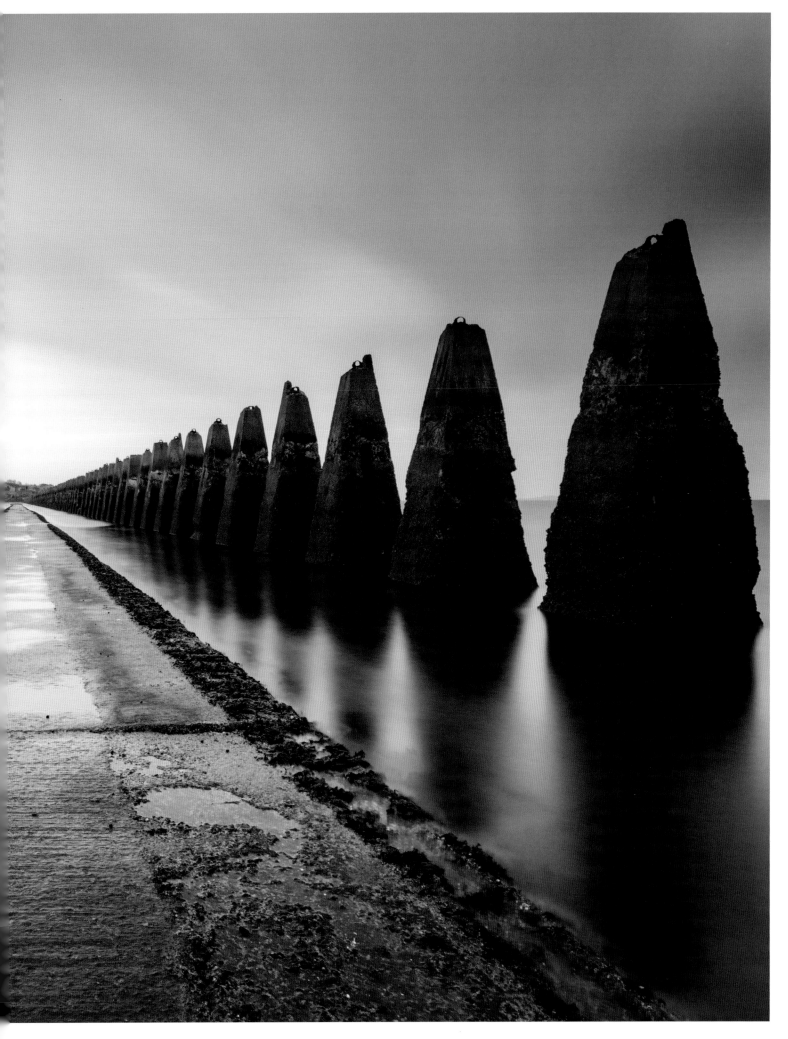

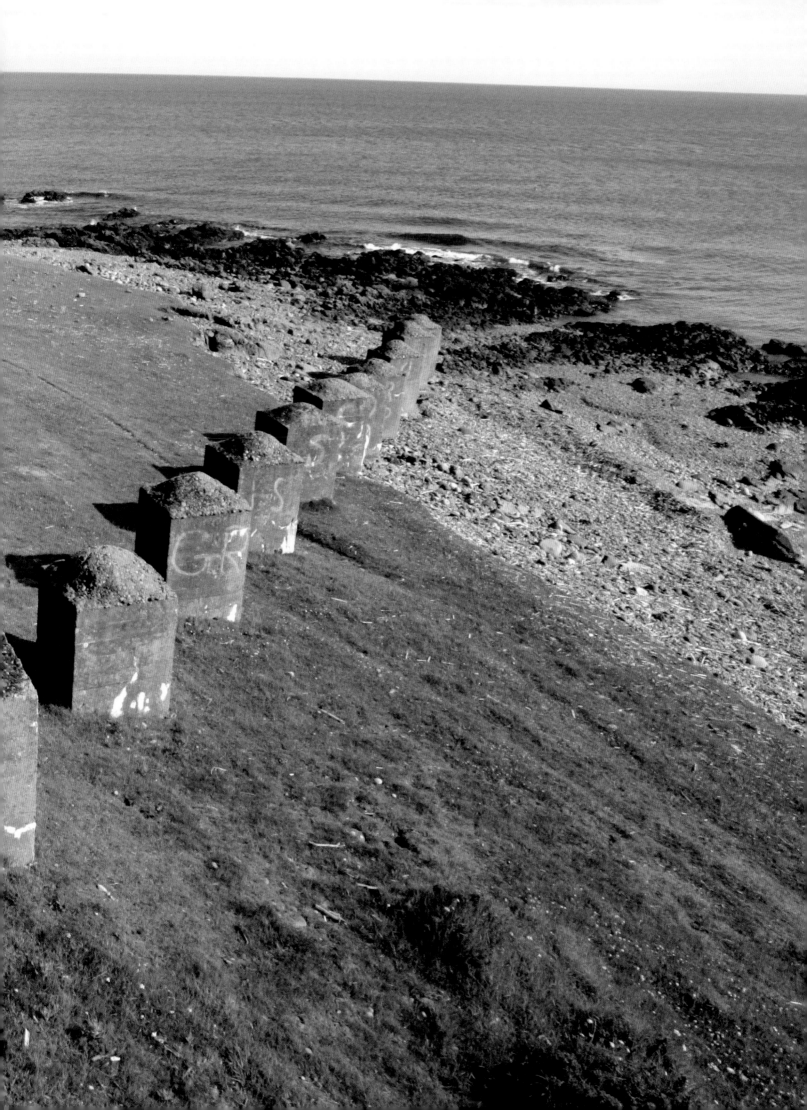

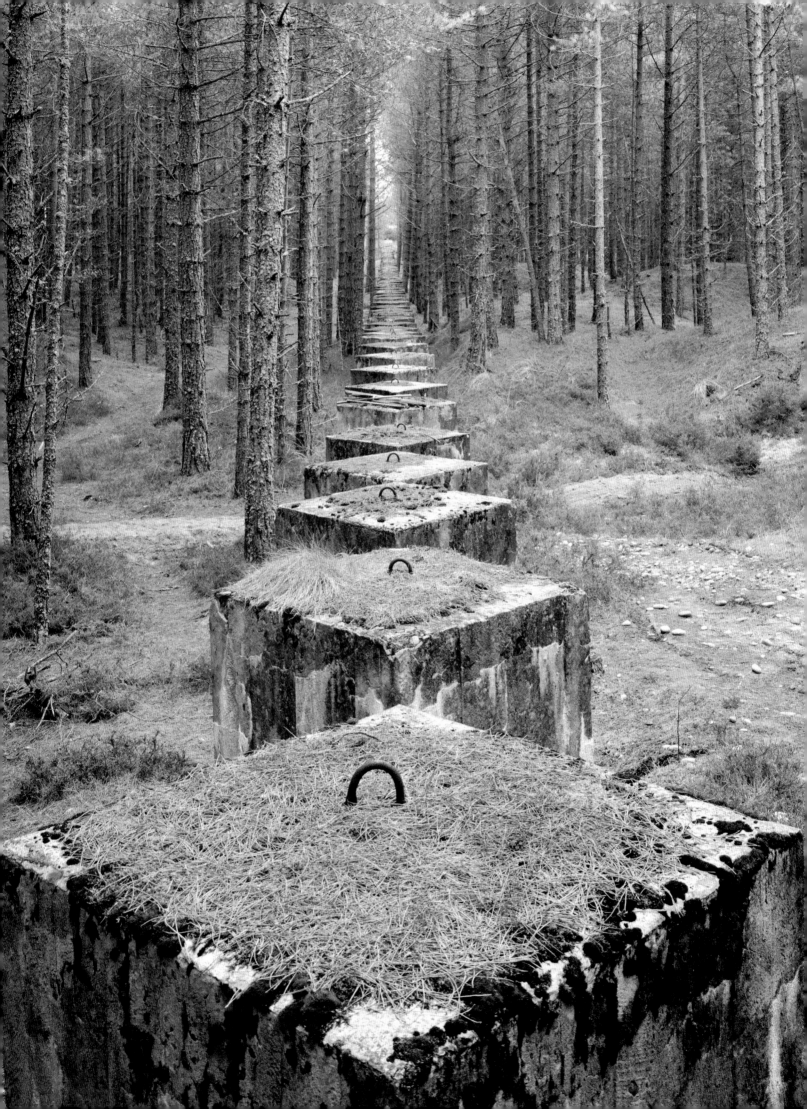

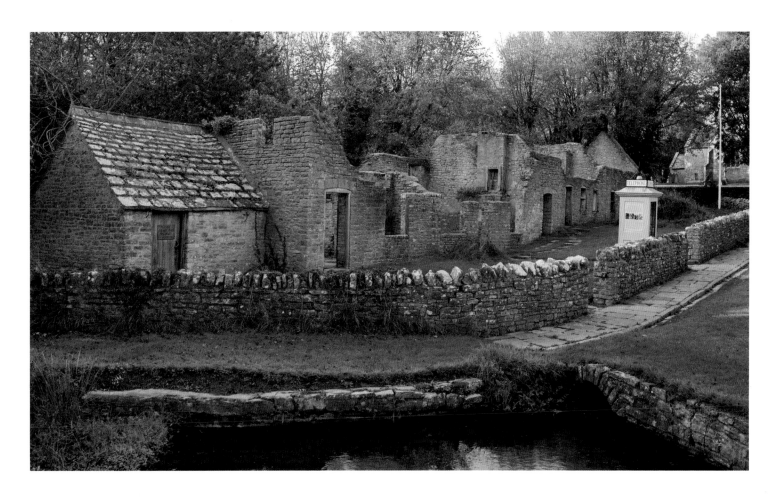

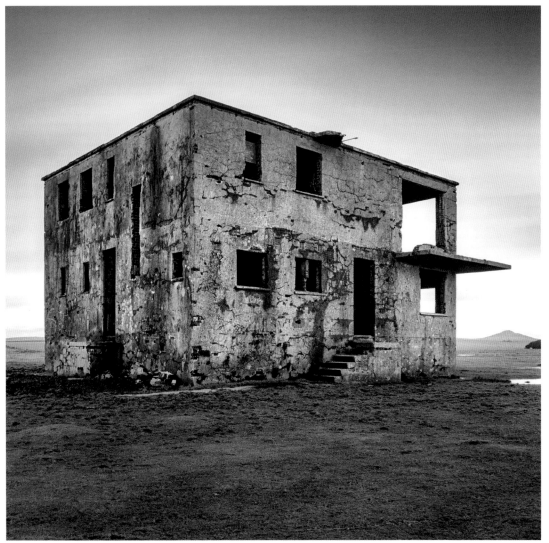

ABOVE:

Deserted Village, Tyneham, Dorset

In 1943, this haunted hamlet was requisitioned for training troops. The D-Day Landings loomed, and Britain's soldiers were going to have to find their way, under heavy fire, through similar villages across northern France.

LEFT:

Control Tower, Davidstow, Cornwall

Well to the west of the famous Battle of Britain fields, RAF Davidstow did its bit in providing anti-submarine patrols in the Bay of Biscay, convoy support and air-sea rescue in the Western Approaches. It also played its part in backing the Normandy Landings of June 1944.

OPPOSITE:

Tank Traps, Lossiemouth II, Moray, Scotland

Mounting a defence against an unpredictable enemy involves endlessly elaborate calculation and second-guessing. The airfield opened on the Moray coast in northeast Scotland to provide protection for the naval port of Lossiemouth had itself to be carefully protected against attack, as these concrete tank traps testify.

159

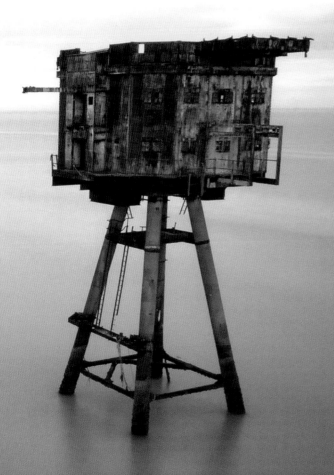

Maunsell Fort, Thames Estuary
Named for Guy Maunsell of the Royal Engineers, forts like this were to play a vital role in offering anti-aircraft cover for merchant vessels in those vulnerable hours as they approached port. Similar installations in the narrower mouth of the Mersey, outside Liverpool, proved a hazard to post-war shipping and were removed.

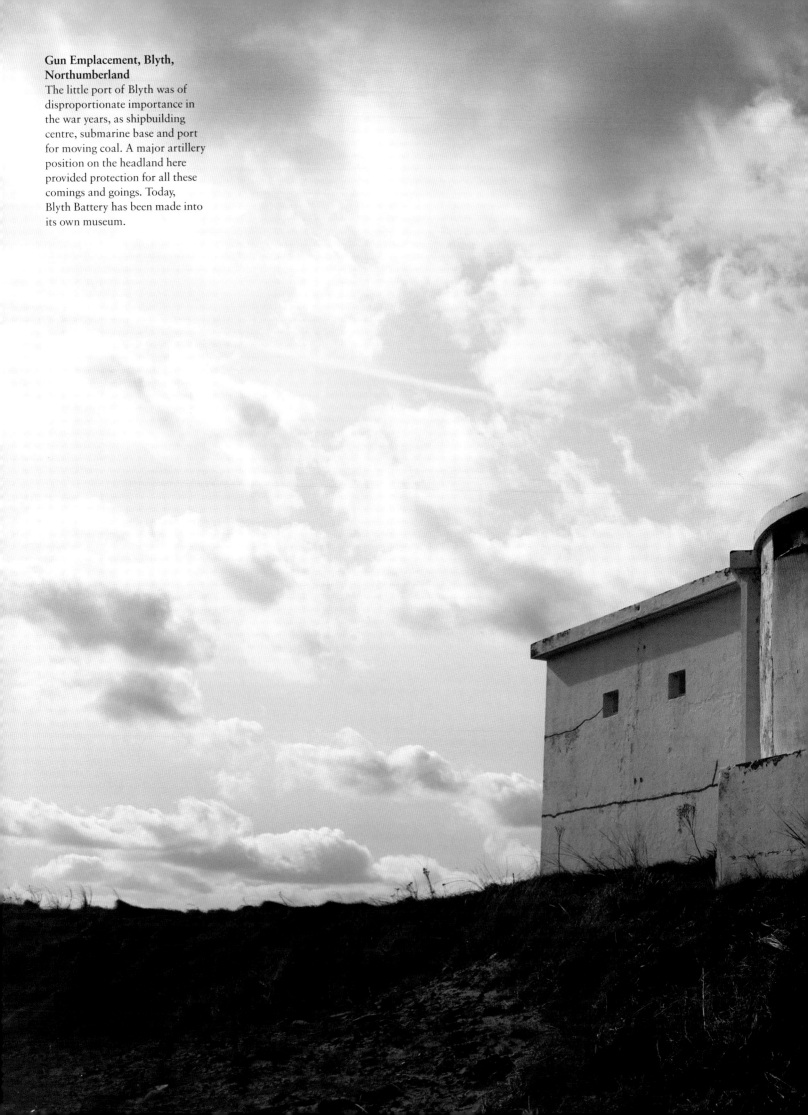

Gun Emplacement, Blyth, Northumberland
The little port of Blyth was of disproportionate importance in the war years, as shipbuilding centre, submarine base and port for moving coal. A major artillery position on the headland here provided protection for all these comings and goings. Today, Blyth Battery has been made into its own museum.

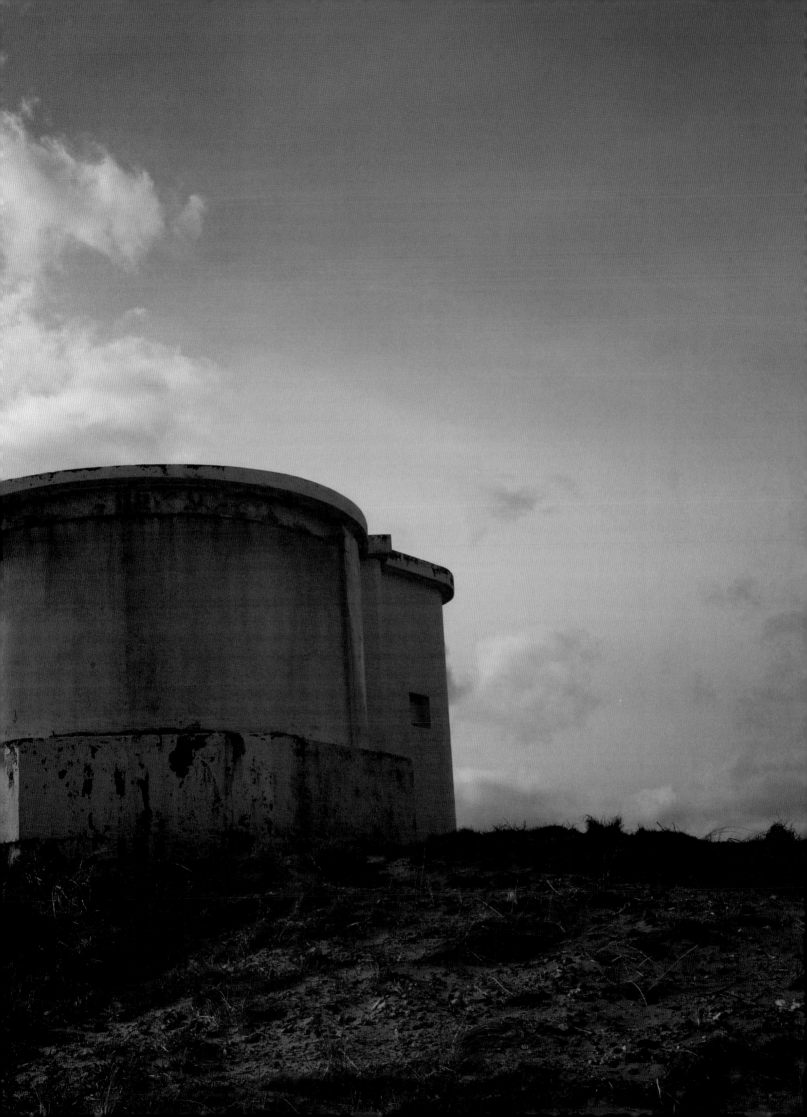

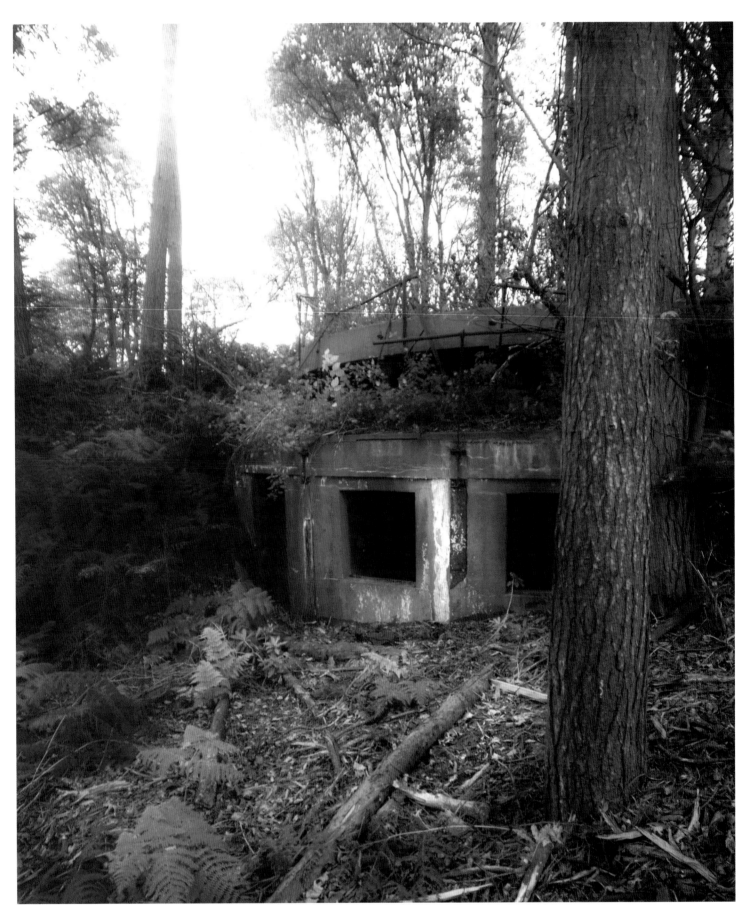

ABOVE:

Emplacement, South Queensferry, Scotland
The Forth Bridge, beneath whose southernmost span this hillside rises, was as strategically important as it was iconic; an obvious target for sabotage or special forces raids. Its destruction would have severed the main land-route north – and, in the worst case, created a 'boom' of wreckage cutting off Rosyth Dockyard from the sea.

RIGHT:

Anti-Tank Blocks, Druridge Bay, Northumberland
Its endless expanse of gently shelving sand make Druridge Bay a perfect spot for walking – or, for that matter, for amphibious landing in time of war. Hence the elaborate precautions – not just these blocks, but pillboxes, trenches – even ditches to stop gliders landing – in case of a bid to invade England by this remote 'back door'.

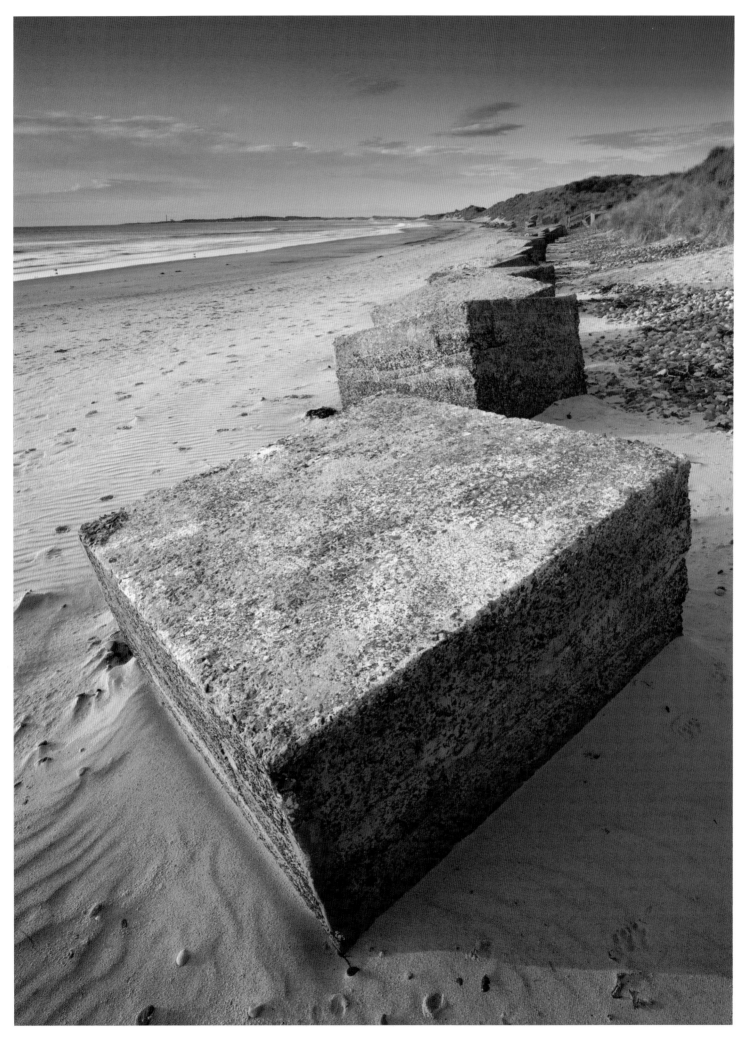

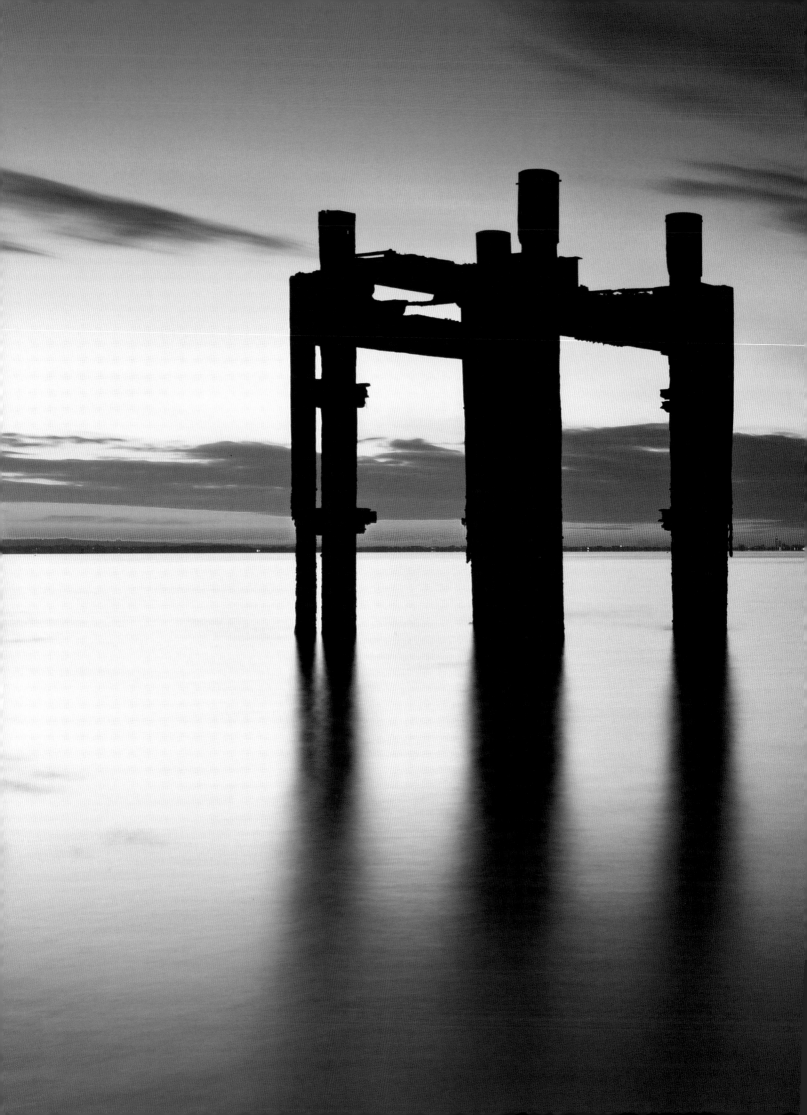

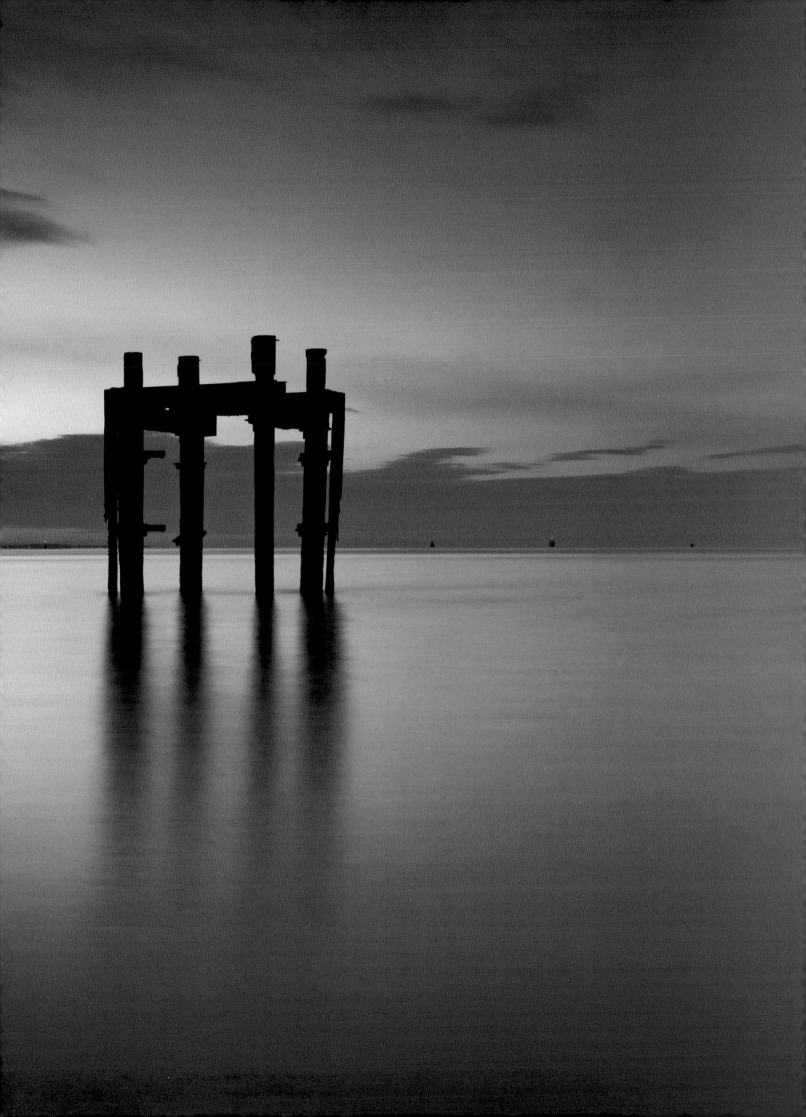

PREVIOUS PAGES:

**D-Day Embarkation Jetty,
Lepe Beach, Hampshire**

On 6 June 1944, this stony beach
near Lymington, on the northern
shore of the Solent, was one of the
main launch-points for Operation
Overlord. Floating harbours,
slipways and other installations
couldn't easily be concealed. Even
so, to keep the Germans guessing,
men and materiel were discreetly
marshalled under cover of the
woodland just inland.

RIGHT:

**Emplacement, Cuckmere Haven,
East Sussex**

Now a famous beauty spot, in the
shadow of the spectacular Seven
Sisters coastal cliffs, Cuckmere
Haven came close to seeing action
of an uglier kind. The gap in the
cliffs was an obvious weak point
in England's natural defences:
major works were carried out
here to prepare against invasion.
Across the country, it is estimated
that over 18,000 concrete pillboxes
were constructed, together
with hundreds of kilometres
of defensive ditches, gun
emplacements, air-raid shelters
and tank traps.

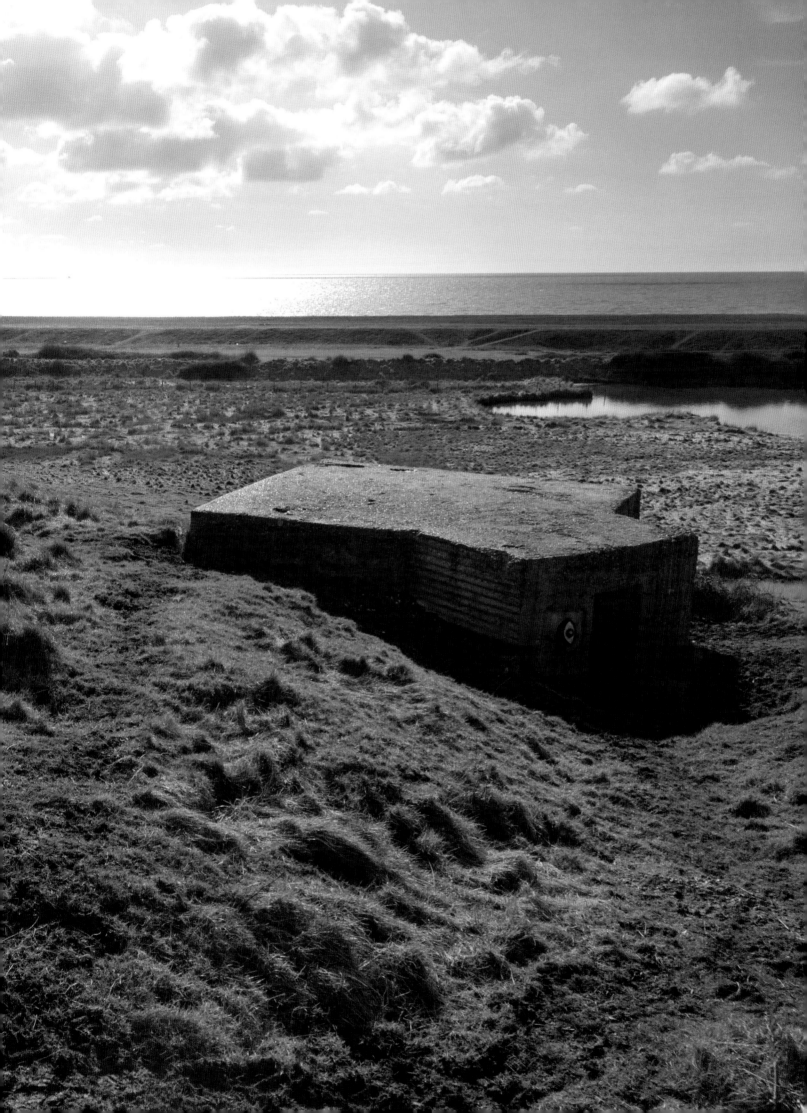

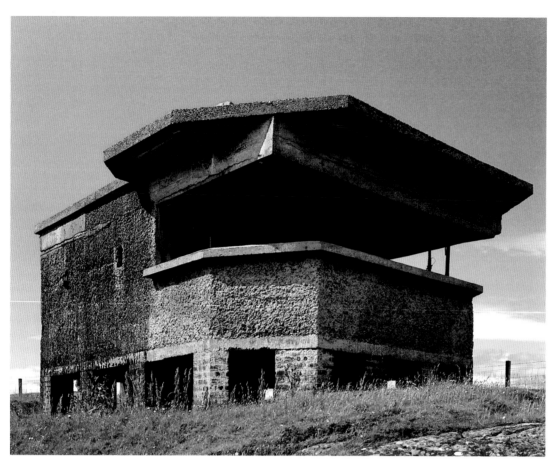

LEFT:

Observation Post, Loch Ewe, Orkney Islands, Scotland
Too remote for even an anxious War Office seriously to regard as a potential invasion site, Loch Ewe had to be carefully guarded nonetheless. From 1942, British, American and Canadian vessels assembled here prior to setting off in the Arctic convoys carrying vital supplies to Soviet Murmansk.

RIGHT:

Concrete Shelters, Hoy, Orkney Islands, Scotland
Abandoned concrete shelters stand on the Island of Hoy, remnants of the lookout stations located around the Royal Navy anchorage at Scapa Flow.

BELOW:

Pillbox, Rye, Sussex
Darkened by decades of wind and rain, set off by the tawny grass, bare trees and grey-blue skies of winter, this pillbox fits perfectly into its austere English setting.

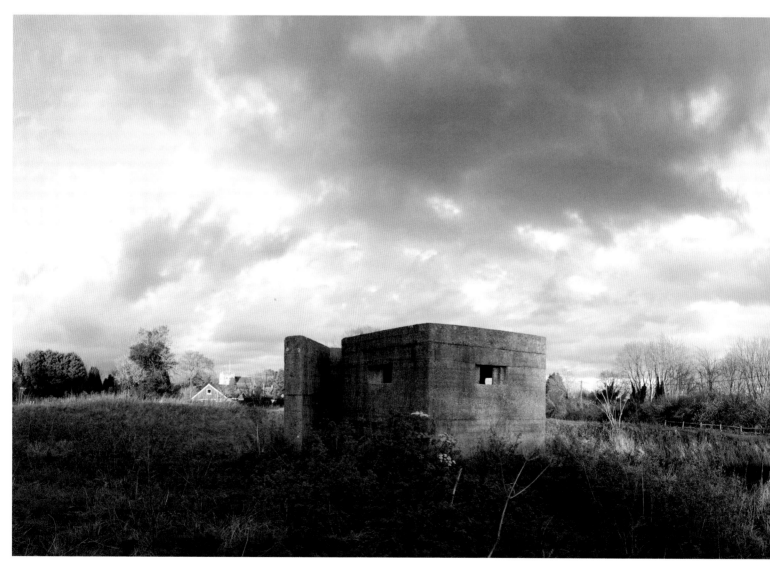

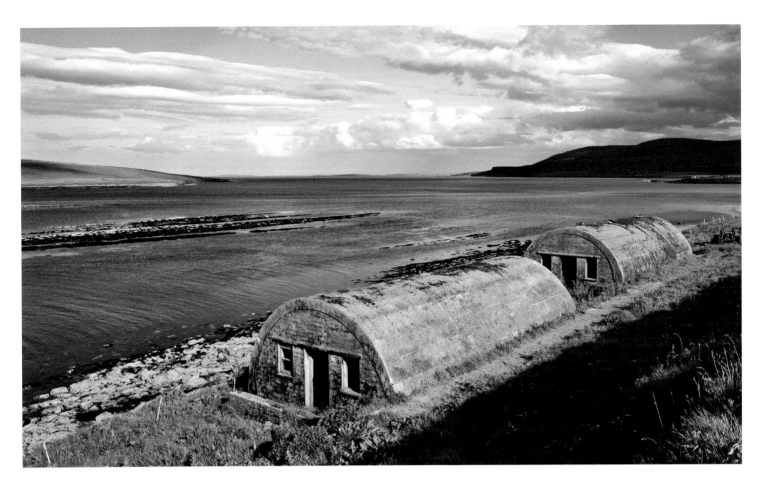

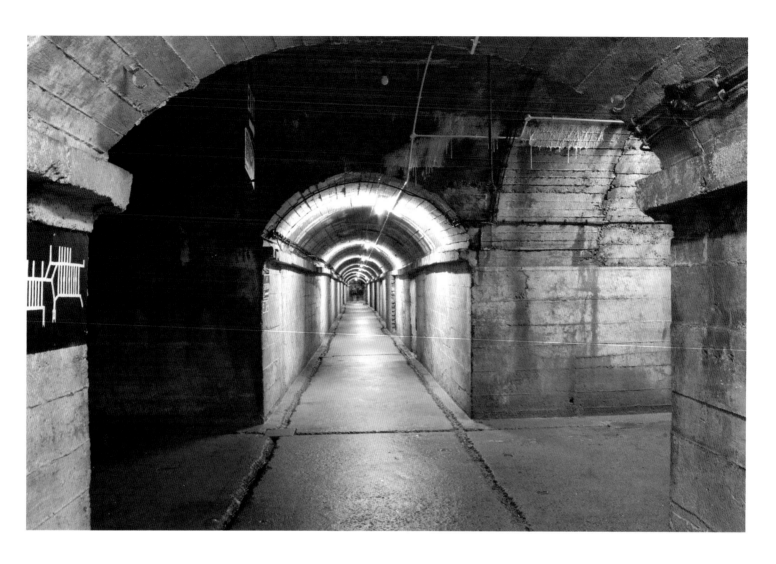

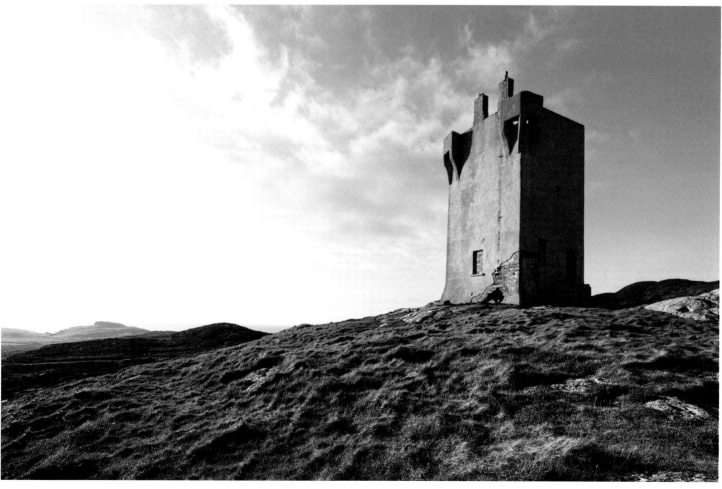

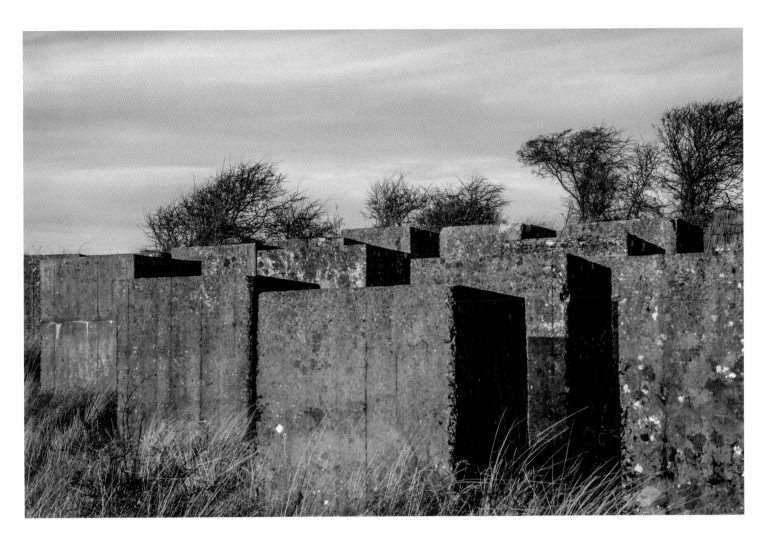

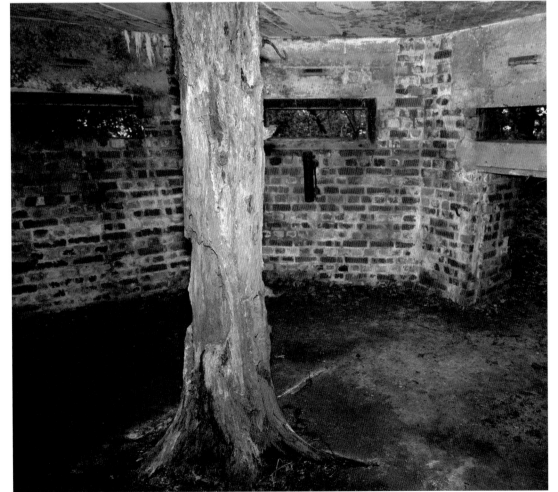

OPPOSITE, TOP:
German Hospital, Guernsey, Channel Islands
The Germans occupied the Channel Islands in the summer of 1940. They soon dug in, creating underground hospitals like the one whose tunnels are shown here.

OPPOSITE, BOTTOM:
Lookout Tower, Malin Head, Republic of Ireland
Irish neutrality during the war didn't bring automatic peace and quiet. Here on Ireland's northerly headland, Britain was secretly allowed to install surveillance equipment for its defence.

ABOVE:
Tank Traps, Aberlady, Scotland
Any German invasion force landing on Longniddry Sands would have had to contend with this obdurate array of concrete blocks.

LEFT:
Pillbox Interior, RAF Biggin Hill, Kent
A key Royal Air Force base protecting London during the war, fighters from Biggin Hill were responsible for shooting down more than 1400 enemy aircraft.

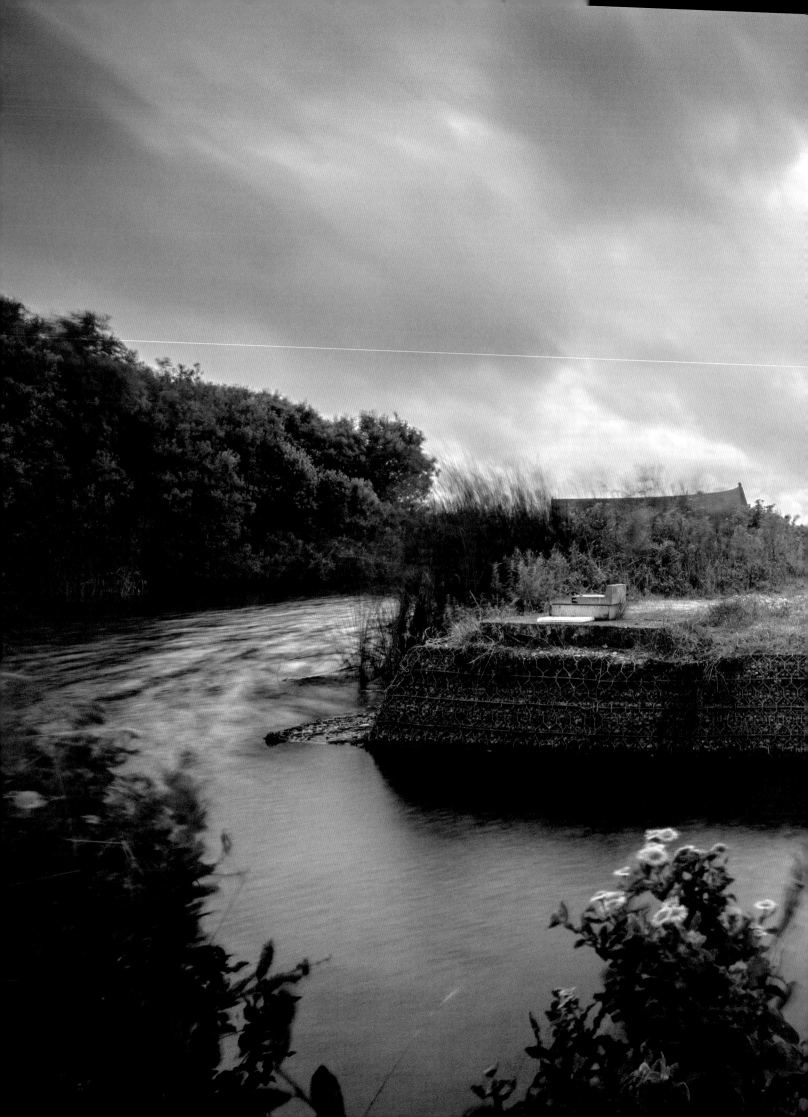

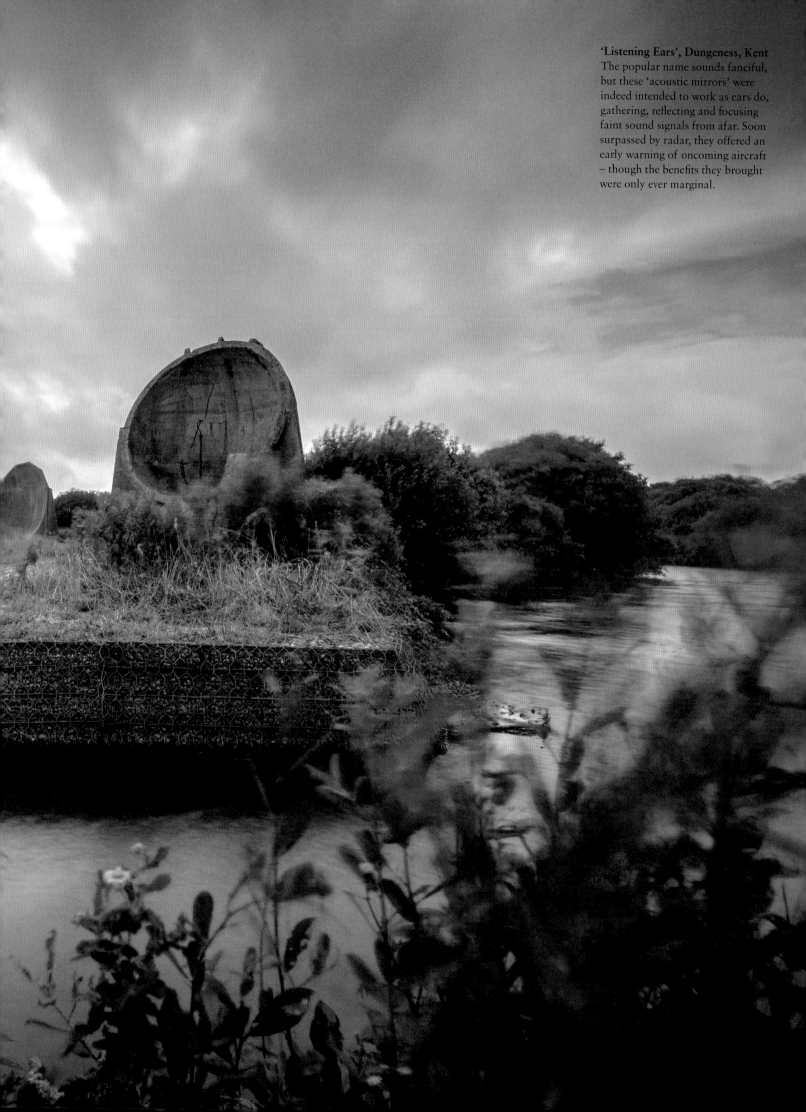

'Listening Ears', Dungeness, Kent
The popular name sounds fanciful, but these 'acoustic mirrors' were indeed intended to work as ears do, gathering, reflecting and focusing faint sound signals from afar. Soon surpassed by radar, they offered an early warning of oncoming aircraft – though the benefits they brought were only ever marginal.

Cabinet War Rooms, Whitehall, London

Deep beneath the streets of central London, these drab chambers were the scene of many a historic meeting – and, undoubtedly, a fair few heated ones, as Churchill and his colleagues steered Britain through its 'Darkest Hour'. Becoming operational in August 1939, just days before the outbreak of war, the War Rooms were manned 24 hours a day until the surrender of Japan in August 1945.

Chiefs of Staff
Conference
Room

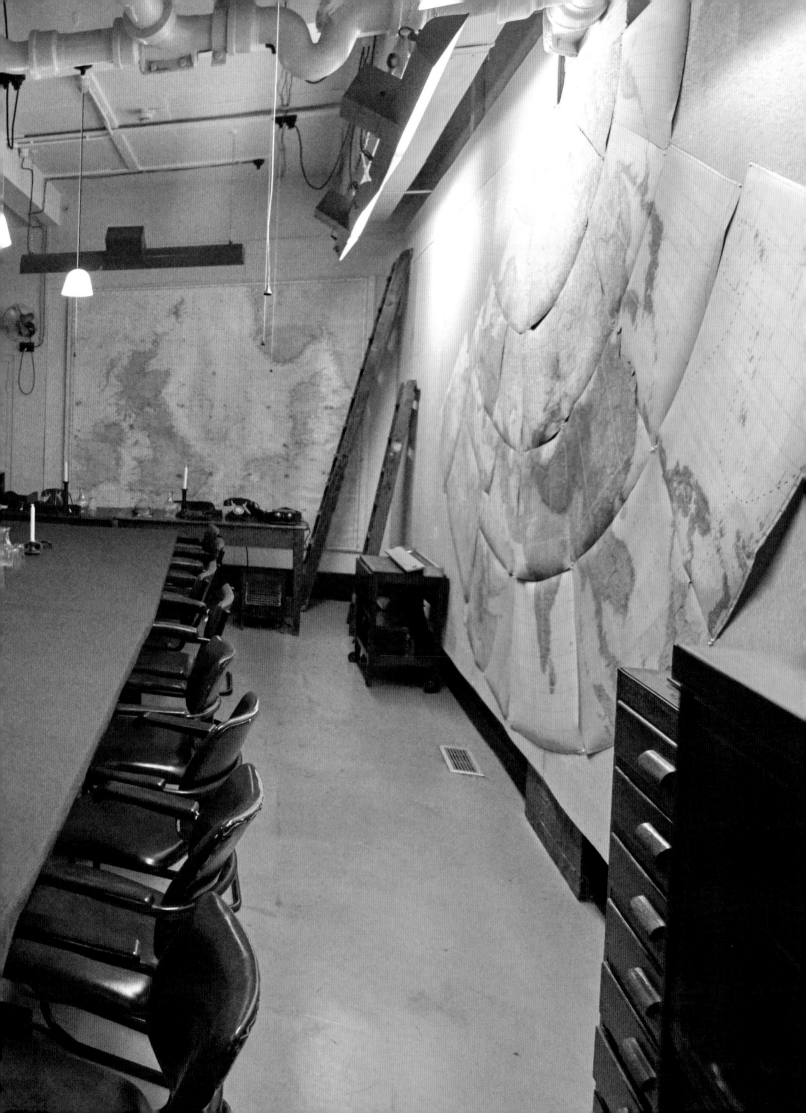

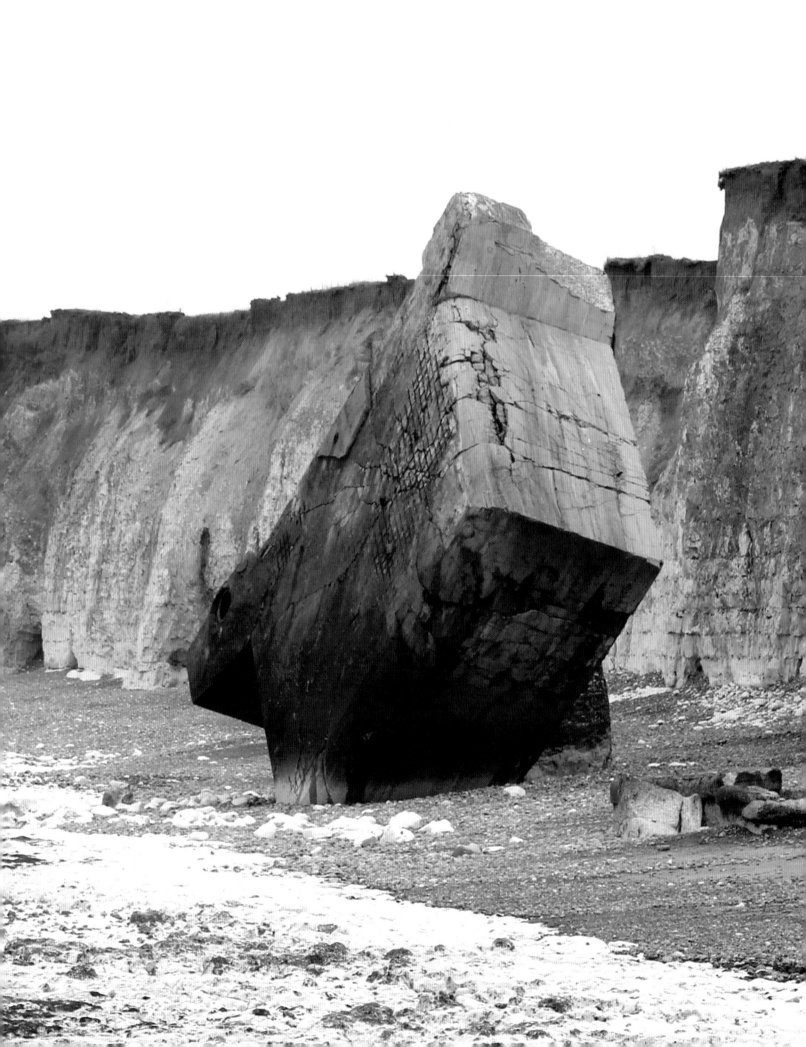

France and the Low Countries

The War in the West got under way in earnest on 10 May 1940, when German forces attacked Belgium, the Netherlands and France. *Blitzkrieg* ('lightning war') is what the Germans called their strategy of smashing enemy defences with carefully co-ordinated armoured, mechanized and air-supported strength. Despite brave resistance, the Netherlands fell within four days.

The Maginot Line fortifications bought France more time. Ultimately, though, it proved irrelevant: the Wehrmacht just went round it and attacked through Belgium. In this theatre particularly, the limitations of major military 'real estate' were cruelly exposed. Despite the ease with which they had given the Maginot Line a swerve, the Germans dug in determinedly themselves, establishing fixed fortifications along the North Sea and Channel coasts. Their effectiveness isn't necessarily discredited by the final success of the D-Day landings, but the outcome calls it into question, at very least.

Any single perspective on so complex an episode as World War II is going to be limited: one that focuses solely on fortifications particularly so. The war in western Europe was waged across wide areas by highly mobile forces; its effects were suffered by civilians on the ground. That's why the existence of a ruined village like Oradour-sur-Glane is so important in testifying to the experiences of ordinary people in the war.

LEFT:
Concrete Bunker, Quiberville Coast, Normandy
The rapid erosion of the chalk cliffs in which it was originally embedded has left this massive concrete construction incongruously stranded. Once it formed part of a German-built 'Atlantic Wall', which ran down the entire length of occupied Europe, all the way from Norway's Northern Cape to the Spanish border.

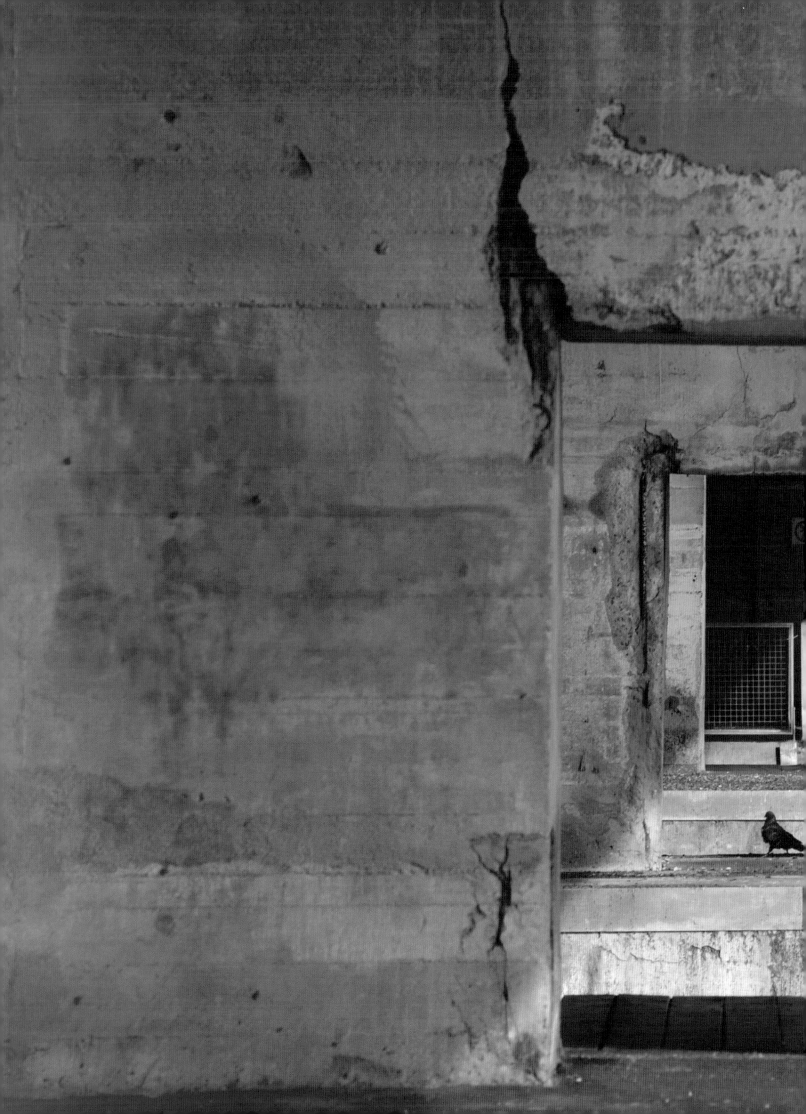

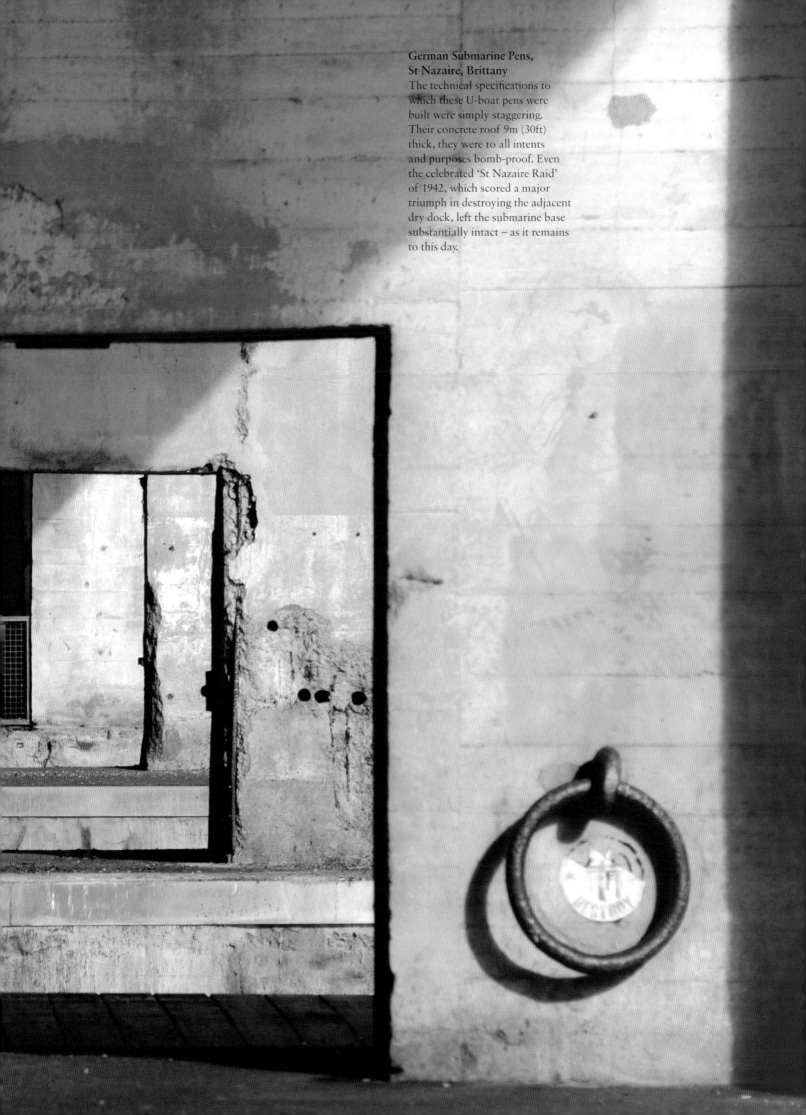

German Submarine Pens, St Nazaire, Brittany
The technical specifications to which these U-boat pens were built were simply staggering. Their concrete roof 9m (30ft) thick, they were to all intents and purposes bomb-proof. Even the celebrated 'St Nazaire Raid' of 1942, which scored a major triumph in destroying the adjacent dry dock, left the submarine base substantially intact – as it remains to this day.

Keroman Submarine Pens, Lorient, Brittany

The Kriegsmarine did not have a 'good war', generally speaking. The U-boats – its great success story – had accordingly to be protected at any cost. Hence such massive – and massively reinforced – concrete structures. Up to 30 vessels at a time could be accommodated at Keroman pens while the Allied aerial bombers did their worst.

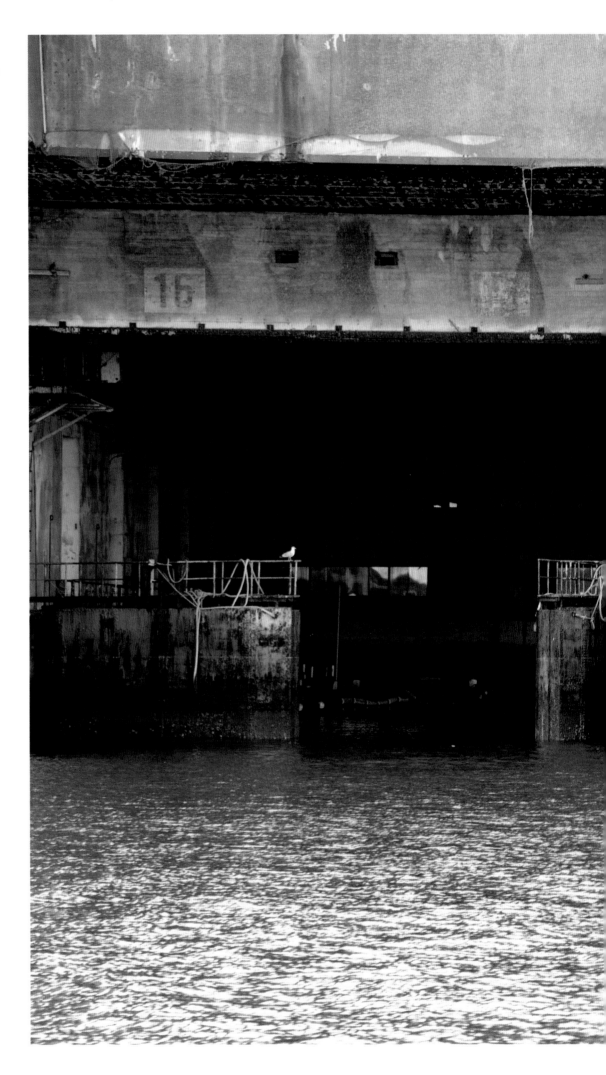

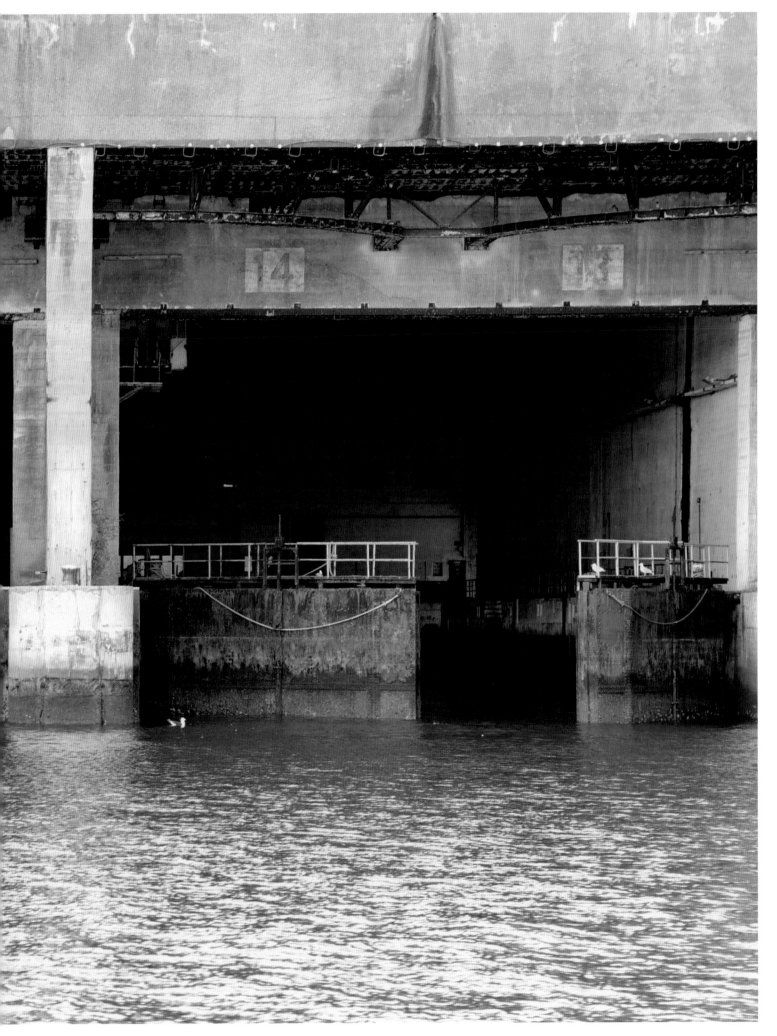

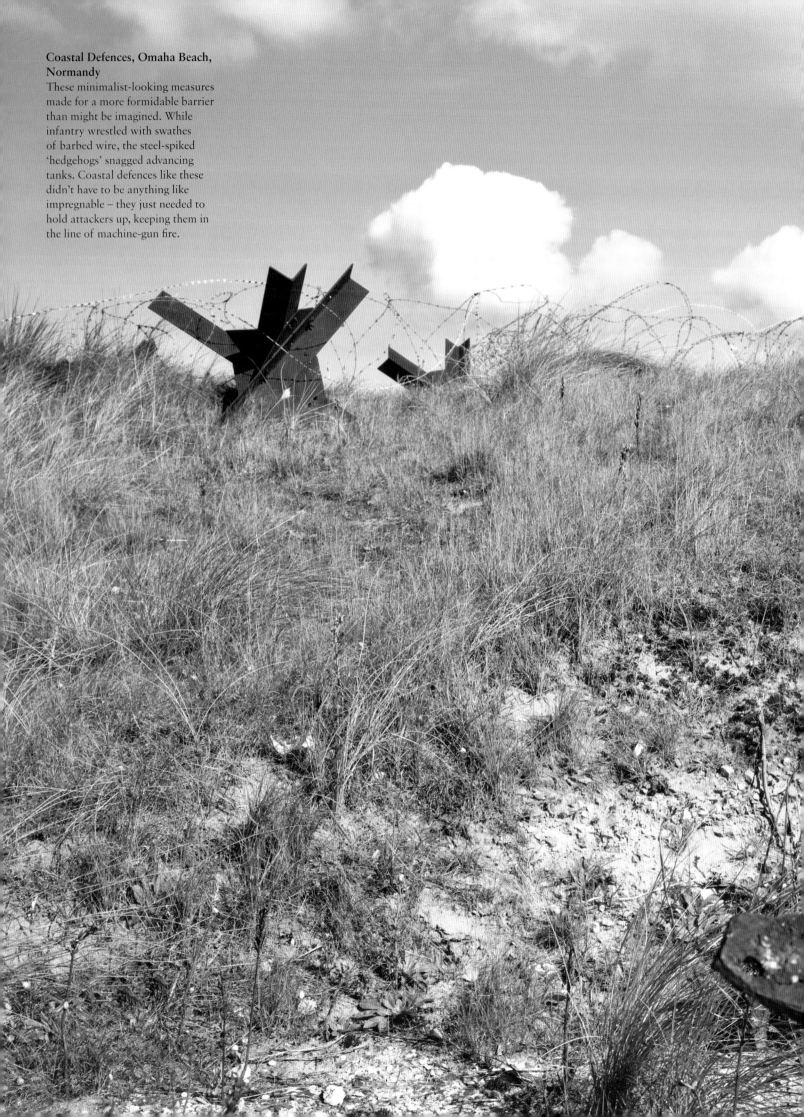

Coastal Defences, Omaha Beach, Normandy
These minimalist-looking measures made for a more formidable barrier than might be imagined. While infantry wrestled with swathes of barbed wire, the steel-spiked 'hedgehogs' snagged advancing tanks. Coastal defences like these didn't have to be anything like impregnable – they just needed to hold attackers up, keeping them in the line of machine-gun fire.

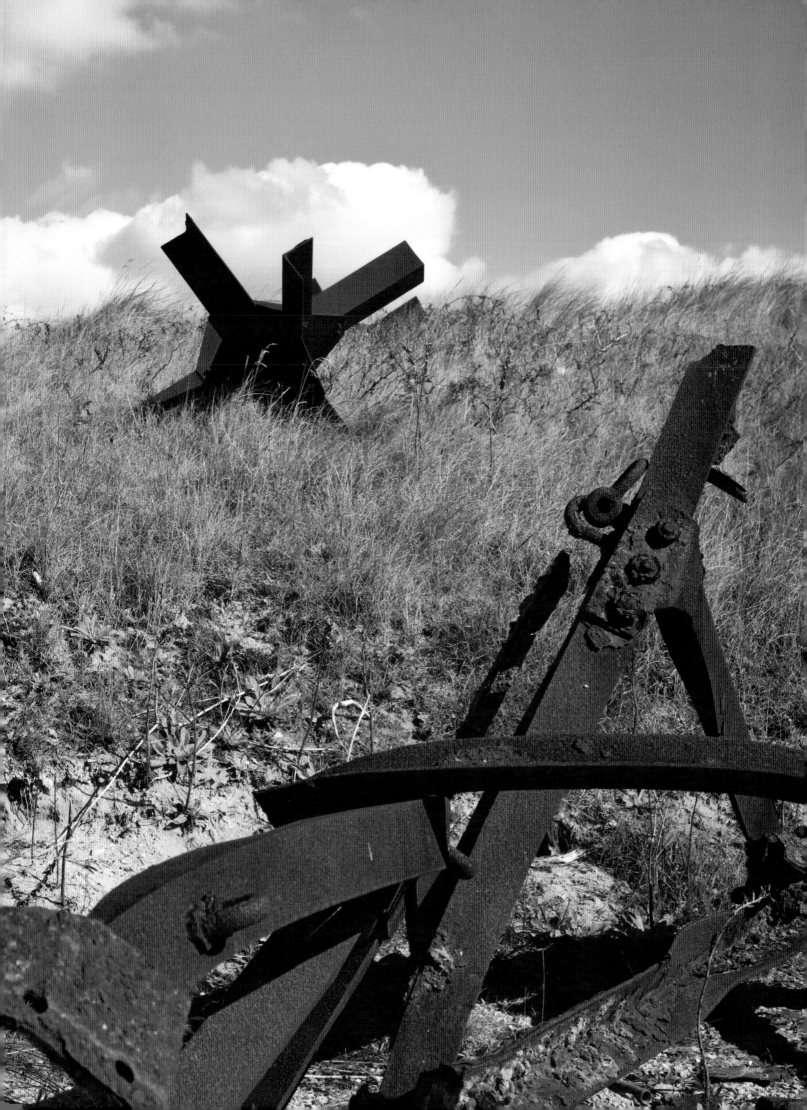

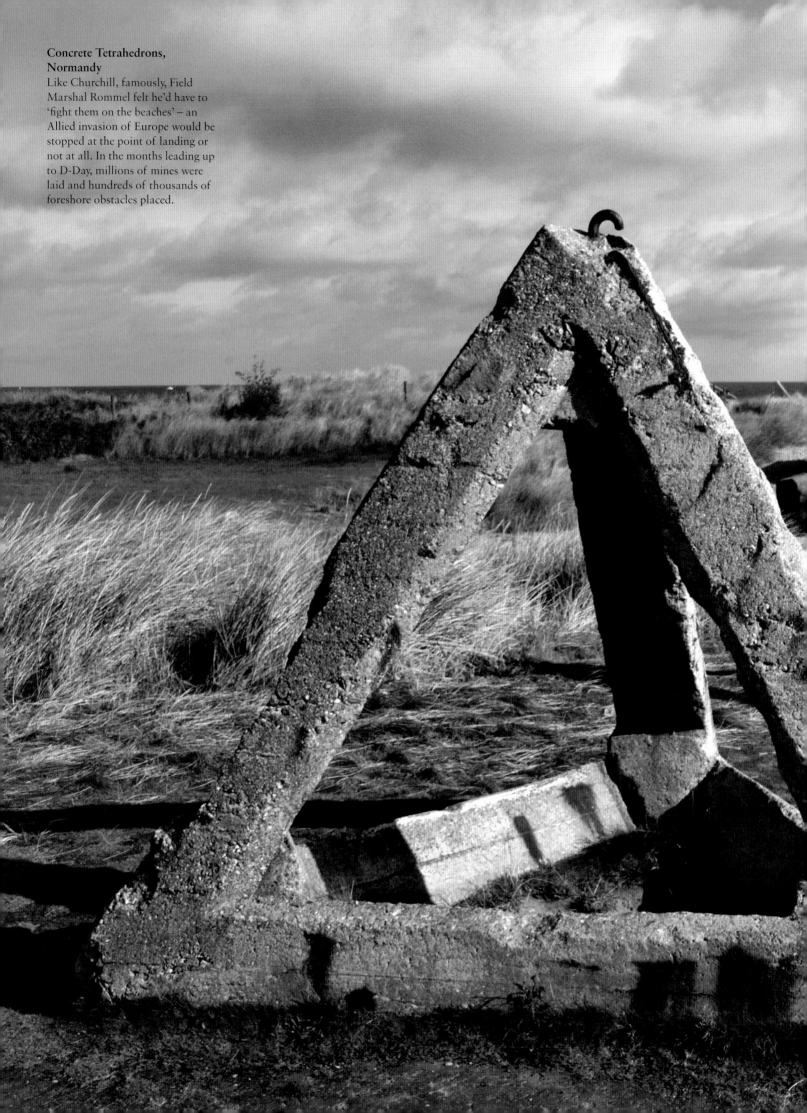

Concrete Tetrahedrons, Normandy

Like Churchill, famously, Field Marshal Rommel felt he'd have to 'fight them on the beaches' – an Allied invasion of Europe would be stopped at the point of landing or not at all. In the months leading up to D-Day, millions of mines were laid and hundreds of thousands of foreshore obstacles placed.

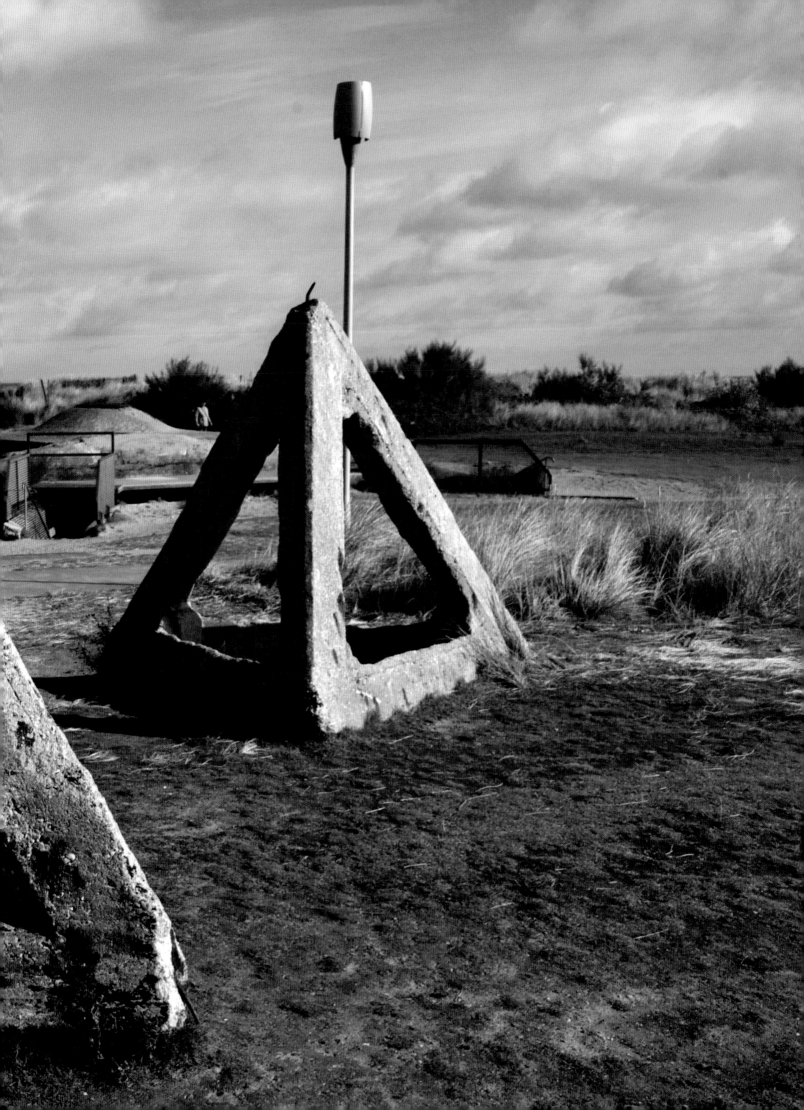

**Entrance, Ouvrage
Schoenenbourg, Bas-Rhin**

Built between 1931 and 1935, as
a key fortification of the Maginot
Line, Schoenenbourg shows both
the possibilities and the limitations
of such defences. During the
German assault of 1940, this
one fortress bore the brunt of
artillery and air bombardment,
its earth-and-concrete carapace
barely dented. Ultimately, though,
the invaders simply sidestepped
Schoenenbourg.

BELOW AND OPPOSITE:

**Corridors, Ouvrage
Schoenenbourg, Bas-Rhin**

The way the wall-grooves (for
housing piping) swerve in parallel
to duck the facing window
spaces here gives this corridor the
incongruous appearance of op art.

Several kilometres of corridors
run between the eight main blocks
of the Schoenenbourg Fortress;
the complex extends almost 30m
(100ft) below the ground. An
electric mini-railway with a gauge
of 0.6m (2ft) allowed ammunition
and equipment to be moved around
with ease.

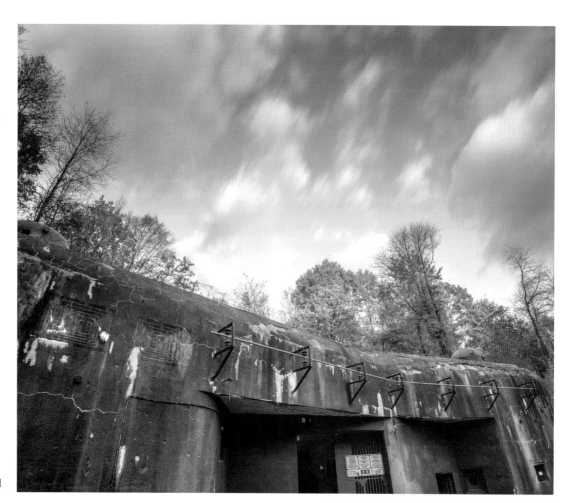

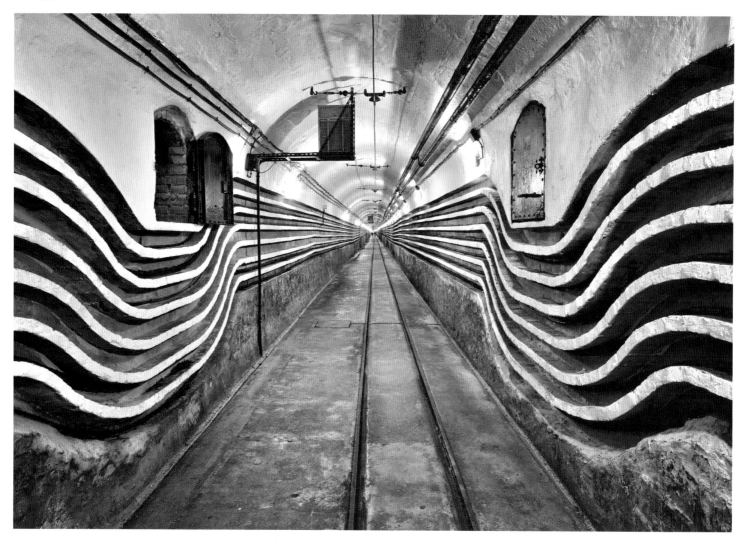

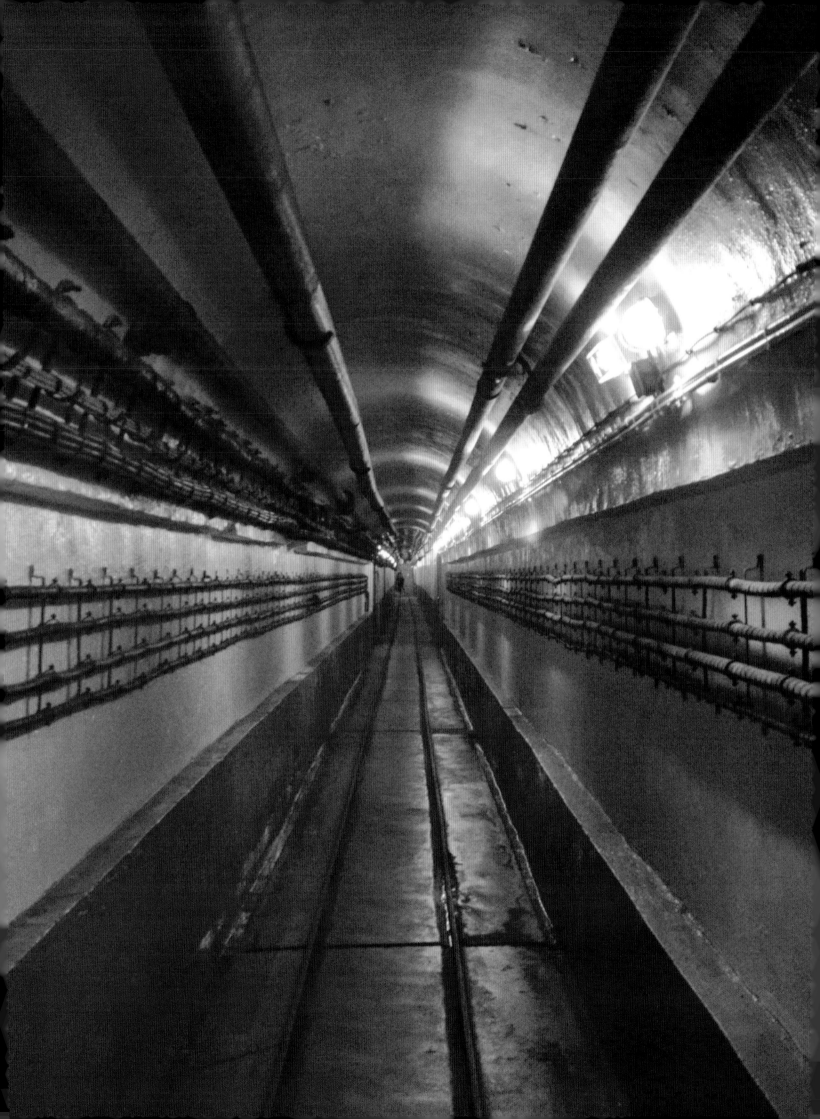

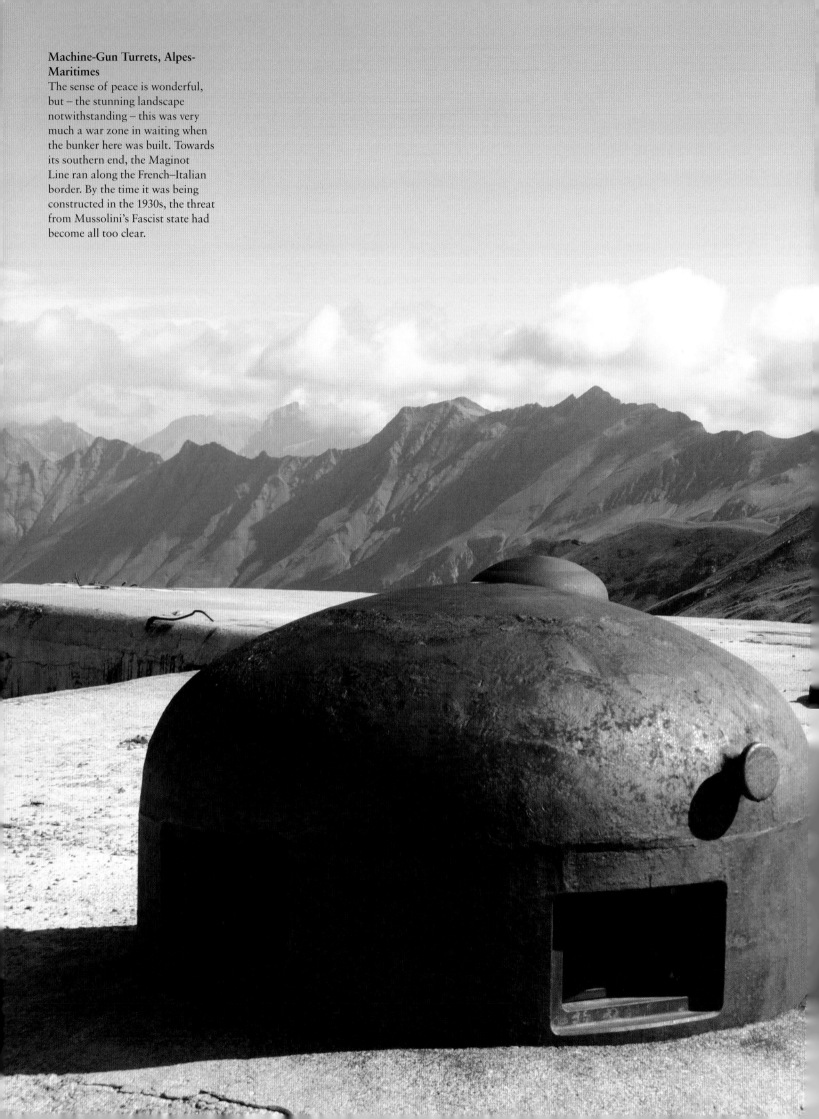

Machine-Gun Turrets, Alpes-Maritimes

The sense of peace is wonderful, but – the stunning landscape notwithstanding – this was very much a war zone in waiting when the bunker here was built. Towards its southern end, the Maginot Line ran along the French–Italian border. By the time it was being constructed in the 1930s, the threat from Mussolini's Fascist state had become all too clear.

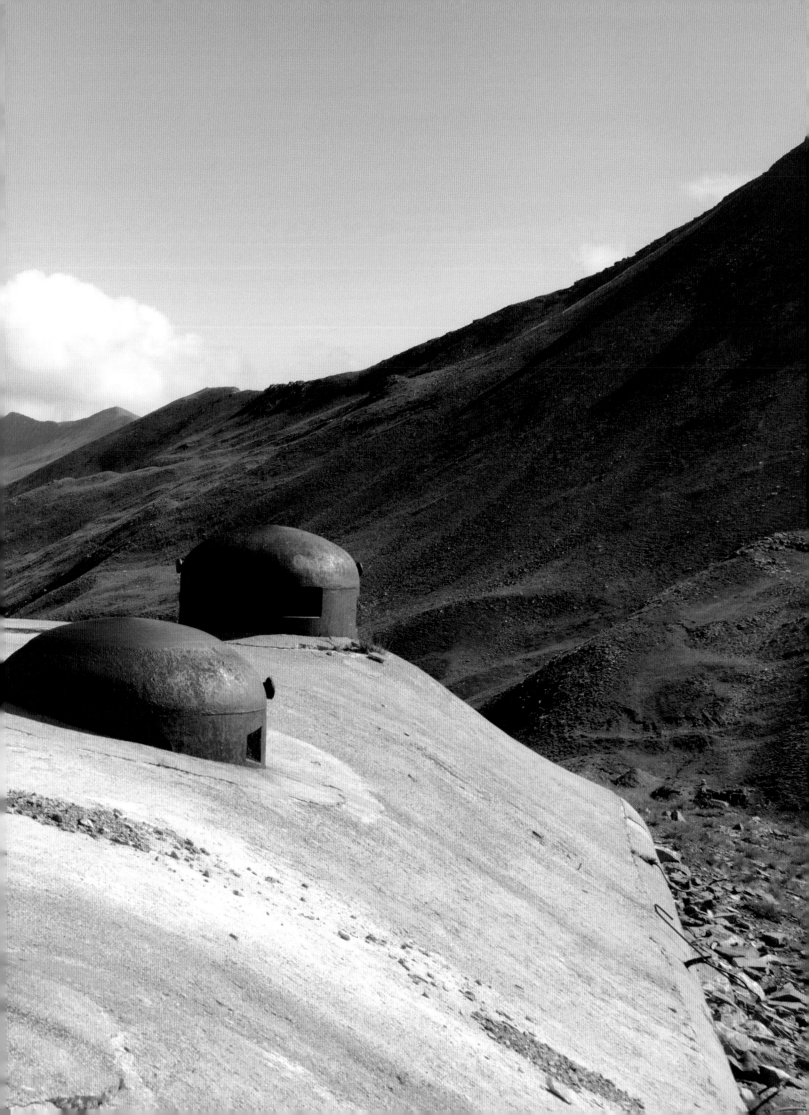

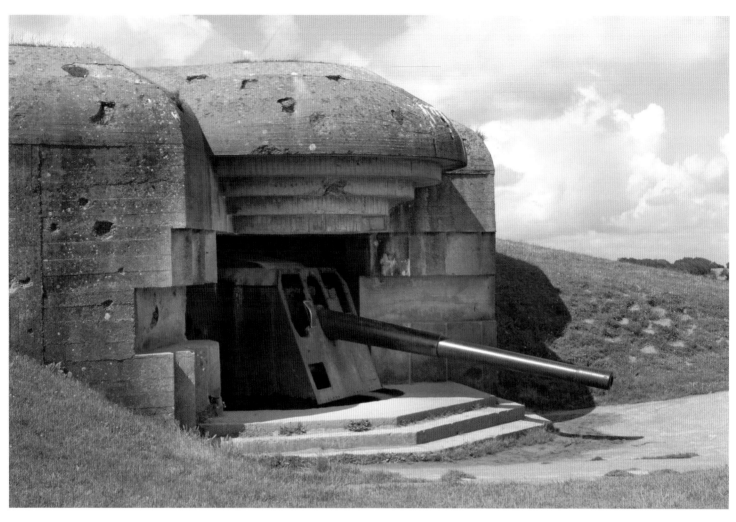

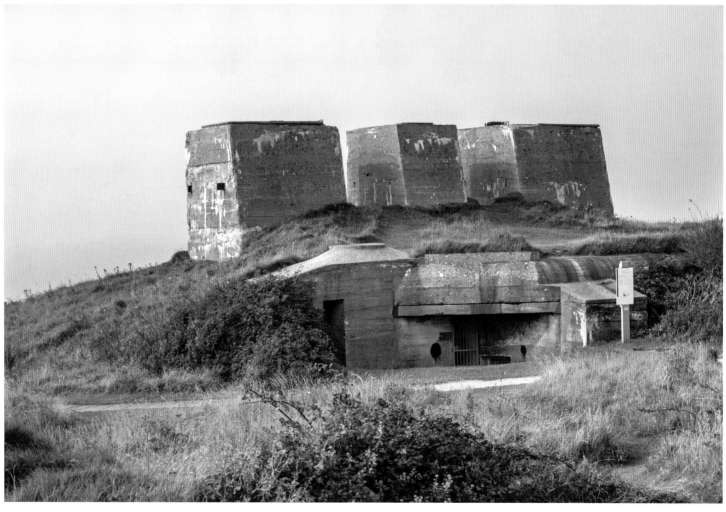

Gun Emplacement, Longues-sur-Mer, Normandy

The Germans built this battery on the Calvados coast as part of their 'Atlantic Wall' – and, when D-Day came, it did its job. Sited between the Allied landing beaches of Gold and Omaha, it withstood constant air and artillery bombardment while raining munitions down on the landing forces.

Radar Emplacement, Cap Fagnet, Normandy

Developed only at a late stage in the war, Germany's Mammut Radar system was highly sophisticated. It tracked fast-moving targets from up to 300km (180 miles) away by building up a picture from a bank of antenna-relays set side by side on a huge rectangular receiver.

Observation Tower-Bunker, Oye-Plage, Pas-de-Calais

La Tour Penchée – or the Leaning Tower of Oye-Plage – has become a well-loved landmark. Local lore has it that this construction wasn't just a lookout position but a decoy, designed to look like a church spire to Allied bomber crews, and so suggest the presence of a town.

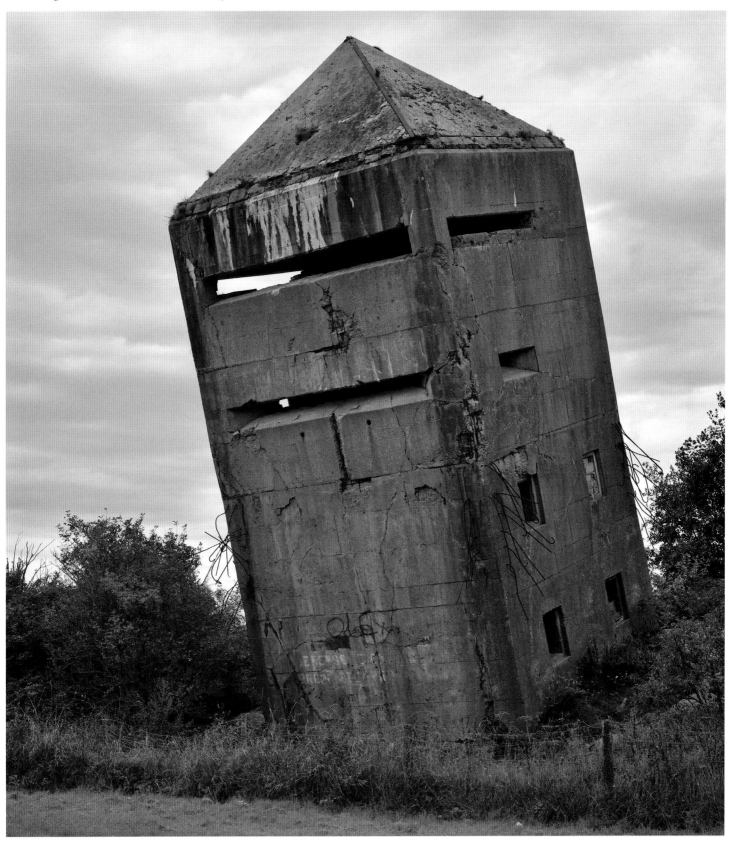

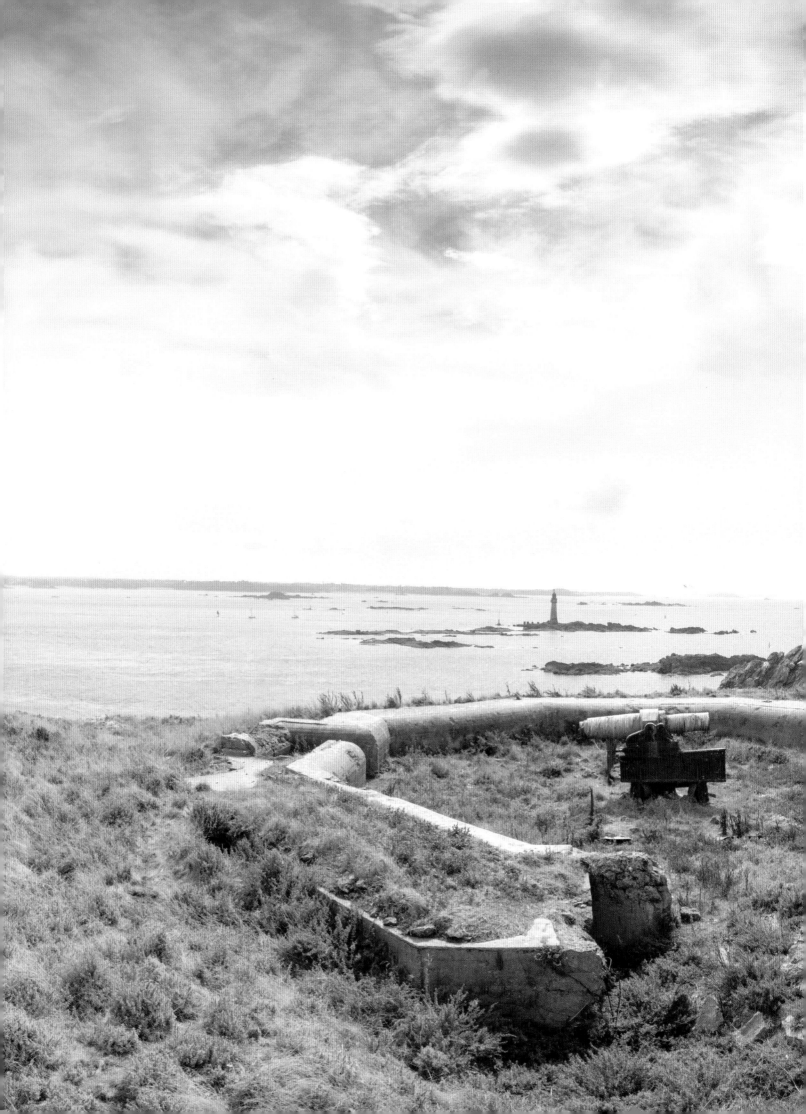

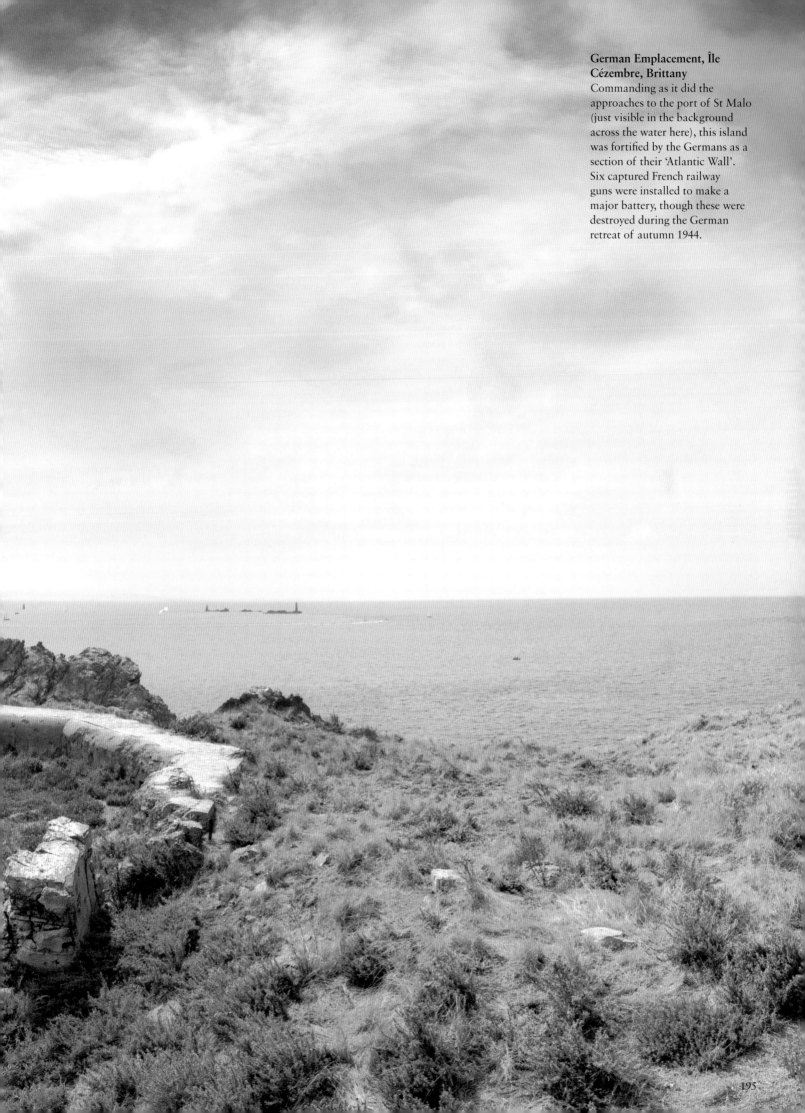

German Emplacement, Île Cézembre, Brittany
Commanding as it did the approaches to the port of St Malo (just visible in the background across the water here), this island was fortified by the Germans as a section of their 'Atlantic Wall'. Six captured French railway guns were installed to make a major battery, though these were destroyed during the German retreat of autumn 1944.

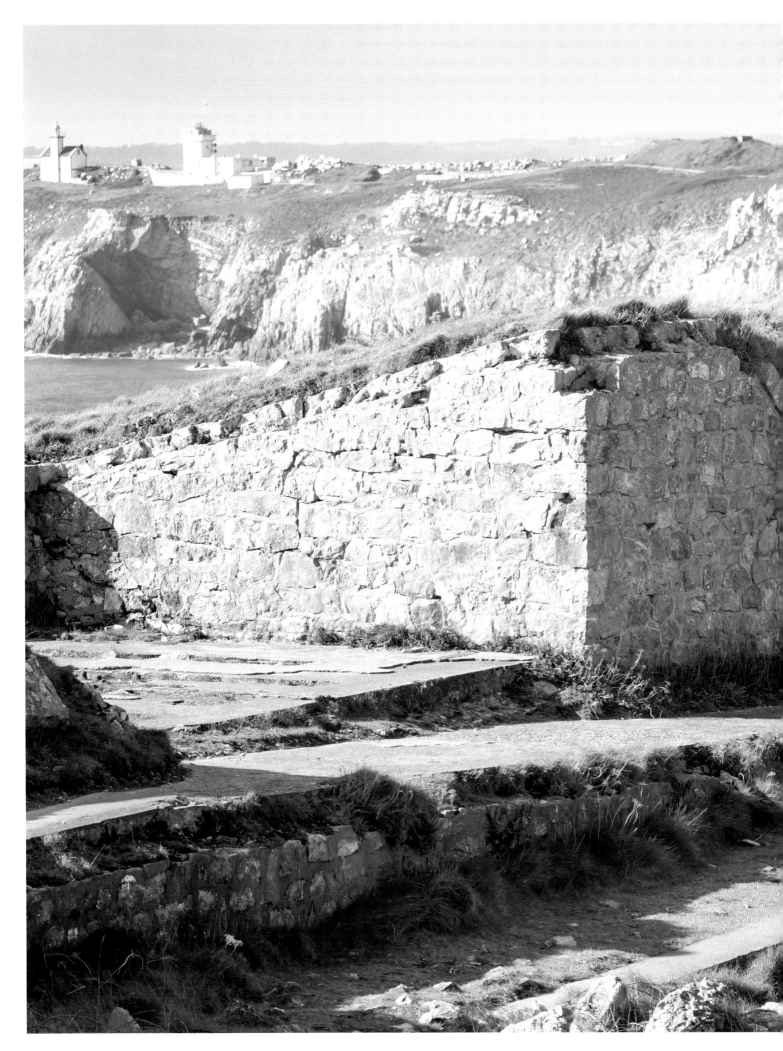

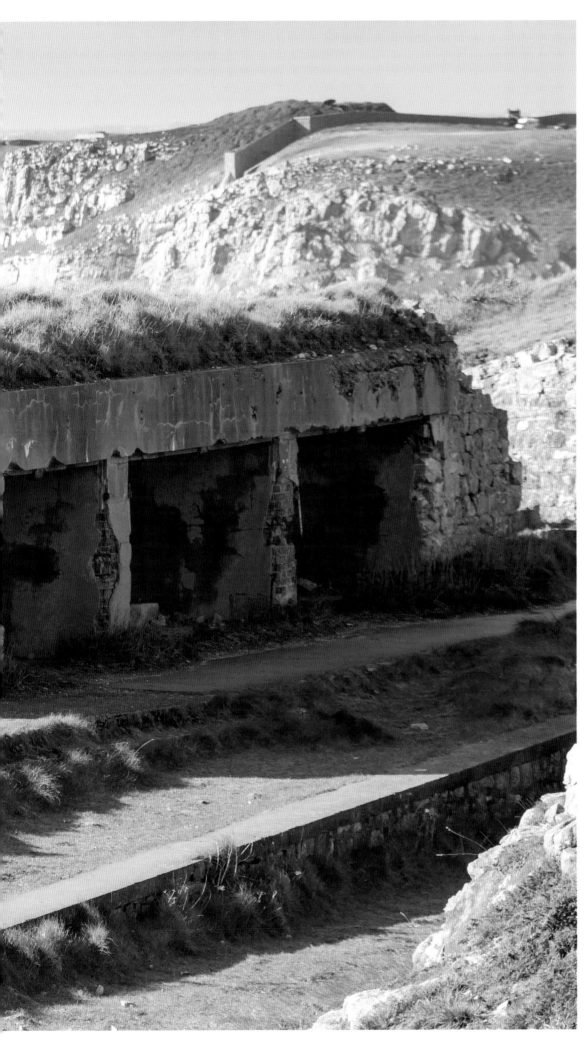

Bunker, Atlantic Coast, Brittany
In its way an awe-inspiring achievement, the Nazis' 'Atlantic Wall' also illustrates the dangers of investing in an idea that impregnability can be engineered. In the event, these colossal works were no more successful in withstanding the Allied invasion in June 1944 than France's Maginot Line had been in holding back the Germans fours earlier.

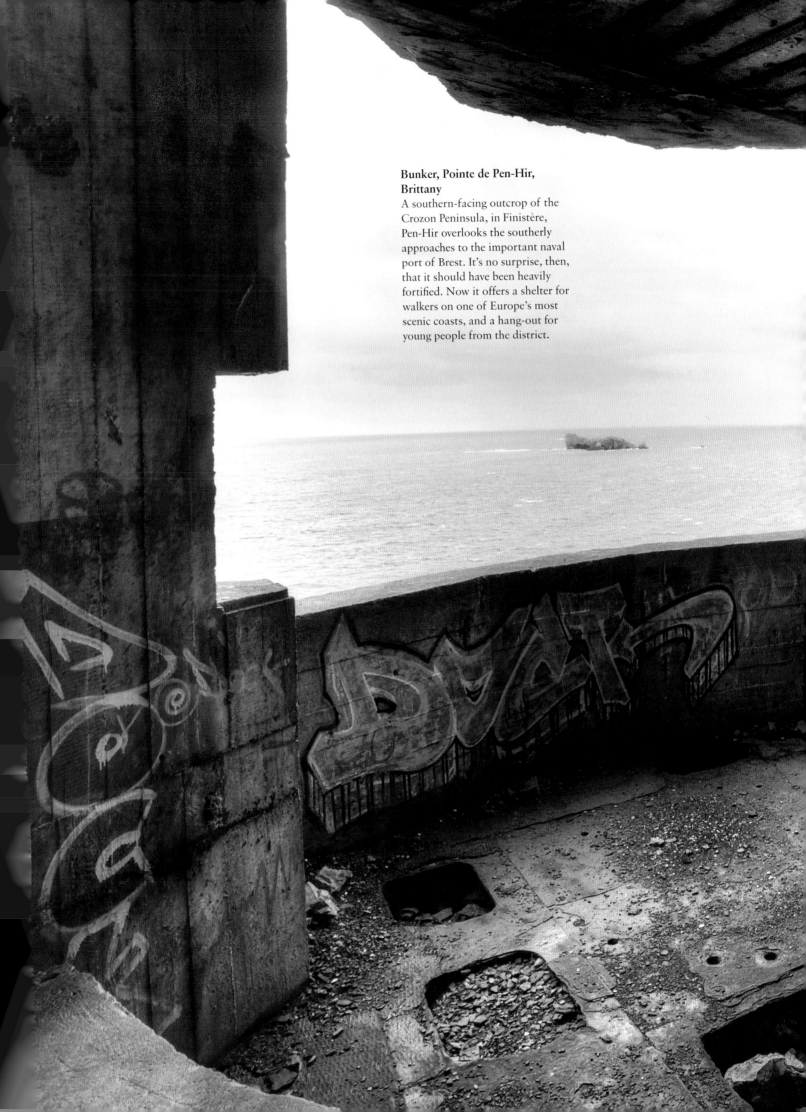

Bunker, Pointe de Pen-Hir, Brittany
A southern-facing outcrop of the Crozon Peninsula, in Finistère, Pen-Hir overlooks the southerly approaches to the important naval port of Brest. It's no surprise, then, that it should have been heavily fortified. Now it offers a shelter for walkers on one of Europe's most scenic coasts, and a hang-out for young people from the district.

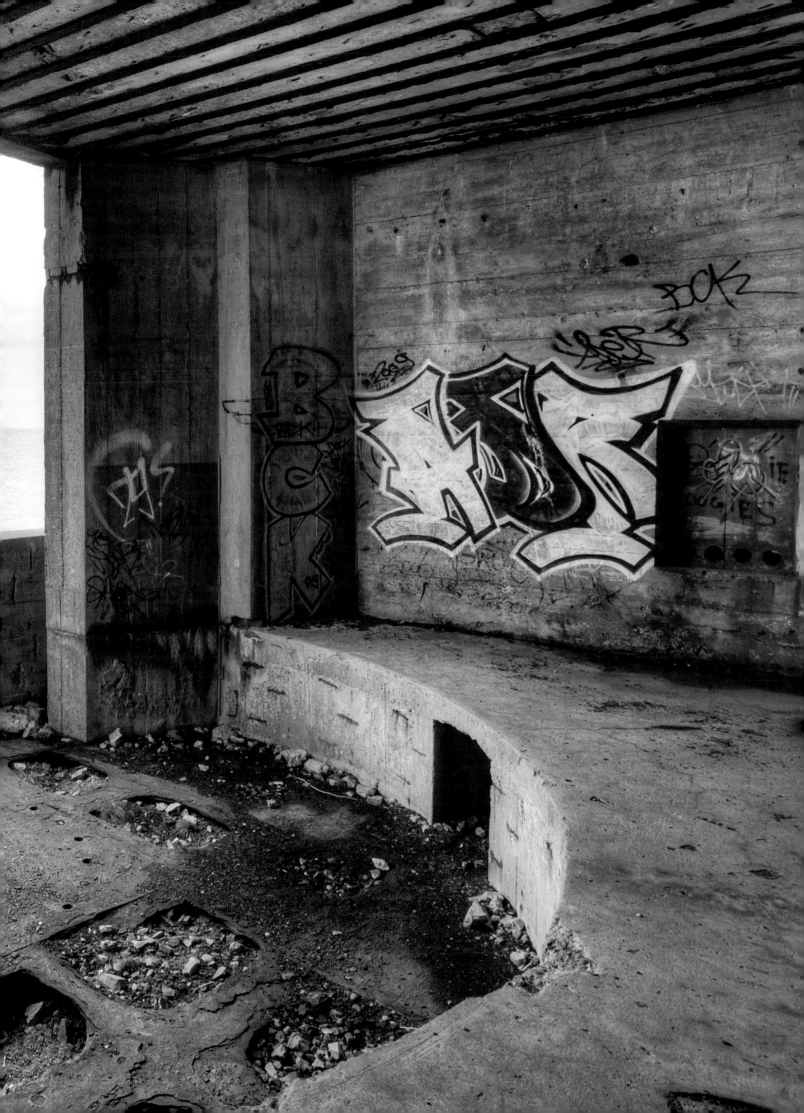

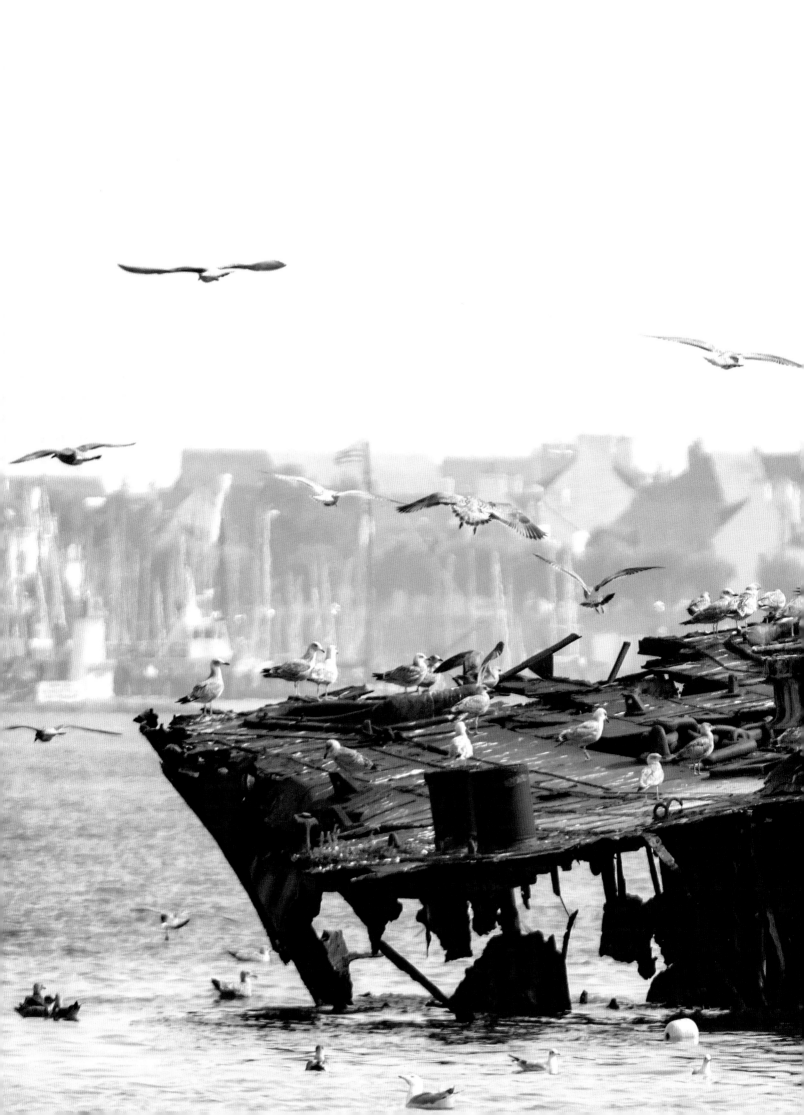

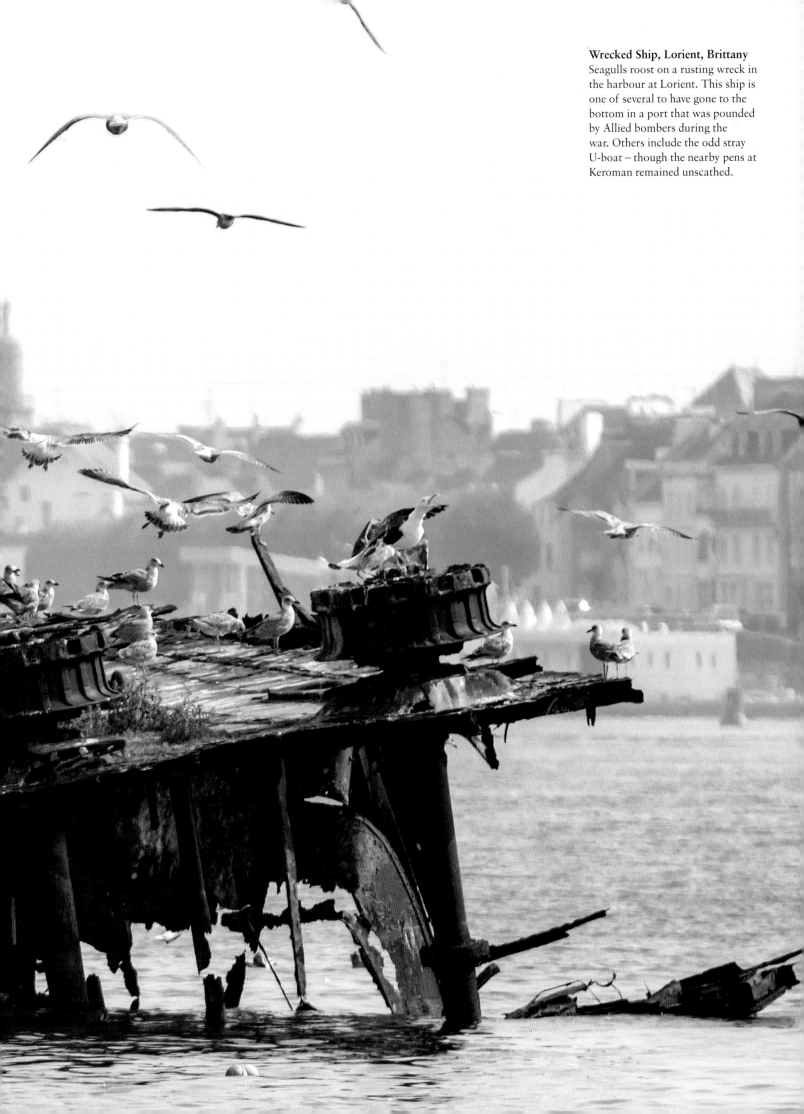

Wrecked Ship, Lorient, Brittany
Seagulls roost on a rusting wreck in the harbour at Lorient. This ship is one of several to have gone to the bottom in a port that was pounded by Allied bombers during the war. Others include the odd stray U-boat – though the nearby pens at Keroman remained unscathed.

Hitler's Bunker, Brûly-de-Pesche, Ardennes, Belgium
Its official codename *Wolfsschlucht* ('Wolf's Gorge') as colourful as its blank walls were unprepossessing, this was built for the Führer at the beginning of June 1940. Hitler made this his headquarters while his armed forces fought the Battle of France in the weeks that followed. Today it serves as an open-air museum.

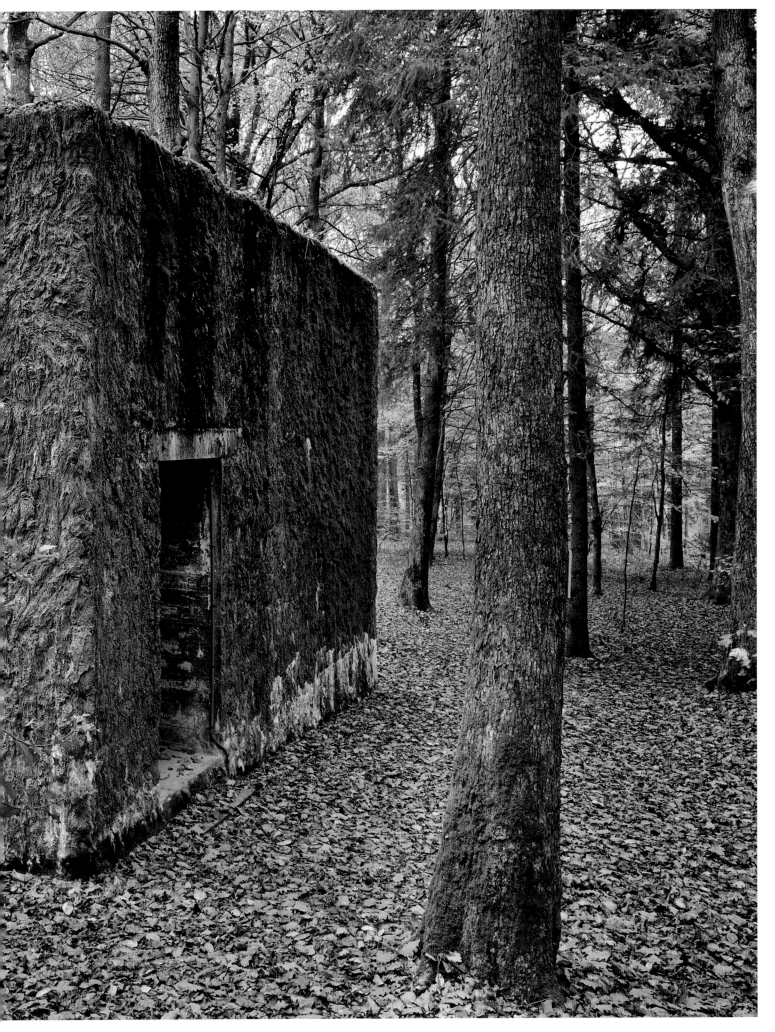

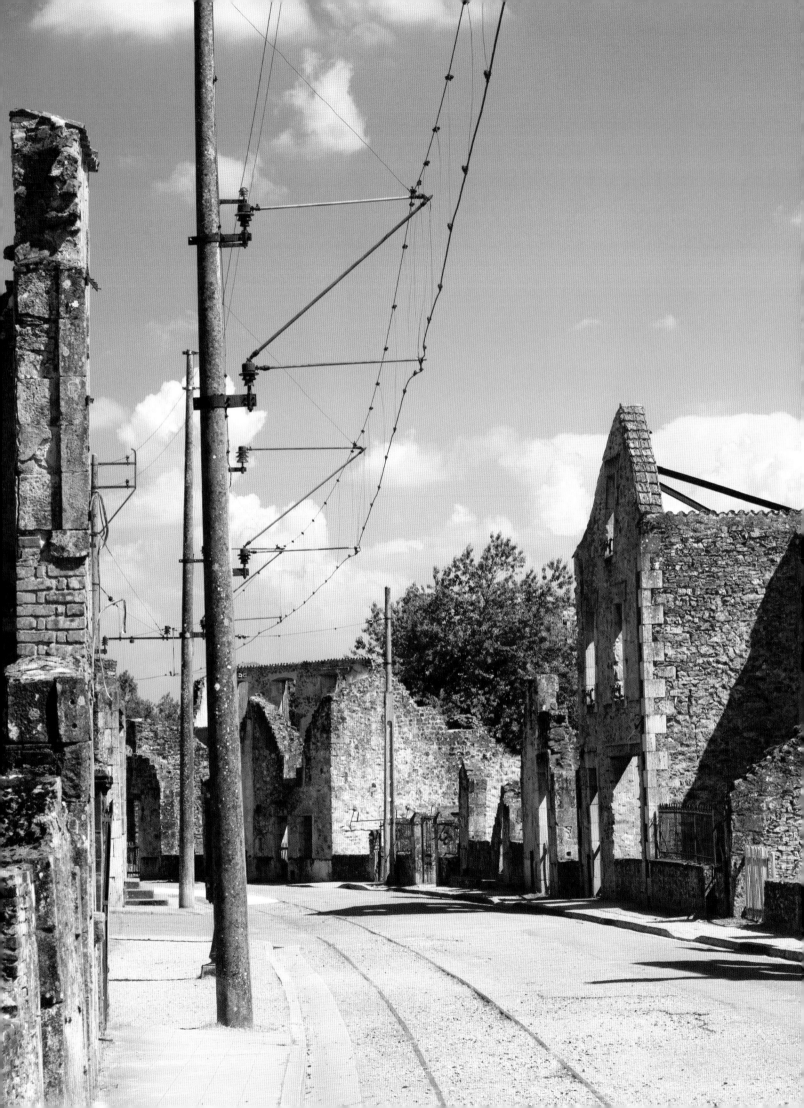

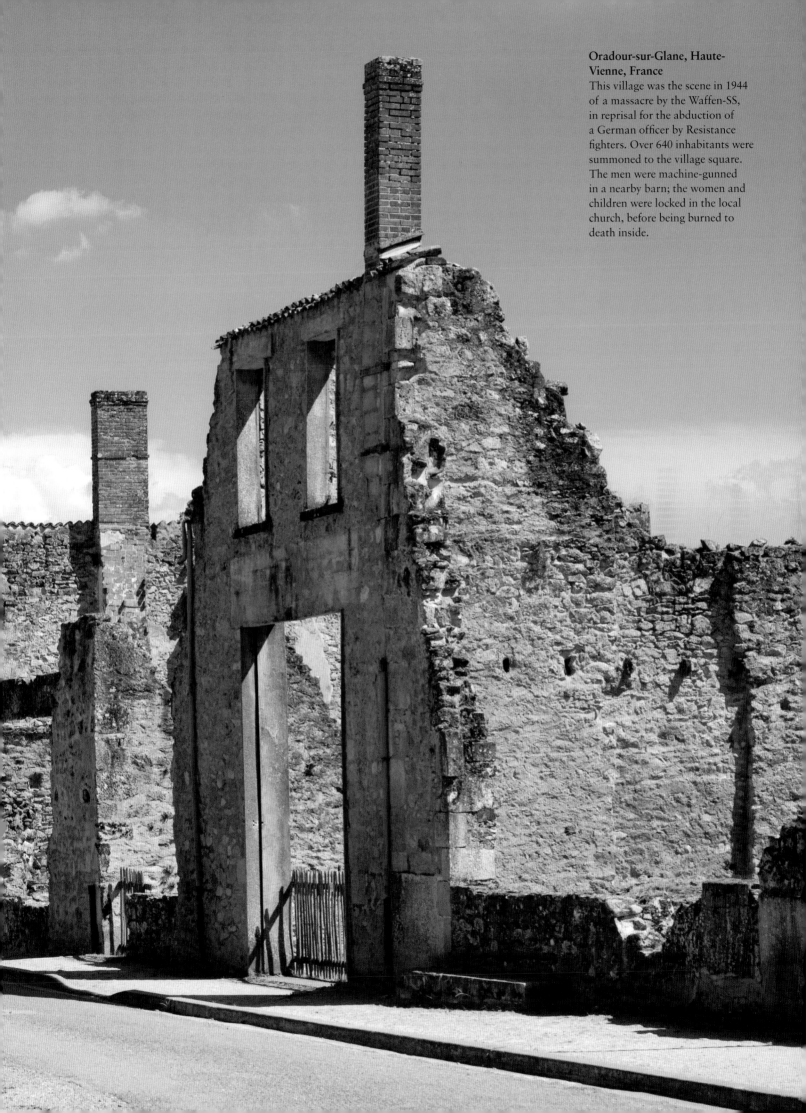

Oradour-sur-Glane, Haute-Vienne, France
This village was the scene in 1944 of a massacre by the Waffen-SS, in reprisal for the abduction of a German officer by Resistance fighters. Over 640 inhabitants were summoned to the village square. The men were machine-gunned in a nearby barn; the women and children were locked in the local church, before being burned to death inside.

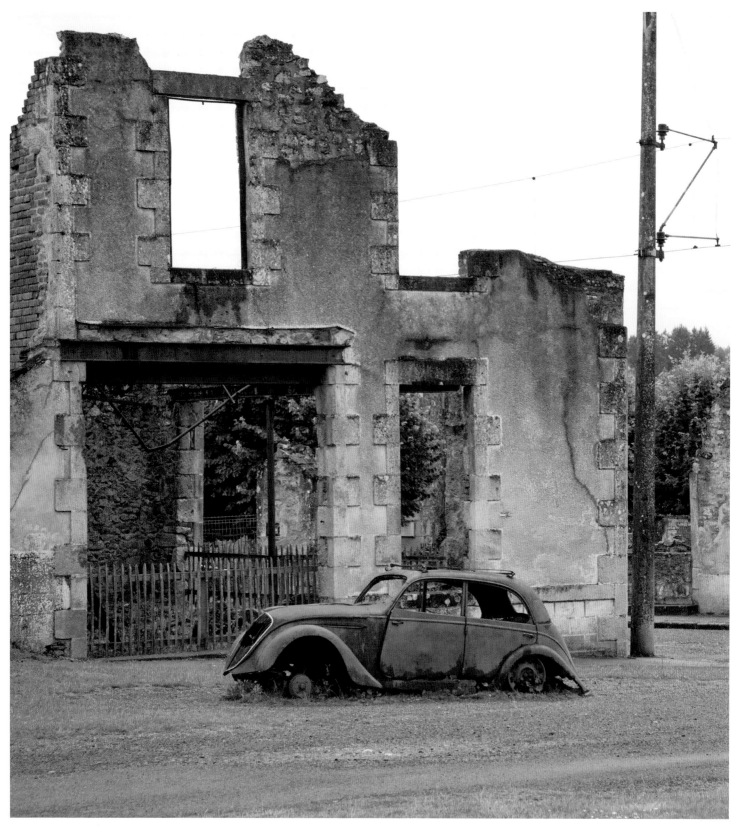

ABOVE:

Oradour-sur-Glane, Haute-Vienne, France
The sort of murderous spree that the Germans committed here may have been routine on the Eastern Front, but it broke with the comparatively civilized conventions so far followed in the West. The troops' commander, SS *Sturmbannführer* Adolf Diekmann, was to have been disciplined, but was killed in action not long after.

OPPOSITE TOP:

Oradour-sur-Glane, Haute-Vienne, France
A scene of death in vulture's-eye-view: Oradour-sur-Glane was preserved as its own memorial – and a monument to all those lost in France's resistance against the occupation.

OPPOSITE BOTTOM:

Oradour-sur-Glane, Haute-Vienne, France
Time stands still in Oradour-sur-Glane, as it has done ever since the massacre of 10 June 1944: a community and its memories preserved in amber. France was naturally shocked, and after the war was over, it was decided to leave the violated village as it was.

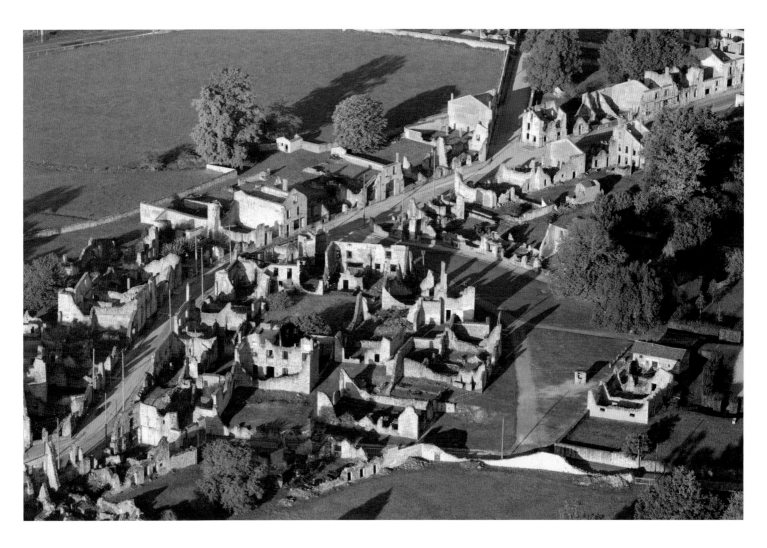

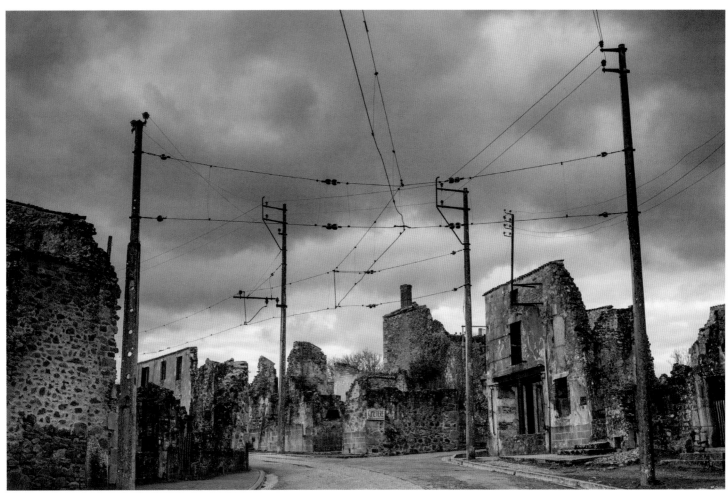

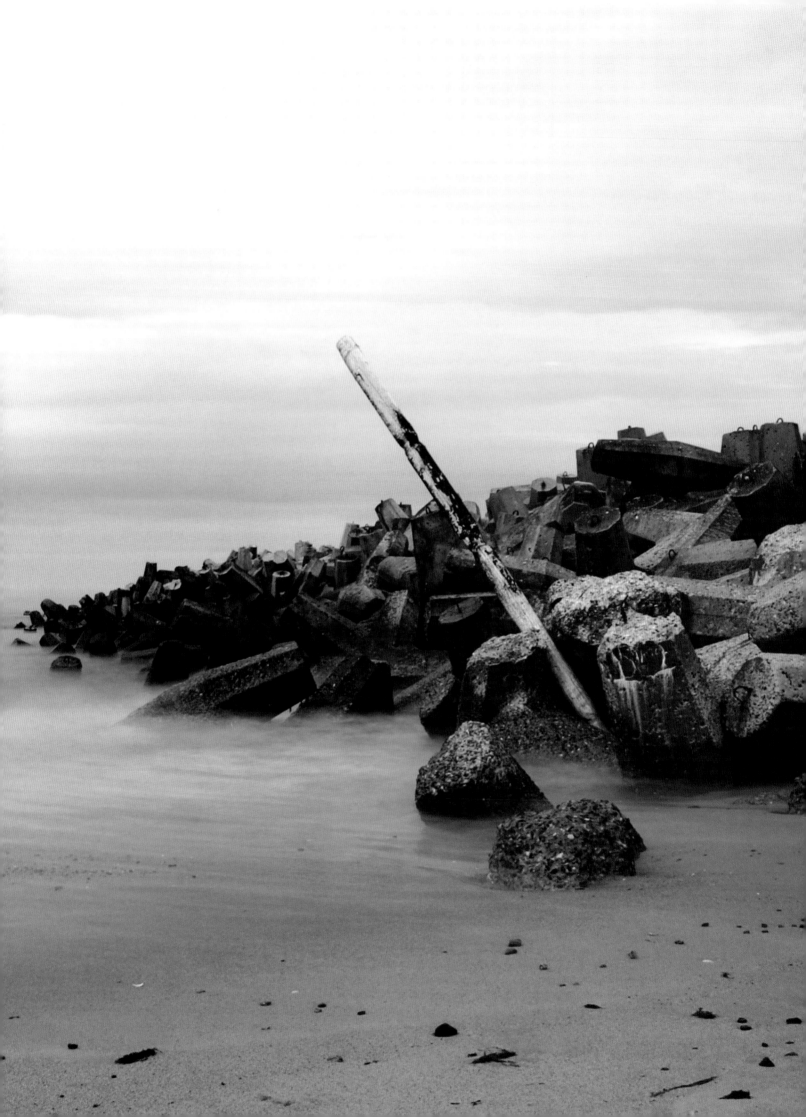

Scandinavia

Through all the diplomatic skirmishings and the military manoeuvrings of the 1930s, the Scandinavian states had stayed steadfastly aloof. Even when war was declared, they had maintained their neutrality, but the Nazis had little time for such niceties. Hitler saw in Denmark a small and effectively defenceless nation, there for the taking. And so it proved: within six hours of its invasion, on 9 April 1940, the whole country was in German hands.

It was only a stepping-stone in any case: Norway was strategically much more important, with its Atlantic outlook and its seaports offering easy access to Swedish iron ore supplies. Within two months,

Norway too was German-held. Free Norwegian forces were to occupy the Arctic island of Spitzbergen (now known as Svalbard) in 1941, but were dislodged by a German raid of 1943. Sweden succeeded in holding on to its neutrality after a fashion, though it couldn't really mean that much in the midst of all-out European war.

Iceland's neutrality went at once, Britain mounting what it saw as a pre-emptive invasion on 10 May 1940, dead-heating with the German assault on Denmark. As in Sweden, the shadow of the conflict had a penumbral presence here: though never officially at war, these countries were deeply embroiled.

LEFT:

Ruined Fortification, Jutland Coast, Denmark
At what point does a ruin cease to be a ruin and become no more than an untidy heap of stones? These concrete fragments now seem emblematic of Denmark's utter helplessness in the face of their Nazi neighbour's overwhelming strength and untrammelled aggression. Danish defence was futile from the start, and finished soon.

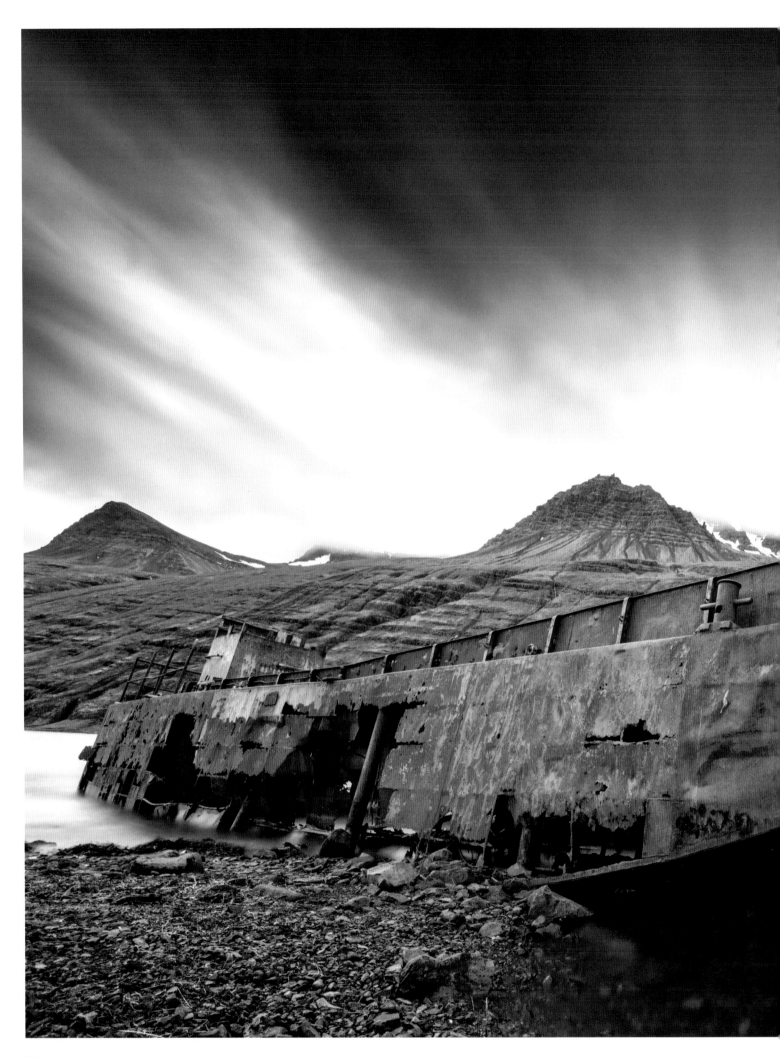

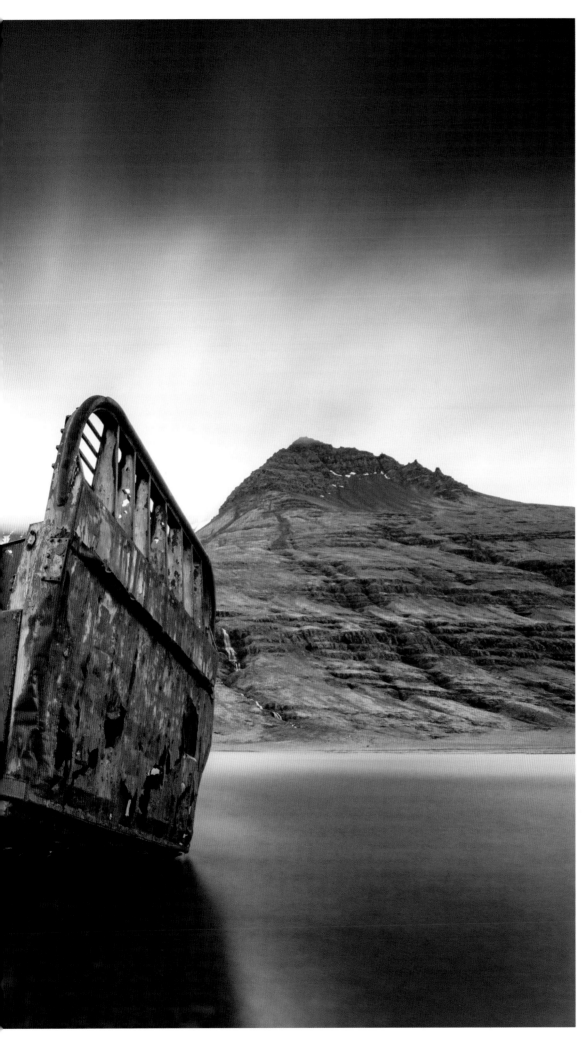

US Landing Craft, Mjoifjordur, Eastern Iceland
On 10 May 1940, Britain's little 'invasion' fleet trundled into Reykjavik Harbour like any other arrival in one of the least dramatic actions of the war. More than 700 Royal Marines took possession of the town and established the Allied base there. Iceland's subsequent handover to US administration a year later was a bureaucratic matter. This American landing craft seems to have been a post-war military-surplus purchase: it is supposed to have been used for ferrying sheep around.

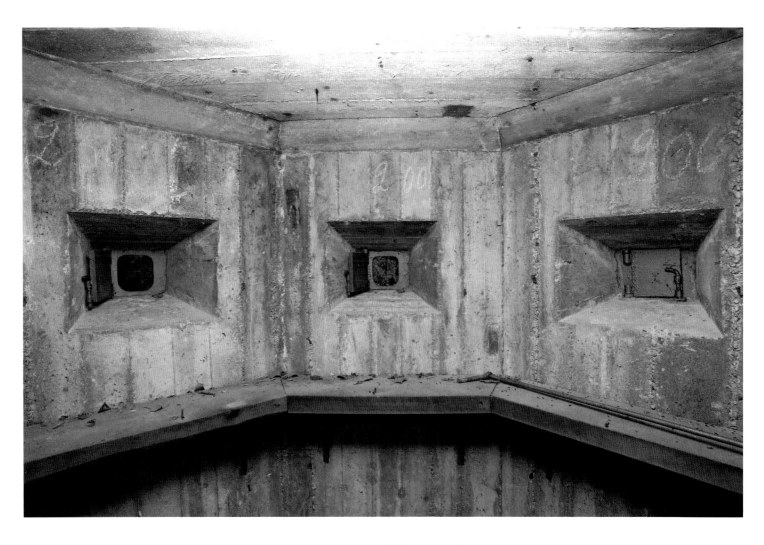

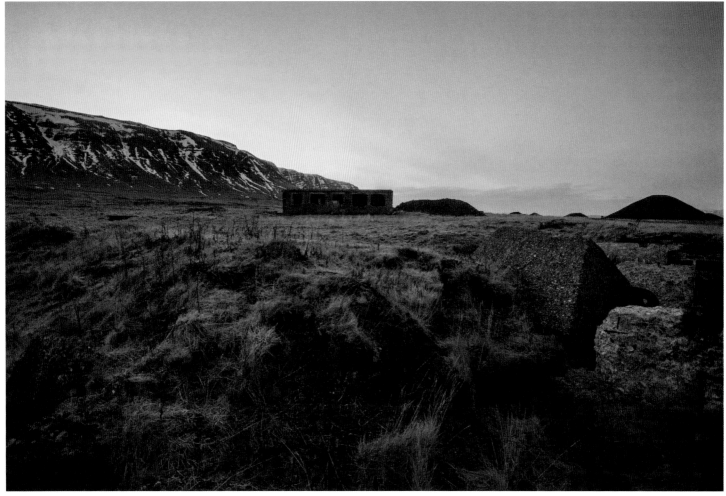

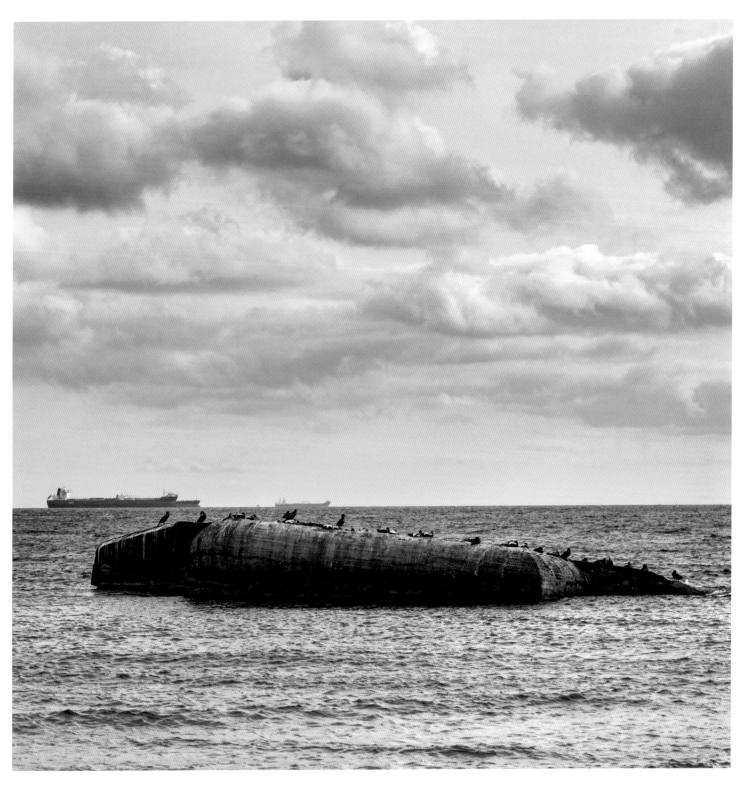

Bunker Interior, Fulunaes, Sweden

Swedes were under no illusion that their neutrality wouldn't have to be defended. In the end, they managed to keep the fighting at arm's length. That said, the compromise they made of carrying on trade with Germany – especially in the iron ore on which the Nazi war-effort so depended – has continued to be controversial to this day.

Concrete Bunker, Hvitanes, Iceland

Britain saw Iceland as key to Allied control of the North Atlantic. Hence this naval base on the country's western coast. But it never saw much action: the mere presence of British vessels here discouraged Germany from what would always have been a recklessly impracticable attempt to take possession for themselves.

Bunker, Grenen, Jutland, Denmark

Jutland's strategic importance doesn't just depend on its proximity to Norway: at its northern end, it surveys the Skagerrak and Kattegat straits, between the North and Baltic Seas. A sandbar links the Skagen Lighthouse and the tip of the Grenen Peninsula – a potential cutting of the corner. This heavily armoured bunker barred the way.

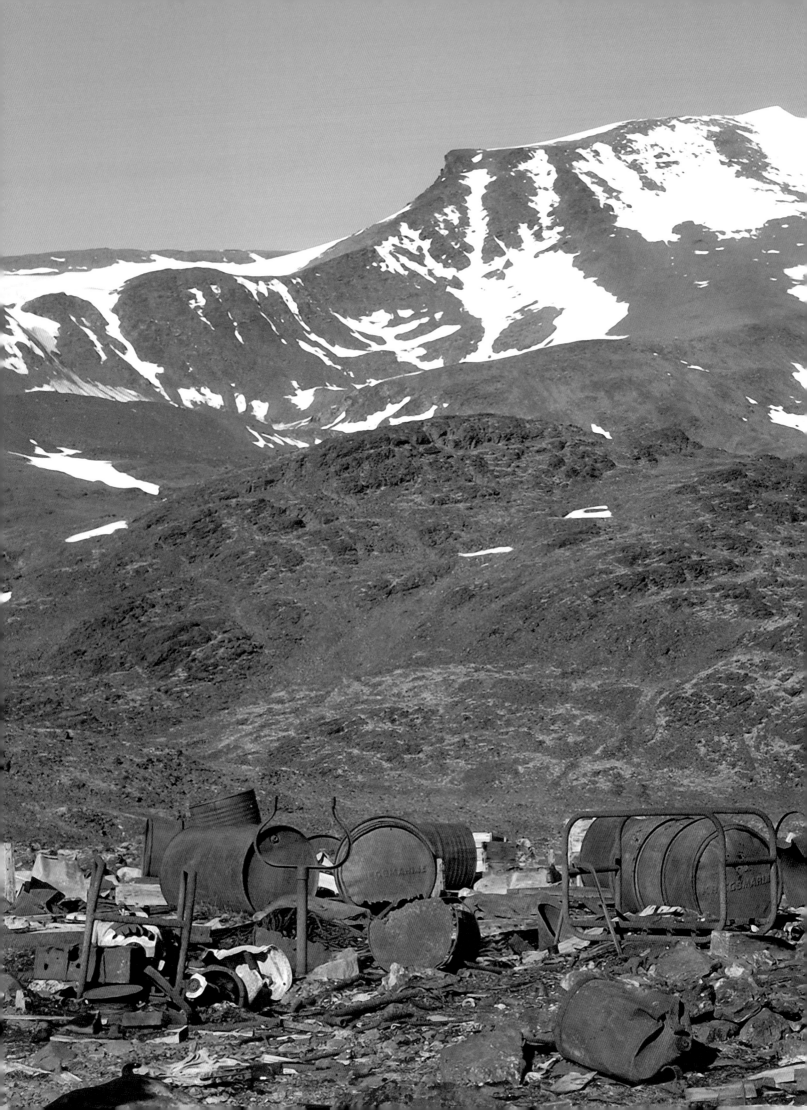

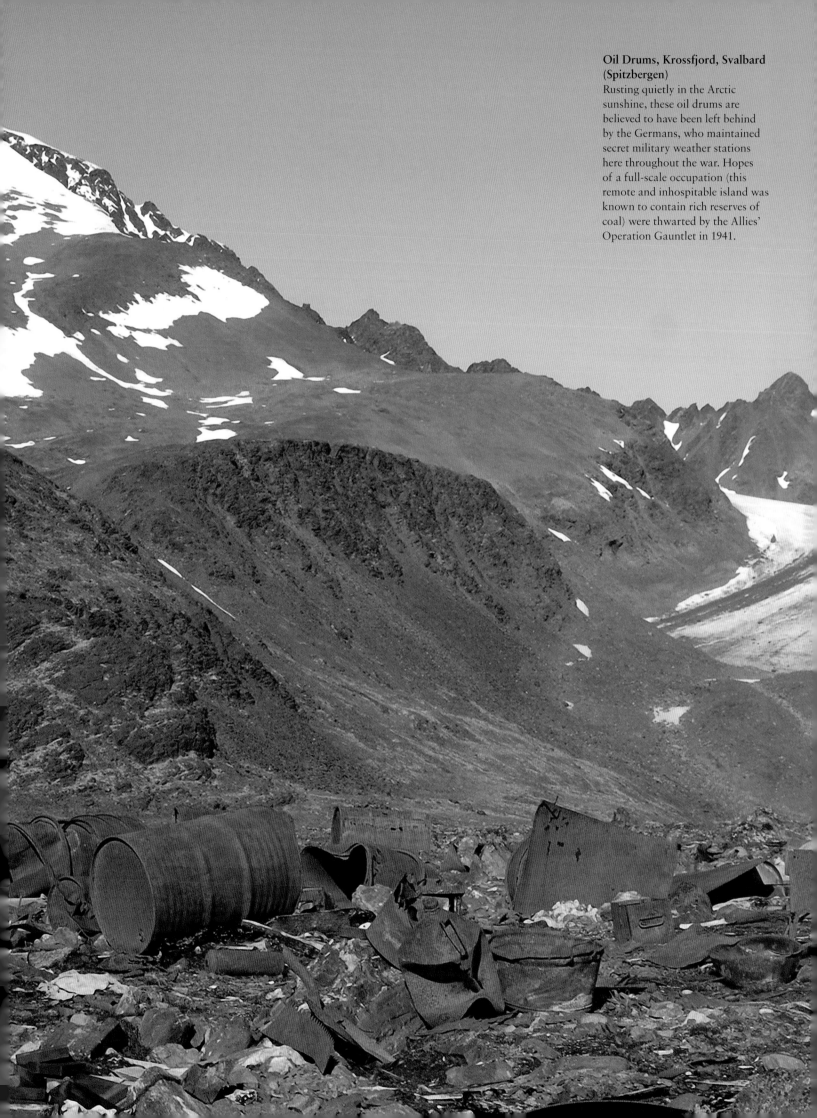

Oil Drums, Krossfjord, Svalbard (Spitzbergen)
Rusting quietly in the Arctic sunshine, these oil drums are believed to have been left behind by the Germans, who maintained secret military weather stations here throughout the war. Hopes of a full-scale occupation (this remote and inhospitable island was known to contain rich reserves of coal) were thwarted by the Allies' Operation Gauntlet in 1941.

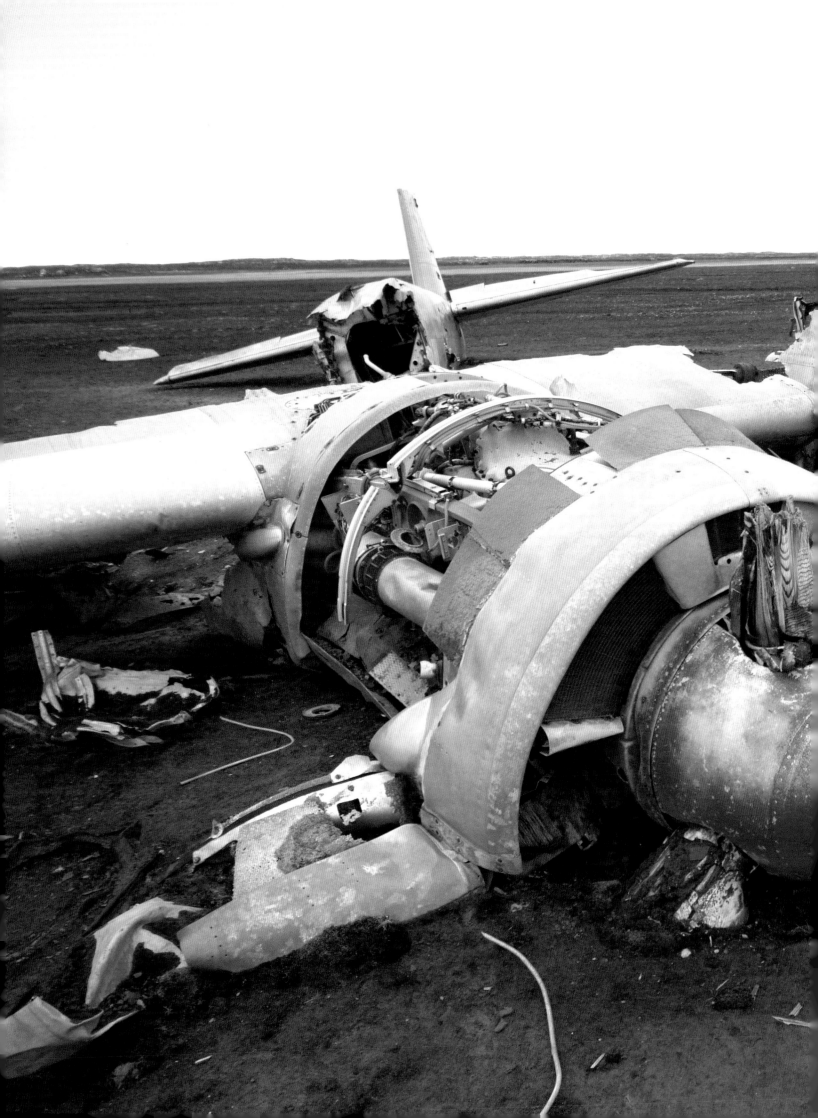

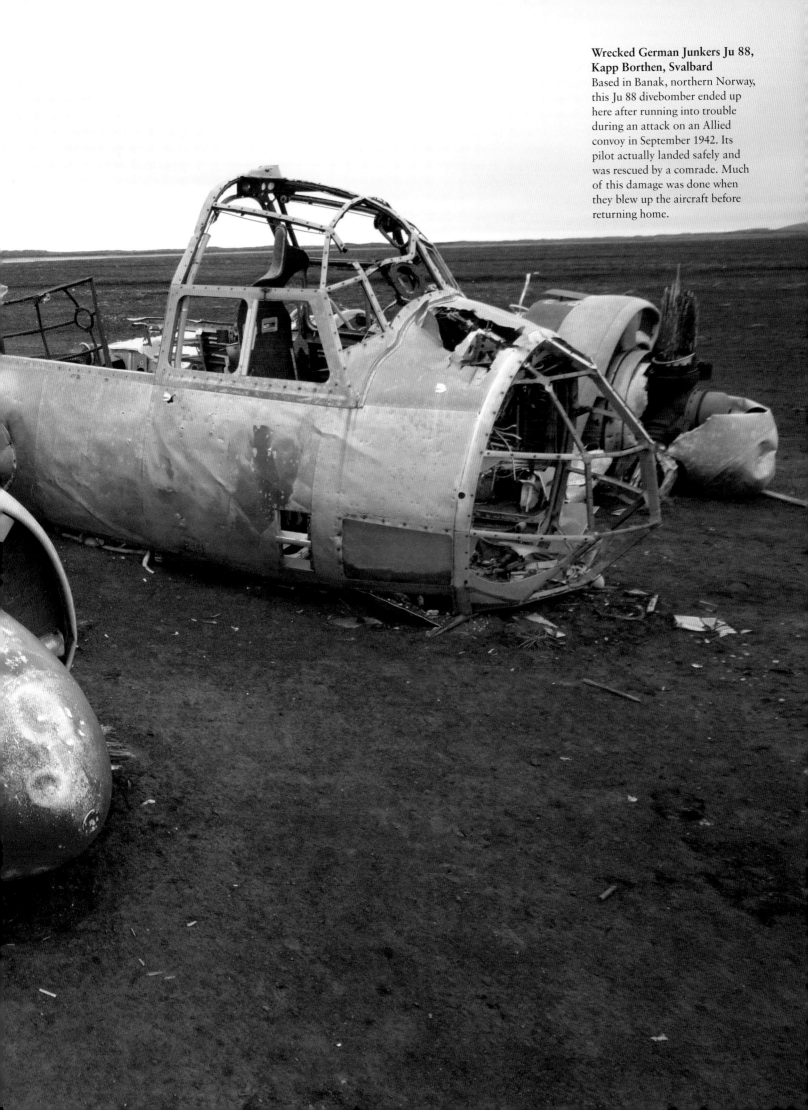

**Wrecked German Junkers Ju 88,
Kapp Borthen, Svalbard**
Based in Banak, northern Norway,
this Ju 88 divebomber ended up
here after running into trouble
during an attack on an Allied
convoy in September 1942. Its
pilot actually landed safely and
was rescued by a comrade. Much
of this damage was done when
they blew up the aircraft before
returning home.

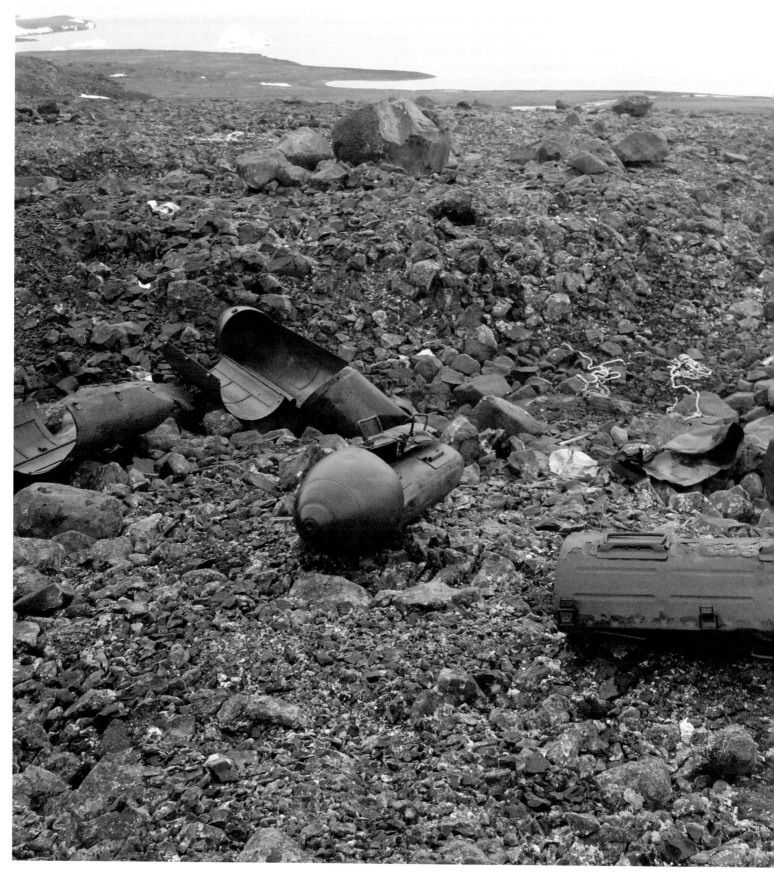

Traces of German Weather Station Schatzgrabber, Alexandra Land, Franz Josef Land
The warring parties struggled to secure any kind of edge they could, in meteorology as in other areas. Indeed, in the Allies' attempts to supply the Soviets through the Arctic Convoys – and the Germans' to frustrate them – weather forecasting could be crucial. Established in 1943, the 'Schatzgrabber' ('Treasure Hunter') station was evacuated the following year.

**Remains of German Weather
Station Knospe, Svalbard**

Oil drums and other detritus
litter the shore at Knospe, on the
Signehamna – a sheltered bay on
the northern side of the Krossfjord,
in the far northwest of Svalbard.
Established in 1941, this secret
weather station was discovered by
the Allies and had to be abandoned
in 1942. Another, 'Nussbaum', was
established not far away.

**Remains of German Weather
Station Nussbaum, Svalbard**

RIGHT:

A notebook and old coffee cup are
among the treasures to be found
among the destroyed remains of
louvred wooden cabinet doors.

OPPOSITE TOP:

These cast-off cans stretch our
sense of what's historic to the very
limit: the shores of the Signehamna
look like a rubbish dump.

OPPOSITE BOTTOM:

A smashed-up radio. It would have
been used to relay daily bulletins
for the benefit of the German
U-boats harrying the Allied Arctic
convoys heading for Soviet Russia.

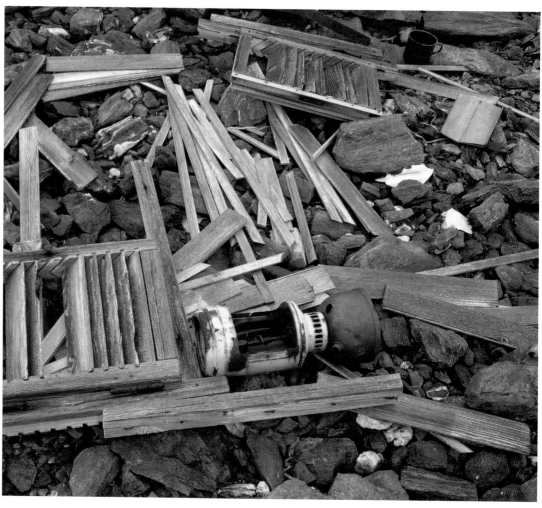

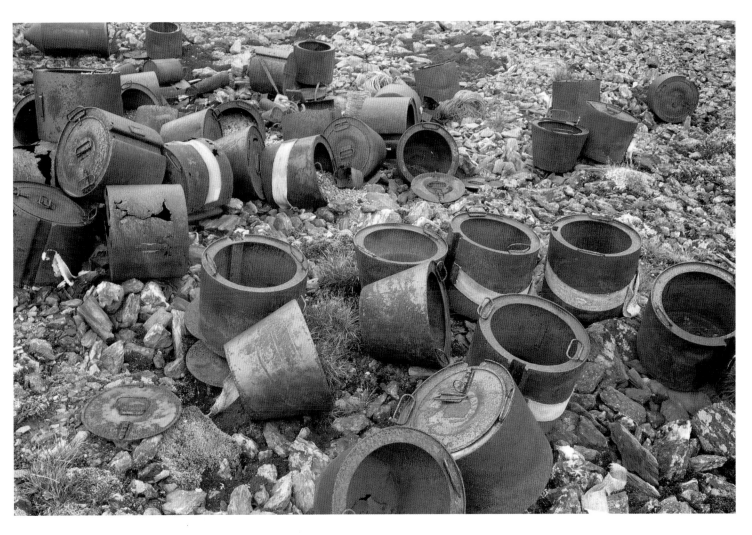

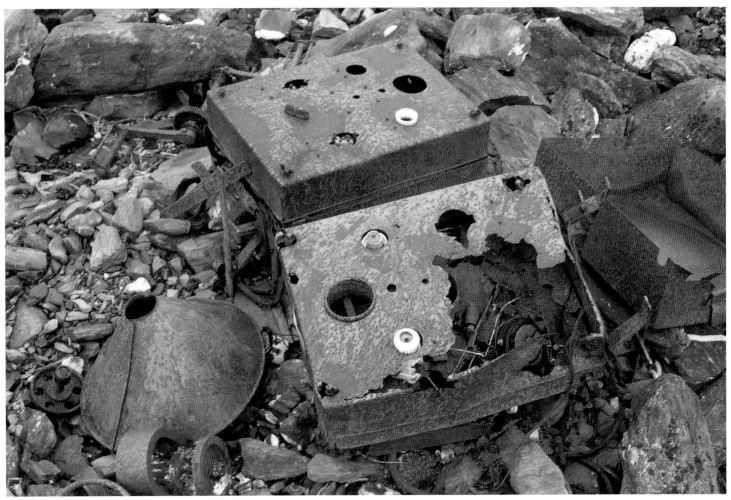

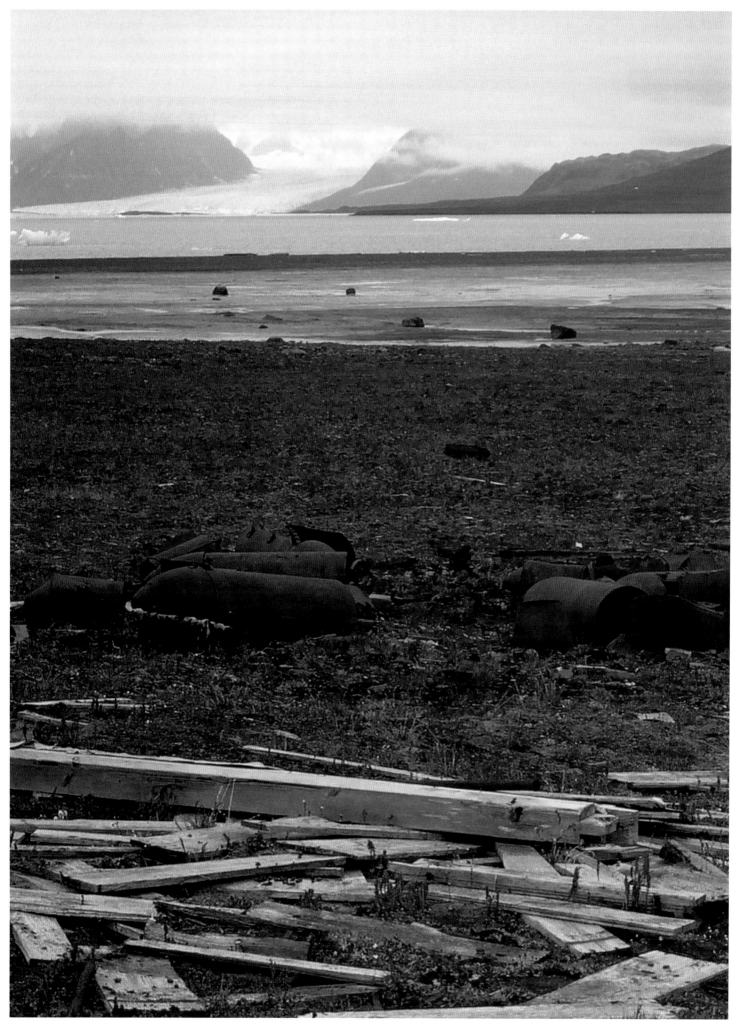

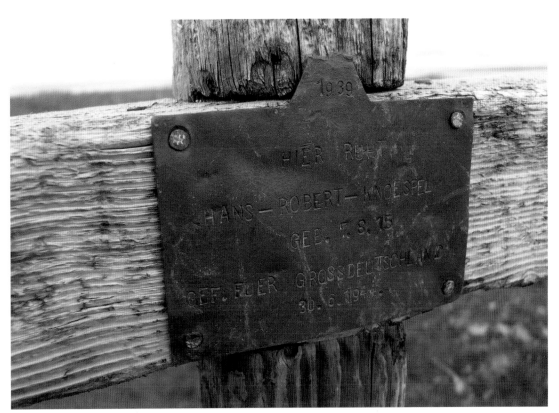

OPPOSITE:

Remains of German Weather Station Kreuzritter, Svalbard
Northeast of the Signehamna, beside the Liefdefjord, another secret weather station was operational 1942–44. Its crew had a chilly time of it, their prefabricated wooden hut being inadequate for winter conditions this far north. In summer, meanwhile, they had to adjourn to a more easily hidden camp some way inland.

LEFT AND BELOW:

Grave, German Weather Station Kreuzritter, Svalbard
Kreuzritter's crew were to be picked up by a U-boat in the summer of 1944. Their commander, Hans Robert Knoepsel, died the day before departure. They had mined a nearby hut to prevent its use by enemy attackers and Knoepsel feared their rescuers might be hurt. He was killed by a blast when he tried to make it safe.

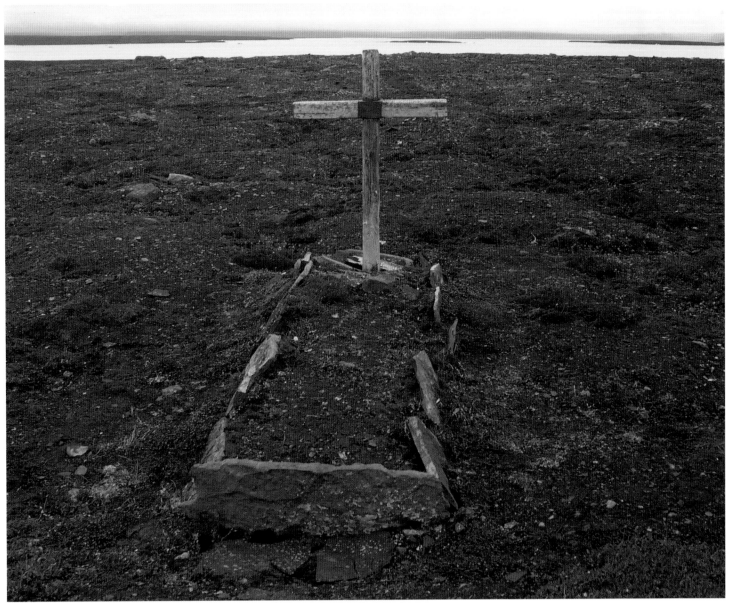

Picture Credits

Alamy: 6 (Amanda Ahn), 7 (Hercules Milas), 11 (John Cairns), 14/15 (Matthias Naumann), 16 (Tony Roddam), 17 both (David Crossland), 24 (JLBvdWOLF), 25 (Bildarchiv Monheim GmbH/Schutze Rodmann), 26/27 (Juergen Hanel), 30/31 (Latitude Stock/Nadia McKenzie), 32/33 (Charles Lupica), 38/39 (Radek Detinsky), 40/41 (Guy Corbishley), 42/43 (Milosz Guzowski), 48 bottom (Christian Kober), 64–65 both (John Zada), 70–71 both (Hagai Nativ), 74/75 (Hercules Milas), 82–83 all (Ferdinando Piezzi), 84/85 (Michael Runkel), 88/89 (Innovation Works UK), 94/95 (National Geographic Creative/Pete Ryan), 98 both (Bjarki Reyr), 99 (RWP Photography/Rick Pisio), 100 (Jaime Boddoff), 101 (David Litschel), 102/103 (Frontline Photography), 106/107 (National Geographic Creative/David Doubilet), 108/109 (Jon Bilous), 110 (Roseanne Tackaberry), 118 top (Tengku Mohd Yusof), 118 bottom (Roseanne Tackaberry), 119 top (Paul Rushton), 125 (dbimages/Derek Brown), 126/127 (Amanda Ahn), 132/133 (Waterframe), 142 top (Travelpix), 142 bottom (Hemis/Vincent Provos), 143 (Rweisswald), 150/151 (Roj Whitelock), 154/155 (Camillo Berenos), 156/157 (Simon Price), 162/163 (Paul Morgan), 164 (Grant Kennedy), 165 (Loop Images/Jason Friend), 166/167 (Adam Burton), 168/169 (Anthony Hatley), 172 top (Stephen Dorey), 173 top (Sally Anderson), 173 bottom (Tom Watson), 174/175 (mvlampila), 176/177 (Rik Hamilton), 180/181 & 182/183 (Claude Thibault), 188 top (Robert Harding/Andreas Brandl), 189 bottom (Didier Zylberyng), 190/191 (Chris Helier), 192 bottom & 193 (Arterra Picture Library/Phillippe Clement), 198/199 (Cyrille Gibot), 202/203 (Arterra Picture Library/Phillippe Clement), 207 top (Aerialphotos.com), 207 bottom (fStop Images/Brian Caissie), 212 bottom (Stephen Taylor), 214/215 (Agenja Fotograficzna Caro/Kaiser)

Professor Eckart Dege: 220–223 all

Dreamstime: 10 (M. Janic) 12/13 (Salih Kulcu), 18/19 & 20/21(Johannes Hansen), 28/29 (Rudmer Zwerver), 34/35 & 36/37 (Stanislav Riha), 44 both (Dmytro Tolmachov), 46/47 (Scorpionpl), 48 top & 49 bottom (Artenex), 52/53 (Teine), 54/55 (Foto280), 56/57 (Elteq5), 58 (Alexey Zarubin), 59 top (Lehakok), 59 bottom (Sergey Grishin), 60/61 (Eugene Seergeev), 68/69 (Stephen Kerhofs), 72/73 (Mkos83), 76 (Adriano Castelli), 77 both (Pavio Allukh), 78/79 (Alberto Masnovo), 80/81 (Antares614), 86–87 both (Grobler Du Preez), 90/91 (David Herraez), 104/105 (JLMphotos), 112/113 (Derek Rogers), 114/115 (Anthonyata), 119 bottom (Seaonweb), 130/131 (Meisterphotos), 159 top (Roy Pederson), 159 bottom (Helen Hotson), 170 (Bobbrooky), 170/171 (Lorna), 178 (Imladris), 189 (Louis-Martin Carriere), 192 top (Photowitch), 194/195 (Piccaya), 196/197 (Fernbach Antal), 200/201 (Bidouze Stephane), 206 (Trouvail), 208 (Heizfrosch), 210/211 (Andrew Deer), 212 top (Johannes Hansen), 213 (Frank Bach), 216/217 (Erectus)

Fotolia: 204/205 (Caravia)

Getty Images: 8 (Walter Bibikow), 22/23 (Mmac72), 45 (Danita Delimont), 49 top (Christian Kober), 62 (National Geographic Magazines/Andy Mann), 92 (Design Pics/Patrick Endres), 96/97 (Lonely Planet Images/Matthew M. Schoenfelder), 116/117 (Universal Images Group/Auscape), 120/121 (Photolibrary/Walter Bibikow), 122/123 (Corbis/Bernard Radvaner), 124 (Universal Images Group/Auscape), 134/135 (Lonely Planet Images/John Elk III), 136/137 (National Geographic/Jason Edwards), 138/139 (Perspectives/David Kirkland), 140/141 (Lonely Planet Images/John Borthwick), 144/145 (Adam Horwood), 146/147 (Nature Picture Library/Michael Pitts), 148/149 (Lonely Planet Images/Travelgame), 152/153 (Moment/ R. A. Kearton), 160/161 (Barcroft Media), 171 (Oxford Scientific/Simon Butterworth), 172 bottom (Image Broker/Paul Mayall), 184/185 (Design Pics/Guy Heitmann), 186/187 (National Geographic/O. Louis Mazzatenta)

Janericloebe: 50–51 all

Yulia Petrova/Russian Arctic National Park: 218/219

Rex Shutterstock: 158 (Marc Wilson)

Shutterstock: 66/67 (Stephen Kerhofs)

Michael Spilling: 128–129 all